PICTURING THE PACIFIC

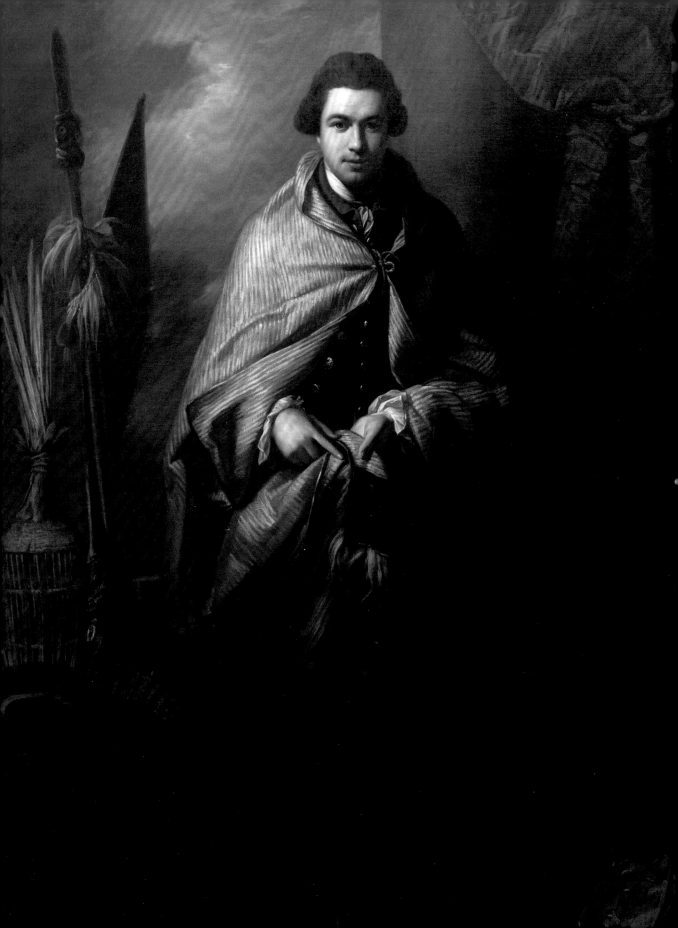

PICTURING THE PACIFIC

JOSEPH BANKS AND THE SHIPBOARD ARTISTS OF COOK AND FLINDERS

JAMES TAYLOR

ADLARD COLES

LONDON · OXFORD · NEW YORK · NEW DELHI · SYDNEY

To Helga Webb, the Queen of Wessex Explorers

ADLARD COLES
Bloomsbury Publishing Plc
50 Bedford Square, London, WC1B 3DP, UK

BLOOMSBURY, ADLARD COLES and the Adlard Coles logo
are trademarks of Bloomsbury Publishing Plc

First published in Great Britain 2018

A catalogue record for this book is available from the British Library

Library of Congress Cataloguing-in-Publication data has been applied for

ISBN: HB: 978-1-4729-5543-2; ePub: 978-1-4729-5544-9; ePDF: 978-1-4729-5545-6

2 4 6 8 10 9 7 5 3 1

Typeset in Adobe Garamond by Lee-May Lim
Printed and bound in China by C&C Offset Printing Co

Bloomsbury Publishing Plc makes every effort to ensure that the papers used in the
manufacture of our books are natural, recyclable products made from wood grown in
well-managed forests. Our manufacturing processes conform to the environmental
regulations of the country of origin.

To find out more about our authors and books visit www.bloomsbury.com
and sign up for our newsletters.

CONTENTS

Foreword ... 6
Acknowledgements ... 7
Introduction ... 8

CHAPTER ONE
ART AND ILLUSTRATION OF PACIFIC EXPLORATION
Joseph Banks' experience of the South Seas, encouragement of voyager artists
and role in the expedition publications ... 12

CHAPTER TWO
EXPLORATION NETWORKS AND PACIFIC RESEARCH CENTRES
Joseph Banks' family background, social and professional connections,
London residences and interest in art for a practical purpose ... 66

CHAPTER THREE
PICTURING THE PACIFIC AND CLASSICAL ANTIQUITY
Joseph Banks' membership of the Society of Dilettanti, his passion
for neoclassicism and its impact on voyager art ... 96

CHAPTER FOUR
FIRST AUSTRALIAN ARTWORK
Joseph Banks' role in Matthew Flinders' *Investigator* voyage and the
creation and exhibition of the earliest landscape in Europe ... 148

CHAPTER FIVE
PAINTING AROUND AUSTRALIA
Joseph Banks' role in the creation of the first series
of oil paintings of *Terra Australis* ... 184

CHAPTER SIX
PROMOTING AUSTRALIA IN PICTURES
Joseph Banks' encouragement of the voyager artist William Westall
and his involvement with free settlement in south Australia ... 232

Conclusion ... 252
Index of Artworks and Artists ... 253

FOREWORD

As a direct descendant of William Westall, the landscape and figure draughtsman who sailed on Flinders' circumnavigation of Australia from 1801 to 1803, it gives me great pleasure to write this foreword. Here for the first time in one volume is an overview of the importance of voyager artists on remarkable expeditions of discovery led by captains James Cook and Matthew Flinders connected by Sir Joseph Banks.

For more than a decade I have had the opportunity to accompany Dr James Taylor on some of his travels to discover more about William Westall's contribution to the illustration and interpretation of Australia, with emphasis on the oil paintings he completed for the Admiralty.

From York to Wiltshire, and many places in between, we went on the trail of Westall's Australian pictures and found ourselves often discussing the influence of Joseph Banks, perhaps the most prominent botanist in British history. Unfortunately, I did not travel with James to Australia where he found out more about Westall's continuing interest in that country.

Whether it was James' support for me in the talk I gave at the National Maritime Museum, Greenwich, or sharing his wide knowledge of art especially marine painting of which I benefitted immensely, it is also gratifying to know that our friendship has also been of mutual benefit. As the great-great-grandson of Westall, the artist's work has been relevant to me throughout my life.

I would like to thank James for seeking out and contributing so much new voyager art material and especially in relation to the career of William Westall. It has been a 'personal expedition' which parallels the voyage of Westall's travels to Australia and beyond.

Richard J. Westall

For a full bibliography for this book visit:
www.picturingthepacific.com

ACKNOWLEDGEMENTS

Many people have been immensely helpful during the research work for this publication. They include: Professor Geoff Quilley, University of Sussex; Michael Rosenthal, Emeritus Professor, University of Warwick; Dr Sarah Thomas, Birkbeck, University of London; Dr Kerry Bristol, University of Leeds; Jenny Wraight, the Admiralty Librarian, HM Naval Base, Portsmouth; Guy Hannaford, Archive Research Manager, United Kingdom Hydrographic Office; Rachel Hewitt, Collections Manager, Royal Academy of Arts; Kiri Ross-Jones, Archivist & Records Manager, Royal Botanic Gardens, Kew; James Piell, Curator, Goodwood Collection; Simon Bird, Charlotte Henwood and Angela Locke all formerly of the Ministry of Defence Art; Eve Watson, Archivist/Librarian, Royal Society of Arts; Joy Wheeler, Librarian, Royal Geographical Society; Sarah Sworder of the Natural History Museum; Charles Greig, independent researcher; Professor Kenneth Morgan, University of Brunel and Professor Jordan Goodman, University College London; Susan Bennett, Hon. Sec, William Shipley Group for RSA History and the access staff of the British Library, British Museum, Cambridge University Library, Central Library Liverpool and the Victoria & Albert Museum.

Also, the picture access and librarian staff of the Art Gallery of South Australia; Dr Gillian Dooley, Honorary Senior Research Fellow, English, Flinders University; Anne McCormick and Rachel Robarts, Hordern House; Professor Alex George, Murdoch University, Perth; Roger Butler and Elspeth Pitt, Australian Prints and Drawings, and Rose Montebello, Coordinator, National Gallery of Australia; Robyn Holmes, Senior Curator of Pictures and Manuscripts, Nicky Mackay-Sim, Curator of Pictures and Dr Martin P Woods, Curator of Maps, National Library of Australia, Canberra; Michelle Hetherington, Senior Curator, National Museum of Australia; Richard Neville, Mitchell Librarian and Sarah Morley, Curator, State Library of New South Wales; Dr Paul Forster,

Queensland Herbarium, Brisbane and the Yale Centre for British Art.

In addition, Captain Michael Barrett, Past President of the Hakluyt Society; Dr John McAleer, University of Southampton; Paul Scott, Sir Joseph Banks Society; Jon Astbury, Dr Katy Barrett, Tina Chambers, Emma Lefley, Gillian Hutchinson, Caroline Hampton, Elizabeth Hamilton-Eddy, Dr Pieter van der Merwe and Dr Nigel Rigby, all from the National Maritime Museum, Greenwich. I am grateful for the generosity of the museum for the short-term Sir James Caird Research Award to examine their collections and records; also, that of the Paul Mellon Foundation and the University of Sussex for travel support to the National Library of Australia, Canberra and the State Library of New South Wales to examine the expedition artwork of William Hodges, John Webber and William Westall.

Thank you to the following organisations for kindly assisting in the provision of illustrations: the Art Gallery of South Australia; National Gallery of Australia; National Library of Australia; National Portrait Gallery of Australia; Art Gallery of New South Wales; State Library of New South Wales; State Library of South Australia and Hordern House; Metropolitan Museum of Art; J Paul Getty Museum, and Yale Center for British Art; Pennsylvania Academy of the Fine Arts; British Library; British Museum; Bonhams; Christie's Fine Art Auctioneers; The Collection Museum, Lincoln; Goodwood Estate; Linnean Society; National Gallery, London; National History Museum, London; National Maritime Museum, Greenwich; National Portrait Gallery, London; Royal Bank of Scotland; Royal Collection; Royal Society; V&A; Wedgwood Museum; Wellcome Collection; also the private collectors who wish to remain anonymous.

Finally, to Richard J. Westall, a direct descendant of William Westall, whose passion for exploring aspects of his forebear's life and work has profoundly imprinted on the author.

INTRODUCTION

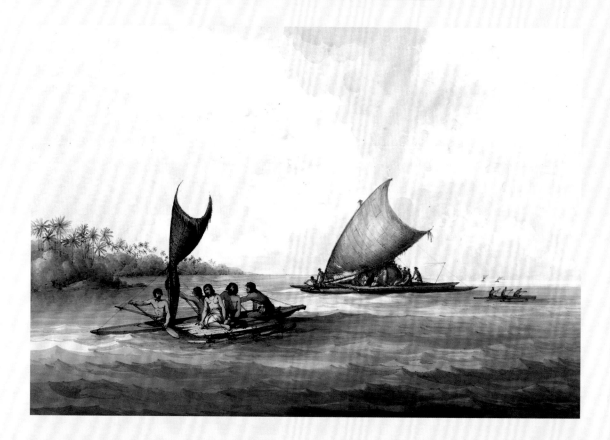

Sir Joseph Banks, 1st Baronet (1743–1820), President of the Royal Society, is perhaps best known today for his passion for botany and his participation with captain James Cook on the pioneering voyage of His Majesty's Ship *Endeavour* to the Pacific from 1768 to 1771.

This led to sensational ethnographic, geographic and scientific discoveries, including flora and fauna, resulting in the *Florilegium* – a magnificent botanical colour printing project, co-authored with fellow naturalist Dr Daniel Solander, albeit published after their deaths – and the first European paintings of the dingo and kangaroo by the acclaimed animal artist George Stubbs. It also led to some of the earliest images of domestic, ceremonial and martial artefacts, body adornments, rituals and customs in Australia,

New Zealand, Tahiti, Hawaii, and other Pacific islands.

Banks' longstanding association and enduring influence with voyages of exploration extended to all known continents, although he had a predilection for the Pacific. The ocean's name derives from the voyage of the Portuguese explorer Ferdinand Magellan who

ABOVE

Boats of the Friendly Islands, hand-coloured soft-ground etching after and by John Webber (1751–93), published by him on 1 August 1791. British Museum. 1872.0713.547. Tonga was known in Britain as the Friendly Islands because of the warm reception given to Cook and his men on their first visit in 1773.

in November 1520, after surviving perilous seas and successfully navigating his way through the Magellan Straits, called the unknown tranquil waters he encountered the Pacific. This translates as 'peaceful', a misnomer given that this gargantuan ocean, the largest and deepest in the world, is more usually known for being turbulent in tandem with ongoing dramatic environmental climate change.

The US National Ocean Service provides a useful summary of this vast region: 'Covering approximately 59 million square miles and containing more than half of the free water on Earth, the Pacific is by far the largest of the world's ocean basins. All of the World's continents could fit into the Pacific basin!'

The lion's share of the imagery in this publication relates to the Pacific, although there are also depictions of lands, people and artefacts relating to the Indian Ocean in western Australia, the Southern Ocean in south Australia, as well as the Timor and Arafura Seas off the northern coastline of Australia. On a few occasions when the word 'Pacific' is used other connected oceans, although not always stated, are included too.

London-born Banks had longstanding links to the county of Lincolnshire. Educated at Harrow, Eton and the University of Oxford, he inherited and married into wealth and could have dissipated the family fortune on frivolities. Instead, he put it to good use expending considerable resources in support of British voyages of exploration and discovery.

Banks was the linchpin of his handpicked shipboard party of experimental gentlemen, as *Endeavour*'s seamen called them. He worked alongside and independently of captain James Cook during the observations on the recently encountered island of Tahiti, in their search for the fabled *Terra Australis Incognita*, or Unknown South Land, as well as in the charting of New Zealand and the east coast of Australia.

This would lead to Banks' recommendation to the British government that Botany Bay was a suitable place to send convicts from Britain, which resulted in the establishment of the first penal colony at Sydney Cove, New South Wales in 1788. Banks was instrumental in expanding the geographical focus of Britain's imperial and colonial policy to include the Pacific.

Joseph Banks, however, ought to be acclaimed too for popularising the placement of professional artists and naturalists aboard British ships exploring the Pacific from 1768 to the mid-1830s. During his own lifetime this included Cook's *Endeavour* expedition, and commander Matthew Flinders' in the *Investigator*, the first ship to circumnavigate Australia in the years 1801–03 (which led to the first accurate map of that island continent and its modern-day name) and beyond to the founding of the city of Adelaide in 1836, the first free settlement in Australia. It also included captain Robert FitzRoy's five-year voyage of the *Beagle* from 1831 to 1836, accompanied by Charles Darwin his naturalist and 'gentleman-companion', resulting in the publication of his ground-breaking book *On the Origin of Species* in 1859.

Long before the advent of photography, Banks encouraged botanical artists, natural-history painters, and landscape and figure draughtsmen to bring back eye-catching, exotic and fascinating depictions of the indigenous people, their artefacts, habitats, customs, rituals and ceremonies, the flora and fauna and the coastal and landscape settings not previously seen, known or fully understood in Europe.

Diverse drawings, sketches, watercolours and oils were created and developed from the artists' exploration experiences, a selection of which were displayed to an enthusiastic, sometimes awestruck and highly critical public at London's leading public art venues. Many others were transformed into engravings for the official and unofficial illustrated voyage publications. Some of them became hugely successful bestsellers with translations into various languages.

As these voyages had a significant scientific orientation, and natural history was regarded as a mainstream science at this time, unsurprisingly a large body of artistic work was documentary in nature, often full of detailed visual information accompanied with descriptive notes. It was widely appreciated, and

acknowledged by Banks, Cook and Flinders, that drawings could make intelligible things that would be difficult, or nigh impossible, to express in words. The professional artists also assisted the captain and those assigned to navigational duties by creating coastal profiles that were essential for navigation and to assert territorial claims.

A smaller (although no less important) body of voyager art exhibits the artistic style of neoclassicism, one that new evidence reveals was privately approved of – and on significant occasions officially endorsed for public consumption – by Banks and his influential circle on behalf of the Admiralty, the government department responsible for controlling the Royal Navy.

Followers of neoclassicism advocated the appreciation, study and collection of the classical antiquities of Greece and Rome. To them, and many others in Europe and further afield, the classical world represented the pinnacle in the cultural achievement of mankind. This was encouraged by the Grand Tourists, who were especially active in the 18th century, and the formation of influential organisations such as the Society of Dilettanti, of which Banks was a prominent and long-serving member.

Founded in the early 1730s, the Society of Dilettanti had a diverse membership. In addition to aristocrats and the landed gentry, it included architects, artists, authors, clergymen, lawyers, military men and politicians. The Society encouraged an interest in classical antiquity and sponsored the creation of new art in a classical style.

The artists featured in this publication associated with neoclassicism include: the landscape and figure draughtsman Alexander Buchan, and Sydney Parkinson, the natural history painter on the *Endeavour* expedition; William Hodges and John Webber, the Admiralty artists on Cook's second and third voyages respectively who covered diverse subjects; and William Westall, selected by Banks as the landscape and figure draughtsman on Flinders' *Investigator* expedition. Ferdinand Bauer, the natural-history painter and Westall's fellow artist is an

exception, although his artworks were far from being dry documentary records.

Bauer combined an attention to detail with an artistry that raised the genre of natural-history painting to a new level. He produced more than 2,000 carefully crafted and exquisitely detailed drawings – predominately botanical artworks – a number of which zoom in and super-size specific parts under the supervision of the shipboard naturalist Robert Brown who effectively used the microscope to analyse specimens. Bauer produced a smaller number of superlative zoological artworks. These included the bizarre-looking duck-billed platypus, which many people refused to believe was a real creature, and the sleep-loving koala.

Across the wide-ranging work of the voyager artists you can find imaginary rather than documentary imagery, with indigenous people resembling figures from classical antiquity. Some are reminiscent of Greek and Roman gods and ancient spear- and sword-wielding warriors; others bring to mind mortal citizens of the Greek or Roman Empire. This is especially evident in the artwork of Buchan, Parkinson, Hodges and Webber in relation to Tierra del Fuego, New Zealand, Tahiti, Hawaii and other Pacific Islands, whereas Westall had a preference for creating Arcadian classical landscape scenes in Australia, some featuring neoclassical figures.

Some of the work of the voyager artists was actually transformed into a neoclassical style back in Britain by other artists, designers and engravers, who had no experience of the Pacific. If this was not as a direct consequence of Banks' involvement, it was by members of his personal and professional circles who advocated this fashionable taste. During the latter part of the 18th century and early 19th century this was further encouraged by the acquisition from Greece and Italy of some of the finest classical antiquities. Some of these privately owned classical treasures were open to the public by appointment, others by admission. Many of them later passed into public ownership.

As President of the Royal Society from November 1778 Banks was also an *ex officio* trustee of the British

Museum that opened to the public in 1759. He was actively involved and would have played a role in arranging for a copy of the celebrated Portland Vase, successfully replicated by Josiah Wedgwood in 1790, to be acquired by the British Museum.

The original vase, owned by the Duchess of Portland (who purchased it from Sir William Hamilton, spouse of Horatio Nelson's mistress), is a masterpiece of Roman cameo glass by an unknown maker. It features classical figures in close proximity with lithe bodies and overlong limbs (all characteristics of neoclassical art), and dates from between AD 1 and AD 25. Banks was involved in its long-term loan to the British Museum in 1810.

Banks himself was depicted in a neoclassical Wedgwood Jasperware portrait medallion, produced around 1779. He is featured in profile wearing a toga, with an accentuated neck and stylised hair that at first sight make him resemble a Roman emperor.

Under Banks' guidance and close supervision, William Westall – the landscape and figure draughtsman on the *Investigator* voyage – was able to create and display an Australian landscape at the Royal Academy of Arts in 1805. It was the first by a professional artist to have visited that island continent.

This led to a special commission championed by Banks for Westall to create ten oil paintings of key parts of Australia. They included views close to Albany and Esperance on the western coast; Adelaide and Kangaroo Island in the south; on the central Queensland coast; also the northern point of Cape York Peninsula, the mouth of the McArthur river and Cape Wilberforce in the Northern Territory. Completed in 1813, Westall's paintings are the earliest series of Australia. They represent the art-historical bridge between the voyages of Captains James Cook and Robert FitzRoy. Many of them were inspired by the landscape conventions popularised by the 17th-century French classical painter Claude Lorrain, popularly known as Claude, an artist admired by members of the Society of Dilettanti.

Banks was instrumental in arranging for one of Westall's oil paintings to be exhibited at the Royal Academy of Arts in 1810 and another two in 1812, and was regularly invited to attend the organisation's grand annual private view that took place in spring before the official public opening.

His influential artistic circle of architects, designers, engravers and painters included prominent artists such as Benjamin West, the President of the Royal Academy of Arts, who painted a forceful full-length portrait of Banks surrounded by artefacts and specimens from the Pacific. Another was the pioneering neoclassical architect James 'Athenian' Stuart, who supported Banks' membership for the Society of Dilettanti.

The adoption of neoclassicism in a selection of the voyager art of Cook and Flinders helped to shape, or rather distort, some people's understanding of Australia, New Zealand, Tahiti, Hawaii and other Pacific Islands. There were aesthetic, economic, political and promotional reasons behind the adoption of this artistic style, which are revealed in the pages that follow.

A striking selection of documentary and neoclassical artworks drawn from the remarkable voyages of Pacific exploration is presented here, all of which in one way or another can be connected to Banks and his influential personal and professional networks.

Drawing upon the official records and publications of the Admiralty, the Royal Navy and the British government – as well as diaries such as that of the Royal Academician Joseph Farington, journals including those of Captains James Cook and Matthew Flinders, letters such as the wide-ranging correspondence of Sir Joseph Banks, and newspapers – a fresh interpretation of British exploration through the art of Pacific exploration, with Banks at its centre, is presented here.

It is Joseph Banks – through his active and longstanding encouragement of the artists, and the creation of their work in all its forms, intertwined with the development of the British Empire – who is largely responsible for 'Picturing the Pacific' in the Enlightenment Age.

ART AND ILLUSTRATION OF PACIFIC EXPLORATION

Joseph Banks' experience of the South Seas, encouragement of voyager artists and role in the expedition publications

Part 1 – Voyage of the *Endeavour*

Joseph Banks participated in captain James Cook's pioneering exploratory and scientific voyage to the Pacific on the *Endeavour* from 1768 to 1771 sponsored by the Royal Society. Founded in 1660 the original and longer name of this eminent and enduring organisation is the Royal Society of London for Improving Natural Knowledge.

Banks was elected a fellow on 1 May 1766 and his certificate of election contained prophetic words. Several sponsors of his application recommended

BELOW

A General Chart Exhibiting the Discoveries made by Captn. James Cook in this and his two preceding Voyages; with the Tracks of the Ships under his Command, By Lieut. Roberts of His Majesty's Royal Navy. Published by William Faden (1749–1836), 'royal geographer to King George III' in 1784. Barry Lawrence Ruderman Antique Maps Inc. The track of Cook's first Pacific voyage is denoted in red; the second in yellow and third in blue.

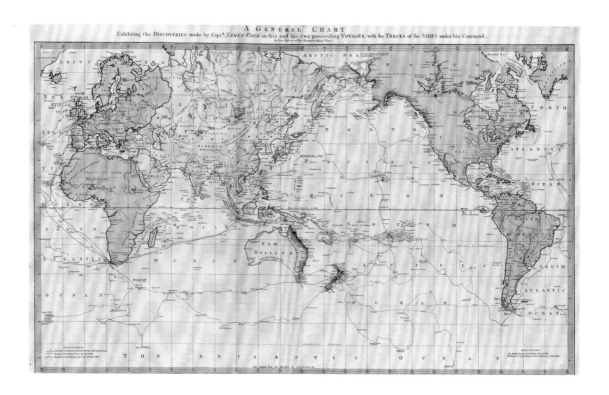

Banks on the basis that he was a gentleman 'versed in natural history especially Botany and other branches of literature and likely (if chosen) to prove a valuable member'. He would become President of the Royal Society in November 1778.

The Royal Society persuaded the Admiralty that 'Joseph Banks … a Gentleman of large fortune … should be permitted to join the expedition with his Suite'.

The principal aim of the voyage was to observe the transit of the planet Venus across the face of the sun that would occur on 3 June 1769. The measurements were taken by other parties in different parts of the world and then collated with earlier observations of the transit to calculate the distance from the earth to the sun, a unit of measurement that was essential to assist with accurate marine navigation.

News of a recently returned Royal Navy exploration ship commanded by Captain Samuel Wallis, and his first encounter with Tahiti in June 1767, encouraged the Royal Society to reconsider its original plans and select that location to observe the transit.

In August 1768 the *Endeavour* set sail from Plymouth with 95 personnel including Banks' party bound for Tahiti. After stopovers in Madeira, Rio de Janeiro and Tierra del Fuego she would arrive in April 1769 well ahead of time to set up telescopes, timekeepers and other equipment needed for the transit. Cook also carried secret instructions to be opened after this task was completed ordering him to search for *Terra Australis Incognita*, or the Unknown South Land.

Cook's Secret Instructions [from the original document]

By the Commissioners for executing the office of Lord High Admiral of Great Britain & ca. Additional Instructions for Lt James Cook, Appointed to Command His Majesty's Bark the Endeavour *Whereas the making Discoverys of Countries hitherto unknown, and the Attaining a Knowledge of distant Parts which though formerly discover'd have yet been but imperfectly explored, will redound greatly to the Honour of this Nation as a Maritime Power, as well as to the Dignity of the Crown of Great Britain, and may tend greatly to the advancement of the Trade and Navigation thereof;…*

…and Whereas there is reason to imagine that a Continent or Land of great extent, may be found to the Southward of the Tract lately made by Captn Wallis in His Majesty's Ship the Dolphin *(of which you will herewith receive a Copy) or of the Tract of any former Navigators in Pursuit of the like kind, You are therefore in Pursuance of His Majesty's Pleasure hereby requir'd and directed to put to Sea with the Bark you Command so soon as the Observation of the Transit of the Planet Venus shall be finished and observe the following Instructions.*

You are to proceed to the Southward in order to make discovery of the Continent abovementioned until' you arrive in the Latitude of 40°, unless you sooner fall in with it. But not having discover'd it or any Evident sign of it in that Run you are to proceed in search of it to the Westward between the Latitude beforementioned and the Latitude of 35° until' you discover it, or fall in with the Eastern side of the Land discover'd by Tasman [Abel Tasman] and now called New Zeland [sic].

If you discover the Continent abovementioned either in your Run to the Southward or to the Westward as above directed, You are to employ yourself diligently in exploring as great an Extent of the Coast as you can carefully observing the true situation thereof both in Latitude and Longitude, the Variation of the Needle; bearings of Head Lands Height direction and Course of the Tides and Currents, Depths and Soundings of the Sea, Shoals, Rocks &ca and also surveying and making Charts, and taking Views of Such Bays, Harbours and Parts of the Coasts as may be useful to Navigation.

You are also carefully to observe the Nature of the Soil, and the Products thereof; the Beasts and Fowls that inhabit or frequent it, the Fishes that are to be found in the Rivers or upon the Coast and in what Plenty and in Case you find any Mines, Minerals, or valuable Stones you are to bring home Specimens of each, as also such Specimens of the Seeds of the Trees, Fruits and Grains as you may be able to collect, and Transmit them to our Secretary that We may cause proper Examination and Experiments to be made of them.

You are likewise to observe the Genius, Temper, Disposition and Number of the Natives, if there be any and endeavour by all proper means to cultivate a Friendship and Alliance with them, making them presents of such Trifles as they may Value inviting them to Traffick, and Shewing them every kind of Civility and Regard; taking Care however not to suffer yourself to be surprized by them, but to be always upon your guard against any Accidents.

You are also with the Consent of the Natives to take Possession of Convenient Situations in the Country in the Name of the King of Great Britain: Or: if you find the Country uninhabited take Possession for his Majesty by setting up Proper Marks and Inscriptions, as first discoverers and possessors.

But if you shall fail of discovering the Continent beforemention'd, you will with upon falling in with New Zeland [sic] carefully observe the Latitude and Longitude in which that Land is situated and explore as much of the Coast as the Condition of the Bark, the health of her Crew, and the State of your Provisions will admit of having always great Attention to reserve as much of the latter as will enable you to reach some known Port where you may procure a Sufficiency to carry You to England either round the Cape of Good Hope, or Cape Horn as from Circumstances you may judge the Most Eligible way of returning home.

You will also observe with accuracy the Situation of such Islands as you may discover in the Course of your Voyage that have not hitherto been discover'd by any Europeans and take Possession for His Majesty and make Surveys and Draughts of such of them as may appear to be of Consequence, without Suffering yourself however to be thereby diverted from the Object which you are always to have in View, the Discovery of the Southern Continent so often Mentioned. But for as much as in an undertaking of this nature several Emergencies may Arise not to be foreseen, and therefore not to be particularly to be provided for by Instruction beforehand, you are in all such Cases to proceed, as, upon advice with your Officers you shall judge most advantageous to the Service on which you are employed.

You are to send by all proper Conveyance to the Secretary of the Royal Society Copys of the Observations you shall have made of the Transit of Venus; and you are at the same time to send to our Secretary for our information accounts of your Proceedings, and Copys of the Surveys and discoverings you shall have made and upon your Arrival in England you are immediately to repair to this Office in order to lay before us a full account of your Proceedings in the whole Course of your Voyage; taking care before you leave the Vessel to demand from the Officers and Petty Officers the Log Books and Journals they may have Kept, and to seal them up for our inspection and enjoyning them, and the whole Crew, not to divulge where they have been until' they shall have Permission so to do.

Given under our hands the 30 of July 1768

Ed Hawke [Sir Edward Hawke, 1st Baron Hawke, First Lord of the Admiralty, 1766–71]

Piercy Brett [Admiral Sir Piercy Brett]

C Spencer [Lord Charles Spencer]

By Command of their Lordships

Php Stephens [Sir Philip Stephens, 1st Baronet, First Secretary of the Admiralty]

The *Endeavour* team, the ship and equipment

To assist Banks during the voyage he assembled a party of eight consisting of the artists Alexander Buchan and Sydney Parkinson, the Swedish naturalist Dr Daniel Solander (the favourite pupil of Carl Linnaeus who became Banks' close friend and curator-librarian), Herman Dietrich Spöring from Finland (a former watchmaker working as an amanuensis, who produced some drawings of botanical and zoological subjects, as well as coastal profiles), two assistants James Roberts and Peter Briscoe, two black servants Thomas Richmond and George Dorlton, and two greyhounds. The party was assembled all at Banks' own expense. Their salaries, kit and equipment, in addition to his own, cost him the enormous sum of £10,000, the modern-day equivalent of more than one and a half million pounds.

King George III – to whom Banks became an intimate adviser on colonial and imperial issues, and agricultural and botanical matters (in particular those of the Royal Botanic Gardens, Kew) – sponsored the expedition to the tune of £4,000. The Admiralty provided the discovery vessel *Endeavour*, a converted Whitby-built collier originally called the *Earl of Pembroke*, as well as the victualling and crew.

For the expedition the 368-ton *Endeavour* had been transformed into a twin-decked, three-masted barque, or bark, with an overall length of 105 feet, a breadth slightly in excess of 29 feet, and a draft of some 14 feet fully laden. She was designed for cargo not guns, being beamy, stout and with a draft enabling her to transport substantial supplies and navigate shallow water. Also, if grounded she could be floated free with greater ease compared to a heavier vessel, a perilous situation that would occur on the Great Barrier Reef.

North Yorkshire-born Cook was familiar with this type of vessel, having sailed in them carrying coal from the Tyne to the Thames, and elsewhere, during his apprenticeship and service to the Walker family of Whitby. Later in 1755 his decision to enlist in the Royal Navy and his skills as a surveyor would take him from local waters to North America to assist with General James Wolfe's invasion of Canada, twice to the South Pacific and on a third fatal quest trying to locate the Northwest Passage.

Subsequent vessels for Cook's voyages were also Whitby-built and of a similar type: the *Resolution* and *Adventure* served on the second expedition, and the *Resolution* and *Discovery* on the third. The space aboard all these ships was confined, the Admiralty's preference being for seaworthiness rather than the optimum comfort of the officers and crew.

For Flinders' *Investigator* voyage, a follow-on expedition that was investigating the coastline of Australia for cartographic and commercial purposes, he was provided with what he described as a comparable ship used by Cook. She was built further up the north-east coast at Monkwearmouth, Sunderland, and was originally named *Fram*, and later named *Investigator* by Banks, who also arranged for her to carry an erectable plant cabin. The vessel leaked so badly, due to a poor conversion prior to departure, that Flinders was forced to prematurely terminate his mission, although what he achieved was remarkable. The side elevation and deck plans of the *Investigator* are published with those of the *Endeavour* in Nigel Rigby's fascinating chapter 'Not At All A Particular Ship…' in *Matthew Flinders and his Scientific Gentleman* (2005).

Returning to the *Endeavour*, a letter from the linen merchant and naturalist John Ellis to the Swedish taxonomist Carl Linnaeus, dated 19 August 1768, states that 'no people ever went to sea better fitted out for the purpose of Natural History, nor more elegantly'. Ellis also asserts that Banks had been encouraged to go on the voyage because of Linnaeus' botanical work and the development of his classification system.

Ellis provides further insights into Banks' participation, writing: 'I must now inform you that Joseph Banks, Esq … a gentleman of £6,000 per

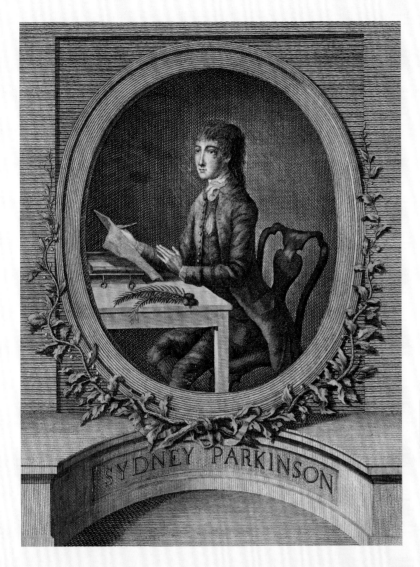

annum estate, has prevailed on your pupil, Dr Solander, to accompany
him in the ship that carries the English astronomers to the new-discovered
country in the South Sea [Tahiti] where they are to collect all the natural
curiosities of the place, and, after the astronomers have finished their
observations on the transit of Venus, they are to proceed under the direction
of Mr Banks, by order of the Lords of the Admiralty, on further discoveries'.

He continues: 'They have got a fine library of natural history; they
have all sorts of machines for catching and preserving insects; all kinds of
nets, trawls, drags, and hooks for coral fishing; they have even a curious
contrivance of a telescope by which, put into the water, you can see the
bottom at a great depth, when it is clear'.

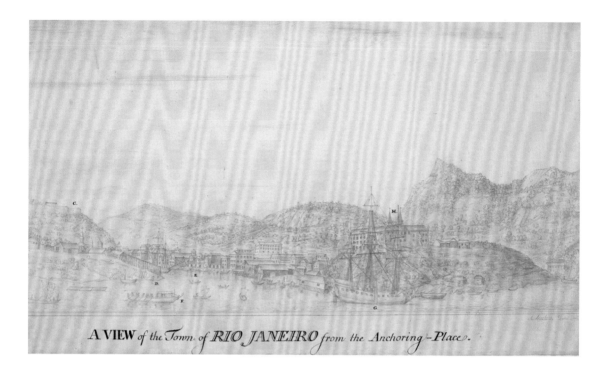

A VIEW of the Town of RIO JANEIRO from the Anchoring-Place.

And furthermore: 'They have many cases of bottles with ground stoppers, of several sizes, to preserve animals in spirits. They have the several sorts of salts to surround the seeds; and wax, both bee's-wax and that of the *Myrica* [used as a preventative against insects]; besides there are many people whose sole business it is to attend to them for this very purpose. They have two painters and draughtsmen, several volunteers who have a tolerable notion of natural history; in short Solander assures me this expedition would cost Mr Banks £10,000.'

Banks' shipboard artists Alexander Buchan and Sydney Parkinson were paid £80 per annum. They had probably been recommended to him by Selkirk-born botanist James Lee, who co-established one of the most respected and long-running plant nurseries, called the Vineyard located in Hammersmith, west London, which survived until the early 20th century. Parkinson was the second son of Joel Parkinson, an Edinburgh-born Quaker and brewer by profession who fell on hard times and left the family destitute.

Sydney Parkinson was initially apprenticed to a fabric merchant and is believed to have studied for a time at the Trustee's Drawing Academy, the forerunner to the Edinburgh College of Art, under the French-born artist master William Delacour. The aim of the Academy was to 'provide instruction for people involved in design for manufacture, in particular promoting the art of drawing for use in designing patterns for the wool and linen industries'.

However, Sydney abandoned this trade, deciding instead to pursue a career as a botanical artist. This encouraged him to move to the south of England where he came across Lee, whose plant nursery provided plenty

ABOVE

Rio de Janeiro, dated November 1768, by Alexander Buchan (died 1769), graphite on paper. British Library, London. BL23920. ff. 7-9. One of three drawings that make up a panoramic view of the harbour and town.

of subject material. Sydney exhibited flower pictures at the Free Society of Artists in 1765 and 1766, some of which are painted on silk. The Natural History Museum in London holds what is believed to be a self-portrait in oils.

Lee may have also recommended fellow *Endeavour* artist Alexander Buchan, of whom remarkably few verifiable details – including that of his appearance – are known, although his surname is certainly of Scottish origin. Buchan specialised in landscape and figures and produced some profiles of the coastlines of Brazil and Tierra del Fuego.

The voyager artists on the *Endeavour* expedition were usually (although not exclusively) guided by Banks and Solander in terms of selecting appropriate subjects, invariably with a view that their artworks might be suitable for illustrations. However, part of the professional artists' duties – especially those with an aptitude for landscape views – related to the essential ongoing chart-making that preoccupied the captain and officers.

When unfamiliar or poorly recorded coastlines came into view Cook and Flinders would instruct the artists and officers to draw coastal profiles. These acted as navigational aids at sea and supported British territorial claims. Some of the profiles were later engraved by the Admiralty and incorporated into the printed charts and atlases, and a selection were published as part of the official voyage publications.

The creation of coastal profiles impacted on the compositional arrangement of the work of the voyager artists William Hodges and John Webber – who sailed with Cook on his second and third voyages respectively – and William Westall, who sailed with Flinders. They incorporated variations of their coastal profiles into some of their oil paintings, a selection of which were exhibited at the Free Society of Artists, the Society of Artists and the Royal Academy of Arts in London.

Three fine examples of this type of hybrid artwork in oils that combined elements of cartography are found in William Hodges' *A View of the Cape of Good Hope, Taken on the Spot, from on Board the 'Resolution', Capt Cooke* [*sic*], 1772; John Webber's *View of Santa Cruz, Tenerife*, 1776; and William Westall's view in Western Australia entitled *Bay on the South Coast of New Holland, discovered by Captain Flinders in HMS 'Investigator'*, 1802.

Insights into their day-to-day working life aboard ship are extremely rare, especially in relation to the artists' work. Normally on a Royal Navy vessel the captain's cabin was his sole domain; however, on voyages of exploration there was flexibility in terms of the function of the space, and on the *Endeavour* voyage it was shared with Banks and Dr Solander, and when required with other officers. The stern windows provided more light, making it the ideal place for developing the charts, examining the specimens and making drawings and paintings, although the men would have used their own cabins too.

In addition to portable boxes of watercolour paints and paper, of which very little is known in terms of their preferred manufacturers, although Reeves, (as identified by Geoff Quilley, Professor of Art History, University of Sussex) was used by officers. This manufacturer had been recommended by Alexander Dalrymple, the Scottish geographer and first hydrographer of the Royal Navy, who noted in his *General Collection of Nautical Publications* (1783) that, 'Reeves's coloured Pencils will be very convenient for giving explanatory touches to the Views of Land'.

One record is especially insightful and memorable concerning the challenges that faced expedition artists working in the Pacific, especially in relation to pesky insects. Banks noted in his *Endeavour* journal on 22 April 1769 while in Tahiti that, 'The flies have been so troublesome ever since we have been ashore that we can scarce get any business done for them; they eat the painters colours off the paper as fast as they can be laid on, and if a fish is to be drawn there is more trouble in keeping them off it than in the drawing itself. Many expedients have been thought of none succeed better than a mosquito net which covers table, chair, painter and drawings, but even that is not sufficient, a fly trap was necessary to set within this to attract the vermin from eating the colours.'

A View of the Cape of Good Hope, Taken on the Spot, from on Board the Resolution, *Capt Cooke* [sic], painted in 1772 by William Hodges (1744–97), oil on canvas. National Maritime Museum, Greenwich. BHC1778. A fine example showing the influence of the voyager artist's coastal profile work influencing the composition of a painting, as discussed on page 21. The vessel featured is the *Adventure*. Table Mountain is often clouded over and the focus on weather conditions here derives from Cook's influence. The ability to be able to read the weather at sea could mean the difference between life and death.

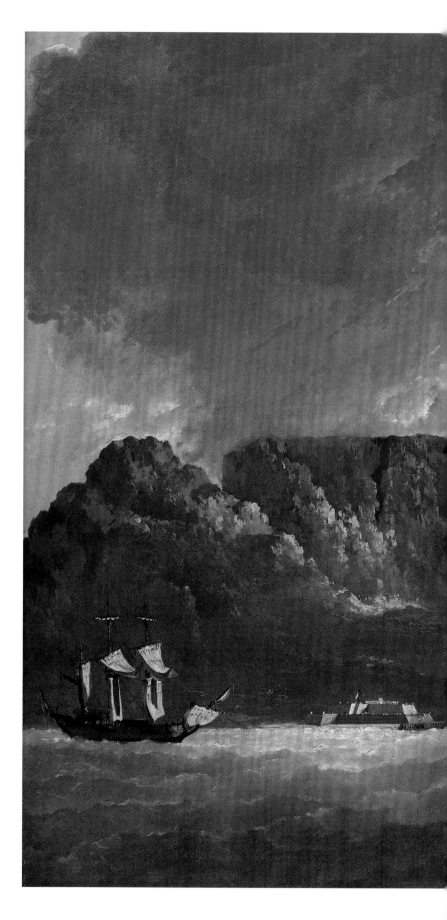

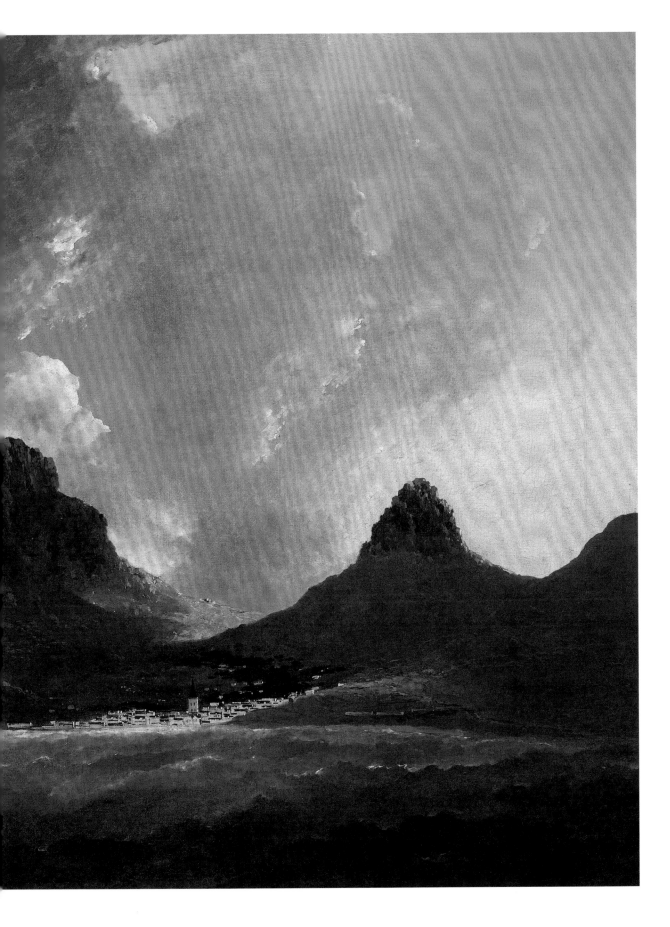

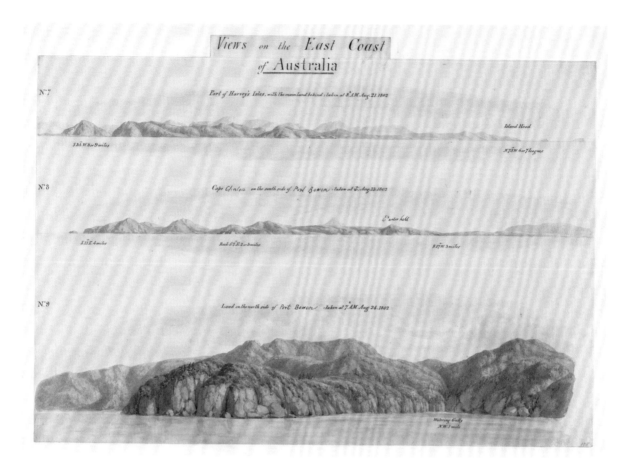

Nº 7 Part of Harvey's Isles, with the mainland behind : taken at 8 A.M. Aug. 21. 1802

Island Head

S.85.W. 8 or 9 miles.

N.75.W. 6 or 7 leagues

Nº 8 Cape Clinton on the south side of Port Bowen : taken at 5. Aug. 23. 1802

S. water hill

S.21.E. 4 miles. Rock S.5.E. 2 or 3 miles. S.17.W. 3 miles.

Nº 9 Land on the north side of Port Bowen : taken at 7 A.M. Aug. 24. 1802

Watering Gully
N.W. 1 mile

A list of the books taken aboard the *Endeavour* by Parkinson was recorded by the artist in one of his sketchbooks, now in the British Library. They included William Hogarth's *Analysis of Beauty*, the plays of Shakespeare, the poetry of Chaucer and Spenser, as well as Homer's *Iliad* and *Odyssey*, Ovid's *Metamorphoses* and Virgil's poems. Shipboard libraries were assembled on subsequent discovery ships that included books on botany, natural history, exploration and travel, some of which the artists studied and copied, sometimes to improve their skills.

Banks assembled a significant library aboard the *Endeavour* largely from his own collection that included books by William Dampier, the first Englishman to visit parts of Australia – notably the western coast and New Guinea – in expeditions spanning the late 1680s to the early years of the 18th century. Dampier's *A Collection of Voyages* was published in four volumes in 1729, and Banks' copy is now in the library of the Royal Society. The diverse nature of the illustrations, which included charts, coastal profiles, botanical and natural history subjects – combined with Dampier's recommendation of the usefulness of having aboard ship a person 'skilled in drawing', which he believed was advantageous over descriptions in words – had a significant influence on Banks and the format of subsequent official Admiralty voyage publications.

ABOVE

View on the East Coast of Australia by William Westall (1781–1850), watercolour and graphite. National Library of Canberra. nla.obj-138893644. One of a series of coastal profiles that were engraved in black and white for the atlas of Captain Matthew Flinders' *A Voyage to* Terra Australis (1814). Banks determined that the name Australia be changed to Terra Australis.

Dampier, and later Banks, would have both been familiar with the work of the 17th-century philosopher and physician John Locke, and a fellow of the Royal Society, who Bernard Smith in *Imagining the Pacific – In the Wake of the Cook Voyages* (1992), acknowledged as being 'but one of many who at that time were beginning to recognise and assert in England the value of drawing for the retention and transmission of information'. Locke in *Some Thoughts Concerning Education* (1683) described 'Drawing [as] a thing very useful to a Gentleman in several occasions, but especially if he travel,' and: 'as that which helps a Man often to express, in a few Lines well put together, what a whole sheet of Paper in Writing would not be able to represent and make intelligible'. *Some Thoughts…* featured again in *The Works of John Locke Esq; Vol. III, London* published in 1722, while the seventh edition appeared in 1768 – the year Banks and Cook sailed for the South Pacific.

Cook echoes the advice of Locke and others through his absorption of the advice offered by the Royal Society and encapsulated in Admiralty Instructions for the *Endeavour* voyage. This also extended to later Pacific voyages. For example, on his second expedition he praised the Admiralty artist William Hodges, noting in journal on 11 May 1773 at Dusky Bay in New Zealand that, 'Mr Hodges has drawn a very accurate view of the North and of the South entrances, as well as of the parts of the bay, and in these drawings he has represented the mood of the country with such a skill that they will, without any doubt, give a much better idea than it is possible with words'.

The *Investigator* commanded by Flinders also carried an extensive library, with publications lent by Banks that included Banks' Dampier four-volume set, those by Alexander Dalrymple, Captain Cook, William Bligh and George Vancouver, also of some French expeditions, among others. Flinders noted a selection of the books in a letter he wrote to Banks from Sheerness prior to the departure of his voyage on 8 February 1801. He featured four headings in the list: 'Instruments, Charts, Stationary [*sic*] and

Books'. The letter is now in the State Library of New South Wales. Flinders indicates with the initials JB which publications were supplied by Banks, although it is not comprehensive.

Paul Brunton, the former Curator of Manuscripts at the State Library of New South Wales, noted in his edited edition of *The* Endeavour *Journal of Joseph Banks – The Australian Journey* (1998) that their version of the journal, preserved in the Mitchell Library, was 'later given as a work of reference' for Matthew Flinders' circumnavigation of Australia aboard the *Investigator*.

In that journal Banks provides a rare insight into his and Dr Solander's day-to-day activities. He wrote on 3 October 1769 when sailing towards the north island of New Zealand: 'Now do I wish that our freinds [*sic*] in England could by the assistance of some magical spying glass take a peep at our situation: Dr Solander setts [*sic*] at the Cabbin [*sic*] table describing, myself at my Bureau Journalizing, between us hangs a large bunch of sea weed, upon the table lays the wood and barnacles; they would see that notwithstanding our different occupations our lips move very often, and without being conjurors might guess that we were talking about what we should see upon the land which there is now no doubt we shall see very soon'.

Brunton also states that Banks took with him a guitar which he was skilled at playing. Extensive records of Banks entertaining indigenous peoples and shipmates with this instrument in the Pacific are sadly lacking. However, Sarah Morley, curator of the State Library of New South Wales, has identified a letter in their collection written by Banks aboard HMS *Niger* in Chateau Bay on 11 August 1766. In this letter, penned during his voyage to Newfoundland and Labrador commanded by his friend and fellow Etonian Constantine Phipps, Banks reveals that music was part of his leisure time: he had 'forsworn the flute' and 'learnt to play upon a new instrument' that he described as a 'guittar'.

Collectively Banks' shipboard artists on the *Endeavour* voyage created an extraordinary pictorial record relating to Rio de Janeiro, Tierra del Fuego,

Tahiti and other Pacific islands, the circumnavigation of the north and south islands of New Zealand, the charting of the eastern coast of Australia and encounters with parts of Indonesia.

First official publication of Cook's voyage

A selection of Banks' shipboard artists' memorable imagery first appeared in an Admiralty-sanctioned literary compilation published in September 1773 by the author and editor Dr John Hawkesworth, which also included earlier accounts of British voyages to the Pacific led by different captains, although no professional artists were assigned to these expeditions. It is titled *An Account of the Voyages undertaken by the order of His Present Majesty for Making Discoveries in the Southern Hemisphere; and Successively Performed by Commodore Byron, Captain Wallis, Captain Carteret, and Captain Cook in the Dolphin, the Swallow and the Endeavour; Drawn up from the Journals which were Kept by the Several Commanders and from the Papers of Joseph Banks, Esq.*

Dr John Hawkesworth was closely associated with *The Gentleman's Magazine*. He had been recommended to John Montagu, 4th Earl of Sandwich, First Lord of the Admiralty, by Charles Burney, the composer and music historian. Like Sandwich, Burney was also a fellow of the Royal Society. Dr Hawkesworth is portrayed in a group portrait of the *Endeavour*'s successful return from the Pacific, painted by the neoclassical artist John Hamilton Mortimer (probably in 1771) and now on display in the National Library of Australia.

Dr Hawkesworth was financially astute and well aware of the potential profits to be made from an official and exotically illustrated voyage publication. He negotiated the vast sum of £6,000 for himself from the co-publishers Thomas Cadell and William Strahan, the printer to the king. However, he had little time to enjoy the money as he died not long after its publication, which was also controversial partly because he had taken liberties with the detailed information provided by Banks, Cook and others. Sir Joshua Reynolds, the first President of the Royal Academy of Arts, had a poor opinion of Dr Hawkesworth, stating that, 'he was insincere and in dress an affected coxcomb'.

The controversy did not detract from sales. It was one of the most popular publications of the 18th century. An example of the fascination and demand for this book is evident in the records of Bristol Library where it was the most requested item from 1773 to 1784. The first-edition three-volume set of 2,000 copies was not cheap, being priced at 3 guineas, although it sold out fairly quickly. A second edition of 2,500 was reprinted two months later.

Banks provided free of charge his *Endeavour* journals, records and the expedition artworks for use in Dr Hawkesworth's official publication. Cook dutifully surrendered his account and records, although he would have to wait until the end of his second Pacific voyage to benefit financially from the sales of that associated publication. As Cook died on the third Pacific expedition, his wife received a share of the profits.

Banks wrote to the classical scholar Thomas Falconer on 7 January 1772, revealing that he was 'overlooking the publication of our voyage which is to Come [*sic*] from the

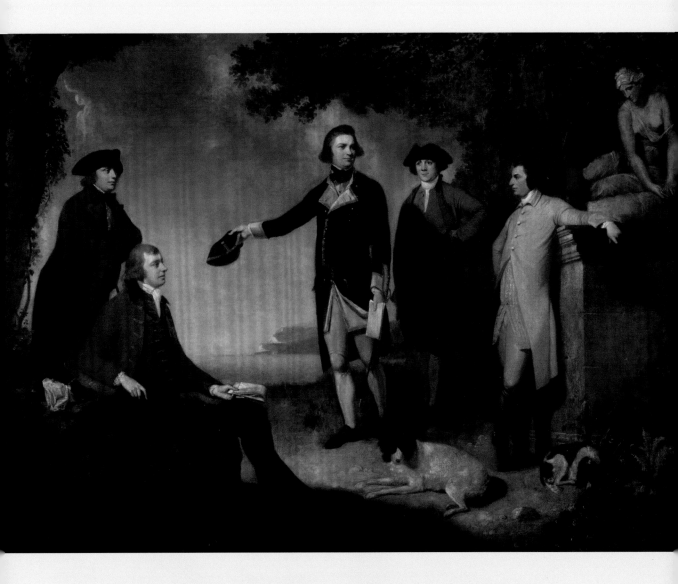

Admiralty having engravings made of all nat. Hist [natural history]'.

The precedent of Banks' involvement with key aspects of the expedition publications started with the *Endeavour* voyage and would later greatly enlarge to include the management and close supervision of artists, engravers and publishers. His role in relation to the publication of Cook's third Pacific voyage also extended to procuring the paper for printing. In terms of Flinders' *Investigator* expedition, the Admiralty gave him the authority to superintend the production of the entire publication.

ABOVE

Lieutenant James Cook (1728–79) in the centre gesturing with his hat; Joseph Banks (1743–1820) seated; John Montagu, 4th Earl of Sandwich (1718–92) leaning on a plinth; Dr Daniel Solander (1736–82) beside Banks; and Dr John Hawkesworth (1715–73) between Cook and Sandwich, painted c.1771 by John Hamilton Mortimer (1740–79), oil on canvas. National Library of Australia. nla.pic-an7351768.

Sydney Parkinson's death and Banks' difficult relationship with his brother

Prior to the publication of Dr Hawkesworth's controversial account, Banks himself faced an embarrassing public dispute – one that became bitter and prolonged – concerning the botanical and natural-history painter Sydney Parkinson. After the premature death of Alexander Buchan resulting from an epileptic seizure on 17 April 1769 at Matavai Bay, Tahiti, Parkinson took on his role of landscape and figure draughtsman. Fortunately, Parkinson created a significant body of work, although on 26 January 1771 he succumbed to disease after leaving Batavia (modern-day Jakarta in Indonesia), then a Dutch colony operating as a strategic location for the Dutch East India Company.

Banks' response to Parkinson's death was recorded in his shipboard journal and demonstrates the importance of carrying artists on board exploration ships (as advocated earlier by Dampier), although it also smacks of youthful arrogance driven by frustration. At the outset of the *Endeavour* expedition Banks was aged 25 compared to Cook's 40 years.

In Banks' journal entry for 17 April 1769 he recounts: 'At two this morn Mr Buchan died … I sincerely regret him as an ingenious and good young man, but his Loss to me is irretrievable, my airy dreams of entertaining my freinds [*sic*] in England with the scenes that I am to see here are vanish'd. No account of the figures and dresses of men can be satisfactory unless illustrated with figures: had providence spard [*sic*] him a month longer what an advantage would it have been to my undertaking.'

Sydney Parkinson's brother, Stanfield, who did not sail on the *Endeavour*, publicly hounded Banks, accusing him of holding back for his own benefit valuable items that had been collected and created during the voyage by the expedition artist. They included shells from a 'choice and rare collection of curiosities, consisting of garments, domestic utensils, rural implements, instruments of war, uncommon shells, and other natural curiosities, of considerable value'. The shell collection was valued at £200.

Stanfield also complained of the modest annual salary Banks had settled on his brother of £80 for the voyage; however, it compares fairly well with the 100 guineas received by John Webber for Cook's

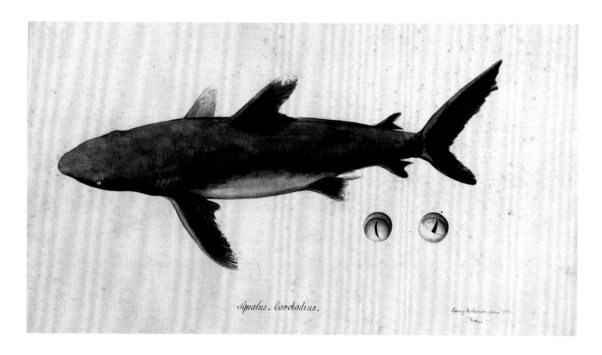

Squalus Carchadius.

third expedition. Stanfield also argued that Sydney had only been contracted to produce botanical artworks, therefore anything else – much of which he considered had been produced in the artist's own time – was therefore now his property according to his brother's last will and testament drawn up prior to the voyage.

Stanfield was wrong about his brother's exclusive focus on botanical specimens. Banks noted in his journal on 30 September 1768: 'This Morn at day break made the Island of Bonavista, one of the Cape Verde Islands: Mr Buchan employd in taking views of the land; Mr Parkinson busy in finishing the sketches made of the shark yesterday.' In addition to botanical subjects, he painted birds, fish and shells.

Stanfield also accused Banks of hiding Sydney's shipboard journal, believing it too was now his rightful property. In addition, the plant nurseryman James Lee also believed that this journal and other items had been bequeathed to him, and wrote to Stanfield threatening legal action. Through Stanfield's own endeavours, and inadvertently those of the mediator Dr John Fothergill (a plant collector, fellow of the Royal Society, and Quaker like the Parkinson family), Stanfield managed to acquire a manuscript version of the journal from Banks (who claimed that the original was lost) and a selection of his brother's expedition artworks.

The dispute was never fully resolved, although Dr Fothergill publicly went on record to state that he believed Banks was not at fault. Stanfield, on the other hand, was committed to a mental institution having been declared insane, but not before he had arranged for the publication of the unauthorised account of the journal illustrated with engravings after his brother's artwork, although a legal order prevented its publication prior to Dr Hawkesworth's account in September 1773. The Parkinson

publication was issued later in the same year under the title *A Journal of a Voyage to the South Seas, in His Majesty's ship, the* Endeavour, *transcribed from the papers of the late Sydney Parkinson*. It turned out to be a notable contribution to the illustrated history of Pacific exploration.

Another unauthorised account of the voyage was published prior to the accounts of Hawkesworth and Parkinson. Titled *A Journal of a Voyage round the World, In His Majesty's Ship* Endeavour it was published in London in 1771. The author is not given but is believed to be James Matra an American-born midshipman aboard the *Endeavour*. Intriguingly he corresponded with and became well acquainted with Banks.

The *Endeavour* voyage had been a remarkable success in many ways. Banks and Dr Solander were feted, in particular Banks to the extent that it appeared as if he, rather than Cook, had actually commanded the voyage. Banks and Dr Solander had an audience with the King and were awarded honorary degrees from the University of Oxford. The voyage elevated them in professional and social circles.

Preferring to live a quieter life ashore, Cook dutifully returned home to the East End of London to be with his wife Elizabeth, the daughter of the owner of the Bell Inn at Wapping, and to develop his charts and write up his journals. Descriptions of him reveal a 'sensible and intelligent' good-looking man, although 'plainly dressed and above 6ft in height', and a 'bashful, modest man, although of an agreeable lively conversation'. Another depicts him as a man with a temper rendering him 'somewhat hasty, although of a disposition the most friendly and humane'. His seafaring career meant that he saw very little of Elizabeth and the children. After Cook's death in Hawaii on Valentine's Day 1779, she lived on an annual pension of £200. All her six children predeceased her, and she died at the age of 93, having been a widow for 56 years.

Cook, however, certainly did not lack determination and perseverance – as to be expected for a man who thrice sailed to the Pacific.

His personal ambition was expressed in the second official voyage publication. He wrote: 'Ambition leads me not farther than any other man has been before, but as far as I think it possible for man to go'.

Banks hopes to sail again to the Pacific with an enlarged team

Joseph Banks had hoped to sail with Cook on his second Pacific voyage – or, as Cook called it, to the 'Great South Sea'. This expedition ranged over the years 1772–75 and was a continuation of the secret Admiralty Instructions issued for the first expedition. Cook's orders were to sail further south to determine once and for all if *Terra Australis Incognita* really existed. Cook proved it did not. The Admiralty, for safety reasons, refused to make extensive structural alterations to the deck of the *Resolution* that Banks had insisted upon to accommodate his enlarged party. His demands to provide suitable accommodation were turned down and therefore Banks and his retinue reluctantly withdrew, but not without a heated exchange of letters and words.

The *Resolution* was Cook's lead vessel on the second and third voyages with the *Adventure* and *Discovery* as the respective support ships. On 11 June 1770 the *Endeavour* had been very fortunate to avoid

ABOVE

Endeavour being repaired in Endeavour River, engraved by William Byrne after Sydney Parkinson (c.1745–71). Illustrated in Dr Hawkesworth's publication (1773). Private Collection. The vessel took several weeks to repair in the Endeavour River (part of modern-day Cooktown) after she was badly damaged on the Great Barrier Reef in June 1770. During the prolonged stay Banks first sighted the kangaroo, which he compared to a greyhound.

shipwreck on Endeavour Reef, on the Great Barrier Reef off the coast of north Queensland; therefore the Admiralty were persuaded that a second ship, although expensive, was a prudent measure.

In order to try and get his way with the shipboard alterations, Banks wrote to John Montagu, 4th Earl of Sandwich (credited with inventing the sandwich) who, although a fair bit older than Banks, became a longstanding friend with a shared passion for fishing. They had both been to Eton, albeit at different times. Banks was adamant that a larger ship should be found to accommodate his party in comfort so that they would be able to effectively undertake their duties. He vehemently argued that his participation was to be undertaken for public benefit. However, all this was to no avail.

Banks was at the dockyard of Sheerness towards the end of May 1772 to witness the removal of the structural additions necessary to accommodate his party, as recorded by a young midshipman John Elliott years later in his memoirs. Elliott recalled:

'Mr Banks came to Sheerness and when he saw the ship, and the Alterations that were made. He swore and stamp'd upon the Wharfe, like a Mad Man; and instantly order'd his servants, and all his things out of the Ship.'

Elliott concluded: 'it has always been thought, that it was a most fortunate circumstance for the purposes of the voyage, that Mr Banks did not go with us; for a more proud, haught[y], Man could not well be, and all his plans seem'd directed to shew his own greatness, which would have accorded very ill, with the discipline of a Man of War, and been the means of causing many quarrels in all parts of the ship.'

Joseph Banks' expectations were high and he had exerted considerable expense in terms of time and money in preparation for the return to the Pacific, so it is hardly surprising that he was upset. That he had a preference to be in control of people and situations, and that he could on occasions be arrogant and haughty is not doubted, but Elliott dismisses, or

is ignorant of, the largely harmonious relationship aboard the *Endeavour* between Banks and his party and Cook and his crew. If Banks' character had really been as Elliott recollected, it is highly unlikely that the Admiralty – even with Banks' wealth and influential connections – would have given him the opportunity to return to the Pacific.

Banks had hoped to take a larger party on the second Pacific voyage. In a letter written around 30 May 1772, he wrote to Lord Sandwich that he had pledged to take, 'as many able artists as the Income of my Fortune would allow me to pay, by whose means the Learned world in general might reap as much benefit as possible from those discoveries which my good Fortune or industry might Enable me to make.'

He also wrote: 'with this view I Engaged Mr Zoffany, a Painter of well known abilities & five others to accompany me, who were to delineate such objects as I might think worthy of presenting to my friends at home, & assist me in keeping such Journals &c. as the nature of the undertaking might require my Friend Dr Solander also voluntarily Engag'd to take the Department of Natural History … besides these six domestic servants also to Collect & preserve such Objects as we might think worthy notice, in all thirteen persons besides myself have I engag'd to spend three years of the Prime of Lifes [*sic*] far removd from their Connexions & amidst the dangers & difficulties of unknown Oceans'.

In total there were four artists: the Frankfurt-born neoclassical artist Johan Zoffany (a favourite painter of King George III and Queen Charlotte and a foundation member of the Royal Academy of Arts), the draughtsmen John Cleveley junior, and the brothers James Miller and John Frederick Miller. There were also two assistants, Peter Briscoe and James Roberts, who had sailed on the *Endeavour* voyage, and two secretaries, Sigismund Bacstrom and Frederick Herman Walden. In addition there were a further six servants and assistants.

Apart from Zoffany, the details on these artists is limited. John Cleveley junior and his twin Robert (who painted naval battle scenes) and their brother James were the sons of the artist John Cleveley the Elder who was closely associated with the royal dockyard of Deptford initially in a practical capacity. He became an accomplished marine painter specialising in dockyard subjects including ship launches. John junior had trained under the topographical artist Paul Sandby (a favourite artist of Banks) who was appointed principal drawing master at the Military Academy at Woolwich. Meanwhile, James Cleveley served as a carpenter on the *Resolution* on Cook's third voyage and is associated directly, or indirectly, with some Pacific views.

John Frederick Miller (his surname was originally Müller) and his brother James were employed by Banks as artists, designers and engravers of diverse subjects including artefacts and natural-history subjects. They were probably introduced to Banks by their artist/engraver father John Sebastian Müller who was associated with various publication projects, including botanical subjects. However, John Frederick Miller displayed botanical artworks in London that Banks had commissioned, although without his permission, and therefore they fell out. In an exchange of letters in May 1776 John felt that Banks was unreasonable in controlling his work and concealing his name from interested parties.

Banks also had Dr James Lind, a fellow of the Royal Society, lined up for the voyage in order to 'assist us with his Extensive knowledge of Natural Philosophy & mechanics'. Lind was a physician and astronomer (and not to be confused with James Lind, the pioneer of naval hygiene).

On 2 June 1772 Cook wrote to Banks: 'Sir, I receiv'd your letter by one of your People acquainting me that you had order'd everything belonging to you to be removed out of the Ship and desiring my assistance therein … The Cook & two French Horn Men are at liberty to go when ever [*sic*] they please.' Clearly unimpressed with the standard culinary fare of the Royal Navy on the *Endeavour* expedition, Banks went to the expense of employing one of his party to serve as a cook. Whilst the 'French Horn

Men' presumably combined various duties, that included those of playing music, specifically on the French horn.

The use of music on board the *Endeavour* in the Pacific had in fact been recommended by the Scottish astronomer James Douglas, 14th Earl of Morton, who was President of the Royal Society from 1764 to 1768. Douglas wrote advisory instructions for the expedition in which music was suggested as a means of developing relationships with indigenous people. However, he cautioned against using a drum or trumpet and recommended that, 'if there are other instruments of Music on board they should be first entertained near the shore with a soft Air'. One of the original manuscript versions of Douglas' letter of instructions, dated 10 August 1768 (with antiquated spelling), is now in the National Library of Australia. It is entitled *Hints Offered to the Consideration of Captain Cooke, Mr Bankes, Dr Solander and the Other Gentlemen who go upon the Expedition on Board the* Endeavour.

Lord Sandwich's letter to Banks dated 22 June 1772 conveyed the hope that his 'zeal for distant voyages would not cease', as he believed it would be 'for the advantage of the curious part of Mankind'. However, he also appears to state fairly bluntly that if he wanted to take a very large party of artists, naturalists etc to the Pacific in the comfortable seagoing surroundings he desired, he should charter a vessel himself and pay *all* the costs. He wrote: 'in order to insure that success to fit out a ship yourself; that and only that can give you the absolute command of the whole Expedition'.

Banks sails to Iceland

Banks had been given some hope that the East India Company, an independent and powerful British maritime organisation, could help him and his party sail to the Pacific. In fact this did not work out. Instead Banks decided to scale down his team and head for Iceland. This is explained in the introduction to Banks' Icelandic journal that he commenced on 12 July 1772 in which he noted, 'In the Mean time I had received several Overtures from the East India Company who seemd inclind to send me on the same Kind of Voyage [to the Pacific] the next Spring as our Adventurers had now set out upon.'

However, the 'Overtures' failed to materialise. Banks continued: 'My People all continued faithful to me. Even Mr Zoffani [*sic*] tho he was, the moment I refused to proceed, sent by the King to Copy some pictures for him in the Florentine Gallery engagd to leave that business & return to me at a fortnights warning.' This was no doubt helped by the fact that Banks had paid Zoffany £300 in compensation for lost earnings on the voyage.

Banks also explained in the Icelandic journal the reason for selecting that country for exploration. He noted: 'The rest [the artists and others he contracted for Cook's second Pacific voyage] were all left upon my hands & as they were considerable running expence I thought it prudent to empl[o]y them in some way or other to the advancement of Science. A voyage of some Kind or other I wishd to undertake & saw none place at all within the Compass of my time likely for furnish me with an opportunity as Iceland, a country which from its being some measure the property of a Danish trading company has been visited but seldom & never at all by any good naturalist to my Knowledge'.

He continued: 'The whole face of the country new to the Botanist & Zoologist as well as the many Volcanoes with which it is said to abound made it very desirable to Explore it & tho the Season was far advanced yet something might be done at least hints might be gatherd which might promote the farther Examination of it by some others.'

In July 1772 when the *Resolution* and *Adventure* departed from Plymouth for the Pacific, Banks and his scaled-down team – included Dr Solander and three artists, John Cleveley the younger and the brothers James Miller and John Frederick Miller – set sail on the *Sir Lawrence* to Iceland.

Not surprisingly there was for a time a cooling

of relations between Banks, Lord Sandwich and Cook, but friendships resumed fairly quickly. Cook's respect for Banks was no doubt genuine; yet it must also have been motivated in part from an acute awareness of his social standing and influential contacts. On 18 November 1772, Cook wrote to Banks during his second Pacific voyage: 'Some cross circumstances which happened at the latter part of the equipment of the Resolution created, I think, a coolness betwixt you and I, but I can by no means think it was sufficient to me to break off all corrsepondance [sic] with a man I am under many obligations too.'

Banks mistakenly believed that his elite team would be the first to explore the active volcanic island of Iceland. After six weeks in Iceland they returned home by way of the Hebrides, the archipelago off the west coast of Scotland, having conducted a successful survey of Staffa.

Banks' detailed descriptions extolling the natural beauties of the basalt columns of Staffa and especially the main sea cave, later named Fingal's Cave, were published by the Welsh antiquarian, author, naturalist and traveller Thomas Pennant in *A Tour in Scotland, and Voyage to the Hebrides 1772* (1774), and led to this uninhabited island becoming a major tourist attraction. This helped to further raise his scientific reputation, which in turn would support his election to the Presidential Chair of the Royal Society in November 1778.

One of John Frederick Miller's Icelandic watercolours was exhibited at the Society of Artists of Great Britain in 1774. It caught the attention of a critical reviewer. Many of his artworks are fascinating images; however, in this instance the critic in the *Middlesex Journal*, 30 April–3 May 1774, noted the picture: 'A View in Iceland, whereon is introduced the various habits of the Natives: taken during his stay with Joseph Banks, Esq and Doctor Solander, in 1772, a drawing in water colours' and curtly concluded: 'Stiff, two miserable sheep.'

The Admiralty took control away from the Royal Society for Cook's second and third Pacific voyages. However, the *Endeavour* expedition had demonstrated the considerable achievements not only in the creation of accurate sea charts that were essential to aid navigation and assert British claims to new territories, but also of artistic and scientific endeavour.

Banks and his team of professional naturalists and artists had created remarkable collections and striking imagery relating to the people and their habitats, artefacts, ceremonies, customs and rituals, and to the coastlines, landscapes, flora and fauna. Therefore his staffing model was copied by the Admiralty, albeit on a reduced scale in terms of participants. This time public money would pay for artists, and to a lesser extent naturalists, on the follow-on Pacific voyages of exploration. This would peak with Flinders' *Investigator* expedition.

Part 2 – Voyage of the *Resolution* and *Adventure*

For Cook's second Pacific voyage the Admiralty selected the artist William Hodges in company with two German-born naturalists, Dr Johann Reinhold Forster and his son Johann Georg Adam Forster (referred to as Georg, also anglicized to George). Both Dr Forster and his son were amateur artists, with Georg being the more accomplished.

For Cook's third voyage there was only one Admiralty artist, John Webber, and no professional naturalists. The omission of professional naturalists on this third voyage derived from the cantankerous and vexatious personality of Dr Johann Forster who had been widely disliked on the second expedition. Therefore the Admiralty decided to rely instead largely on William Anderson (the surgeon on the *Resolution*) and William Wade Ellis (one of the surgeon's mates on the *Discovery*) to take on the roles of naturalists. Ellis was also a gifted amateur artist who produced some expedition artworks. However, the achievements in terms of natural history on this voyage, perhaps not surprisingly, fell short of the previous Pacific voyages.

Naturalists and artists on later voyages of exploration

Notable exceptions in terms of naturalists being permitted to sail on Admiralty voyages in the 19th century include Charles Darwin on the *Beagle*, whose father paid for his participation, and Darwin's close friend the botanist Joseph Dalton Hooker, who sailed on several expeditions in the Victorian era including Captain James Clark Ross' Antarctic expedition from 1839 to 1843. In 1855 Hooker was appointed assistant director of the Royal Botanic Gardens, Kew, and a decade later became the director there.

The Royal Society and the Royal Navy collaborated again on the *Challenger* voyage of 1872–1876 that laid the foundations of oceanography.

Zurich-born John James Wild was an oceanographer and gifted natural-history illustrator who served as the official expedition artist. This voyage also made use of photography facilitated by an on-board darkroom. The scientific findings were published by John Murray in 50 volumes between 1885 and 1895.

W.ᵗʰ HODGES Esᵖ.RA.

Landscape Painter to the Prince of Wales.

From an Original Painting by Mᶜ.Westall.

ABOVE

Portrait of William Hodges (1744–97) engraved by John Thornwaite after Richard Westall (1765–1836), published 1 June 1792. Yale Center for British Art, Paul Mellon Collection. 49483-B1977.14.12383. Hodges was selected as the Admiralty artist on Cook's second Pacific voyage.

After Cook's third Pacific voyage, the Admiralty consciously tried to become independent of civilian artists serving on Royal Navy ships. There was a suspicion among some senior naval officers with respect to the usefulness of civilians and the potential problems that they might cause aboard naval ships. This had already been highlighted by the objections of Admiral Edward Hawke, 1st Baron Hawke, to the size of the scientific party aboard the *Endeavour*. Hawke was First Lord of Admiralty from 1766 to 1771, yet Banks adroitly navigated around him by enlisting the support of lower-ranked but well-connected officers and officials – especially the secretaries to the Admiralty – to ensure that he and his party sailed with Cook.

However, whenever possible, the Admiralty's preference was to use the uneven skills of Royal Navy officers rather than professional shore-based painters. To achieve this goal the Admiralty was aware that the skills of fledging naval officers needed to be improved, and therefore the professional maritime artist John Christian Schetky – a regular exhibitor at the Royal Academy of Arts and marine painter to consecutive British royal rulers George IV, William IV and Queen Victoria – was contracted to teach art to naval cadets at the Royal Naval College, Portsmouth. He was appointed Professor of Drawing in 1811 until its closure in 1836. Among the beneficiaries of this educational establishment was Robert FitzRoy, the *Beagle*'s captain, who passed top of his class.

FitzRoy produced some artworks himself during the *Beagle*'s celebrated second voyage, most notably portraits of the Fuegians that were taken back to Britain including Fuegia Basket, Jemmy Button and York Minister. This and many other images featured in the official voyage account of 1839, which also included the *Beagle*'s previous voyage with the *Adventure* to South America. It is entitled *Narrative of the Surveying Voyages of his Majesty's Ships* Adventure *and* Beagle *between the years 1826 and 1836 describing their examination of the Southern Shores of South America and the* Beagle*'s circumnavigation of the globe*.

Inspired by Banks' private/public partnership model used on the *Endeavour* expedition, FitzRoy

engaged at his own expense and at different times two professional shipboard artists, Augustus Earle and Conrad Martens, to ensure high-quality imagery for the official voyage publication in that hope that it would raise his reputation and advance his career.

Interestingly Earle had written to Banks on 4 January 1818 (National Archives, Kew), hoping that he would use his influence to place him on a voyage of exploration, although his attempt was not successful. He wrote: 'I am an artist by profession and am honored by the friendship of Captain Hurd [Thomas Hurd, the second Admiralty Hydrographer], & hearing from him that a voyage of discovery is about to be undertaken, I am anxious for an appointment to attend it, in my profession – could I sir be favoured by an interview with you.'

Cook's second Pacific voyage: the participation and problems with the Forsters

The publication of Cook's second Pacific voyage was written by Cook himself. It was published in 1777 and titled *A Voyage Towards the South Pole, and Round the World: Performed in His Majesty's Ships the* Resolution *and* Adventure, *in the Years 1772, 1773, 1774, and 1775*… Editorial assistance was provided by the Rev. John Douglas, a fellow of the Royal Society and the Society of Antiquaries of London, who was a Canon of Windsor and became Bishop of Salisbury in 1791.

Banks, Lord Sandwich and the Admiralty officials had a challenging time in preventing Dr Johann Forster from publishing an unauthorised expedition account ahead of Cook's official publication. Banks found Dr Johann Forster to be a difficult character, although he was respectful of his intellectual ability. He had a better relationship with his son Georg.

A striking double portrait of the Forsters was painted by the Turin-born artist John Francis Rigaud who settled in London and became a Royal Academician. Painted after the voyage in London in 1780, Rigaud depicts them engaged in their expedition work at Tahiti. For many years this portrait was in a private collection until it was acquired by the National Portrait Gallery of Australia in 2009.

The Forsters were awarded the parliamentary grant of £4,000 that had originally been approved to engage the services of Dr James Lind to participate on the voyage but was transferred to them after Banks and Lind's withdrawal from the expedition. Although this was a substantial sum, it had to cover their salaries and all their expenses including costly technical equipment and many provisions for the three-year voyage. When the *Resolution* called into Cape Town, Dr Forster incurred the additional cost of engaging Anders Sparrman, the Swedish naturalist and student of Carl Linnaeus, as his assistant, who also produced some artworks.

By the time the Forsters returned to England there was little of the fund remaining. Dr Forster summarised his accounts in a letter to Banks in December 1778 indicating that they returned with only £235, and this was soon depleted. The Forsters were forced to sell their artworks to Banks, including plants drawn by Georg, for which they were paid £420.

Dr Forster adamantly believed that he had been given authority to write and publish the official account for profit by Banks' friend Daines Barrington, the antiquary, lawyer, naturalist and fellow of the Royal Society. The Forsters had been approached to join the Pacific voyage at short notice, and so it is plausible that Barrington – as a form of inducement to get them to sign up for the expedition – suggested that they might well be involved in and benefit from the official voyage publication.

Dr Forster's challenge to the Admiralty turned into a long-running and vitriolic dispute generating considerable correspondence. A legal order was instigated against him to prevent the publication of an unauthorised account; however, as this did not apply to his son, it was written by and issued under Georg's name, although parts of it were likely to have been a collaborative work. It was published prior to Cook's account in 1777 and entitled *Voyage Round the World in His Britannic Majesty's Sloop* Resolution, *Commanded by Capt. James Cook, during the Years, 1772, 3, 4, and 5.*

The SPRUCE FIR of NEW ZEELAND. Nº LI

Published Feb.ʸ 1ˢᵗ 1777, by Wᵐ Strahan in New Street, Shoe Lane, & Thoˢ Cadell in the Strand, London.

Although unillustrated it remains one of the most important and remarkably vivid accounts of Cook's second voyage to the Pacific and his exploration in Antarctic waters. However, Dr Forster was frustrated with the poor sales and lack of royalties. This is expressed in Forster's December 1778 letter to Banks in which he also reveals the preferential publishing arrangement enjoyed by Cook. He recounts: 'My Son's book has as yet not brought us in one single Shilling; there are still 570 Copies unsold; for though everybody allows that it is infinitely superior to Capt. Cook's performance…'

He continued: 'however it could not sell well, as Lord Sandwich gave to Capt. Cook not only the plates [the illustrations], but also the expences of the press, paper & printing of the plates, in order to sell it with all the plates for 2 Guineas a Copy; which is in the Eyes of the majority of the public a great inticement for purchasing the book.'

Dr Johann Forster later published *Observations Made During A Voyage Around the World On Physical Geography, Natural History And Ethic Philosophy* in 1778, which is very different in content although no less important. James C Hamilton observes in his book review for *Cook's Log* (2010) that, 'The significance … is not only that it was an 18th-century Enlightenment travel book and an account of observations during Cook's Second Voyage, but also, most importantly, it was a study of peoples of the Pacific.'

As with the *Endeavour* voyage the publications of Cook and Forster were preceded by the publication of an unauthorised account this time written by the Irishman John Marra who had served aboard the *Resolution*. It is titled *Journal of the* Resolution*'s Voyage, In 1772, 1773, 1774 and 1775* and was published in London in 1775. Marra's book is in fact the earliest first-hand account of the Antarctic regions. Intriguingly Dr Forster had helped to prepare it for publication.

Banks' role in Cook's second-voyage publication was wide-ranging and included advising on botanical matters. On 24 May 1776 Cook wrote to Banks from his Mile End home in the East End of London: 'Capt. Cook presents his Compliments to Mr Banks, thanks him for his kind congratulations [Cook had been promoted to the rank of Captain] and for the Drawing of the New Zealand Spruce, he will speak to Lord Sandwich to have it engraved, and if his Lordship Consents, will be obliged to Mr Banks for a description.'

Cook, Banks and the usefulness of plants featured in the voyage publication

On 10 July 1776 Cook wrote again to Banks from the *Resolution* anchored in Plymouth Sound while preparing to depart for his third Pacific voyage. On his mind were matters relating to the publication of his previous expedition. The letter reveals Banks' and Cook's involvement in highlighting the usefulness of plants.

Cook wrote: 'As you was so obliging as to say you would give a description of the New Zealand spruce tree, or any other plant, I desired Mr Stahan [*sic*] [William Strahan, printer and publisher] and Mr Stuart [identified by the art historian Kerry Bristol as James 'Athenian' Stuart], who have the Charge of the Publication, to give you extracts out of the Manuscripts of such descriptions as I had given (if any) for you to correct or describe yourself, as may be most agreeable.'

He added that 'the [New Zealand] Spruce Tree & Tea Plant and Scurvy Grass' would be useful for his publication, and concluded: 'whatever plates of this kind falls to my share, I shall hope for your kind assistance in giving them some short account of them'.

Collectively Cook understood that the New Zealand Spruce, the Tea Plant and Scurvy Grass had health benefits for his crew, but precisely what they were and how they worked was not known at that time. In fact the tips of spruce trees are a rich source of vitamin C, which would have helped to prevent and cure scurvy. After arriving in Pickersgill Harbour, New Zealand in March 1773 some of his men were ill and in part Cook credited the 'spruce beer' as the reason they 'soon became strong and vigorous'. When Banks suffered from scurvy he took 6 ounces of lemon juice according to 'Dr Hulme's method' and was cured within a week.

Cook featured his own recipe for 'spruce beer' in the official voyage publication. He wrote retrospectively in May 1773: 'We at first made our beer of a decoction of the spruce leaves; but, finding that this alone made it too astringent, we afterwards mixed with it an equal quantity of the tea plant (a name it obtained in my former voyage, from our using it as a tea then, as we also did now), which partly destroyed the astringency of the other, and made the beer exceedingly palatable, and esteemed by everyone on board.'

William Hodges produced an oil painting for the Admiralty entitled *View in Pickersgill Harbour, Dusky Bay, New Zealand* in which a sailor can be seen staggering along a tree used as a natural gangplank to the *Resolution* anchored close to shore. Whether or not this seaman is ill or intoxicated, or perhaps both, cannot be determined. The image did not feature in the official voyage publication of 1777.

William Hodges: Admiralty artist on Cook's second Pacific voyage

London-born Hodges had trained under the classical landscape painter Richard Wilson in Covent Garden, London. His invitation to participate in Cook's Pacific voyage was influenced by Henry Temple, 2nd Viscount Palmerston, a fellow of the Royal Society, a member of the Society of Dilettanti, a Lord of the Admiralty and a close friend of Banks.

The alignment of Banks, Lord Palmerston and Lord Sandwich, the First Sea Lord – all of whom were prominent members of the Royal Society and the Society of Dilettanti – makes it highly likely that Banks was involved in various ways in the transformation of Hodges' expedition artworks

View in Pickersgill Harbour, Dusky Bay, New Zealand, painted 1773–76 by William Hodges (1744–97), oil on canvas. National Maritime Museum, Greenwich. BHC2370. Pickersgill Harbour is in the southland of the South Island. On 28 March 1773 Cook wrote, '…hauled the Sloop *[Resolution]* into a small creek and moored her head and stern to the Trees and so near the Shore as to reach it with a Brow or stage which nature had in a manner prepared for us by a large tree which growed *[sic]* in a horizontal direction over the water…'

into Pacific subjects (see chapter 3), some of which were executed in a neoclassical style, for the official publication.

Hodges' art was also put to good use aboard Cook's lead ship the *Resolution*, and there is a record of him teaching in the captain's great cabin, as recollected in the private memoir of John Elliott, that is now in the British Library. Elliott joined the *Resolution* as a midshipman 'not yet 14 years old'. He noted, 'Myself, Mr Roberts [Henry Roberts] and Mr Smith [Isaac Smith, Cook's nephew] were when off Watch, Employ'd in Captn Cooks Cabbin either Copying Drawings for him, or Drawings for ourselves, under the Eye of Mr Hodges.'

Only a very small number of Hodges' oil paintings featured as engraved plates in the voyage account, with most of his imagery deriving from his expedition drawings and watercolours and those worked up on his return to London. Hodges painted an oil of Easter Island for the Admiralty; however, they chose instead a very different version for the official publication – derived in part from artworks by Hodges that are now missing, but also perhaps from an 'improved' composition by another designer or engraver.

Hodges' oil painting entitled *A View of the Monuments of Easter Island* [Rapanui] painted c.1776 is remarkable for being the earliest depiction in oils of that remote Pacific island. The island was first encountered by Jacob Roggeveen who commanded an expedition sponsored by the Dutch West India Company to find the Unknown South Land. This island, memorable for its monolithic human figures called moai, had been named Easter Island as Roggeveen arrived there on Easter Sunday in 1722.

Hodges' Easter Island painting differs considerably from the engraved version published in the official voyage account in 1777, although they are likely to have been developed around the same time. The engraving was produced by William Woollett and entitled *Monuments in Easter Island.* Only two moai appear in the engraved illustration compared to four in the painting. In the illustration a native of the island stands beside a moai, while a partial human skeleton – perhaps intended as a *memento mori* – is depicted in front of rocks covered with vegetation. In the painting can be seen close to a group of moai a single human skull, with a human bone beside a surveying instrument, perhaps also intended as a *memento mori.*

Cook wrote in the voyage publication, 'It will hardly be doubted that these piles of stone had a meaning; probably they might mark the place where people had been buried, and serve instead of the large statues.' They are now widely believed to have been created to honour deceased prominent forebears including chieftains.

Cook's second Pacific voyage sailed further south than any previously recorded expedition, and in the course of penetrating 71°10'S he was

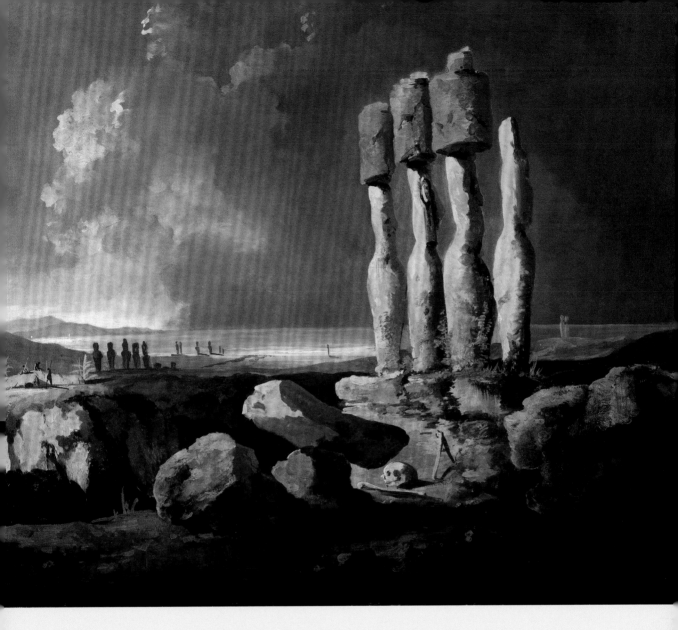

the first European to encounter South Georgia Island and the South Sandwich Islands. He disproved the existence of the fabled *Terra Australis Incognita*.

Mai is brought to Britain

The voyage was also memorable for bringing Mai to Britain. This Ra'iatean man, often mistakenly referred to as Omai, had sailed to Britain aboard the *Adventure* commanded by Tobias Furneaux. In 1767 during Captain Samuel Wallis' Pacific voyage he had been injured during a violent skirmish, although this

did not deter his desire to visit Britain. Hodges is one of several artists who painted his portrait. One version was painted for the surgeon and anatomist Dr John Hunter; a different version for the Admiralty was engraved for Cook's voyage account.

In London Mai was placed under the protection of Banks, who acted as his guardian. This was not only a reflection of Banks' status but also his previous experience in interacting with indigenous people. Banks had befriended, along with other officers and crew, the Ra'iatean man Tupaia and his assistant after they joined the *Endeavour* in July 1769.

Cook had initially refused to let them stay aboard, although he changed his mind once Banks assured him that he would personally take responsibility for them. Tupaia's skills as a navigator, mapmaker and translator were admired, and he was able to communicate with the indigenous people of New Zealand.

It may well have been Banks who provided Tupaia with paints and instructed Sydney Parkinson to give him some rudimentary art lessons that resulted in some quirky Pacific pictures – including what is believed to be a portrait of Joseph Banks trading a crayfish for a piece of cloth, created around 1769, that is now in the British Library. Unfortunately, Tupaia and his assistant never reached Britain, both dying in December 1770 from a disease contracted in Batavia.

Banks presented Mai to court, where he met King George III and Queen Charlotte. This meeting was visualised in the engraving entitled *Omiah* [sic], *the Indian from Otaheite presented to their Majesties at Kew, by Mr Banks & Dr Solander, July 17, 1774* after an anonymous artist. Banks with Dr Solander accompanied Mai on a mini-tour visiting their friends in the north and south of England.

Whilst staying with Constantine John Phipps, 2nd Baron Mulgrave at Mulgrave Castle in North Yorkshire, it was reported in the *York Courant* on 26 July 1774, that 'The Native of Otaheite, who was at Court the other Day, had received some Instructions for his Behaviour in addressing his Majesty, but so great was his Embarrassment when his Majesty approached him, that he forgot every Thing but that of kneeling; and when his Conductors endeavoured to make him speak to the King, he could only stretch out his Hand, and get out the familiar Phrase of How do you do? Which, it seems, was the first English Phrase he learned, and has been the common Term

of Salutation daily made Use of by him ever since to all Strangers. His Majesty freely shook him by the Hand. The innocent native Freedom of this Indian Visitor caused a good deal of Mirth and Pleasantry among the Noblemen, &c. attending the Levee…' It continued: 'This spirited Adventurer is to continue with Mr Banks during his Stay in England, which it is presumed will be for some Years, until he has acquired the English Language, and a thorough Knowledge of the Customs of this Country.'

Not surprisingly Mai was a popular dining companion among the high society of London during his two-year residence. He was admired for his charm, wit and exotic looks and noted for his idiosyncratic behaviour such as extravagant bows. Lord Sandwich, First Lord of the Admiralty, Dr Samuel Johnson the lexicographer, Charles Burney and his daughter Frances Burney the author, diarist and playwright, and Anna Seward the poet were among those who had the honour to meet him.

Mai was also portrayed by the artists Nathaniel Dance-Holland, Sir Joshua Reynolds and William Parry. Parry's depiction is intriguing and the painting may well have been commissioned at Banks' behest. The artist had studied at William Shipley's drawing Academy, and later under Sir Joshua Reynolds, and became an Associate of the Royal Academy of Arts.

Parry's triple portrait in oils, painted between 1775 and 1776, features Banks standing in the centre to emphasis his scientific and social importance, Banks' fellow naturalist and assistant Dr Daniel Solander seated to the right, and the full-length flamboyant figure of Mai to the left. Banks points to Mai in an affected manner, while Solander pauses from writing notes, as if he is being classified and described as a natural-history specimen. However, it is also likely that Banks was pointing to tattoos on Mai's hand, which cannot be seen in the painting.

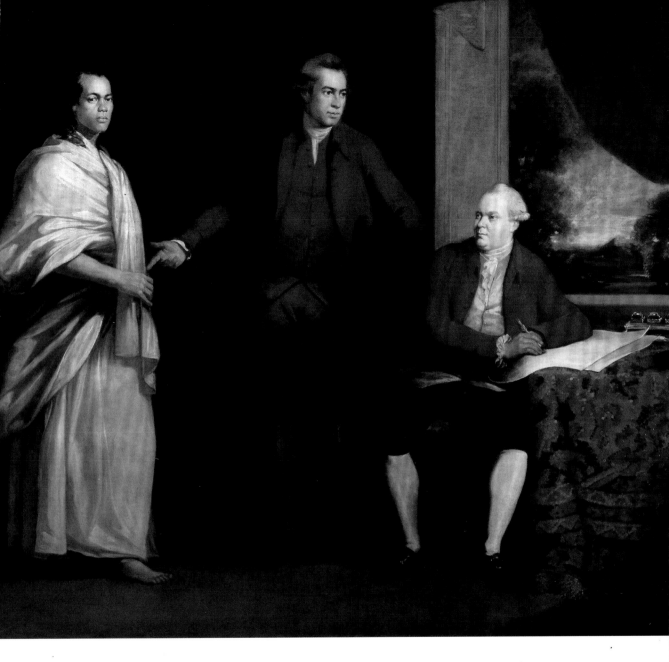

ABOVE

Omai [Mai] (c.1753–c.1780), Sir Joseph Banks (1743–1820) and
Dr Daniel Solander (1736–82), painted c.1776 by William Parry
(1743–91), oil on canvas. National Portrait Gallery, London /
National Museum Cardiff / Captain Cook Memorial Museum,
Whitby. NPG6652.

Part 3 – Voyage of the *Resolution* and *Discovery*

The return of Mai to the Pacific was used as a pretence by the Admiralty to cover the true purpose of Cook's third voyage to the Pacific. The Admiralty Instructions specified the surveying and charting of the north-west coast of America and the quest to discover a north-west passage between the Atlantic and the Pacific around the top of America that would be useful for British communication and trade.

Cook also mentioned in his letter to Banks dated 10 July 1776 when the *Resolution* and *Discovery* were preparing for departure that, 'he gave Omai three Guineas which sent him on Shore in high Spirits, indeed he could hardly be otherwise for he is very much carressed here by every person of note, and upon the Whole, I think, he rejoices at the prospect of going home'.

By August 1777 Mai had been returned to Huahine, one of the Society Islands. The numerous gifts given to Mai are highlighted by Harriet Guest in 'Omai's Things' published in *Cook & Omai: The Cult of the South Seas* (2001). They included 'a barrel organ, and a collection of miniature figures (of soldiers, animals, coaches and so forth) … an

assortment of fireworks, portraits of the king and queen and, perhaps, of Cook; an illustrated Bible; a jack-in-a-box; handkerchiefs printed with the map of England and Wales; two drums; a suit of armour'. The armour was made for him at the Tower of London and presented to him by Lord Sandwich.

Prior to departure, Mai also acquired 'a compass, globes, sea charts and maps, as well as some guns, powder and shot'. After a suitable site was found, a house was built for him by the shipboard carpenters. There were comments about how Mai had wasted his time among the high society of Britain by engaging in genteel pursuits rather than learning anything of practical use. Georg Forster, for example, stated that

BELOW

The Narta, or Sledge for Burdens in Kamtchatka, hand-coloured aquatint, after and by John Webber (1751–93), published by him on 1 July 1789. British Museum. 1872.0713.569. A man on skies takes a short break with his dogs, who have been pulling a sledge laden with firewood on the Kamchatka Peninsula in the far east of Russia.

he had been sent home, 'without knowledge, skills, or "articles of real use" to his people or to himself'. However, Mai was not all that he seemed and appears to have exaggerated his status in Britain. Banks' friend Daines Barrington, in a letter dated 26 June 1775 to the physician and scientist Sir Charles Blagden who became Secretary of the Royal Society, reported Cook describing Mai as a 'very great black-guard'.

Banks and the publication of Cook's third Pacific voyage

Banks was intimately connected to the production of the publication of Cook's third Pacific voyage that covered the years 1776–80. He can also be indirectly associated with the selection of John Webber, the Anglo-Swiss expedition artist, who had received a classical training in Bern, Paris and London. Dr Solander is credited with identifying him as a candidate for the voyage after viewing his work at the Royal Academy of Arts. However, the close personal and professional relationship between Solander and Banks, who was his patron, necessitated consultation at the very least and almost certainly Banks' approval.

In fact Webber was not the first choice, as it is known that the Society of Dilettanti had earlier approached Thomas Jones (addressed in chapter 3), a fellow pupil of William Hodges studying under Richard Wilson. This also explains the short notice given to John Webber to prepare for the voyage which he reveals in a fascinating letter to his cousin written prior to departure, indicating his salary and his motivation for accepting the appointment. This was first published in Rüdiger Joppien and Bernard Smith's *The Art of Captain Cook's Voyages*, Vol. 3 (1988).

Webber wrote, 'This idea my dear cousin, no doubt will seem rather strange to you, but to me it was enough to see that the offer was advantageous and besides, contained the matter which I had always desired to do most (to know, to sail and to see far away and unknown countries).'

He continued: 'The Admiralty appointed me for 100 Guineas per year and above that paid all the

expenses of my work. This together with the means which I hoped to have received on my return, in order to distinguish myself with images of novelties, gave me hope that my lot would be happier in the end, if God spared my life. All this was decided eight days before my departure, and I was in quite a hurry to pursue all matters that were necessary.'

Webber was in a strong negotiating position with the Admiralty officials. The voyage left Plymouth on 12 July 1776. A letter dated 24 June 1776 from the Admiralty to Cook outlines Webber's role and the support he would receive during the voyage. An identical letter in terms of content had earlier been sent to Cook in relation to the participation of William Hodges for the second Pacific voyage.

The Admiralty letter states, 'Whereas we have engaged Mr John Webber Draughtsman and Landskip [*sic*] Painter to proceed in His Majesty's Sloop under your command on her present intended Voyage, in order to make Drawings and Paintings of such places in the Countries you may touch at in the course of the said Voyage as may be proper to give a more perfect Idea thereof than can be formed by written description only; You are hereby required to and directed to receive the said Mr John Webber on board giving him all proper assistance, Victualling him as the Sloop's company and taking care that he does diligently employ himself in making Drawings or Paintings of such places as you may touch at, that may be worthy of notice, in the course of your Voyage, as also of such other objects and things as may fall within the compass of His abilities.'

Banks can also be linked to Cook's third voyage through his membership of the Royal Society. He was a senior fellow at the time when the Royal Society proposed a similar scheme that was taken up by the Admiralty. This time a key part of Cook's Admiralty Instructions tasked him to sail as far north as possible. He was turned back by ice in the Bering Strait. The furthest latitude that Cook reached was 71 degrees North and this was reflected in John Webber's large-scale epic oil painting entitled *A Party from His Majesty's ships* Resolution *&* Discovery *Shooting sea-horses, Latitude 71 North, 1778.*

Webber's painting depicts walruses being killed to supplement food supplies. It was exhibited at the Royal Academy of Arts in 1784, and although Webber enjoyed commercial success with his Pacific artworks, one critic reviewing this picture noted in the *Morning Chronicle, and London Advertiser* that, 'This representation may be in nature, but we must leave to the admiration of the *Icelandic Connoisseur*, what is an unpleasing picture in Great Britain'. The painting later hung at Admiralty House, the official residence of the First Lord of the Admiralty in Whitehall that was designed by Samuel Pepys Cockerell (the great-great-nephew of the famous diarist Samuel Pepys) and first opened in 1788. Cook's third voyage in terms of its achievability was well ahead of its time: an article by John Vidal in the *Guardian* on 9 February 2016 concluded that by 2040 global warming might enable ships to take this ice-free shortcut – or, as it is popularly known, the Northwest Passage.

RIGHT

A Party from His Majesty's ships Resolution & Discovery *Shooting sea-horses, Latitude 71 North, 1778*, painted in 1784 by John Webber (1751–93), oil on canvas, National Maritime Museum, Greenwich. BHC4212. Sea-horses are better known today as walruses.

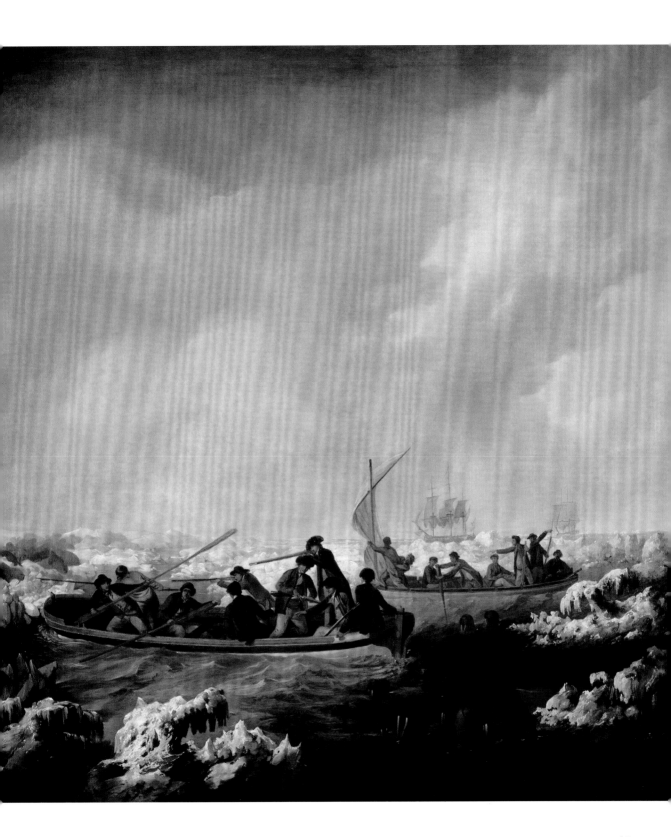

Banks' intimate involvement in Cook's third Pacific voyage publication

Banks willingly took on a senior management role offered by the Admiralty to oversee the production of the third Pacific voyage account, which also incorporated the written work of James King who sailed aboard the *Resolution*. As Cook's second lieutenant, King shared the captain's astronomical duties, and after Cook's tragic death in Hawaii in February 1779 he played an even greater role in the expedition and its successful return to Britain. Initially after Cook's death, captain Charles Clerke took overall command of the expedition. After Clerke's death from tuberculosis on 22 August 1779, John Gore took his place and appointed King as captain of the *Discovery*.

On their return to London, Lord Sandwich wrote to Banks on 10 October 1780 informing him that, 'I attended Captain King & Mr Webber the painter to his Majesty on Sunday last at Windsor, where we went thro' [*sic*] an examination of the drawings, charts &c which seemed to give great satisfaction; the drawings are very numerous being near 200 in number, and I think are exceedingly curious & well executed; but before any measures are taken about them, I wish to consult you how to preserve those that are not published, &c to select those that are meant for publication.'

He continued: 'I also wish to have your opinion about the Journals [compiled by Cook and continued by King] which are now in my possession, which I think should be made publick with as little delay as the nature of this business will allow.'

Banks generally shared Lord Sandwich's satisfaction with Webber's expedition work, although he believed that one portrait by this artist was below par. It was an oil painting of Captain Cook – one of several versions – that he considered to be a poor likeness. In a letter to Professor Johann Friedrich Blumenbach (the German anthropologist, naturalist and physician, and a fellow of the Royal Society) written from Soho Square in 31 December 1793, Banks highlighted his criticism of Webber: 'That gentleman indeed was by Profession a Lan[d]scape painter, & what he has done in the portrait Line I have given little Credit to, for he Drew a Picture of Capt. Cook which did not in any degree resemble him, tho his hard & markd features were So Strong as to make it almost impossible for anyone to miss his Likeness.'

In fact Webber was one of only three artists to paint Cook from life – the others being Nathaniel Dance-Holland and then William Hodges. One version of Webber's oil portrait of Cook was published by the artist in 1784 as a stipple engraving after a drawing that was executed early on in the voyage, as the print is inscribed 'Painted at the Cape of Good Hope'.

LEFT

Captain James Cook (1728–79), painted in November 1776 by John Webber (1751–93), oil on canvas, feigned oval. National Portrait Gallery, London. NPG26.

For the voyage publication Lord Sandwich was dependent on Banks' advice and assistance including guidance on who should benefit from the royalties of the sales of the publication, on the supervision of the Admiralty artist John Webber and the engraving of his artworks, and on obtaining suitable paper from France and the publication of a French edition.

Banks complied with all the requests. In fact he considered his help in such matters to be his duty. Writing to Henry Dundas, the Secretary of State for the Home Department, Banks stated, 'I think it is my duty in all matters of literary import, which I consider as my department, to give every assistance in my power to his Majesty's Ministers.'

The production of the third publication encountered a number of challenges such as problems with the plates being struck off (a 'strike off' is a test print produced prior to publication to ensure that the image and its placement are all in order), and the tardiness of some of the engravers.

Lord Sandwich wrote to Banks on 9 September 1782: 'Mr Webber is very ready, if he receives your

instructions to that purpose to superintend the rolling Press, and see that the plates are properly struck off; this I understand was omitted in the former publication, and that the work suffered greatly for want of such inspection.'

He also wrote, 'The thing that seems to threaten delay is the engraving the plates that are still behind; I find Mr Wollett [William Woollett] who is to undertake one of the principal ones has not yet begun, and before this letter is closed I shall have the names of the others who are equally tardy, and I hope

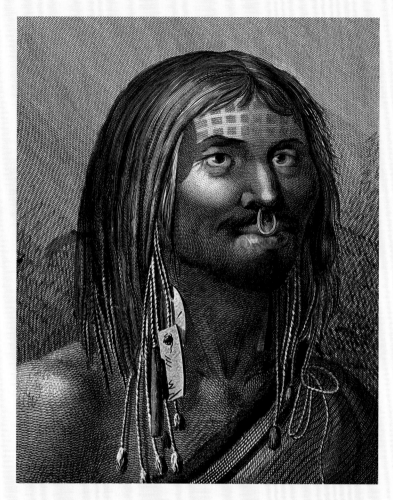

you will give yourself the trouble to write to them & to say everything you can to press them forward.' The other tardy engravers were John Hall and James Heath.

In 1783 with Banks' assistance – prompted by Lord Sandwich, and under the overall control of two successive First Lords of the Admiralty (Admiral Augustus Keppel, 1st Viscount Keppel and Admiral Richard Howe, 1st Earl Howe) – the engravers Woollett, Hall and Heath were successfully chased up. Some of the early proofs, including two portraits titled *Woman of Nootka* and *Man of Nootka* relating to Cook's exploration of Nootka Sound off the west coast of Canada's Vancouver Island, were finally acquired for scrutiny by Banks and Webber. This was fortunate as they were wholly unsatisfactory.

Banks' letter to the publisher George Nicol dated 9 October 1783 shows the dire situation. He wrote, 'there is hardly a good impression among the whole – that the plates are intirely worn out – that the impressions are all very dirty – & many of them mildewd in the Soaking – & such as they are the whole of them purposely mixed – no two succeeding impressions being alike – all these facts, & many more too numerous to mention Mr Webber is so sensible of, that he confesses he is ashamed to… write to you on the Subject'.

Banks' correspondence with George Nicol reveals how he was able to diplomatically raise the concerns and bring pressure to bear to resolve the issues relating to the engraved plates and the proof prints.

The Rev. John Douglas was appointed again to edit the publication, and assistance was drawn from others who included Admiralty hydrographer Alexander Dalrymple, the principal proponent of the existence of *Terra Australis Incognita*, or Unknown South Land, who from the outset had set his sights on leading the *Endeavour* expedition, although the Admiralty preferred Cook. Also of assistance was Henry Roberts, who served with Cook on his last two voyages (and received drawing lessons from Hodges on the second expedition) and on the third was instrumental in carrying out navigational and chart-making work. Roberts became a gifted amateur artist, which helped in the preparation of his detailed charts for the atlas of the third publication. He also created a world map indicating the tracks of Cook's three Pacific voyages which is reproduced here.

Remarkably everything finally came together in the publication of the multi-volume account co-authored by Cook and King in 1784 titled *A Voyage to the Pacific Ocean. Undertaken, by the Command of his Majesty, for making Discoveries in the Northern Hemisphere. To determine The Position and Extent of the West Side of North America; its Distance from Asia; and the Practicability of a Northern Passage to Europe. Performed under the direction of Captains Cook, Clerke, and Gore, In His Majesty's Ships the* Resolution *and* Discovery, *In the Years 1776, 1777, 1778, 1779, and 1780.* The text volumes included 24 engraved plates, maps, charts and a table, and the atlas featured 61 engraved plates after Webber and two maps.

The initial print run of this eagerly awaited official account sold out on the third day of publication, although it was not the first to appear in print. The financial profit from Cook's third voyage publication was impressive. On 14 January 1801 the publisher George Nicol wrote to Banks reporting on the accounts of the work: 'I find that the clear profits, that has arisen to be divided, is about £4,000. And that the present Sale, which though now small about

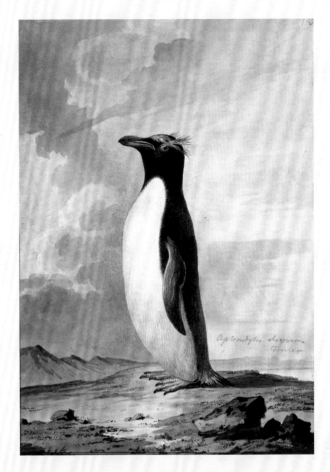

ABOVE

Macaroni Penguin, 1777, by John Webber (1751–93), watercolour on paper. British Museum.1914.0520.384. Macaroni penguins were sighted by Cook and his men at Desolation Island (later Kerguelen Island) towards the end of December 1776. It is closely related to the Rockhopper, and some sources suggest that this is the type shown here. The Macaroni has red eyes, and perhaps the yellow eye visible here is explained by an error on Webber's part, who saw the Yellow-eyed penguin in New Zealand and assumed this to be the correct colour.

£40 p ann. Clear of all deductions; which is likely to continue several Years, as there are still a great number of the 3rd Edn. [Edition] Remaining.'

Nicol went on to credit the Admiralty and Banks: 'You will remember Sir, that from the Generosity of the Admiralty, and your own liberal notions, the Book was ordered to be given to the Publick at little more than Prime Cost – But notwithstanding that Resolution, from the unwearied pains you took with the Engravers & other Artists, and the consequent respectable appearance the Work made, the Sale has been so great, as to produce the above Sum of clear Profits to those, to whom the Admiralty have been pleased to allot it'.

Even though the Admiralty had made it clear that officers and crew were obligated to surrender their journals and records so as not to compete with the official publication, a selection were issued without permission. However, none of these unauthorised accounts were a match for the official publication.

Unofficial publications of Cook's third Pacific voyage

The first unauthorised version was produced by German-born Johann Heinrich Zimmermann who enlisted on the *Discovery* as an able seaman and later became the coxswain in July 1776. His journal written in German is of limited interest and was first published in Mannheim and later in Munich in 1781 and 1783 under the title *Reise um die Welt mit Capitain Cook*. Further translations followed in French, Dutch and Russian.

William Wade Ellis, one of the surgeon's mates and a talented amateur artist, incurred Banks' wrath when in dire financial straits he sold his account for 50 guineas. It was first published in London in 1782 and titled *An Authentic Narrative of a Voyage performed by Captain Cook and Captain Clerke, in His Majesty's Ships* Resolution *and* Discovery, *during the Years 1776, 1777, 1778, 1779, and 1780; in search of a North-West Passage … including a faithful Account of all their Discoveries, and the unfortunate Death of Captain Cook…* It featured a folding chart and 21 engraved plates after his own artworks.

Ellis' career might have taken a different turn as he had been recommended to Banks by Captain Charles Clerke in a letter written at sea aboard the *Resolution* on 18 August 1779. This also reveals that Cook and his officers were consciously acquiring things for Banks' Pacific collection. He wrote, 'I must beg leave to recommend to your notice Mr Will Ellis one of the surgeon's mates who will furnish you with some drawings and accounts of the various birds which will come to your possession.' He continues: 'he has been very useful to me in your service in that particular, [natural history] & is I believe a very worthy young man & I hope will prove worthy of any services that may be in your way to confer upon him.'

Banks wrote to Ellis on 23 January 1782, confirming that he would purchase the drawings referred to by Captain Clerke but stated that he was 'sorry you have Engaged in so impudent a business as the publication of your Observations. From my situation & Connexions with the board of Admiralty from when only I Could have hop'd to have servd you I fear it will not in future be in my power here aft to do what it might have been, had you askd & followd my advice'.

The American-born John Ledyard, who served on Cook's voyage as part of Royal Marine Corp, arranged for his unauthorised account to be published in America in 1783

under the title *A Journal of Captain Cook's Last Voyage to the Pacific Ocean, and in Quest of a North-West Passage, between Asia & America, Performed in the Years 1776, 1777, 1778 and 1779*. This unillustrated (except for one chart) publication contained large parts plagiarised from Dr Hawkesworth's earlier accounts, and from John Rickman, who served aboard both the *Resolution* and *Discovery*, ending as second lieutenant on the former.

Rickman's publication was yet another unauthorised account published in London in 1781 under the title *Journal of Captain Cook's last voyage to the Pacific Ocean on Discovery; performed in the Years 1776, 1777, 1778, 1779 ...* It featured one folding map and a small number of engraved plates. However, it did provide additional details of Cook's death that were not included in the official publication.

Banks' promotion of plant collectors on British voyages of exploration

Banks can also be connected to Cook's third Pacific voyage through a professional representative sailing at his behest. With Cook's assistance he had arranged to place David Nelson the gardener-botanist aboard the *Resolution* for the purpose of collecting seeds and specimens primarily for the Royal Botanic Gardens, Kew. Nelson had been recommended by James Lee who co-owned and managed the Hammersmith-based garden nursery.

Nelson received some training from Banks himself prior to his departure and Banks personally paid for his salary and other expenses during the voyage. After his return Nelson continued working as a gardener at the Royal Botanic Gardens for several years before Banks arranged for him to join captain William Bligh on the infamous voyage of the *Bounty* in the years 1787–90. Banks also placed gardener-botanists – some at his own expense – on voyages to other parts of the world. The aim of the *Bounty* expedition was to transport breadfruit trees from Tahiti to the West Indies in order to establish it as a cheap food source.

Banks was one of several people who had publicly encouraged this initiative, and earlier at his behest breadfruit had been drawn by Sydney Parkinson on the *Endeavour* expedition, then developed into a full-colour artwork back in London and engraved by John Frederick Miller. Bligh connects to Cook's Pacific voyages in that he had served as sailing master aboard the *Resolution* on Cook's third voyage. In turn Matthew Flinders served with Bligh on the second successful breadfruit voyage in the *Providence* from 1791 to 1794.

ABOVE

Breadfruit, *Artocarpus altilis* after Sydney Parkinson (c.1745–1771), engraved by John Frederick Miller. Illustrated in Dr Hawkesworth's publication (1773). Private Collection. First seen by Banks in Tahiti, he proposed to King George III that it would be an ideal cheap food supply for slaves in the West Indies, however it was not initially liked. The timber of the breadfruit tree was mainly used for dwellings.

Part 4 – Voyage of the *Investigator*

Banks had learned from the unedifying experiences of dealing with Stanfield Parkinson and Dr Johann Forster. The Admiralty had issued basic agreements to William Hodges and John Webber for Cook's second and third Pacific voyages; however, Banks drafted a detailed contract on behalf of the Admiralty for the specialist team he selected for Flinders' *Investigator* voyage of 1801–03 that was signed and witnessed at his London home, 32 Soho Square.

Following a temporary falling-out with the Admiralty in 1772, Banks fairly quickly earned their full respect and trust. Banks acted as a consultant to Cook for the second Pacific voyage publication, while for the third account he was authorised by Lord Sandwich to supervise the artists and manage many of the technical aspects, which he did willingly.

In April 1801 during the arrangements for the equipment and personnel for the *Investigator* Banks wrote to Sir Evan Nepean, 1st Bart, Secretary to the Admiralty, requesting some changes: 'Is my proposal for an alteration in the undertaking for the Investigator approved?' The reply was: 'any proposal you may make will be approved. The whole is left entirely to your decision'.

Further evidence of Banks' empowerment by the Admiralty in relation to artistic and publication matters associated with the *Investigator* voyage can be found in the letter to him from Sir John Barrow, 1st Bart and Second Secretary to the Admiralty, written on 15 January 1811.

Barrow wrote: 'I have to express to you the thanks of their Lordships for the handsome manner in which you have been pleased to offer your superintendence to the management of the draughtsmen, engravers &c who are to be employed: an offer of the value of which my Lords are too sensible not to accept of it with pleasure and satisfaction.'

His positive tone continued: 'Mr Yorke [Charles Philip Yorke, First Lord of the Admiralty] said he would be quite satisfied to leave it to yourself & depute me to represent the Admiralty'.

Banks' contracts for the shipboard team of specialists, also called scientific gentlemen, obligated them after their return to hand over their collections and work to the Admiralty so that Banks could assess what was important and what could be used for an official publication. Whatever was not required was returned to the specialist to be used for their own benefit.

In the *Memorandum of Agreement for Scientific Party of Investigator* (see full document below) that Banks drew up for the Admiralty, the fourth point specified that, 'Their Lordships consider the Salary allotted to each Person as a full compensation for the whole of his time, they expect therefore that all journals, remarks, Memorandums, Drawings, Scetches [*sic*], Collections of Natural History and of Habits, Arms, Utensils, Ornaments &c of every kind be delivered up on the return of the Ship'.

ABOVE

Sir Evan Nepean, 1st Baronet (1752–1822), by Richard Crosse (1742–1810), portrait miniature. Bonhams. Nepean was an influential politician and colonial administrator, who helped Banks with Australian and Pacific projects.

Memorandum of Agreement for Scientific Party of Investigator

In order to prevent all misunderstanding between the Lords Commissioners for executing the Office of Lord High Admiralty of the United Kingdom and the Persons employed by their Lordships as scientific assistants on board his majesties ship the Investigator for the purpose of exploring the country of New Holland: Their Lordships have been pleased to Issue the following instruct[tions] & commands, to be obeyed by all Persons so employed; and it is expected that every Person so employed do sign his name in testimony of his acquiescence in the terms on which their Lordships are pleased to employ him:

1st Their Lordships require every Person employed as a Scientific Assistant on board the Investigator, to render voluntary obedience to the Commander of the Ship, in all Orders he shall from time to time issue, for the direction of the conduct of his Crew, or any part thereof.

2nd Their Lordships require that all persons so employed on all occasions conduct themselves peaceably, quietly and civilly to each other, each readily assisting the other in his respective department, to the utmost of his ability, in such manner as will best promote the success of the Public Service in which they are jointly engaged, and unite their individual endeavours into one general result.

3rdly Their Lordships require the Draughtsmen employed for Natural History, to pay due attention to the directions he shall receive from the naturalist, & the Draughtsman employed for Landscape and Figures, to pay regard to the Opinion of the Commander, in choice of Objects mos[t] fitting to be delineated, and their Lordships moreover require the Gardener, and the Miner, to pay obedience to the Naturalist, in all such Orders as he shall think fit to give them.

4thly Their Lordships consider the Salary allotted to each Person as a full compensation for the whole of his time, they expect therefore that all journals, remarks, Memorandums, Drawings, Scetches, Collections of Natural History and of Habits, Arms, Utensils, Ornaments &c of every kind be delivered up on the return of the Ship, to such Persons as their Lordships shall direct to receive them.

5thly In order however to encourage the Persons engaged in this undertaking to exert themselves to the utmost in accomplishing the Object of their Mission, Their Lordships hereby declare: that if the information collected during the voyage is deemed of sufficient importance, it is their Lordships intention to cause it to be published in the form of a Narrative, drawn up by the Commander on a Plan similar to that pursued in the Publication of Captain Cook's Voyage, and to give such pecuniary Assistance as their Lordships shall see fitting for the Engraving of Charts, Plans, Views, Figures &c and that in such case the most interesting observations of Natural History & the most remarkable Views of Land & delineations of People &c will be inserted therein.

6thly Their Lordships moreover declare that in case the Persons employed in this undertaking as Scientific Assistants are industrious in their several Departments, civil & Obliging to each other, &

co-operate together on all occasions, in making the general work in which they are jointly engaged compleat, by assisting each other & uniting their efforts for the advantage of the Public, it intended that the Profit derived from the Sale of the said Publication shall be divided between the Commander & the Assistants, in proportion to the good conduct each shall have held during the voyage, & the comparative advantage the Publication shall in the opinion of their Lordships derive from the Labours of each Individual.

7thly Their Lordships moreover declare that after such descriptions, drawings & scetches as shall be found necessary for the Illustration & Embellishment of the intended Publication shall have been Selected by such Persons as their Lordships shall be pleased to appoint, and such specimens of Natural History, Arms, Implements, Habits, Ornaments &c as their Lordships think fitting shall have been applied to such purposes as their Lordships shall approve, the remainder of the descriptions of Plants and Animals &c the Scetches of all Kinds shall be at the disposal of the Persons who have made them, for the purpose of being Published by them whenever it is thought proper, at their own risque, and for their own Advantage, provided however that all such Drawings as shall be finished during the voyage & such scetches as their Lordships shall order to be finished after the return of the Ship shall be considered as the Property of the Public and lodged in the Depot, of the Admiralty when required so to be, and that the remainder of the Collections of Natural History, Arms, Habits, Implements, Ornaments &c shall be at the disposal of the Persons who have collected them, all this however on condition that each Person shall during the Voyage have behaved himself with propriety to the rest; Their Lordships reserving to themselves the Power of punishing all deviations from good humor and perfect harmony among parties by withholding from the Persons offending such parts of the benefits above described as they shall think proper.

We the undersigned Robt Brown, Naturalist, William Westall, Landscape & Figure Draughtsman, Ferdinand Bauer, Botanic Draughtsman, Peter Good, Gardener and John Allen, Miner, in testimony of our concurrence in the above terms and as a Pledge for Our Obedience to all such Instructions and Commands as their Lordships shall be pleased to issue to Us, during the time We shall be in their Lordships employ, have Signed our names to this Engagement on the Twenty Ninth Day of April in the Year of our Lord 1801.

Banks specified in the contract that if the team members co-operated they would be rewarded with a proportion of the profits from the sales of the official voyage publication. In this instance no profits were forthcoming. Although of immense value to the seafarer and containing some fascinating information and intriguing landscape views and botanical illustrations, this publication was deemed to be too technical and expensive for the general British public during a period of intense financial pressure at the end of the protracted Napoleonic Wars.

William Westall and the first series of oil paintings of Australia

Joseph Banks' management of the *Investigator* voyage involved the close supervision in the creation of a remarkable series of ten landscape oil paintings by William Westall for the Admiralty. The artist is addressed in detail across chapters 4, 5 and 6. Firstly on his own, and then later with the assistance of Flinders after his return to England following a lengthy detainment of around six and half years in Mauritius in October 1810, Banks arranged for Westall to develop them from his expedition drawings that were kept at 32 Soho Square, London. They were completed in 1813.

Westall's paintings are the earliest to visualise key parts of Australia.

Three of them, with Banks' support, were exhibited at the Royal Academy of Arts and after the completion of the series they were hung in Admiralty House.

Banks also supervised the production of nine engravings – eight from the series of ten oil paintings and an additional one after a selection of drawings and watercolours – to embellish the main text of the official account published in 1814 and entitled *A Voyage to Terra Australis, Undertaken for the Purpose of Completing the Discovery of that Vast country, and Prosecuted in the Years 1801, 1802, and 1803, in His Majesty's Ship the* Investigator, *and Subsequently in the Armed Vessel* Porpoise *and* Cumberland *Schooner, with an Account of the Shipwreck of the* Porpoise, *Arrival of the* Cumberland *at Mauritius, and Imprisonment of the Commander during Six Years and a Half in that island.*

The atlas of this publication (generally known by the shortened title *A Voyage to Terra Australis*) featured 16 charts by Flinders and his officers, as well as 28 coastal profiles by Westall. In addition there were 11 black and white botanical illustrations on ten plates (the tenth features two illustrations) by the shipboard artist Ferdinand Bauer, who created the drawings through the supervision of the shipboard naturalist Robert Brown, some of which were developed under the management of Banks after their return to London.

Ferdinand Bauer aboard the *Investigator*

Banks was a patron of the Austrian-born brothers Ferdinand and Franz Bauer. He selected Ferdinand to paint botanical and natural-history subjects on the *Investigator* voyage. In a letter to William Marsden, Secretary to the Admiralty he stated that, 'Mr Ferdinand Bauer & his brother [Franz] who has the honor to be Botanical Painter to His Majesty at Kew, are nearly [equal] in abilities, they are [the] most Skilful painters of natural history in the Kingdom, and, in my poor opinion are not Equal'd in our Part of Europe.' He arranged for Franz to be employed as the first resident artist at the Royal Botanic Gardens on an annual salary of £300.

Their botanical illustration technique reflects the Linnaean system of classification in that they often feature the entire plant in flower, with individual images on the same sheet of the bud, and fruit invariably dissected to reveal the internal structure. Feldsberg-born Ferdinand and his brother Franz were influenced by and received early training from their father who was court painter to the Prince of Liechtenstein. They then received tuition from the anatomist and botanist Dr Norbert Boccius, before studying at the Akademie der

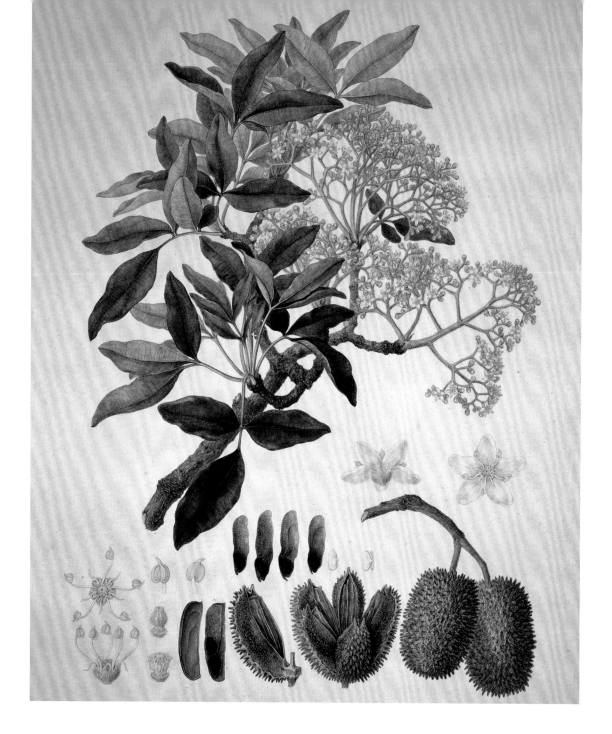

Bildenden Künst in Vienna where they worked for the celebrated naturalist, Nikolaus von Jacquin, the director of the botanical garden at Vienna University.

Ferdinand Bauer accompanied John Sibthorp, the Sheradian Professor of Botany at the University of Oxford on his eastern Mediterranean expeditions that resulted in many of his botanical drawings and some landscape views featuring in the magnificent *Flora Graeca*. This was published in parts from 1806 to 1840, and is regarded as one of the treasures of the Bodleian Library. During Banks' time as a student at Oxford his professor of Botany was John's father Humphry Sibthorp, who relinquished the chair in favour of his son.

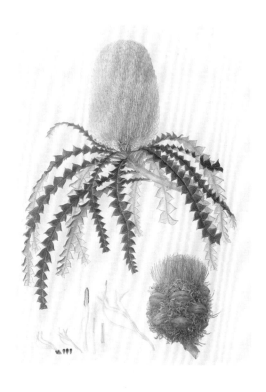

Bauer's acclaimed artistry and meticulous attention to detail attracted the attention of the German writer Johann Wolfgang von Goethe who wrote a short essay on the artist's botanical work of 1817, in which he states: 'we are enchanted at the sight of these leaves: nature is revealed, art concealed, great in its precision, gentle in its execution, decisive and satisfying in its appearance'. Yet, for all the praise, surprisingly there is no surviving portrait of this immensely gifted artist (although an oil of Franz is known by an unidentified artist).

The botanical plates were published on 12 February 1814 and engraved mainly by Elizabeth Byrne, John Pye and F Sansom. They included: *Cephalotus follicularis*, the Australian pitcher plant; *Franklandia fucifolia*, the Lanolin bush; *Dasypogon bromeliifolius*, the Pineapple bush; *Calectasia cyanea*, the Blue Tinsel lily; and *Corysanthes fimbriata*, the Fringed Helmet orchid.

Bauer's first botanical plate – named in tribute to Matthew Flinders – was *Flindersia australis*, commonly called Crow's Ash and also known as Australian teak. It had been collected at Broad Sound, Queensland on 18 September 1802. This hard golden timber has many practical applications and continues to be commonly used today for boats, decking and furniture.

Various botanical specimens after Ferdinand Bauer's artwork were named after Joseph Banks, Robert Brown and Ferdinand Bauer. Some featured in the *Illustrationes Florae Novae Hollandiae* with descriptions by Brown that were published in 1813 prior to the official voyage publication. They included *Banksia coccinea*, or Scarlet Banks, found on the south-west coast of Australia; *Banksia speciosa*, or Showy Banksia that was collected at Lucky Bay, Western Australia in January 1802; *Brunonia australis*, or Pincushion, probably collected at Port Clinton, Queensland in August 1802; and *Genoplesim baueri*, or Brittle Midge Orchid, collected near Port Jackson, across the months of April and May in 1805.

Compared to the small body of landscape and figure work created by Westall of well under 200 artworks (although Flinders was satisfied with his

work), Bauer was a prolific artist who even surpassed Banks' expectations by producing more than ten times that number.

Ferdinand Bauer's 'painting by numbers'

Bauer faced the same challenge as Parkinson on the *Endeavour* expedition (see chapter 2) in that there was too much material to address and not sufficient time – or for that matter suitable conditions (working afloat proved challenging) – to complete finished coloured artworks. He needed a process of speeding up his work rate. He adopted a colour-code system whereby he made carefully crafted graphite drawings with numbers allocated to specific parts.

In total over a thousand numbers were used, with each one corresponding to a colour tone. Bauer almost certainly used an annotated visual aid, not yet located, to enable him to complete the artworks later on the voyage or back in Britain. By way of this 'painting by numbers' system – one that had been invented earlier and used by land-based artists – he was able to produce a large body of remarkable work.

Banks reveals Bauer's working system in a letter to William Marsden on 25 January 1806. He notes, 'the quality of scetches he has made during the voyage & prepared in such a manner by references to a table of colors as to enable him to finish them at his leisure with perfect accuracy, is beyond what, I confess, I thought it possible to perform'.

BELOW

Duck-billed platypus, *Ornithorhynchus anatinus* by Ferdinand Bauer (1760–1826), watercolour on paper. National History Museum, London. 2281. The platypus is found in eastern Australia, from Northern Queensland to Tasmania, and this example is based on sketches made in Port Jackson, New South Wales in July 1802.

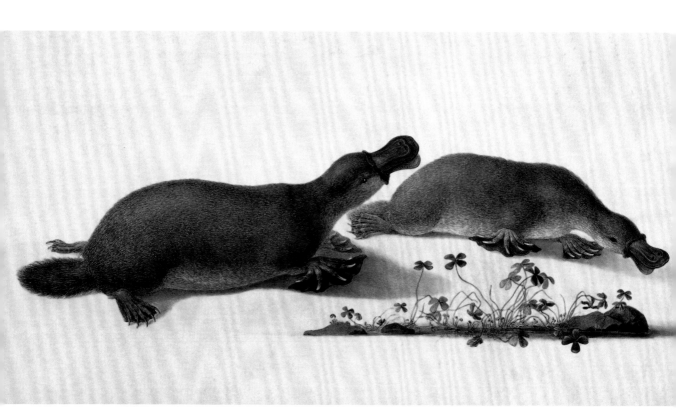

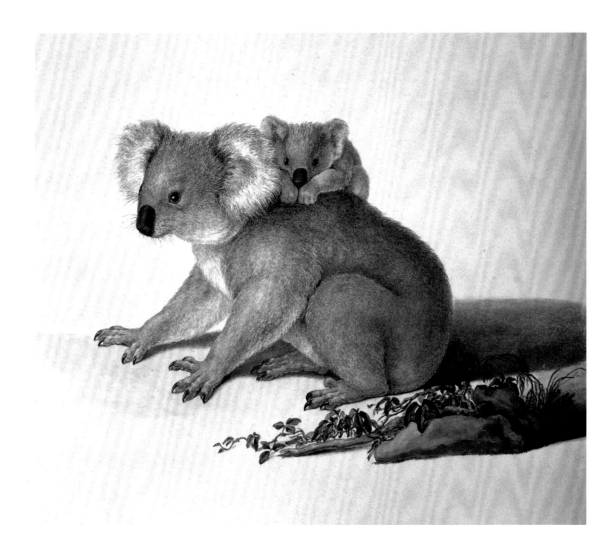

ABOVE

Koalas, *Phascolarctos cinereus*, by Ferdinand Bauer (1760–1826), watercolour on paper. National History Museum, London. 11161. Based on sketches made in Sydney in August 1803 but probably from animals caught in Hat Hill, south of Botany Bay.

Banks had the opportunity to feature a selection of Ferdinand Bauer's exquisite zoological artworks as engravings in the voyage publication. At 32 Soho Square, he scrutinised the artist's green and golden bell frog, the frontal and side views of Brown's leatherjacket, the shape of the blue swimmer crab, the bizarre nature of the duck-billed platypus, the careful rendering of the woolly fur of the koala and the kangaroo-like Black-Footed Rock-Wallaby, the colourful plumage of Port Lincoln Parrot and the rainbow lorikeet, the quirky personality of the weedy sea-dragon and the cute-looking western barred bandicoot, among other artworks.

Frustratingly for the public, Banks decided to leave them all out. Perhaps he was aware that there were cost implications and technical limitations in terms of faithfully reproducing these artworks in engraved

formats. This has been suggested by Neil Chambers, editor of the Banks correspondence project, in terms of an explanation for Banks' abandonment during his lifetime of the complex *Florilegium* project.

Joseph Banks was aware of his experience and expertise as a voyager scientist, as revealed in a letter to fellow Etonian Edward Hasted of February 1782: 'I may flatter myself that, being the first man of Scientifick [*sic*] education who undertook a voyage of discovery, & that voyage of discovery being the first which turned out satisfactorily to this enlightened age, I was in some measure the first who gave that turn to such voyages.'

Banks benefited from a remarkable exploration network of personal and professional contacts, one that he nurtured and capitalised on throughout his career. This was a network connected to his London residences that also operated as centres of Pacific research.

During his lifetime Banks gave away parts of his *Endeavour*

ABOVE

Rainbow lorikeets, *Trichoglossus haematodus moluccanus*, by Ferdinand Bauer (1760–1826), watercolour on paper. National History Museum, London. 11163. The birds were shot at Port Phillip on 30 April 1802. Found in coastal eastern areas of Australia, in forests, woods, parks and gardens from Cape York Peninsula in the north to the Eyre Peninsula and Kangaroo Island in the south.

collections that included a significant amount of ethnographic and zoological material, as these were not his core interests, and he deemed them to be better suited for study by specialists in other private and public collections. However, visitors to his London homes were often amazed at his collections and researchers benefited from the foremost natural-history and travel-writing library, herbarium and art collection relating to the Pacific.

BELOW

Weedy seadragon, *Phyllopteryx taeniolatus*, by Ferdinand Bauer (1760–1826), watercolour on paper. National History Museum, London.10639. Caught at King George Sound on the West coast of Australia in December 1801, although first collected by Sir Joseph Banks on the *Endeavour* voyage.

EXPLORATION NETWORKS AND PACIFIC RESEARCH CENTRES

Joseph Banks' family background, social and professional connections, London residences and interest in art for a practical purpose

Beyond his participation on the *Endeavour* voyage, Banks' advice, encouragement and support to the British government on imperial, colonial and exploration matters operated through an extensive network of influential contacts. Many of these contacts were also fellows of the Royal Society and/or members of the same clubs or organisations facilitated whenever possible through personal meetings in his London home that operated as a research centre, and supported by considerable correspondence.

The task of completing Joseph Banks' *Indian and Pacific Correspondence…* in eight volumes was completed as recently as 2014 under the editorial control of Neil Chambers. The *Scientific Correspondence of Sir Joseph Banks…* in six volumes, also edited by Chambers, had been completed in 2007.

Banks benefited from many educational, financial and social advantages, being well connected through his schooling at Harrow and Eton with further education at the University of Oxford (although, like many wealthy gentlemen of his time, he left without a formal degree). He inherited considerable wealth that gave him financial independence from an early age. His passion for botany started in his youth having been ignited by reading a family copy of John Gerard's *The Herball or Generall Historie of Plantes*, published in 1597.

In 1782 Banks stated, 'Botany has been my favourite Science since my childhood'. After the death of his father William in September 1761 he and his sister Sarah Sophia moved to Chelsea, London. His friend John Montagu, the future 4th Earl of Sandwich who became First Lord of the Admiralty was another resident. Banks visited the Chelsea Physic Garden, where he was guided by Philip Miller, the chief gardener and a fellow of the Royal Society.

A good example of Banks' financial independence relates to his time at Oxford. Initially he had been taken aback by Humphry Sibthorp, the Sherardian Professor of Botany, who refused to give public lectures, but this did not stop the enterprising Banks from obtaining permission to employ Israel Lyons, a botanist and mathematician from the University of Cambridge, to provide tuition. His financial independence was further strengthened later in life when – in the spring of 1779, two years before he was knighted – he married Dorothea Hugessen, the eldest daughter of a wealthy landowner from Kent. Banks' fellow Etonian Constantine Phipps, 2nd Baron Mulgrave, the polar explorer who rose to become a Lord of the Admiralty, helped to establish his reputation for natural history and especially botany. He features in Joshua Reynolds' Dilettanti group portrait. In 1766 he sailed with Phipps aboard His Majesty's Ship *Niger* to Newfoundland and Labrador to study the flora and fauna. Later Banks used Carl Linnaeus' classification system in the publication of the first descriptions of their collections from these countries.

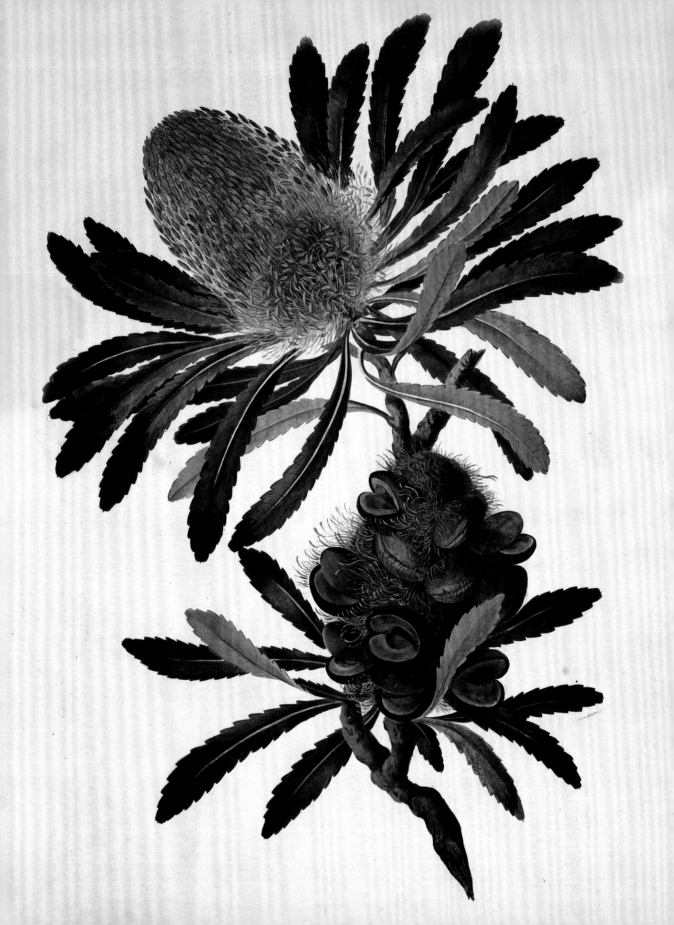

The Royal Society network of influence

This voyage coincided with Banks' election to the Royal Society in 1766, an organisation that provided the main professional network from which Banks could – as the unpaid, unofficial minister – advise the King and the government on imperial and colonial matters.

The evidence of Banks' influence extending deep inside the Admiralty is revealed through the significant number of senior Royal Navy officers and officials who were fellows of the Royal Society during his presidency and while he was a senior fellow. They included his friend John Montagu (elected 1740); Alexander Dalrymple (elected 1771), the first Admiralty Hydrographer; Constantine Phipps, 2nd Baron Mulgrave (proposed by Banks and elected 1771); and George John Spencer, 2nd Earl Spencer (elected 1780), one of the Lords of the Admiralty and a co-signatory authorising the *Investigator* expedition.

Four Secretaries to the Admiralty also became fellows of the Royal Society and all played a notable role assisting Banks with the *Investigator* voyage at various stages. In chronological order they are: William Marsden (elected 1783), who became Vice-President of the Royal Society; Sir John Barrow, 1st Baronet (elected 1805), a longstanding president of the Royal Geographical Society; John Wilson Croker (elected 1810) who organised the transfer of William Westall's Australian expedition artworks to

32 Soho Square for Banks to evaluate and store; and Sir Evan Nepean, 1st Baronet (elected 1820), who was instrumental in arranging for Banks to receive full Admiralty approval to place his specialist team aboard the *Investigator*.

In 1764 Dr Daniel Solander was elected a fellow of the Royal Society. At that time he was working at the British Museum cataloguing the natural-history collections. He became Banks' curator-librarian, closest professional adviser and travelling companion until his premature death in 1782. In fact Banks acknowledged him as a dear friend, who was widely liked and renowned for his lively conversation and distinctive waistcoats.

Dr Solander had appeared as the second name on a long list of eminent gentlemen supporting the nomination of Cook for fellowship of the Royal Society, the first being that of Banks. He was elected on 29 February 1776 on the grounds that, 'Captain James Cook of Mile-end, a gentleman skilful in astronomy, and the successful conductor of two important voyages for the discovery of unknown countries, by which geography and natural history have been greatly advantaged and improved'. In the same year Cook also received from the Society their highest honour, the Copley Medal. Cook acknowledges Banks' influence in his election to the Royal Society, and also the award.

LEFT

Old Man banksia, *Banksia serrata*, after an outline drawing by Sydney Parkinson (c.1745–71) completed by John Frederick Miller (1759–96), graphite and watercolour, intended for the *Florilegium*. Natural History Museum. 7151. Native to the east coast of Australia, this is one of the species collected by Sir Joseph Banks during the *Endeavour* voyage in 1770.

Banks' family homes and links with Lincolnshire

Although Joseph Banks was born in Argyll Street in Soho in central London, he regarded himself as a 'son of Lincolnshire' because of longstanding family interests in that county. The Banks family money derived largely from astute farm, land and property purchases principally from Lincolnshire but also in Derbyshire and Staffordshire. His great-grandfather Joseph Banks (1665–1727), his grandfather Joseph Banks (1695–1741), and his father William Hodgkinson Banks (1719–61) who took the middle name Hodgkinson as part of condition to secure a family inheritance, all entered parliament and were deputy-lieutenants of Lincolnshire. Banks' grandfather and his uncle Robert Hodgkinson Banks were also fellows of the Royal Society.

In 1714 Banks' great-grandfather purchased Revesby Abbey in Lincolnshire, a 2,000-acre estate for around £14,000 that became the main family home outside of London. Joseph Banks of the *Endeavour* maintained this property and homes at Overton Hall near Ashover in Derbyshire and Spring Grove House in Middlesex.

Banks and his family spent a considerable amount of time in his respective London homes owned at different times, in particular 32 Soho Square, London. This was determined by his work commitments to the Royal Society. Soho Square was his principal London residence from August 1777, one that he shared with his wife Dorothea, who had inherited a fortune of some £14,000, and his sister Sarah Sophia Banks (none of them had children). Both Dorothea and Sarah Sophia dutifully managed the affairs of the house, hosted or helped at the numerous working breakfast meetings and Sunday evening *conversaziones*.

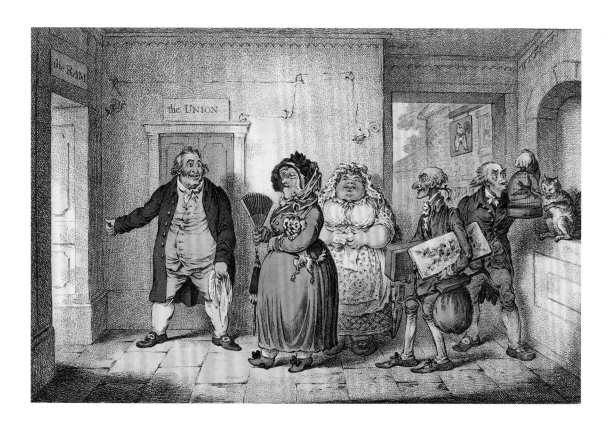

Dorothea and Sarah were also collectors in their own right – ceramics being of interest to Dorothea, and coins, medals and paper ephemera including satirical prints to Sarah. The latter formed an important and often-overlooked collection of around 19,000 items that was left to the British Museum. It is the subject of Arlene Leis' research work entitled *Sarah Sophia Banks: Femininity, Sociability and the Practice of Collecting in Late Georgian England* (University of York, PhD, 2013). The caricaturist James Gillray brutally lampooned Banks' unmarried sister, who is now acknowledged as having had an important influence on the development of her brother's botanical interests and other collecting habits in *An old maid on a journey* (published by Hannah Humphrey in 1804).

The extent of 32 Soho Square being used as a public space over many years is revealed in Sir Richard Phillips' *The Picture of London for 1802*, published as a 'correct guide to all the Curiosities, Amusements, Exhibitions, Public Establishments, and remarkable Objects, in and near London'. The writer John Feltham was associated with Phillips' publication and probably compiled the sections – including one headed 'Literary Assemblies' with a subsection titled 'Sir Joseph Banks, President of the Royal Society'. It noted that Banks 'receives, on every Thursday morning, during the society's meetings, his friends, members of the society, and gentlemen introduced by them, at a public breakfast in his house in Soho-Square. The literary, and much more, the scientific news of the day, are the topics of the conversations of this place'. It also remarked: 'New and curious specimens of subjects in antiquities, in natural history, &c are often produced for the inspection of the persons who then assemble', and: 'On every Sunday evening, too, during the session of parliament and the meetings of the Royal Society, the same gentleman opens his house for the reception of a Conversation assembly of his literary and philosophical friends, and of all gentlemen, whether natives of this country or foreigners, whom his friends introduces.' Phillips' guide continued to include this information on Banks' social and professional gatherings at Soho Square for more than a decade, including the 1815 edition.

32 Soho Square was also where Banks was able to interact with respective curator-librarians and supervise the team of 'in-house' artists and engravers working, at different times, on the *Florilegium* and other Pacific projects. All of this highlights that this London home in particular was the most significant research centre relating to global voyages of exploration, especially those in the Pacific, from the late 1770s until Banks' death in 1820.

LEFT

An old maid on a journey, hand-coloured etching after and by James Gillray (c.1756–1815) published on 20 November 1804 by Hannah Humphrey. National Portrait Gallery, London. NPGD12837. The floral panel under the gentleman's arm highlights one of the passionate interests of Banks' sister, and Banks himself.

14 New Burlington Street: Banks' first London home

In 1772 the Rev. William Sheffield, Keeper of the Ashmolean Museum at the University of Oxford, vividly recalled a visit to Banks' previous London residence at 14 New Burlington Street. In particular he was struck by Sydney Parkinson's botanical and zoological artworks. Writing to the naturalist and ornithologist Rev. Gilbert White, Sheffield was awestruck by the experience. He recounted, 'His house is a perfect museum; every room contains an inestimable treasure [that included] the choicest collection of drawings in Natural History that perhaps ever enriched any cabinet, public or private; 987 plants drawn & coloured by Parkinson; and 1300 or 1400 more drawn, with each of them a flower, a leaf, and a portion of the stalk coloured, by the same hand, besides a number of other drawings, of animals, fish, birds, &c.'

The number of artworks by Parkinson that Sheffield observed included those developed from his partially finished coloured examples by other artists employed by Banks back in Britain. Parkinson had completed 280 of more than 900 botanical drawings during the voyage. The specimens had been collected by Banks and Dr Solander in Madeira, Brazil, Tierra del Fuego, the Society Islands, New Zealand, Australia and Java.

Parkinson's system of creating a partially completed study with observations and colour reference notes, usually on the back of each drawing, was introduced for two main reasons. Firstly, as the landscape and figure draughtsman Alexander Buchan had died early on in the voyage at Tahiti on 17 April 1769, this meant that Parkinson had to focus on aspects of his work. Therefore a simplified botanical art record with reference notes meant that he could produce a far greater number of artworks. Secondly, Parkinson also had to work swiftly in order to sketch, draw and colour before the plants wilted and their colours faded. The intention was that he would return later on in the voyage, when time allowed, to complete the designs. Sadly the opportunity never arose, for on 26 January 1771 he died from dysentery contracted shortly after leaving Batavia (Jakarta).

However, Parkinson's time-saving art format that had certainly been encouraged – and perhaps even suggested – by Banks and Dr Solander, enabled five other artists: Thomas Burgis, John Cleveley the younger, the brothers John Frederick Miller and James Miller, and Frederick Polydore Nodder, who executed many of the Australian plants, to complete the botanical work in the sea-free and comfortable environment of Banks' London residences. They were also aided in terms of contours and form, although not colour, by the pressed and dried specimens of Banks' *Endeavour* herbarium that is now in the Natural History Museum, London.

LEFT

Stone fish, *Synanceja verrucosa*, by Sydney Parkinson (c.1745–71), watercolour. Natural History Museum, London. 3081. This venomous fish, that disguises itself as a rock on the seabed, is found in the coastal regions of the Indo-Pacific. The artist could have seen it at various places on the *Endeavour* voyage.

The *Florilegium*

The *Florilegium* was a complex botanical colour engraving project based on the discoveries from the *Endeavour* voyage and co-authored by Banks and Dr Solander. However, the project – although well advanced – was abandoned for various reasons including the premature death of Solander in 1782. A plausible explanation can be found in the technical limitations of printmaking at that time in reproducing some of the details of the plants. This was a concern raised by Benjamin Franklin, the inventor and politician who was familiar with Banks through shared fellowship of the Royal Society.

Franklin wrote to an unidentified correspondent on 3 November 1773: 'Mr Banks is at present engaged in preparing to publish the Botanical Discoveries of his voyage. He employs 10 engravers for the plates, in which he is very curious so as not to be quite satisfied in some cases with the expression given by either the graver, Etching or Metzotints [*sic*], particularly where there is a wooliness or a multitude of small points on a leaf.'

Joseph Farington, the Royal Academician and diarist, recollected on 8 July 1794 that, 'Sir Joseph Banks' Botanical work [*Florilegium*], which has been carrying on many years, and for which 1500 plates are engraved, is not likely to be published as was expected. Some think Sir Joseph does not choose to encounter the opinion of the world on the merits of it, and, indeed, it is probable ill-disposed criticks wd. [*sic*] not be wanting.'

The copperplates, all fairly uniform in size and measuring around 18 x 12 in, were deposited in the British Museum with other parts of Banks' collections after his death according to his will, through arrangements made by his last curator-librarian Robert Brown.

It was not until the second half of the 20th century that the engravings of *Banksia serrata* – commonly called old man banksia, or saw banksia and *Deplanchea tetraphylla*, or the Golden Bouquet – would be commercially printed by Alecto Historical Editions. *B. serrata* is one of the small number of original *Banksia* species collected by Sir Joseph Banks on the eastern coast of Australia in 1770. The publishers used 743 botanical plates to produce what they titled *Banks' Florilegium*. The engravings are

ABOVE

New Zealand flax, *Phormium tenax*, completed by Frederick Polydore Nodder in 1789 from an original outline sketch by Sydney Parkinson (c.1745–71) started circa 1769, watercolour. Natural History Museum, London. 8133. The potential usefulness of flax excited Banks, and an illustration of it by Nodder appears in Benjamin West's full-length portrait of him.

Golden bouquet tree, *Deplanchea tetraphyllia*, after an original outline drawing by Sydney Parkinson (c.1745–71) by Frederick Polydore Nodder (1751–1800), graphite and watercolour, intended for the Florilegium. National History Museum, London. 8092. This spectacular fast growing small tree grows in the coastal and monsoon forests, and rainforest from Cape York to Townsville in North Queensland.

printed in colour *à la poupée. The* first edition was published in association with the British Museum (Natural History), known officially from 1992 as the Natural History Museum, and issued in 35 parts between 1980 and 1990.

Sheffield elaborated on the contents of three rooms of New Burlington Street. What he described highlights the diverse range of Banks' acquisitions and reflects the importance of his specialist circle of collectors. In fact the artworks of Parkinson were only a very small proportion of what became popularly known later as 'Banks' Museum', which featured a sensational collection of 'natural and artificial curiosities'.

Sheffield noted: 'First the Armoury; this room contains all the warlike instruments, mechanical instruments and utensils of every kind, made use of by the Indians in the South Seas from Tierra del Fuego to the Indian Ocean – such as bows and arrows, darts, spears of various sorts and lengths, some pointed with fish, some with human bones, pointed very finely and very sharp, skull-crackers of various forms and sizes, from 1 to 9 feet long, Stone hatchets, chisels made of human bones, canoes, paddles, etc.'

He went on to describe the second room, which contained: 'the different habits and ornaments of the several Indian nations they discovered, together with the raw materials of which they were manufactured. All the garments of the Otaheite [Tahitian] Indians and the adjacent islands are made of the inner bark of the *Morus papyrifera* and of the bread tree *Chitodon altile;* this cloth, if it is may be so called is very light and elegant and has much the appearance of writing paper, it is more soft and pliant; it seems excellently adapted to these climates; indeed most of the tropical islands, if we can credit our friend's description of them, are terrestrial paradise.'

He continued: 'The New Zealanders, who live in much higher southern latitude, are clad in a very different manner; in the winter they wear a kind of mats [*sic*] made of a particular species of Cyperus grass. In the summer they generally go naked, except a broad belt about their loins, made of the outer fibres of the cocoa nut, very neatly plaited, of these materials they make their fishing lines both here and in the tropical isles. When they go upon an expedition or pay or receive visits of compliment, the chieftains appear in handsome cloaks ornamented with tufts of white Dog's hair; the material of which these cloaks are made, are produced from a species of *Hexandria* plant very common in New Zealand;

something resembling our Hemp, but of finer harl, and much stronger, and when wrought into garments is as soft as silk; if the seeds of this plant thrive with us, as probably they will, this will be perhaps the most useful discovery they made in the whole voyage.'

Sheffield observed that the third room contains, 'an almost numberless collection of animals; quadrupeds, birds, fish, amphibians, reptiles, most of the new and nondescript [not yet accurately described]. Here I was lost in amazement, and cannot attempt particular description.'

Banks' collections had been carefully displayed with the assistance of Edward Jenner, the pioneer of the smallpox vaccine.

By the time Banks was settled into his Soho Square residence in 1777, he had enlarged his collections and had considerably more space in which to accommodate and display them. Banks was not alone in creating a Pacific collection. Lord Sandwich had also accumulated a notable one – with the assistance of Cook, Banks and others – key parts of which would later be transferred for public display at the British Museum.

Pacific collections

The Picture of London for 1802 featured a section on the British Museum, 'established by act of parliament, 1753'. The guide lists ten main collections that included 'The Curiosities collected in Cooke's [sic] Voyages round the World'.

A brief and in parts damning description of the contents of the Pacific display can be found in *The Picture of London for 1806*, revealing the way the curators had juxtaposed an artefact from the Friendly Islands in the South Pacific with one from ancient Egypt. In 1773 Cook first visited Tonga, known in the west as the Friendly Islands, because of the cordial reception he received during his second Pacific voyage.

The guide indicates that, 'In the left corner is the mourning dress of an Otaheitean Lady, in which taste and barbarity are singularly blended; and opposite are the rich cloaks and helmets of feathers from the Sandwich Islands … Over the fire-place are the Cava bowls, and above them, battoons [sic], and other weapons of war. The next objects of attention are the idols of the different islands presenting, in their hideous rudeness, a singular contrast with many of the works of art by the same people; near these are the drums, and other instruments of music. In the door-way leading from the room, is a small glass case, containing a breast-plate from the Friendly Islands,

contrasted with another of an Egyptian mummy, and exhibiting a singular coincidence.'

A selection of 'natural and artificial curiosities' of the Pacific also featured in some popular commercial attractions notably in Sir Ashton Lever's Leverian Museum, or as it was called the Holophusicon, located at Leicester House in Leicester Square, London. This ran from 1775 to the mid-1780s. Cook is known to have donated some Pacific items for this attraction.

Phillips' guide for 1802 mentions 'The Leverian Museum', revealing that this collection was sold by lottery and won by 'Mr Parkinson', no relation to Sydney the artist. He 'built a very elegant and well-disposed structure for its reception, about a hundred yards from the foot of Blackfriars Bridge, on the Surrey side.'

It was open every day with an admission price of one shilling. And the guide continued, 'Besides quadrupeds, birds, fishes, insects, fossils, shells, and corals, there are a great variety of antiquities and curious reliques.'

Donations from Lord Sandwich, Banks and the Forsters (the father and son naturalists on Cook's second Pacific voyage) were made during their lifetimes to the Universities of Cambridge and Oxford, and later transferred to the Museum of

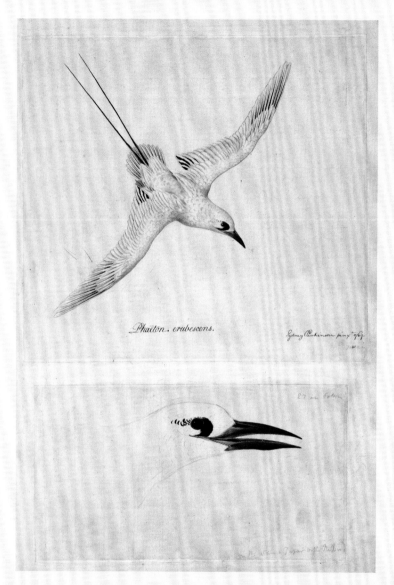

Phaëton. erubescens.

Sydney Parkinson pinx 1769.

Archaeology and Anthropology and the Pitt Rivers Museum respectively. However, of all these collections, there was nothing to match Banks' multi-layered collection comprising herbarium, library, artworks, artefacts and wide-ranging natural and artificial curiosities.

New Burlington Street had been purchased by Banks in 1767, encouraged by a close relationship with his uncle Robert Banks Hodgkinson who became his guardian after his father's death in 1761, and who lived at 2 New Burlington Street. In Alexander JP Raat's *The Life of Governor Joan Gideon Loten (1710–1789): A Personal History of a Dutch Virtuoso* (2010), he provides a valuable insight into Loten's London residence that was in the same street and very close to where Banks was living.

Interior of 14 New Burlington Street

Raat describes New Burlington Street as being the last developed by Robert Boyle, 3rd Earl of Burlington, who carried out the majority of the development. He recounts that, 'The houses were highly uniform in terms of their external appearance and were intended for residential occupation by people of substance. Each of the houses contained a basement, had three storeys and a garret, and had a brick front which was three, or possibly four, windows wide. The colour of the brickwork was reddish brown.'

He adds: 'The first three floors of each house had two rooms consisting of a dining and breakfast parlours on the ground floor, drawing rooms on the first (or principal) floor, and bedrooms with closets on the second floor. The garrets became three chambers for the servants. A single staircase of stone served the whole building and existing evidence suggests that it was placed in the middle of the house with a room in front and behind it. The house-keeper's room, servant's hall, kitchen and scullery were to be found in the basement. A detached stable containing a double coach-house, stabling for six horses and accommodation for the coachmen could be found in the court-yard at the back of the house.' Joan Gideon Loten, the former Dutch Governor of Ceylon, shared Banks' interest in natural history and was a frequent visitor to his house. He wrote of Banks that he 'amuses himself always with the most precise researches that astonish his fellow-men'.

Sydney Parkinson: Banks' botanical and natural history painter

Banks arranged to have some of Loten's Ceylon watercolours from the East Indies copied by Sydney Parkinson, who was in his employ prior to the *Endeavour* expedition. This is probably how he first met Parkinson's brother Stanfield, who worked as an upholsterer and had been paid by Banks for work at New Burlington Street.

Dr Daniel Solander was both a doctor and friend to Loten. Letters from Loten written from his New Burlington address to his brother often mention him in favourable terms. One fascinating letter contains information on the working relationship of Banks and Solander after the *Endeavour* voyage and insights into Sydney Parkinson's character.

In September 1771 Loten wrote, 'Dr Solander entered and stayed until 10 o'clock when he moved to my neighbour Banks across the street to stay the night. Although Dr Solander has a private apartment at the British Museum, he will stay with Mr Banks until all their drawings of animals, birds, fishes, insects, the herbaria &c: have been ordered.'

He continued: 'I have already seen 32 Atlas portfolios, most of them either finished or sketched by that able and exact draughtsman and watercolour painter the late young man Sidney [sic] Parkinson, who, although, a Quaker, very friendly and communicative and who often came to me to spend half a morning to show me the things he had drawn &C.'

Banks' paintings of the kangaroo and dingo

Even though Loten was a close neighbour and visitor to Banks' home, oddly he makes no reference to a pair of oil paintings that reinforced Banks' residence as the must-see private 'Pacific Museum' in the heart of London. Painted by George Stubbs, they were originally entitled *A Portrait of Kongouro from New Holland, 1770* and *A Portrait of a Large Dog from New Holland, 1770*. In the 18th century the spelling of kangaroo appears in various forms, including kongouro or kanguroo. The 'Large Dog' was actually a dingo. Both paintings are signed and dated 1772. They are similar in size and were likely to have been displayed close together.

Banks commissioned Stubbs to paint the pictures that were exhibited as a pair at the Society of Artists in London in 1773. At that time Stubbs was president of that organisation. This Liverpool-born artist combined art and science in his work. Many

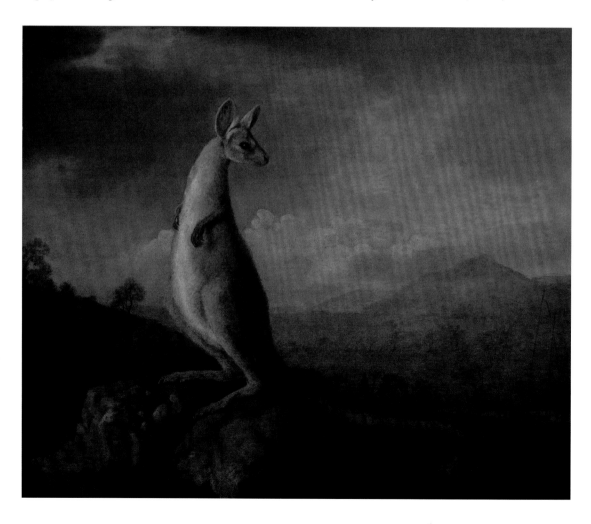

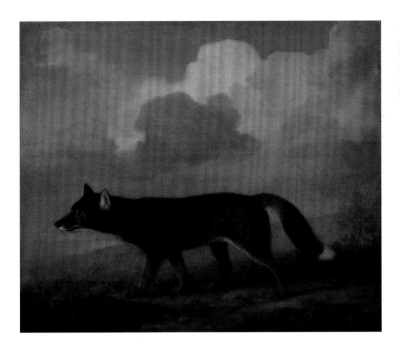

years of research informed his acclaimed publication *The Anatomy of the Horse*, published in 1766, and he became the pre-eminent equine and animal artist of the 18th century. Earlier Banks had worked with Stubbs, commissioning him to draw some lemurs – one of several depictions of them now in the British Museum.

Stubbs' paintings were displayed at Banks' London homes – firstly at New Burlington Street and then 32 Soho Square in the library. After Banks' wife's death in 1828 they were passed down to her relatives by descent before being acquired by Mrs Alicia Pearson, a descendant from a branch of the family resident at the Elizabethan estate of Parham Park in Sussex. They were offered for sale in the early 2010s, and at the end of a fundraising campaign backed by Sir David Attenborough and competing against the National Gallery of Australia, they were eventually acquired by the National Maritime Museum, Greenwich in 2013.

Not surprisingly, Stubbs' depiction of the kangaroo caught the attention of some contemporary commentators in newspapers and journals, albeit in a cursory form as lengthy art reviews were not undertaken in the 18th century. One critic calling himself 'No Dictator' in the *Morning Chronicle, and London Advertiser*, 1 May 1773 noted, 'The Kongouro – An early piece of animal painting, but the subject rather extra-ordinary'.

Another brief review by a different critic, published in the same paper of 8–11 May, mentioned a few of Stubbs' exhibits including 'A portrait of the Kongouro, from New Holland', and wrote, 'These pictures lend additional support to the reputation Mr Stubbs has universally and deservedly acquired in the line of animal painting.'

However, other reviewers were not complimentary of the artist's work. A reviewer of *The Public Advertiser* on 7 May 1773, signing themselves 'A Critic', thought that 'His Horses and Dogs are admirably drawn; and his Performances in general are finely coloured; but he employs himself on subjects [perhaps referring to the kangaroo and his landscapes] which are not my Delight, and which I attend to principally from my Respect for his Genius.' Another commentator from the *Middlesex Journal* on 15–18 May 1773 was far from enamoured with Stubbs' attempt at landscapes, writing: 'The

reputation Mr Stubbs has so justly acquired in animal painting, has led him into a boldness of introducing it in an inferior degree, by launching into landscape', and that his landscapes were 'little better than [the] rude efforts of a pupil.'

As Stubbs lacked first-hand experience of the Pacific, the landscape-setting and the kangaroo were supplied to the artist in various forms, in part through recollections from Banks and Dr Solander. The curious appearance of the kangaroo almost certainly derives from an inflated or stuffed kangaroo skin, likely to be the young female caught by Banks' greyhound on 29 July 1770 in the period when the *Endeavour* was being repaired on the Endeavour River (now part of modern-day Cooktown) after being damaged on the Barrier Reef.

The kangaroo's head position is also peculiar, being turned to look behind as if the animal is wary of someone or something stalking it. It is also possible that Stubbs had access to drawings of kangaroos by Sydney Parkinson, as two are known although they might have been returned to his brother during the dispute with Banks. Specialist debate on precisely what species Stubbs depicts in this picture and from which part of Australia – as well as the reference sources used – have a long, and at times acrimonious, history that continues today.

To date no insightful reviews have been found of the poor dingo and no engraving is known. In the absence of dingo bones, skulls or skins it is likely that this painting was produced largely from memory.

Returning to the kangaroo: Dr George Shaw – the botanist, physician and zoologist, and keeper of the British Museum's natural-history department – may well have seen Stubbs' paintings at the Society of Artists and also in both of Banks' London homes. He was a fellow of the Royal Society and moved in the same circles as Banks. Shaw's interest in Australian animals featured in various publications, notably that of the *Zoology of New Holland* published in 1794. Later he described the kangaroo as 'the most extraordinary and striking animal which the Southern Hemisphere has yet exhibited to our views'.

Dr Samuel Johnson, the lexicographer, was so taken with the kangaroo popularised by Banks' artistic commission that it was reported that on at least one occasion he enjoyed emulating the curious creature. According to Jeffrey Meyers in *Samuel Johnson the Struggle* (2008), an observer recalled that Dr Johnson, 'a tall, heavy, grave-looking man, would stand up to mimic the shape and motions of the animal', and that: 'Nothing could be more ludicrous. He stood erect, put out his hands like feelers, and gathering up his coat tails of his huge brown coat so as to resemble the pouch of the animal, made two or three vigorous bounds across the room!' Banks was a close friend of Johnson and was a pall-bearer at his funeral in Westminster Abbey in 1784.

James 'Athenian' Stuart's kangaroo picture and Pacific illustrations

Intriguingly Stubbs' kangaroo was not the only one on display in London in the spring of 1773. Banks' friend James 'Athenian' Stuart (the architect, artist and engraver, who proposed Banks to be a member of the Society of Dilettanti and later was tasked by the Admiralty, as revealed by art historian Kerry Bristol, to supervise artistic aspects of Captain Cook's second Pacific voyage publication, almost certainly with Banks' assistance) exhibited four artworks at the Free Society, a rival London art group to that of the Society of Artists. One was entitled *The Kongaroo, an animal in New Holland – undescribed by any naturalist*.

In addition to Stuart's design of a kangaroo, three other artworks were submitted under his name: *Interview of the Hon. Commodore Byron, and*

the Patagonian; *The natives of Otaheitee attacking the Dolphin Frigate, Capt. Wallis*; and *Interview of the Princess Oberhea, and Capt. Wallis in Otaheitee.* A note in the exhibition catalogue stated, 'For the unpublished account of the last Voyage round the World'.

Judy Egerton, author of the Stubbs' *Catalogue Raisonné* with support from Kerry Bristol, suggests that Stuart's picture was an engraving or drawing, and that Stuart had hoped his version of the kangaroo would be used to illustrate Dr Hawkesworth's publication, although William Strahan the publisher opted instead for an engraving of Banks' oil painting by Stubbs. Stuart is addressed further in chapter 3.

The three additional non-fauna subjects relate to earlier British voyages of exploration which also appeared in Dr Hawkesworth's account. They were engraved by others, although they were not all acknowledged on the plates. One is associated with Vice-Admiral, Rt Hon. John Byron's mission to establish a permanent naval base in South America in the early 1760s. The others are associated with Captain Samuel Wallis' global voyage with Philip Carteret in the *Dolphin* and *Swallow* in which Wallis first encountered Tahiti in June 1767. Once back in Britain, his account of Tahiti determined that the *Endeavour* headed for that island to observe the transit of the planet Venus.

Benjamin West's portrait of Banks

Banks and his uncle Robert Banks Hodgkinson had many interests in common. Hodgkinson was the likely commissioner of the most impressive and largest portrait of Joseph Banks, portraying him aged 29 as the pioneering collector of Pacific natural history (illus p.2). It was painted by the Anglo-American Benjamin West, who became President of the Royal Academy of Arts, and it is now displayed at the Usher Art Gallery, part of The Collection in Lincoln, but for many years it was believed to be missing. It had been on display at Overton Hall in Derbyshire, the home of Banks Hodgkinson that was bequeathed to Banks after his death in 1792.

Following Banks' death the portrait remained at Overton and, after selling at auction to the Australian businessman Alan Bond, it was eventually purchased for public display in Lincoln. In addition to art, the Banks Hodgkinson's estate came with financial interests in what had been a phenomenally lucrative lead mine.

In December 1771 – only a few months after Banks' return from the Pacific – Benjamin West started painting his imposing portrait, measuring a stupendous 7½ x 5 feet. It was probably finished late in 1772 and was displayed at the Royal Academy of

Arts in 1773, which at that time opened to the public in April. The painting was also engraved in mezzotint by John Raphael Smith and published in 1773.

West's portrait – probably too large to hang in Banks' London residence – depicts him full-length, standing and surrounded by items collected during the *Endeavour* voyage. They include to the left of the picture a Tahitian feathered helmet (*fau*) worn by high-ranking individuals, a paddle (*hoe*) and quarterstaff from New Zealand, the latter used for parrying and striking. In the bottom right of the painting is a hafted adze, bark cloth-beater and cleaver – a handheld fighting weapon that Banks noted that the Māori called 'Patoo patoos'.

The portrait reflects the Rev. Sheffield's vivid recollections of what he experienced at New Burlington Street, and spotlights Banks as *the* Pacific collector by placing him in a central, dominant position. He wears and gestures towards his Māori cloak (*kaitaka*) made of New Zealand flax. His right forefinger points to the open folio visible on the ground below, which depicts the New Zealand flax plant pictured by Frederick Polydore Nodder (one of Banks' 'in-house' artist-engravers) after the original *Endeavour* artwork by Sydney Parkinson.

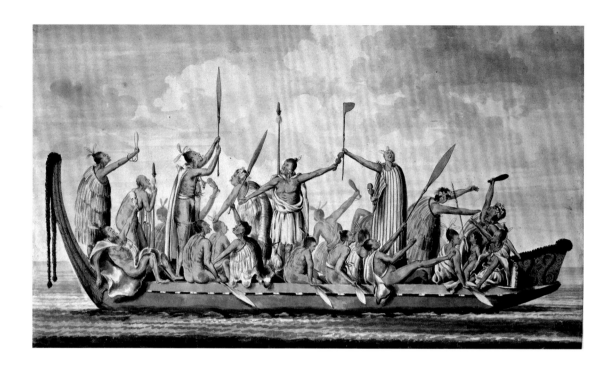

Botany, art, manufactures and commerce

Banks' hope for the commercial success of New Zealand flax was, however, never fully realised. It was exported to Britain and New South Wales primarily for rope-making but, as Neil Chambers explains in *Endeavouring Banks…* (2016), 'other fibres eventually proved more suitable, and its use became entirely superseded by the production of synthetic materials in the twentieth century'. However, in the 19th and part of the 20th centuries Chambers also states that, 'production continued for a range of purposes, including cordage, woolpacks and floor coverings'.

Banks had an interest in ornamental plants but he was particularly fascinated by those with a useful purpose, with an eye for benefits to Britain and her colonies in terms of manufacturing and medicines. His interest chimed with many others including those members of the London-based society of which he was an early member that is usually known by its shortened title, the Society of Arts. It was established by the drawing master, inventor and

social reformer William Shipley in 1754, and its full title encapsulates its inaugural mission statement: the 'Society for the Encouragement of Arts, Manufactures and Commerce'. (It received the prefix Royal in 1908.)

From its inception the importance of drawing was emphasised by the 11 founder members who agreed, among other matters, 'to consider of giving Rewards for the Encouragement of Boys and Girls in the Art of Drawing; it being the Opinion of all present that the Art of Drawing is absolutely necessary in many Employments, Trades and Manufactures, and that the Encouragement thereof may prove of great Utility to the Public'. This proposal was formally adopted and the scheme quickly expanded to include different competition categories for various age groups.

The Society of Arts offered medals and monetary prizes for its competitions, including a premium relating to an initiative to encourage the movement of breadfruit from the Pacific to the West Indies,

as had been supported by Banks. It also hosted the first exhibitions of contemporary art in London, which became known as the Free Society of Artists. Through a breakaway group formally established in May 1761 – named the Society of Artists of Great Britain (often shortened to Society of Artists) – it acted in tandem with the Society of Dilettanti as a catalyst for the formation of the Royal Academy of Arts in 1768, assisted by the regal connections of the neoclassical architect Sir William Chambers, with Joshua Reynolds (a former member of the Society of Artists) as its first president.

Recipients of prizes in the late 1770s would have received them in the Great Room that was later decorated with a series of six large-scale 'mural' paintings in a neoclassical style collectively entitled *The Progress of Human Culture* by the Royal Academician James Barry, who was Professor of Painting at the Royal Academy of Arts from 1782 to 1799. Barry completed the series after several years of work largely in the early 1780s, but returned to make additions and changes in later years. William Pressly in *James Barry's Murals at the Royal Society Arts – Envisioning a New Public Art* (2014), supported by research by the late DGC Allan, presents an award-winning account of their development and influence. They are arguably the 'most impressive series of history paintings in Great Britain'. One mural called *The Thames, of the Triumph of Navigation* features a portrait of Captain James Cook.

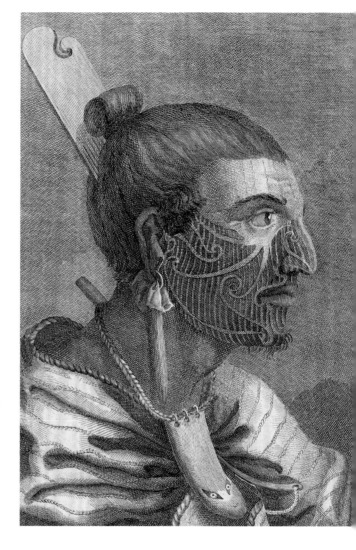

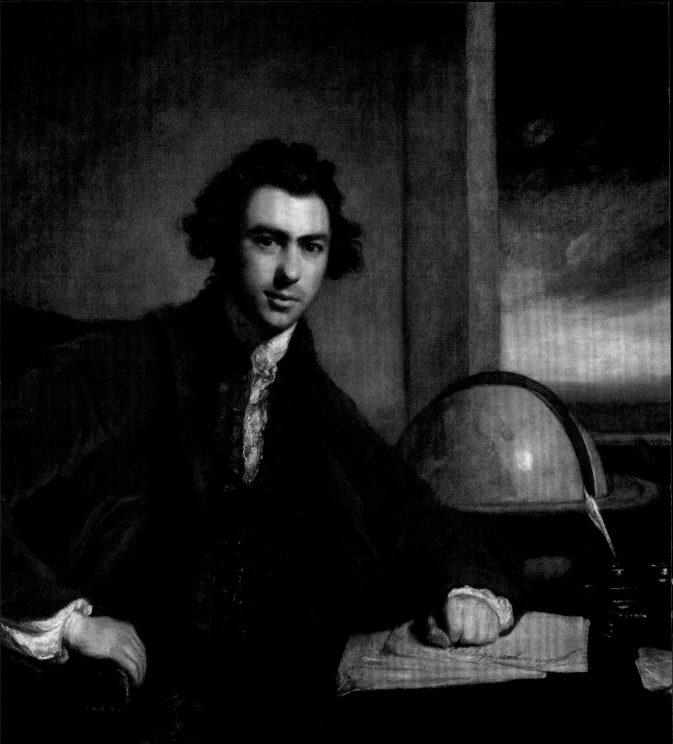

Banks' character, personality and association with portrait painters

Reynolds was an artist well known to Banks. He paid him for two very different portraits: one featuring just himself, and another as part of two group portraits for the Society of Dilettanti (see chapter 3) of which they were both active members. Over the course of his life Banks was captured many times in a wide range of formats and media by acclaimed painters, printmakers and sculptors and collectively their artwork acted to spotlight his diverse achievements and (in modern advertising parlance) in some instances strengthen the Banks 'brand'. These portrait images were particularly important after he was elected President of the Royal Society on 30 November 1778, as Banks had to fend off a vociferous faction of hard-line scientists who wished to displace him because he was considered by some to be a power-crazed naturalist from the Presidential Chair of the Royal Society.

Unknown at the time, Banks' power, influence and wealth were utilised to develop his extensive private collections, including those of the Pacific, and a superlative library of natural-history and travel literature (which were accessible to any serious researcher) that would largely end up in public collections, principally the British Library, British Museum and Natural History Museum.

Insights into aspects of Banks' character and personality – beyond midshipman Elliot's recollection in his memories – are revealed by contemporary diarists rather than in paintings and prints. In

1774 James Boswell, 9th Laird of Auchinleck, the biographer of Dr Samuel Johnson, compared Banks to an elephant and wrote that he was 'quite placid and gentle, allowing you to get upon his back or play with his proboscis.'

In 1796 Joseph Farington thought that Banks' 'manners were rather coarse and heavy'; however, in 1816 Sylvester Douglas, 1st Baron Glenbervie (the lawyer, politician and fellow of the Royal Society), described him as 'awkward in his person, but extremely well bred', and stated that, 'In short he is one of the many instances to prove that personal graces are far from essential to politeness.'

Banks probably holds the record, outside of the British royal family, of being painted by three presidents of the Royal Academy of Art. In chronological order they are: Sir Joshua Reynolds, Benjamin West and Sir Thomas Lawrence. After returning from the *Endeavour* voyage, Banks commissioned Reynolds to paint his portrait. It hung first in New Burlington Street and later in the library of Soho Square. It was started in 1772 after his return from the Pacific and completed after his Icelandic and Hebridean expedition in 1773.

Reynolds depicts Banks as a gentleman-adventurer seated at a table with his left hand resting on a letter that bears the inscription *'Cras Ingens Iterabimus Aequor'*, which can be translated as 'Tomorrow we set out once more upon the boundless main'. This appears to demonstrate Banks' personal ambition to return to the Pacific. The freestanding globe and stormy coastal landscape seen through the window highlight his global voyaging and his endurance in challenging climes. The portrait was engraved by William Dickinson.

Banks later commissioned Nathaniel Dance-Holland to paint a three-quarter-length portrait of Cook in captain's full dress uniform. Dance-Holland was the son of the architect George Dance,

LEFT

Sir Joseph Banks, 1st Bart (1743–1820), painted 1771–73 by Sir Joshua Reynolds (1723–92). National Portrait Gallery, London. NPG5868. This portrait was created to harmonise with Banks' portrait of Captain James Cook by Nathaniel Dance-Holland that hung at 32 Soho Square.

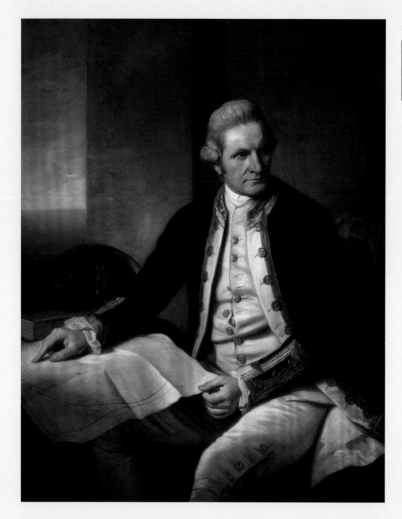

a foundation member of the Royal Academy of
Arts and a member of the Society of Dilettanti. He
became a successful portraitist, later served as Member
of Parliament for East Grinstead, and was made a
baronet in 1800. He took the name Holland from
one of his wife's relatives.

A letter from Cook to Banks written from his
Mile End home and dated 24 May 1776 also reveals
when he started to sit for the artist. He wrote that he,
'intends to be at the West end of the Town tomorrow
Morning, and thinks he could spare a few hours
before dinner to sit for Mr Dance, and will call upon
him for that purpose about 11 or 12 oClock.'

In terms of the compositional arrangement of

Cook seated at his desk holding his chart of the Pacific
featured in Dance-Holland's portrait, this echoes
that of Reynolds earlier portrayal of Banks. As both
portraits are the same size, measuring 50 x 40 in,
and are known to have hung in the library of Banks'
principal London home at 32 Soho Square, it is clear
that he wanted them to visually harmonise. They are
now in the National Maritime Museum, Greenwich
and the National Portrait Gallery, London respectively.
The Dance-Holland portrait was engraved by John
Keyse Sherwin, who also produced prints after William
Hodges' artwork – some in a neoclassical style – for
Cook's second Pacific publication.

Sir Thomas Lawrence depicts an animated and

authoritative Banks sitting in the Presidential Chair of the Royal Society with the red sash and star of the Order of the Bath clearly on view. Painted around 1805 and exhibited at the Royal Academy of Arts in 1806, there is no hint of the debilitating gout that Bank suffered, particularly in later life, and which was pretty much the only thing that prevented him from attending to professional and social business.

The Lawrence portrait has rarely been on public display since it was acquired by the British Museum, although it was well known in Banks' lifetime through various engravings, with the best-known version engraved and designed by Anthony Cardon and Anthony William Evans and published on 1 January 1810. Lawrence had earlier drawn a graphite portrait of Banks, around 1795, that is now in the National Portrait Gallery, London.

The Royal Academician Thomas Phillips, who became Professor of Painting at the Royal Academy Schools, also executed several forceful portraits of Banks directly confronting the viewer, some seated in the Presidential Chair of the Royal Society. He first painted Banks in 1808 for the Spanish astronomer and mathematician José de Mendoza y Rio in which he holds the 1808 Bakerian lecture by the chemist Sir Humphry Davy, 1st Bart who would later become President of the Royal Society.

On 12 September 1808 from Revesby Abbey, Banks wrote a surprisingly coy response to Thomas Phillips' request for advice regarding the commercial prospects of the publication of an engraving after this portrait: 'That you have Painted a Picture of me that does honour to your Talents as an Artist, I am Quite sure, but whether a Print Taken from that Picture will be a Profitable Concern is a matter of which I, who never was Concerned in the Science of money Getting, have not the means of Forming a Proper Judgement.'

The last variant by Phillips was commissioned after Banks' death by the Royal Horticultural Society in August 1820. Banks was one of the prime movers in the establishment of this organisation, which was founded in 1804 but had first been mooted four years earlier by John Wedgwood, son of the pottery magnate Josiah Wedgwood. Phillips portrays Banks in his study seated at a table – probably in his Heston home to the west of London (a residence from which he could travel more easily to see the King and the Royal Botanic Gardens, Kew) – upon which rests a botanical artwork of a Spring Grove peach by Sir William Jackson Hooker, the botanist and botanical illustrator who later became the Director of the Gardens. All highly appropriate for this epitaph painting.

An earlier portrait variant of Banks by Phillips, painted in 1812, depicts him with red sash and star. It was engraved by the Italian Niccolò Schiavonetti. There is correspondence between Banks and Phillips regarding the suitability of Schiavonetti. Banks suggested William Sharp as a more suitable candidate, but in this instance Phillips' preference prevailed.

It is hardly surprising that the red sash and star of the Order of the Bath – and to a lesser extent the red ribbon that holds the medal around the neck of the recipient – feature heavily in the canon of Banks' portraits as this was an honour conferred by the King on 1 July 1795. Banks having been awarded this honour was exceptional since it was usually an award reserved for senior members of the Diplomatic Service and prominent military figures.

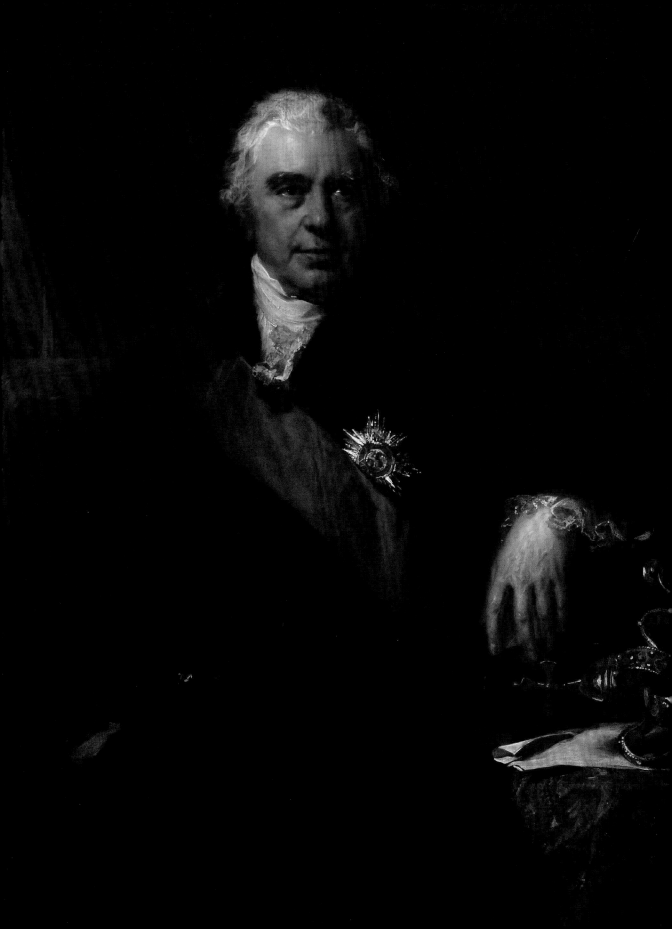

Mocking Banks in pictures

Earlier in 1781 Banks had been awarded the rank of baronet, meaning he could add the prefix 'Sir' to his name. He was admitted to the Privy Council in 1783. Newsworthy events and stories were quickly captured by the many satirists and caricaturists active in 18th-century Britain, including the renowned James Gillray, whose etchings attracted attention across all social classes. His work was widely available to view as it was often prominently featured in printsellers' windows in London and in major towns and cities across Britain.

Gillray's etching of Banks, as with all his work, was sold coloured or uncoloured at a cheaper price. It was published on 4 July 1795 by Hannah Humphrey (with whom Gillray lived in central London) and cheekily titled *The great South Sea Caterpillar, transformed into a Bath Butterfly*. Banks wears the red sash of the Order of the Bath and his butterfly wings are adorned with sea creatures, his metamorphosis having been brought on by the brilliant rays of the sun whose orb is superimposed with an image of the British royal crown. This lampooning print highlights Banks' dependence on the King's patronage.

There were also satirical images of Banks by several other artists and printmakers produced on other occasions, including foppish depictions of Banks (and of Dr Solander) produced by Mary and Matthew Darly, the London-based husband-and-wife partnership of caricaturists and printsellers. One of their popular prints published in 1772 relates to

Banks' return from the *Endeavour* expedition and is captioned *The Fly Catching Macaroni*.

Chelsea-born Gillray was the son of a soldier from Lanarkshire who later became an outdoor pensioner of Chelsea Hospital. Gillray learned letter-engraving, wandered with a group of strolling players and had the ambition to be portrait painter. To this latter end he studied for a time at the Royal Academy Schools, supporting himself through printmaking. However, he failed to make his reputation as a portraitist and turned instead to caricature – of which he is widely considered to be one of the greatest exponents.

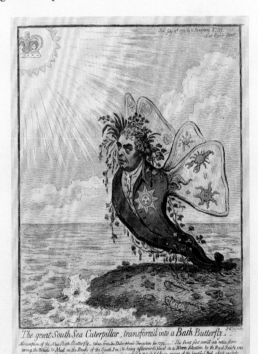

The great South Sea Caterpillar; transform'd into a Bath Butterfly.

32 Soho Square

By the time Banks moved into 32 Soho Square he had enlarged his collections to include diverse paintings, drawings and prints. In 1777 for the sum of £4,000 Banks acquired an 'elegant and Spacious Leasehold House' previously owned by the artist and architect George Steuart. The residence was a three-storey, L-shaped house with a garret and an extensive basement, and constructed of a reddish-brown brick.

A recreation of the exterior appearance of 32 Soho Square and the interior arrangement of rooms has been assembled by Banks' biographer Harold Carter and published in his book *Sir Joseph Banks* (1988) with assistance from John Sambrook. Carter's mammoth work remains the seminal publication on his life, although it is far from being comprehensive in terms of Banks' patronage of artists and involvement in voyages of Pacific exploration. The original 17th-century house was rebuilt for the city banker Sir George Colebrooke between 1773 and 1775, although the architect is unknown. It is part of the Portland Estate.

Carter provides a brief house tour: 'The main entrance from the Square was through a large hall with the entrance to the great stairs of Portland stone on the left and the door to the servants' stairs on the right. To the left was the main eating parlour and behind the foot of the main stairs was a small library, the "little den", off which the so-called "passage room" gave access to the covered way leading to the back premises.' The 'passage room' also provided access to the 'Engravers' Room' where Banks' 'in-house' artists worked on the *Florilegium* and other voyager art projects.

Carter notes that on the first floor 'above the entrance hall was the front drawing room and next to it, above the eating parlour, the "great room", or south drawing room, 28 feet by 25 feet, the largest in the house'. He continues: 'The ground floor frontage on Dean Street was occupied by the stable facilities for five horse and two coaches … but the space of immediate concern to Banks in 1777 was clearly on the upper floors, especially the library with its windows opening over Dean Street.'

It is likely that the 'great room' also doubled as the Royal Society 'council chamber', 'which was furnished with a magnificent yellow marble chimney-piece set with a green Jasperware plaque [manufactured by Josiah Wedgwood] of the "Offering to Flora"'. The art historian Rüdiger Joppien believes it was probably modelled by William Hackwood, and it is known that fellow Wedgwood modeller John Flaxman adapted the plaque to Banks' mantelpiece.

The library measured an impressive 32 feet long by 20 feet in width, to which Banks made extensive alterations. Adjacent to the library was the herbarium, which Carter noted was an important workplace although in terms of information 'there is little known'.

There is a lively view of the south-west corner of Soho Square by the artist George 'Sidney' Shepherd featuring a drover with cattle and sheep. This was published as part of the popular London Street Views series by Ackermann's Repository in the form of hand-coloured aquatints in 1812. Banks' home can be picked out to the far left, with its elegant porch of Ionic columns, plain shafted, supporting an open pediment hood that was probably added by Banks in the 1770s (or, if not, it certainly conformed to his taste). An early 20th-century depiction of his residence was drawn in black and white by Hanslip Fletcher, an artist and illustrator with a keen eye for the rapidly changing architectural aspects of London.

Oddly, given the significance of 32 Soho Square, there is a dearth of period interior views. Two small-scale sepia drawings – one of part of the library overlooking Dean Street and the other of Banks' study – now in the Natural History Museum, London were created by Francis Boott, an American-born botanist, physician and fellow of the Linnean Society (elected in 1819). The library in particular offers a tantalising glimpse into Banks' remarkable

Pacific research centre. Boott's membership of the Linnean Society and the association of Banks and Brown are the key to the creation of these rare views.

Banks was instrumental in founding the Linnean Society through his encouragement of Sir James Edward Smith to purchase for £1,000 the collections of the Swedish botanist, physician, taxonomist and zoologist Carl Linnaeus after his death. Smith became the Society's first president. After Banks' death his will specified that Robert Brown, who became his curator-librarian after the *Investigator* expedition, had the use of 32 Soho Square and his collections. Brown rented out the back premises of Soho Square for the official business and meetings of the Linnean Society from 1821 to 1857. David Don, a fellow Scottish botanist, also lived at 32 Soho Square, assisting Brown and serving as the librarian of the Linnean Society from 1822 to 1841. Brown was later President of the Society from 1849 to 1853.

Boott's sepia views are believed to date from the 1820s when Brown occupied the house, and (judging from the collections present) most likely prior to their transfer to the British Museum that Brown had arranged in 1827. One depicts the main library room overlooking Dean Street and the other Banks' study. The former reveals the ordered arrangement of bookcases and multifarious publications, and

confirms that this was a place of methodical research and serious study. To the right above the storage cupboards is a display of neoclassical female portrait busts that almost certainly formed part of Banks' personal art collection.

The neighbourhood of 32 Soho Square at that time was not fashionable, but this was of no concern to Banks, who wanted ample accommodation for family and business use and to be within fairly easy reach of the Royal Society in Somerset House, his main place of work. If gout was not adversely affecting him (or the extra weight he gained in later life), the commute was walkable at less than a mile.

From the 1780s to 1850 the architectural complex of Somerset House accommodated the Royal Society, the Royal Academy of Arts, and the Society of Antiquaries. This large complex of neoclassical buildings on the south side of the Strand beside the Thames was designed by Sir William Chambers in 1776. Chambers was a fellow of the Royal Society and had designed the Great Pagoda at the Royal Botanic Gardens, Kew that was completed in 1762 as a gift for Princess Augusta, the founder of the gardens and the mother of the future King George III. The close proximity of these societies highlights the interconnectedness of art and science at this period, up to the death of Banks in 1820.

Banks' relationship with the Society of Antiquaries and Royal Academy of Arts

On 27 February 1766 Joseph Banks was elected a member of the Society of Antiquaries of London (in the same year as his election to the Royal Society), being recommended as 'a Gentleman of great Merit, Learning & other Accomplishments, & particularly well versed in the Antiquities of this and other Nations'. Banks had a longstanding interest – as did some of his family forebears, notably his guardian Robert Banks Hodgkinson who succeeded

him to serve on its council in 1786. However, this was eventually displaced by his other concerns, in particular commitments to the Royal Society.

Banks' close relationship with the senior artists of the Royal Academy of Arts, and with the organisation itself, was crucial to promote not only his work but also that of the voyager artists and, by association, the accomplishments of the expeditions with which he was involved. Banks' position as President of the

Royal Society and his social standing led to regular invitations to the annual dinner and private view of the Royal Academy of Arts held prior to the official public opening of the exhibition.

Sometimes Banks was joined by Dr Solander at the Royal Academy dinners. With catalogue in hand, as there were no labels on the gallery walls (a practice continuing today as the catalogue sales raise essential revenue for this non-publicly funded organisation),

Banks would have engaged eminent guests – including many members of the Society of Dilettanti – in conversation with the achievements and progress of British Pacific exploration, as well as other colonial interests, when artworks by William Hodges (including his subjects relating to India, yet another country that occupied the attention of Banks), John Webber and William Westall were displayed.

Banks' passions beyond botany and accuracy of drawing

The Royal Academician Joseph Farington (see illus on page 159), who was also a senior figure in the administration of the Royal Academy of Arts, recorded in his diary on 13 December 1793 the occasion when he was showing Banks and the antiquarian Samuel Lysons drawings that he had made at Valenciennes in northern France. He noted: 'Accuracy of drawing seems to be a principal recommendation to Sir Joseph.'

A few years later, on 21 January 1796 during a meeting with the Shakespearean scholar Edmond Malone, Farington also reported what he believed was Banks' prime passion: 'His knowledge and attention is very much confined to one study, Botany.'

These diary entries by Farington contain part of the truth. Banks' interests were wide-ranging and his subjects and artistic taste went well beyond botany and realism. The evidence clearly points to Banks sharing similar passions to Lysons, those associated with classical antiquity.

Samuel Lysons was a pioneering archaeologist who investigated Roman sites in Britain and specialised in mosaics. Lysons held the distinguished position of Keeper of the Records at the Tower of London from 1803 to 1819. He was also a competent artist who exhibited at the Royal Academy of Arts between 1785 and 1801, an organisation to which he was appointed the honorary antiquary professor. Banks' close friendship with him extended into their professional lives through shared memberships – in particular fellowship of the Society of Antiquaries and the Royal Society to which Lysons was elected in 1797 and later served under Banks as the vice-president and treasurer from 1810 to 1819. Banks' widely shared passion for the classical world, and in particular his membership of the Society of Dilettanti, would make a sensational impact on the visual art of Pacific exploration.

PICTURING THE PACIFIC AND CLASSICAL ANTIQUITY

Joseph Banks' membership of the Society of Dilettanti, his passion for neoclassicism and its impact on voyager art

Edward Smith's *Life of Sir Joseph Banks* (1911) reported what Banks supposedly said in relation to the Grand Tour: 'Every blockhead does that; my Grand Tour shall be the one round the whole globe'. Irrespective of the veracity of this statement, Banks certainly socialised with and befriended many 'blockheads' as he was an active and longstanding member of the Society of Dilettanti.

The Society of Dilettanti can trace its origins back to the 17th century, although it was formally established in the early 1730s as a London drinking and dining club with like-minded members all having been inspired by their cultural experiences – in high and low forms – of the Grand Tour of Italy and Greece in particular but also Egypt, Malta and Turkey.

This influential group of wealthy and well-connected members sponsored the study of ancient Greek and Roman antiquities and promoted excavations and surveys, thereby helping to pave the way for modern archaeology. The creation of new work in a classical style was encouraged and became known across the arts as neoclassicism.

The enduring influence of neoclassicism and 'its versatility in every branch of art' is the subject of David Irwin's *Neoclassicism: Art and Ideas* (1997), which asserts that 'between about 1750 and 1830 … Neoclassicism held sway for roughly eighty years'. It was a phenomenally wide-ranging and influential movement in Britain, Europe and further afield.

Leading members and sympathisers with the aims of the Society of Dilettanti advocated a particular style of drawing and painting. The characteristics of neoclassical art transposed onto the indigenous people of the Pacific include: lithe bodies with overlong limbs; attenuated necks; classical-style hair that is often cropped and wavy; regular facial features sometimes with a pronounced nose; and a focus on the musculature of the torsos of the semi-naked or naked. If clothed, the figures sometimes have a classical-style drape or toga-esque garb. Another characteristic is the careful arrangement of figures in close proximity, with contrived postures, dramatic gestures and a demeanour of emotional restraint. Some of the neoclassical figures and their arrangement evoke the figures on a classical frieze.

From its inception the Society of Dilettanti was a renowned drinking club, and meetings were often raucous affairs (as noted on occasions in the official minutes). The libertine nature of its membership is affirmed by Jason M. Kelly in *The Society of Dilettanti – Archaeology and Identity in the British Enlightenment* (2009). He writes that, 'according to libertine tradition, elites were entitled to be both lords of rule and misrule. Running their estates and attending to their duties in Westminster went hand-in-hand with whoring, drinking, and duelling in early eighteenth-century London. The dichotomy – between respectability and licentiousness – was central to the elite practices of eighteenth-century dilettantism and no group reveals this better than the Society of Dilettanti.'

However, this organisation also had a shared serious purpose – one that from the outset it hoped would have an enduring influence on British culture. In the early 1740s a resolution added the toast '*Esto praeclara; esto perpetua*', which translates as 'Let it be noble, let it last forever'. The Society is still active today, and although neoclassical art is out of fashion, neoclassical architecture still enjoys a widespread popular following. One of the high-profile professional practices is Quinlan & Francis Terry

who advertise themselves as 'Traditional Architects of New Classical
Buildings' and whose neoclassical creations have been championed by
Charles, Prince of Wales.

By the late 1750s the Society of Dilettanti usually met on alternate
Sundays for dinner at the Star and Garter in Pall Mall, London. Banks
was elected on 1 February 1774, having been sponsored by the avant-
garde neoclassical architect, artist and engraver James 'Athenian' Stuart.
A fascinating insight into Stuart's professional and social associations
– and, of particular importance here, his close working relationship
with the Admiralty – is highlighted in Kerry Bristol's 'The Social World
of James "Athenian" Stuart', published in Susan Weber Soros' *James
'Athenian' Stuart: The Rediscovery of Antiquity* (2006).

Stuart's middle-name sobriquet derived from his travels to Athens and Naples. As Kerry Bristol reveals, in the 1740s and 1750s Stuart spent some time in Florence and the majority of his time in Rome, with Naples only coming towards the end of his sojourn in Italy. Stuart travelled with architect Nicholas Revett to Athens to explore the ruins and especially the Acropolis, and although it is not yet determined if the Society of Dilettanti sponsored the trip, they would have provided much-needed support in transforming the artworks into illustrations for the publication titled *The Antiquities of Athens and other monuments of Greece* first issued in 1762. The publication was instrumental in popularising, later in the 18th century, a Greek style.

Earlier in April 1758 Stuart's nomination form to become a fellow of the Royal Society reveals that he considered himself (as did his friends) a 'history painter' as well as an architect. It reads, 'Mr James Stuart of Grosvenor Square History painter and Architect, eminent in his profession and who hath particularly applyed himself to the study of antiquity, during a long residence in Greece and Italy, as will appear in a work now publishing by him in four volumes in folio, entitled, "The antiquities remaining in the city of Athens and province of Attica".'

Stuart was a close friend of Banks and Dr Solander, as revealed in a letter Solander wrote to Banks on 5 September 1775 after the return of Cook's second voyage. Solander noted, 'Tomorrow I am to dine with Mr Maskelyne at Greenwich [Rev. Nevil Maskelyne, the Astronomer Royal] with Capt. Cook, Sir John Pringle [the physician and President of the Royal Society to whom Banks would succeed], Stuart [James 'Athenian' Stuart] and Roy [William Roy, surveyor and founder of the Ordnance Survey], &c. – Your company & Captain Phipps [Lord Mulgrave] has much been wish'd for.'

Banks' intimate and enduring relationship with the Society of Dilettanti

Banks progressed through the ranks of the Society of Dilettanti and he was elected to the position of 'Very High Steward' in 1778. In this capacity he served as Secretary and Treasurer until June 1794, followed by Secretary until 19 February 1797 when business matters relating to the Royal Society, Flinders' *Investigator* voyage to the Pacific and concerns relating to his own health became his main preoccupations.

Another of the Society's toasts was 'Grecian taste and Roman spirit'. Kelly also observes that they were, 'getting out of hand by the 1760s: a resolution was passed in April 1767, according to which toasting during dinner would cost the toaster and the receiver half a crown each. In an indulgent moment in 1778, the society banned temperance by fining a guinea to those who requested coffee or tea at dinner.'

Kelly also notes that, 'Sexual jokes, while they rarely entered the minutes are evidenced on 1 April 1781, when Lord Sandwich proposed that Joseph Banks present a "Hottentot" pudendum at the next meeting, a reference to Banks' famed ethnographic studies and sexual exploits and the eighteenth-century belief that Khoikhoi women [native to southwestern Africa] possessed exaggerated sexual organs.'

The drinking, socialising and light-hearted nature of the Society is highlighted again in a letter of 1750 from Henry Harris (the first treasurer) to the politician Henry Fox (later 1st Baron Holland) in relation to the election of Admiral George Anson (1st Baron Anson, and the first Englishman to sail around the world). Harris was not short of puns when he wrote, 'Last Sunday was Dilettanti … Anson was Balloted for, and unanimously chosen as a member. I won't steal an old joke and Talk of shewing him more of the world than he saw in Circumnavigating it: but we shall, I fancy, make Him Drink and subscribe very liberally, which will be two quite new and surprising Discoveries in his Lordship's character.'

Commodore Anson's membership and
martial mission to the Pacific

In September 1740 Commodore Anson during the War of the Austrian Succession (1740–48) had set off across the Atlantic in the *Centurion* leading a small fleet of six ships with the purpose to capture Spanish treasure ships or, if it was accessible, treasure on land. In the course of his martial mission only the *Centurion* returned safely, and he acquired vast amounts of booty. He crossed the Pacific, stopping at the island of Guam in the western Pacific, and arrived in Macao Roads, China in November 1742. He finally arrived back in England in June 1744.

Ric Wharton in *The Salvage of the Century* (2000) reveals that it took 32 wagons to transport the treasure from Portsmouth to the Tower of London. Accounts vary widely as to its actual value but one estimation of its current value is in the region of £50,000,000. Anson was entitled to prize money, netting him an eye-watering £18,750,000 (in today's money). He would later be knighted and become First Lord of the Admiralty.

In June 1744 he finally arrived back in Britain to a hero's welcome. An account of his expedition was published in 1748 entitled *A Voyage Round The World In the Years 1740–1744 by George Anson, Esq., now Lord Anson, Commander in Chief of a Squadron of His Majesty's Ships, sent upon an Expedition to the South-Seas* … compiled from his papers by Richard Walter, M.A, Chaplain of His Majesty's Ship the *Centurion*.

This was illustrated with 42 copperplate engravings mainly of charts and coastal profiles – some of them by Johann Sebastian Müller (Miller), the father of the Miller brothers employed by Banks. Apart from one intriguing 'Plan of a Flying Proa taken at the Ladrone Islands', this account lacked the wide-ranging exotic and fascinating imagery that would first appear in Dr Hawkesworth's compilation account, followed by Cook's subsequent Pacific publications.

Many of George Anson's interests were shared by his elder brother Thomas, including membership of the Dilettanti and fellowship of the Royal Society. Their respective residences were Moor Park in Hertfordshire and Shugborough in Staffordshire (the Anson family home) and to varying degrees they were patrons of James 'Athenian' Stuart. Susan Bennett, Honorary Secretary of the William Shipley Group for RSA History, confirms that Stuart nominated the brothers as members of the Society of Arts, with Thomas being elected in 1757 and George in 1758.

ABOVE

The Dilettanti Vase Group, engraved by William Say after Sir Joshua Reynolds (1723–92) and published on behalf of the Society between 1812 and 1816. British Museum.1830.0612.1.

Banks' promotion of the Society of Dilettanti museum

The pleasurable pursuits of the Society of Dilettanti ran in tandem with the serious business of patronage and projects. While Banks was a senior official he advanced the proposition of building a museum to house existing and future collections of the Society. This proposal had been originally mooted by Thomas Pitt, 1st Baron Camelford, in 1784 who offered two of his townhouses in Grosvenor Square, London to be redesigned by Sir John Soane, a specialist in neoclassical architecture. Soane later became a Royal Academician and was appointed Professor of Architecture at the Royal Academy Schools. He is probably best known today for his redesign of the Bank of England and design of the Dulwich Picture Gallery.

Prior to the members' vote on the proposal, Soane started the designs which were later published in 1788. Kelly notes that, 'The rooms would house casts of important classical sculptures and a library. The ground floor would be a library, and the first floor would be a museum with a small "Council Chamber" of 19 by 16 feet.' He also notes: 'The collections would reflect the history and archaeological interests of the Society of Dilettanti … [that were] reinterpreted for a neoclassical audience.'

On 7 February 1785 Banks set out a strong case hoping that the museum proposal would be approved by the members. He stated, 'We have the most noble repositories for Natural History, and we have establishments for the encouragement of the Arts; but a Musaeum [sic] for what is properly called Virtu has been long wanting. I am persuaded that were such a gallery once instituted, contributions would not be wanting: and that valuable acquisitions would soon render it an object to all such as have a true relish for the beauties of Antiquity.'

The proposal was rejected partly on the grounds that it would be expensive not only to implement, with costly interior decorations, but also to maintain.

Diverse and influential membership of the Society of Dilettanti

The Society of Dilettanti comprised many affluent representatives of the landed aristocracy, but anyone with the means and a taste for the classical world would be considered for membership (although numbers were restricted). The professions of members were wide-ranging and included architects, army officers, artists, authors, clergymen, interior and garden designers, lawyers, politicians and Royal Navy officers. The celebrated actor David Garrick and diplomat Sir William Hamilton were also members. Banks was familiar with Hamilton's collection.

Sir William Hamilton served as the British diplomat to the Kingdom of the Twin Sicilies, became a specialist in volcanology and a fanatical collector of classical antiquities. Famously he was the husband of Lady Emma Hamilton. His nephew the Rt Hon. Charles Francis Greville was a close friend of Banks and a Dilettanti member who was appointed to the Admiralty Board in the early 1780s. Charles had been the previous beau of Emma, which led to her marriage to Sir William. Emma's famous theatrical 'Attitudes' were partly inspired by the poses of figures on some of Hamilton's classical vases.

Key parts of Sir William's collections were acquired by the British Museum. Sir Richard Phillips' *The Picture of London For 1802* noted the ten main collections of the museum that included 'Sir William Hamilton's Etruscan, Grecian, and Roman Antiquities'.

The Portland Vase and its reproduction by Sir Josiah Wedgwood

Sometime between 1778 and 1780 Sir William Hamilton acquired the Barberini Vase. In 1784 it was purchased by Banks' friend Margaret Cavendish Bentinck, Duchess of Portland, and renamed the Portland Vase. Their relationship was augmented by a shared friendship with Dr Solander, as the Duchess had been an early patron engaging him to classify her natural-history collection. Her collection also included items relating to the Pacific. The Portland Vase is an exquisite blue and white Roman cameo glass decorated with classical scenes, and was created by an unidentified maker between AD 1 and AD 25. In fact the scenes have not been identified with certainty, and this mystery adds to the fascination of the artefact.

The Portland Vase was and remains widely revered as one of the finest examples of classical art. It took pride of place in the Duchess' private museum located at Bulstrode, her private Buckinghamshire residence that was opened to the public on occasions. After her death in 1785 it was auctioned off in the following year with many other items from her collection. Banks would have been involved in the negotiations regarding its long-term loan to the British Museum from 1810 as he was an *ex officio* trustee of the museum and a regular attendee at the official meetings. It was eventually purchased by the British Museum in 1945.

Sir Josiah Wedgwood was a Dilettanti sympathiser and visitor to meetings, although not formally a member. After several years of trials, by 1790 he finally succeeded in creating a successful replica of the Portland Vase in black Jasperware, later in blue Jasperware, with applied and hand-finished white reliefs featuring neoclassical figures modelled by the Royal Academicians John Flaxman and Henry Webber (brother of John Webber the Admiralty artist appointed to Cook's third Pacific voyage).

It was viewed by Banks when it was displayed between April and May 1790 in Wedgwood's London showroom at 12–13 Greek Street – very close to 32 Soho Square, where in fact Wedgwood was also entertained by Banks. Such was the public excitement in viewing Wedgwood's replica that visitors were admitted by ticket only and the numbers restricted to 1,900, although this also worked as a publicity stunt. Banks would have been involved in the acquisition of one of Wedgwood's replicas of the Portland Vase for display at the British Museum.

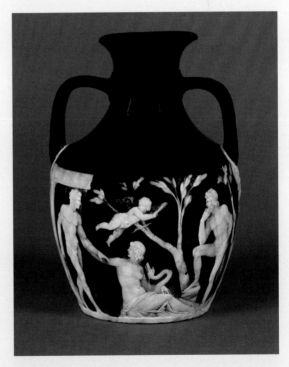

ABOVE

The Portland Vase, created by an unknown Roman maker between AD 1 and AD 25. British Museum. 1945.0927.1. Amphora in translucent dark cobalt blue and opaque white cameo glass.

Sydney Cove Medallion

Henry Webber is connected to the Pacific through his design of the Sydney Cove Medallion. In November 1788 Commodore Arthur Phillip, the first Governor of New South Wales, (recommended by Banks) sent clay from the colony, specifically Sydney Cove, to Banks at 32 Soho Square. It was then passed on to Josiah Wedgwood who engaged Webber to design the medallion that was modelled by William Hackwood, who had also been involved in the production of the Portland Vase. It featured figures in allegorical and classical form, three women as 'Hope', 'Art' and 'Peace' and a man representing 'Labour' in what was titled 'Hope encouraging Art and Labour under the influence of Peace, to pursue the employments

necessary to give security and happiness to an infant colony'.

As the title is long, it is often simply referred to as the Sydney Cove Medallion. The design was engraved by Thomas Medland to prominently feature on the title page of Phillips' *The Voyage of Governor Phillip To Botany Bay with an Account of the Establishment of the Colonies of Port Jackson & Norfolk Island...* published in 1789, and embellished with 55 copperplates. Medland exhibited at the Royal Academy of Arts and was landscape engraver to the Prince of Wales, later King George IV.

Banks was involved in the selection of illustrations that included the work of Robert Cleveley and Peter Mazel. Cleveley was the twin brother of John Cleveley junior (also called the Younger). His depiction of *Natives of Botany Bay* depicts three indigenous Australians – two in a boat and one standing close by ashore holding a spear – in a neoclassical style that brings to mind Thomas Chambers' engraving of *Two of the Natives of New Holland, Advancing to Combat* relating to the *Endeavour* expedition. Banks was one of the 'noblemen and gentlemen' thanked in the credit section entitled 'Advertisement' for his 'kind assistance and free communications'.

ABOVE

Sydney Cove Medallion designed by Henry Webber (1754–1826) with assistance from William Hackwood for Wedgwood, 1789. Wedgwood Museum. The clay to create this and other medallions was sent from Sydney Cove, New South Wales to Sir Joseph Banks in London. The object's fragility is reflected by the extensive cracks.

RIGHT

Captain Arthur Phillip (1738–1814), 1786 painting by Francis Wheatley (1747–1801), oil on canvas. National Portrait Gallery, London. NPG1462. Wheatley imagines a future event, the landing of Phillip on the Pacific coast of Australia at Sydney Cove on 26 January 1788. Phillip was the first Governor of New South Wales and rose to become a Vice-Admiral.

Banks as a Roman emperor, the Elgin Marbles and Claude

Banks had an earlier artistic connection with Josiah Wedgwood and John Flaxman. The latter won prizes from the Society of Arts and spent several years in Rome partly funded by Wedgwood for whom he had started working as a modeller in 1775. A bill survives from the artist for 'The Portrait of Mr Banks modelled in Clay' dated August 1779, and this almost certainly refers to the portrait medallion in Jasperware that features Banks in sharply defined profile with accentuated neck, stylised hair and wearing a toga making him resemble a Roman emperor. It's a rare piece and not present in the Wedgwood Museum, and the British Museum have kindly provided for the first time a digital colour image for this publication. Flaxman also created for Wedgwood a medallion of Banks' wife wearing a toga, and another version of Banks in a realistic style.

Banks was also associated with the Elgin Marbles, arguably the best-known classical treasure. They were named after the Scottish soldier and diplomat Thomas Bruce, 7th Earl of Elgin and 11th Earl of Kincardine, who removed them from the Parthenon in Athens and brought them to England where they were displayed in a temporary museum in 1807 before being acquired for the British Museum in 1816. Lord Elgin was twice blackballed for membership of the Society of Dilettanti and, although he was accepted in 1831, by then his interest in participation had waned.

Authors, taster-makers and patrons of the Society of Dilettanti included Sir George Beaumont, 7th Baronet (whose art collection included works by the French classical landscape artist Claude that would influence the voyager artists of William Hodges and William Westall), Thomas Hope (the art collector, author, banker and interior-decorator), and Richard Payne Knight (the archaeologist and classical scholar, who when he was resident in London was Banks' neighbour in Soho Square). Knight had a significant collection of art by Claude and he and another

member Sir Uvedale Price, 1st Baronet, wrote influential publications on aesthetics; Knight's was *Analytical Enquiry into the Principles of Taste*, issued in 1805, and Price's was *Essay on the Picturesque, As Compared with the Sublime and The Beautiful*, published in 1794.

Portraits of the Dilettanti and their encouragement of Royal Academy of Arts' students

Among the notable artists associated with the Society of Dilettanti were three Presidents of the Royal Academy of Arts: Sir Joshua Reynolds, Benjamin West and Sir Thomas Lawrence, all of whom painted Banks. Interestingly the Royal Academy of Arts itself – the most prestigious art organisation in Britain at that time – had been persuaded to help the Society of Dilettanti. An announcement in the *London Evening Post* of 10–12 May 1774 noted that, 'At a late meeting of the Royal Academicians, it was agreed to support the Deletanti [*sic*] Society sending pupils abroad for the further encouragement of the arts; the recommendation of this object came immediately from a Great Personage.'

Sir Joshua Reynolds had an intimate involvement with the organisation. Between 1777 and 1779 as part of his role as the official artist to the Society, he painted a pair of group portraits described as 'The Dilettanti Vase Group' that included Sir William Hamilton and 'The Dilettanti Gem Group' that featured Sir Joseph Banks. Sir George Beaumont observed that Reynolds had modelled these portraits on the compositional style of the Italian Renaissance painter Paolo Veronese, whose imaginative use of chiaroscuro he much admired.

The sitters for the Dilettanti portraits all paid Reynolds directly the sum of £36 15s. The paintings were widely known through engravings that continued to be issued in the Victorian era. As Kelly points out, these pictures were, 'both emblematic and celebratory. They represented the individual collector, the elite libertine, the convivial society, and the spirit of Enlightenment inquiry. They embodied the full flower of Enlightenment dilettantism. How they were hung is a mystery. Possibly in the new room at the Star and Garter Tavern in Pall Mall'.

Extended illustration caption for Reynolds' Dilettanti paintings

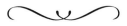

The sitters of 'The Dilettanti Vase Group', from left to right, are Sir Watkins William Wynn (1749–1789) pointing to the vase in the centre of the table; Sir John Taylor, 1st Baronet (1745–1786), standing with eyes looking outwards and holding a woman's garter in his left hand; Stephen Payne-Gallwey (1750–1803) seated left with glass raised to his mouth; Sir William Hamilton (1730–1803), gesturing to the book on the table; Richard Thompson (1745–1820) in the robes of the Arch Master of the Society, raising a glass in his right hand speaking to Walter Spencer-Stanhope (1749–1822) in profile turned to the left; whilst John Lewin Smyth (1748–1811) leans on the table, listening to Hamilton. (This image is on page 101.)

The sitters of 'The Dilettanti Gem Group' are, from left to right, Constantine Phipps, 2nd Baron Mulgrave (1744–1792) holding a glass and gesturing with his right hand; Henry Dundas, 1st Viscount (1742–1811) standing and examining a ring; Kenneth Mackenzie, 1st Earl of Seaforth (1744–1781); Rt Hon. Charles Greville (1749–1809); John Charles Crowe (died 1811); Francis Osborne, 5th Duke of Leeds and to the far right, Sir Joseph Banks, 1st Baronet (1743–1820).

ABOVE

Port Jackson, Sydney, 1804 by William Westall (1781–1850), watercolour. Victoria and Albert Museum, London. FA.485. Note the lithe figures and long limbs of the Aboriginal Australians which are characteristic of neoclassical art.

Reynolds' portrait of Mai

Around 1786 Reynolds completed a masterly full-length individual portrait of Mai, perhaps at the behest of Banks who acted as his guardian after he had been brought to Britain from Cook's second Pacific voyage. It was engraved by John Jacobi and published by John Boydell in 1780. Prior to his return on Cook's third Pacific expedition, Dr Samuel Johnson recalled Mai 'had Passed his time, while in ENGLAND, only in the Best company; so that all that he had acquired of our Manners was GENTEEL'.

Christopher Thacker in *The Wildness Pleases: The Origins of Romanticism* (1983) believes that right from the outset Mai had a plan that he wanted to execute with British help, 'to return to his native islands, and there to avenge his father, who had been killed in an inter-island raid'. He was returned to the Pacific, although the plan did not work as he had hoped.

Reynolds depicts Mai as a classical character. The flowing loose robes and turban are part fact and part toga-esque fancy. He draws upon his 1752 pose of the Royal Navy Commodore Augustus Keppel, 1st Viscount Keppel (later First Lord of the Admiralty), with whom he had sailed to the Mediterranean, to depict Mai in the style of a classical statue partly inspired by his familiarity with the celebrated marble sculpture the *Apollo Belvedere* and other works.

The Greek god Apollo is portrayed as a standing archer, although the bow itself is not present. It is believed to be a Roman copy of the period of the Emperor Hadrian, circa AD 120–140 of a missing bronze created circa 350–325 BC by the Greek sculptor Leochares, and is displayed in the Vatican Museum. Classical sculpture was admired and studied during Reynolds' travels in Italy from 1750 to 1752, when he was seeking inspiration for new subjects and wealthy patrons.

The *Apollo* was championed as the perfection of the Greek aesthetic ideal from the mid-18th century by the German archaeologist and art historian

ABOVE

Captain the Honourable Augustus Keppel (1725–86) engraved and published by Edward Fisher after Sir Joshua Reynolds (1723–92) in 1759. British Museum. 1833.0610.46. The original painting is in the National Maritime Museum, Greenwich. He became 1st Viscount Keppel, and in the years 1782–83 was twice First Lord of the Admiralty. Reynolds drew upon various classical antiquities to create this composition of his friend and early patron.

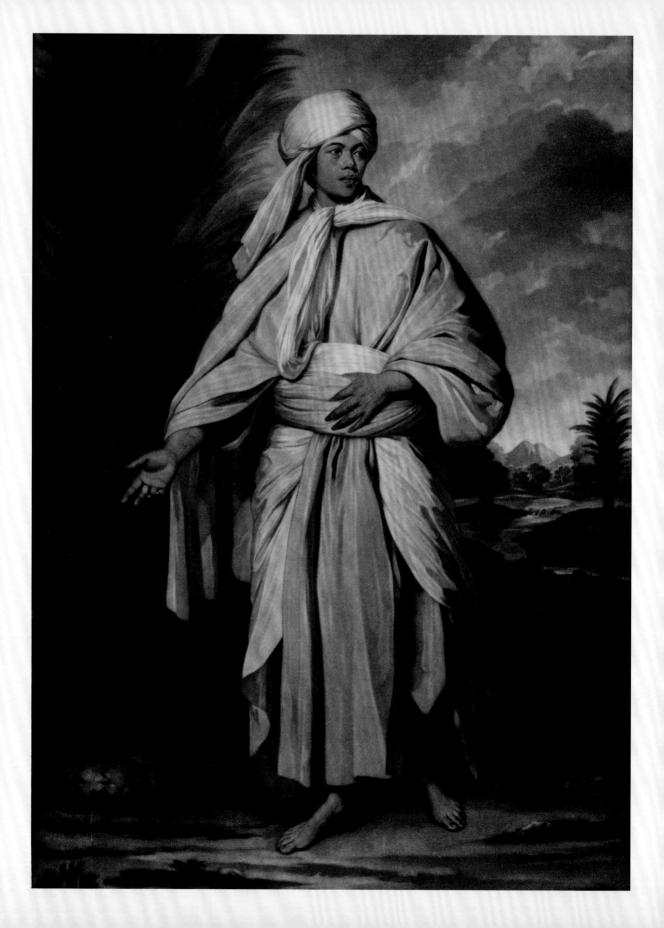

Johann Joachim Winckelmann, and copies of the cast were widely available in Europe. Such was its widespread fame that Napoleon looted it from the Vatican during the Italian campaigns of the French Revolutionary Wars (1792–1802) and displayed it at the Louvre. It was finally returned to Rome after Napoleon's fall from power in 1815.

Another statue, this time of the Emperor Tiberius (first century AD), is one that made a lasting impression on Reynolds. It was also looted by Napoleon; however, it remains today in the Musée du Louvre. This marble statue is a contender as a reference source for both Commodore Keppel's portrait and that of Mai, especially the former in terms of the angle of the head, the gesticulating right arm, the restrained left arm and positioning of the feet.

Viscount Keppel succeeded Lord Sandwich as the First Lord of the Admiralty in 1782. He continued to assist Banks with the management of the production of Cook's third Pacific voyage publication.

Banks' assistance from the Society of Dilettanti and Lord Sandwich's Grand Tour

Several other Royal Navy members of the Society of Dilettanti were helpful to Banks in terms of his personal passions and professional pursuits (which are often hard to separate) such as botany, natural history and Pacific exploration, as well as his encouragement of voyager artists and the process of publishing the official expedition accounts. They included Banks' friends and fellow Etonians John Montagu, 4th Earl of Sandwich (who served as the First Lord of the Admiralty across three periods of his career: 1748–51, 1763 and 1771–82), and Constantine John Phipps, 2nd Baron Mulgrave (who took Banks to Newfoundland and Labrador prior to joining the *Endeavour* expedition). Lords Sandwich and Mulgrave were also fellows of the Royal Society, with the latter serving as Vice-President from 1778 to 1792 during Banks' presidency. The former's position as First Lord of the Admiralty also meant that he was an *ex officio* trustee of the British Museum.

Lord Sandwich's Grand Tour reveals his interest in travel writing, record-keeping and use of art for a practical purpose. He kept a journal of his Mediterranean travels that was edited and largely written (uncredited) by his chaplain John Cooke. It was published some years later in 1799 and titled *A Voyage performed by the late Earl of Sandwich round the Mediterranean in the years 1738 and 1739*.

During his travels Sandwich commissioned the Swiss artist Jean-Étienne Liotard 'to draw the dresses of every country they should go into, to take prospects of all the remarkable places which had made a figure in history; and to preserve in the memories, by the help of painting those noble remains of antiquity which they went in quest of'.

The extent of Lord Sandwich's continental peregrinations is captured by the garden architect and historian Joseph Spence, who wrote: 'We other travellers are quite eclipsed when one talks of Lord Sandwich. A man that has been all over Greece, at Constantinople, Troy, the pyramids of Egypt, and the deserts of Arabia, talks and looks with a greater air than we little people can do that have only crawled about France and Italy.'

Banks never ventured to Italy, Greece or Egypt, yet

he would have overshadowed most of the members – arguably even Lord Sandwich – with his first-hand accounts of the Pacific and displays in his London residence of 'natural and artificial curiosities' that members could compare to items from classical antiquity. Although Lord Sandwich also had a significant collection of Pacific artefacts – which was later transferred to the Museum of Archaeology and Anthropology via his alma mater Trinity College, Cambridge, and also to the British Museum – he had never sailed to the Pacific.

Constantine Phipps, 2nd Baron Mulgrave, was an eminent Royal Navy officer and polar explorer who rose to become a Lord Commissioner to the Admiralty. On 4 June 1773 he set off from Deptford on a voyage towards the North Pole in overall command of two ships: the *Racehorse* and the *Carcass*. Dr Solander classified and described the natural-history specimens for the expedition account that was published in 1774 under the title *A Voyage towards the North Pole, undertaken by His Majesty's Command, 1773*. Lord Mulgrave also credited Banks for his 'very full instruction in the branch of natural history'.

However, Lord Mulgrave's voyage is best remembered for the inclusion of a young midshipman named Horatio Nelson and his unauthorised action in trying to shoot a polar bear in order to take a rug back for his father's fireside in Norfolk. After Nelson became famous, this spurred on artists to depict the naval hero's youthful encounter with the arctic beast. One of the best-known of these artworks, *Nelson and the bear*, was painted by Richard Westall (the older half-brother of William selected by Banks for the *Investigator* voyage), who was an influential Royal Academician. In terms of age and experience Richard Westall was a fatherly figure to William, who taught him to draw and paint. He was a crucial figure in his artistic and technical development, notably in relation to his Australian and Pacific pictures.

Richard Westall's *Nelson and the bear* formed part of a series of largely neoclassical oil paintings that embellished the first illustrated biography of Nelson published in 1809 by the Rev. James Stanier Clark and John McArthur (entitled *The Life of Admiral Lord Horatio Nelson*). These oil paintings can be seen in the National Maritime Museum, Greenwich.

Influential engravers of the Society of Dilettanti and imagining the Pacific

Several leading printmakers were members of the Society of Dilettanti including the fashionable neoclassical Italian-born engravers and designers Francesco Bartolozzi and Giovanni Battista Cipriani who settled in London. Banks was also familiar with them through membership of the Society of Antiquaries. Their skills and celebrity status led to their appointment as foundation members of the Royal Academy of Arts that had been established in 1768 by the royal approval of King George III, with its inaugural exhibition held the following year. Bartolozzi and Cipriani are pictured in John Francis Rigaud's triple portrait painted in 1777, now displayed in the National Portrait Gallery, London.

Bartolozzi and Cipriani transformed a selection of Banks' *Endeavour* artworks by Alexander Buchan and Sydney Parkinson from Tierra del Fuego and the Society Islands respectively into neoclassical scenes for Dr Hawkesworth's publication.

Alexander Buchan's original drawing heightened with gouache – entitled *Inhabitants of the Island of Terra* [Tierra] *del Fuego in their hut* and dated January 1769 – is now in the British Library. Five adult Fuegians and a baby are depicted in a small hut huddled round a fire with skins over their shoulders. Most of them appear fairly wretched, although one appears to smile. Buchan provides no landscape setting.

After Bartolozzi had engraved the image from an 'improved' design by Cipriani the result was jaw-dropping in terms of its transformation. The hut and group of Fuegians around the fire have been enlarged and situated in a classical landscape framed by a tree and rocky vegetation. The Fuegians have expanded to seven adults, two children and a baby, and their demeanour is generally happy. The skins have been replaced by toga-esque garb. The facial features of the foreground figures, and their poses – especially the man seated by the fire with his outstretched hand and the older child standing on one leg balancing with a spear – bring to mind classical sculptures. The older child is reminiscent of a cherub without wings.

The 'improved' design featured in Dr Hawkesworth's publication. It seems highly likely that both Sandwich and Banks, who after all had paid for the artist's participation, would have seen proofs of the engraved illustration. Certainly in terms of the payment for the design it would have been signed off with the approval of Sandwich, who was First Lord of the Admiralty.

Rüdiger Joppien and Bernard Smith in *The Art of Captain Cook's Voyages*, Vol. 1 (1985) identified that the complexity of this 'improved' composition owed a formal debt to an early work by Cipriani entitled *An offering to Ceres* completed around 1767 for the Eating Room at Osterley Park, now situated in the London Borough of Hounslow. The commissioning of this painting related to the respective work of the brothers Francis and Robert Child (of the Child banking family) in remodelling the original Tudor house by the neoclassical architect and interior designer Robert Adam in the 1760s.

Sydney Parkinson's sepia drawing entitled *Natives of Terra* [Tierra] *del Fuego with their Hut*, also now in the British Library, is a similar subject to Buchan's of the same period, although the composition is more sophisticated. It features a woman with a child on her shoulders, walking towards a hut erected under a tree. Parkinson has carefully framed the picture space with an arrangement of rocks and vegetation. It is likely that Cipriani referenced aspects of this drawing for the illustration discussed above from Dr Hawkesworth's publication.

Giovanni Battista Cipriani's *A View of the inside of a house in the Island of Ulietea with the representation of a dance to the music of the country* artwork (now part of the Dixson collection in the State Library of New South Wales) was developed from several original drawings by Sydney Parkinson. It was also engraved by Bartolozzi for Dr Hawkesworth's account. Ra'iatea – then referred to as Ulietea (or Ulieta) – is the second-largest island in the Society Islands after Tahiti.

In Cipriani's picture three dancers perform to the music of drums and a nose-flute. The toga-like garb, gestures and poses of some of the figures can be linked to neoclassical art and design, while the interior construction of the Tahitian building (that might be based on a missing drawing by Parkinson) is part fact and part fancy. The emphasis given to the ordered arrangement of the columns brings to mind topographical drawings or engravings relating to the ruins of classical Greek and Roman temples.

In his *Endeavour* journal Banks described the people of Ulietea in August 1769: 'they dance especialy [sic] the young girls whenever they can collect 8 or 10 together, singing most indecent words using most indecent actions and setting their mouths askew in a most extraordinary manner, in the practise of which they are brought up from their earlyest [sic]

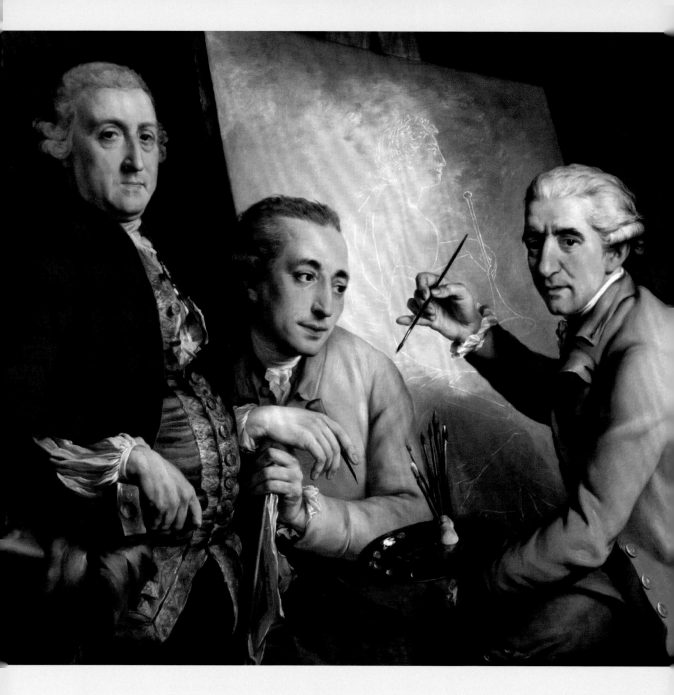

ABOVE

Giovanni Battista Cipriani (1727–85), to the right, and Francesco
Bartolozzi (1727–1815), in the centre, painted in 1777 by John
Francis Rigaud (1742–1810), oil on canvas. National Portrait Gallery,
London. NPG3186. The Florentine artists are with the Italian sculptor
Agostino Carlini. Initially Cipriani and Bartolozzi shared lodgings in
London, with the former's reputation as a decorative artist being
enhanced by the latter's engravings.

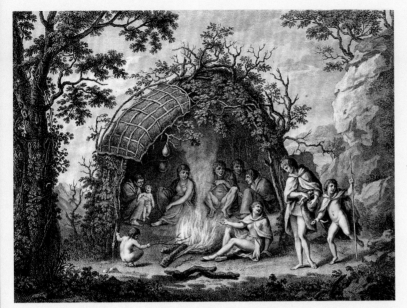

childhood; in doing this they keep time to a surprising nicety, I must almost say as true as any dancers I have seen in Europe tho their time is certainly much more simple.'

Cipriani transformed *A View of the inside of a house in the Island of Ulietea…* into an oil painting around 1772 (known by the shortened title *A Dance in Raiatea*) displayed at Goodwood House in West Sussex, a building notable for key parts being executed in a neoclassical style by James Wyatt, a rival architect to Robert Adam.

The painting is widely stated as having been acquired by George Lennox, 4th Duke of Richmond, although the subject and the style of the artwork is a better fit in relation to his father, Charles Lennox, 3rd Duke of Richmond, who was an army officer, a politician, fellow of the Royal Society and a member of the Society of Dilettanti. This is a view shared by James Piell, the current curator of the Goodwood Collection, although he notes that 'unfortunately the Duke's papers sadly disappeared after his death, having been left to his illegitimate daughter'. The 3rd Duke was a patron of various artists, including the Italian Pompeo Batoni who built up a formidable reputation for painting Grand Tourists in Rome, as well as Sir Joshua Reynolds and George Stubbs. In his retirement he started what would develop into the famous Goodwood racecourse.

John Hamilton Mortimer, the painter of the group portrait featuring James Cook, Joseph Banks, Lord Sandwich, Dr Daniel Solander and Dr John Hawkesworth, can be linked to the Duke of Richmond. Michelle Hetherington, Senior Curator of the National Museum of Australia, has uncovered new details of this often-overlooked oil painting that dates from around 1771. In 1778 Mortimer was elected an Associate of the Royal Academy of Arts.

Mortimer's training was extensive and Hetherington notes 'that from a fairly early age he befriended the artist Joseph Wright of Derby by 1758 Mortimer and Wright

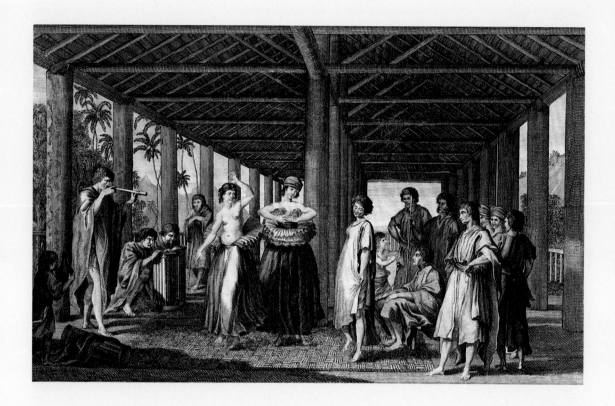

were drawing at the Duke of Richmond's sculpture gallery under the direction of Joseph Wilton' [a sculptor and foundation member of the Royal Academy of Arts] and that 'It was here that Mortimer also met, impressed and became a protégé of Giovanni Battista Cipriani, who had been appointed by the Duke to instruct the pupils in painting.' The Admiralty artist William Hodges is believed to have studied under Wilton's direction, although it is odd that Edward Edwards, the artist and author of *Anecdotes of Painters who have resided or been born in England* (1808), fails to mention this detail as he had been a student.

Hetherington explains that Charles Lennox, 3rd Duke of Richmond, opened a school for the study of painting and sculpture at his own house in Privy Garden, Whitehall, soon after his return from the Grand Tour. A feature of the gallery was the large number of plaster casts 'moulded from the most select antique and modern figures at that time at Rome and Florence'.

Stanfield Parkinson's unauthorised publication of the *Endeavour* voyage on behalf of his late brother features a combination of fascinating imagery. Most of the engravings by the London-born printmaker Thomas Chambers – who exhibited at the Society of Artists from 1761 to 1773 (where he probably met the Parkinson brothers) and was later

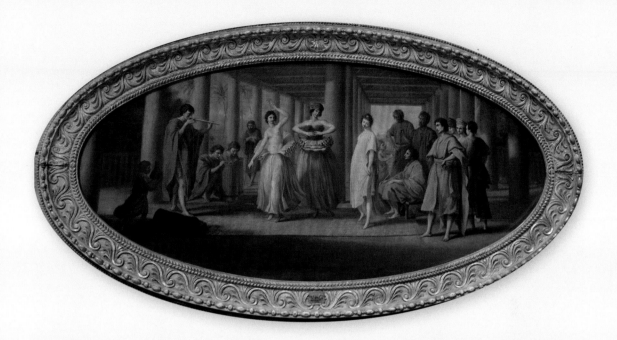

elected an Associate of the Royal Academy of Arts in 1770 – are matter-of-fact in their execution. However, one entitled *Two of the Natives of New Holland, Advancing to Combat* (probably based on one or more missing drawings by Sydney Parkinson) is notable for its neoclassical characteristics. The nose piercings of the Australian Aboriginals and body paint appear authentic but their postures and the pronounced attention to the musculature on their bodies evoke classical sculpture. Even the weapon held by the foreground figure brings to mind, at least at first sight, a sword of the Roman Empire.

Joppien and Smith also identified a likely source for the postures of the Aboriginal figures that relates to the sculptural pairing of the Harmodius and Aristogeiton, two lovers from ancient Athens who killed the tyrant Hipparchus. Their physicality, sense of impending action and forward motion, with both men stretching out their arms – one above and the other below their respective shoulders – appears to mirror that of the Aboriginals. The lovers were popularly known as Tyrannicides, or Tryant Slayers, and became a prominent and enduring symbol of Greek democracy. The acclaimed originals by the Athenian sculptor Antenor and later versions by Kritios and Nesiotes (who were probably pupils of Antenor) are lost and are known through Roman copies.

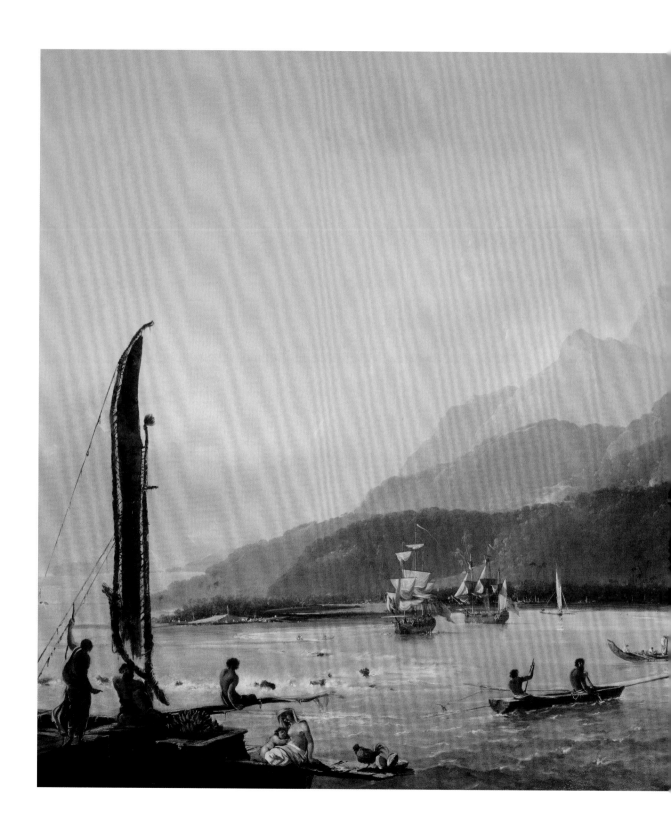

LEFT

A View of Matavai Bay, in the island of Otaheite, 1776, by William Hodges (1744–97), oil on canvas. National Maritime Museum, Greenwich. BHC1932. The classical references here (see pages 130–31) follow on from warriors, Gweagal men from the southern shores of Botany Bay, depicted by Chambers after missing artwork by Sydney Parkinson (featured to the right).

BELOW

Two of the Natives of New Holland, Advancing to Combat, engraved by Thomas Chambers after Sydney Parkinson (c.1745–71), published in the artist's posthumous publication, *A Journal of a Voyage to the South Seas* (1773). Private Collection.

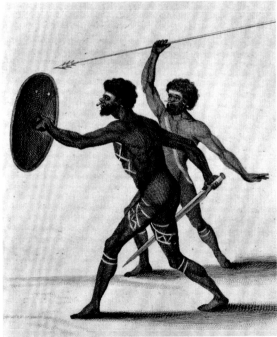

William Hodges' Pacific pictures, engravers and classical allusions

After Banks' withdrawal from Cook's second Pacific voyage it was the Society of Dilettanti who championed the appointment of the Admiralty artist William Hodges. London-born Hodges was the son of a 'smith', probably a worker in metals, based in St James' market. He studied at William Shipley's drawing school and was apprenticed to the classical landscape painter Richard Wilson in Covent Garden. Hodges received awards from the Society of Arts, and became an Associate of the Royal Academy of Arts in 1786 and a Royal Academician in 1787.

Edward Edwards recounts that the youthful Hodges obtained the position of Admiralty artist 'through the interest of the late Lord Palmerston, at that time one of the Lords of the Admiralty, and that he 'resided alternatively in London and the country, in particular Derby, where he painted some scenes for the theatre of that town'.

Hodges collaborated on the oil painting of the *Interior of the Pantheon, Oxford Road* that was exhibited at the Society of Artists in 1772 and much impressed Edwards. William Pars painted the figures of this vast artwork and was a fellow student of Hodges' at Shipley's drawing school. He had a close working relationship with the Society of Dilettanti (his drawings were engraved for the *Ionian Antiquities* published in 1769), and earlier accompanied Lord Palmerston to Switzerland, the Tyrol and Rome. He probably recommended Hodges for Cook's second voyage.

Henry Temple, 2nd Viscount Palmerston, was a fellow of the Royal Society who had undertaken the Grand Tour in the early 1760s and reached Rome and Naples, amassing then and later a significant collection of art and classical antiquities. This prominent member of the Society of Dilettanti held several high-profile government positions including appointments to the Board of Trade and Treasury. He was also a Lord of the Admiralty between 1766 and 1777, which brought him into direct professional contact with Lord Sandwich.

Although Banks was not formally a member of the Society of Dilettanti when Cook's second Pacific voyage departed, and he had his own voyage to Iceland uppermost on his mind, his influential network of contacts would have conveyed to him the names of the replacement Pacific team prior to departure. Banks was a practical man who does not appear to have born grudges – or if so there are few recorded – and fairly quickly he came to terms with the reality that he would not be sailing with his handpicked party on Cook's follow-on expedition.

That Banks did receive some information about the replacement team is known from the introduction to his Icelandic journal, in which he noted, in his characteristic quirky grammar and spelling: 'Upon my refusal to go out the ships [*Resolution* and *Adventure*] were orderd to proceed & in order to do so as much as possible even in the branch of Natural history Mr Forster [Dr Johann Forster] a gentleman Known to the learned world by his translations of several Books was Engaged under the immediate protection of the King.' He also noted that 'soon after Mr— [name not given] a young man who chief [*sic*] studied architecture was joined to him as Landscape & figure painter. This young man was so much in debt that he was obligd to leave town without acquainting a single soul of where he intended to go & no sooner was in Known that he was Plimouth [Plymouth] than Baylifs were sent down to apprehend him whoom he Escapd by keeping continualy on board the Ship. With these gentlemen on board the Ships Resoltuon & adventure saild from Plymouth on the 12th of July 1772'.

The line after 'Mr' represents a blank space as Banks does not appear to know his name. However, is this really William Hodges to whom he refers?

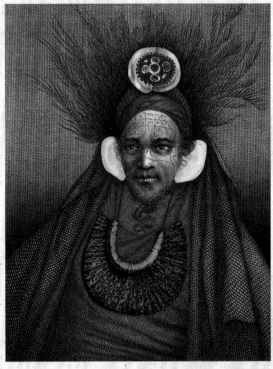

ABOVE

Man of New Caledonia, engraved by F. C. Aliament after William Hodges (1744–97), published in *Cook's A Voyage Towards the South Pole…* (1777). Private Collection. This is based on the drawing, dated September 1774, from the National Library of Australia. The man (in two views) is of chiefly status denoted by his conical hat and the bark spear-launcher attached. New Caledonia is in the Pacific Ocean around 750 miles east of Australia.

ABOVE

The Chief at Sta [Santa] Christina, engraving by John Hall after William Hodges (1744–97), published in *Cook's A Voyage Towards the South Pole…* (1777). Private Collection. On 22 July 1595 the Spanish expedition led by Álvaro de Mandaña first encountered the Pacific island, which is part of the Marquesas, naming it Santa Cristina. Cook sighted it in 1774, and it was later named Tahuata Island. Note the wonderful shell ear decorations.

Hodges was relatively young at 28, but he had not studied architecture – if that is indeed Banks' intended meaning. He might be referring to some of his architectural painting subjects including the *Interior of the Pantheon* and also artworks of the Polygon in Southampton designed by the architect Jacob Leroux and exhibited at the Society of Artists in 1771.

Hodges turned out to be an inspired choice, as he produced some of the most memorable light-suffused and visually striking Pacific paintings of Cook's collective voyages, some of which connect to the scientific interests of the Forsters and the literary descriptions of incidents and places by Georg. Although he mainly focused on drawings and watercolours, he also produced oil paintings. Seven pictures – of which at least three were oils and the others watercolours – were shipped back from South Africa to London according to Cook's instructions for receipt

by Sir Philip Stephens, First Secretary to the Admiralty, who arranged for them to be exhibited at the Free Society of Artists in 1774.

The subjects included views of the islands of Madeira and Santiago, and the Cape of Good Hope that was 'taken on the spot'. As John McAleer points out in *Captain Cook and the Pacific* (2017, co-authored with Nigel Rigby), there was a promotional purpose behind their shipment and public display in Britain's metropolis: the large painting of the Cape of Good Hope, 'acted as a striking, if rather cumbersome postcard informing the Admiralty and others in Britain that the expedition had successfully reached the southernmost tip of Africa'.

Cook wrote again to Stephens shortly after his return to London on 22 March 1775, recounting: 'I transmit this [letter] together with an account of the proceedings of the whole Voyage and such Surveys, Views and other drawings as have been made in it ... The Views are all by Mr Hodges and are judiciously chosen and executed in so masterly a manner as will not only shew the judgment and skill of the artist but will of themselves express their various designs, but these are not all the works of that indefatiable [*sic*] gentleman, there are several other Views, Portraits and some valuable designs in Oyl [oil] Colour, which for want of proper Colours, time and conveniences, cannot be finished until after our arrival in England.'

Cook confirms that Hodges made some oil paintings – or more precisely oil sketches or studies – later on in the voyage, although with limited time and paints he specifically left them unfinished to be completed back in Britain or when he was able to replenish his art supplies.

Dr Solander wrote to Banks on 7 August 1775: 'This moment Capt. Cook is arrived. I have not yet had an opportunity of conversing with him, as he is still in the board-room [of the Admiralty] giving an account on himself & Co. He looks as well as ever.' In the same letter Dr Solander reveals he had managed to speak with William Hodges. He wrote, 'Hodges says the Ladies of Otaheite & Society Islands are the most handsome they have seen – But the Man [*sic*] of the Marquesas seem to cart the prize.'

If Banks was referring to Hodges in his Icelandic journal, then Dr Solander's assessment of the artist's nature given in this letter shows a positive side to his character. He states: 'Hodges seems to be a very well behaved young man.'

On Hodges' return to London, Lord Sandwich, as First Lord of the Admiralty, wasted little time in proceeding with the official publication and setting Hodges in motion to develop his work for the official account. While Lord Sandwich had overall control, through Kerry Bristol's research it is known that James 'Athenian' Stuart was also engaged by the Admiralty (ie Lord Sandwich) to assist with the management of the publication. Banks' close friendship with Viscount Palmerston, Lord Sandwich and Stuart point to the likelihood that he was also involved in an advisory/consultancy capacity.

Lord Sandwich wrote to Banks on 19 August 1775: 'Mr Hodges the designer is directed to finish the drawings, particularly those that are to be selected for engraving; and I shall give directions that as fast as they're finished they shall be framed & glazed.'

He even considered the possibility of offering Hodges a royalty on the sales of the voyage publication, although this was not instigated. The same was considered for John Webber the artist on Cook's third voyage, and again not implemented.

ABOVE

The Destruction of the Children of Niobe, painted in 1760 by
Richard Wilson (1714—82), oil on canvas. Yale Center for British Art,
Paul Mellon Collection. 423-B1977.14.81. Wilson was a foundation
member of the Royal Academy of Arts and an influential art teacher,
whose pupils included Joseph Farington, William Hodges and
Thomas Jones.

A View of Cape Stephens in Cook's Straits with Waterspout, painted in 1776 by William Hodges (1744–97), oil on canvas. National Maritime Museum [NMM], Greenwich. BHC1906. According to NMM curators this picture, 'fuses continuous narrative, landscape, classical references and other diverse elements with personal experiences of the voyage'.

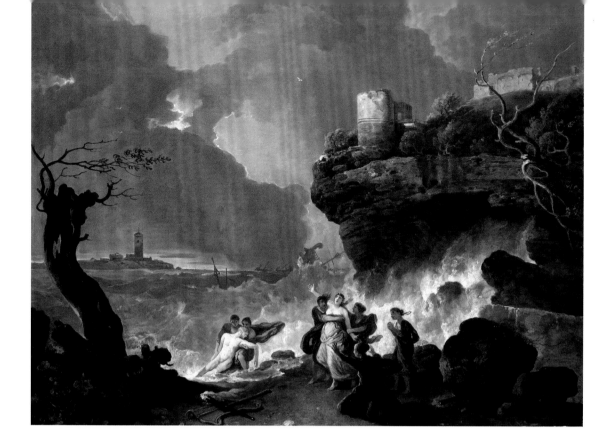

Dr Solander informed Banks on 5 September 1775 that Hodges was 'to have 250 [salary] a year so long as he is engaged by the Admiralty to finish the drawings and paintings he has made during the Voyage – They are very fine – But will take up to 3 to 4 years to finish them, at least'.

Hodges would have needed considerable assistance because of the complexity of the project. That he also had an official supervisory role is supported by Edward Edwards in *Anecdotes of Painters* (1808), who noted that the artist was 'to superintend the execution of the plates which were engraved after them, to serve as illustrations of the narrative'.

However, as John Bonehill points out in *William Hodges 1744–1797: The Art of Exploration* (2004), there was a necessity to manage 'a team of artists drawn from several London workshops, including such skilled and popular engravers as Francesco Bartolozzi, James Basire, William Byrne, James Caldwell, Giovanni Battista Cipriani, John Hall, Benjamin Pouncey, John Keyse Sherwin, William Watts and William Woollett'.

Bonehill continues: 'The scale and scope of the illustrational programme for the Admiralty's account – running to some thirty-five plates, encompassing maps, charts and diagrams, as well as images classifiable as still-life, genre, landscapes, portraits and history – required great flexibility on the part of those commissioned, especially given the novelty of the subjects, and was a fundamentally collaborative process.'

Maidstone-born William Woollett, one of the team of artists referred to by Bonehill, was one of the most successful printmakers of the 18th century. He enjoyed royal patronage, being appointed engraver-in-ordinary to King George III in 1775,

and had a successful relationship with the London-based printseller John Boydell. Among his most successful prints, some of which he published himself, were those engraved after Richard Wilson that had a profound influence on the work of his student William Hodges, and later William Westall.

The Welshman Richard Wilson was a pioneering and influential landscape painter. He was a foundation member of the Royal Academy of Arts, and received awards from the Society of Arts. Prior to Sir Joshua Reynolds he travelled to Italy, settling there from 1750 to 1757, with a particular focus on Rome. Wilson's paintings combine realistic elements of the Dutch landscape tradition with the ideal style of the classical landscapes of Claude.

On returning home he exhibited *The Destruction of the Children of Niobe* at the Society of Artists in 1760, with the original title of *A large Landskip with the story of Niobe*, to critical acclaim. This oil painting is now in the Yale Center for British Art, New Haven. It led to many commissions from British landowners wanting their properties painted in a classical style.

Wilson's subject was inspired by Homer's *Iliad*, which relates Niobe's hubris that saw her punished by having her children killed by the gods Apollo and Artemis. The painting was engraved by William Woollett and published by John Boydell. The popularity of Wilson's picture is highlighted by Martin Postle in *Inspiration and Imitation: Wilson, London and The School of Rome* (2014) who noted that, 'Boydell announced the publication of *Niobe* in October 1761, for which he apparently paid Woollett an unprecedented engraver's fee of £120. In return he allegedly netted a profit of £2,000.'

The art-historical importance of Wilson's painting is summarised by the Yale Center for British Art's curatorial team who stated that it, 'inaugurated a new, revolutionary category of painting. By melding the established genres of landscape and history painting, the artist created a challenging hybrid: historical landscape', and that: '*Niobe* established Wilson's reputation as an artist capable of rivalling his French and Italian counterparts, an extraordinary achievement at a time when indigenous art was considered inferior to European art by British connoisseurs'. They concluded: 'Wilson's transformative vision … had a decisive impact both on his pupils, notably William Hodges and the following generation of artists.'

Wilson's picture was an important reference source for Hodges' 1776 dramatic and moody large-scale painting *A View of Cape Stephens in Cook's Straits with Waterspout*. The area is located off the north-west coast of the South Island of New Zealand in the stretch of sea separating the islands. Hodges borrowed and adapted various elements including the neoclassical figures that dominate the foreground of Wilson's composition, and also from another painting *Ceyx and Alycone*, as revealed below, and featured them in his own painting.

Hodges also referenced Wilson's painting of *Ceyx and Alycone* that was exhibited at the Society of Artists in 1768 and entitled *A storm at day-break, with the story of Ceux*, [Ceyx] *Alcione, Ovid Metam* [Ovid's *Metamorphoses*]. It was engraved by William Woollett and published by him in 1769. The painting is now in the National Museum of Wales. Sarah Ingle of the museum notes that, 'According to the Roman author Ovid, Ceyx, King of Tracninia, was drowned while on his way to consult the oracle in Claros. His Queen, Alcyone, who learned of the tragedy in a dream, is shown distraught with grief as the ghostly white corpse of her husband is brought ashore. The king and queen were turned into birds – the Alcyones.'

Hodges' painting is part fact and part classical fantasy. He adapted and borrowed several elements from Wilson's *Ceyx and Alycone* such as the hill fortification (which Hodges

transforms into a Māori pa on fire), the dramatic gesturing of the figures, and the wild windswept and expressive vegetation, trees and rocks. The factual part of Hodges' picture largely lies in the water-spouts observed by Cook and his crew. Hodges followed the example of Wilson, who in turn was inspired by Claude in his attempt to elevate landscape to the higher status of history painting.

Hodges and Wilson also borrowed pictorial elements from the 17th-century French painter Gaspard Dughet – in particular his *Seascape with Jonah and the Whale* painted in 1653 that includes the classical figures, stormy sea and sky, craggy rocks and a coastal fortification on fire and being hit by lightning. This painting had been acquired for the Royal Collection by Frederick, Prince of Wales around 1745, and was well known through an engraving by Francois Vivares published in 1748.

Dughet and the Italian artist Salvator Rosa among others helped to popularise biblical and stormy classical coastal and landscape scenes in the 17th century, and their appeal endured well into the first half of the 19th century. Dr Johann Forster was conscious of the popularity of these artists and subjects. In his *Observations Made during a Voyage round the World...* (1778) he observed while sailing in New Zealand's Dusky Sound that, 'Some of the cascades with their neighbouring scenery, require the pencil and genius of a SALVATOR ROSA to do them

justice'. He continued: 'however the ingenious artist, who went with us on this expedition has great merit, in having executed some of these romantic landscapes in a masterly manner'.

Hodges created a variant of *A View of Cape Stephens in Cook's Straits with Waterspout* with the focus this time on a more factual depiction of the waterspouts and weather conditions. It featured as an engraved double-page illustration for the expedition astronomers William Wales and William Bayley's publication *The Original Astronomical Observations, made in the course of a Voyage towards the South Pole, and round the World, in his Majesty's Ships the* Resolution *and* Adventure (1777).

William Hodges' Pacific oil paintings were exhibited at the Society of Artists, the Free Society of Artists and the Royal Academy of Arts. They received a mixed reception in terms of their painting style and subject matter. A reviewer for *The St James's Chronicle, or, British Evening-Post* of 3–6 May 1777, calling himself 'Gaudenzio', had seen Hodges' Pacific artworks at the Royal Academy of Arts. He stated: 'The War-Boats of the Islands of Otaheite, &c by Mr Hodges are very curious, and there is great Merit in the Views.'

A comparison of Hodges' aforementioned artwork that has acquired a long-winded title (*The War-Boats of the Island of Otaheite and the Society Isles, with a View of part of the Harbour of Ohameneno* [Haamanino], *in the island of Ulieta* [Ra'iatea], *one of the Society Islands*, 1777) with the expedition accounts reveals striking artistic license. (Illus pp. 96–97.)

When Cook and his crew returned to Tahiti in April 1774 they observed close to 160 large vessels of war preparing to attack the neighbouring island of Moorea. On 26 April Cook wrote in his journal that, 'The Cheifs [*sic*] i.e. all those on the Fighting Stages were drist [dressed] in their War habits, that is in a vast quantity of Cloth Turbands, breast plates and Helmmets [*sic*].'

Hodges features only three canoes, with some of their crew wearing a fusion of native and classical-style clothing. Some of their poses and postures are inspired by ancient sculpture. The shore is empty except for an intimate group of five people: two men wearing toga-esque garb and dramatically gesturing beside a young woman, and a mother holding a baby. The mother wears a classical drape and is depicted in a pose recalling an image of the Madonna and Child. An imposing tree to the left and part of the canoe to the right frame the picture space. This framing device, combined with the strong contrast of light and dark, echoes the classical landscapes of Claude and Richard Wilson, Hodges' master.

On 30 April 1774 Cook comments in his journal that 'Tarevatoo the Kings brother gave me the first notice of these Canoes being at Sea and knowing that Mr Hodges made drawings of everything curious, desired of his own accord that he might be sent for, I being at this time ashore with Tarevatoo: Mr Hodges was therefore with me and had an opportunity to collect some materials for a large drawing or Picture he intends to make of the fleet assembled at Oparre which will convey a far better idea of them than can be express'd by words.'

In May 1774 Georg Forster in *A Voyage Round the World* (1777) noted, 'the view of the Taheitian [*sic*] fleet frequently brought to our mind an idea of the naval force which that nation [ancient Greeks] employed in the first ages of its existence, and induced us to compare them together.'

In the *Morning Chronicle* of 28 April 1777, the reviewer observed that, 'Mr Hodges, who in last year's Exhibition [Royal Academy] had several views of bays, &c about the Island of Otaheite, has this year a large piece exhibiting the war boats of that Island, and a view of part of the harbour of Ohamaneao, &C. The public are indebted to this artist for giving them some

idea of scenes, which they before knew little of. It is rather surprising however, that a man of Mr Hodges's genius should adopt such a ragged mode of colouring; his pictures all appear as if they were unfinished, and as if the colours were laid on the canvas with a skewer.'

The loose-handling and application of paint with its ragged appearance adopted by Hodges was singled out on various occasions for criticism. A satirical reviewer calling himself Sir Solomon Gundy wrote damning poetry on the Royal Academicians he particularly disliked, and this was published in 1792. His poem on Hodges compared him to a scene painter (which, according to Edward Edwards, he indeed had experience of through work in the theatre in Derby) and criticised his depictions of people. With reference to his use of colour and handling of paint, it stated: 'Your Harl'quin-jacket landscapes patch'd so thick, with various colours almost make one sick.'

Yet it is precisely this 'ragged mode of colouring' employed by Hodges that helps to reveal something of the character of Captain Cook in Hodges' portrait of him painted between 1775 and 1776. It was probably commissioned and owned by his early patron Admiral Sir Hugh Palliser. The free application of paint, combined with the dramatic light and shade, creates a brooding and intense portrait of the explorer. It highlights Cook's steely determination combined with fatigue that is hardly surprising for a man who had twice – and in fairly quick succession – circumnavigated the world. A different version by Hodges (with some similarities to this portrait that is now in the National Maritime Museum, Greenwich) was engraved for the first volume of Cook's second Pacific voyage publication.

In around 1776 Hodges painted for the Admiralty two oil paintings that are notable for their classical allusions. Although they are of different sizes, they can still be considered (albeit loosely) as a contrasting pair. They depict interior and exterior scenes of Tahiti and are entitled *A View taken in the bay of Otaheite, Peha* [Tahiti, Vaitepiha] (now popularly known as 'Tahiti Revisited') and *View of Matavie Bay in the Island of Otaheite*. Versions of these paintings were exhibited at the Royal Academy of Arts in 1776. The originals that were exhibited are believed to be those in the collections of Anglesey Abbey and the Yale Center for British Art, New Haven (see pages 66–67).

'Tahiti Revisited' helped to confirm in the minds of the exhibition visitors that Tahiti was an earthly paradise. Female figures bathe in and rest by the river, undisturbed by Cook's men. Their nakedness reinforces the sensual nature of the scene with erotic charms. There is a classical allusion in this quasi-voyeuristic scene. The foreground woman drying herself, with tattoos on her lower back and buttocks, evokes Diana – the chaste goddess of nature, animals and the hunt in Roman mythology – who was discovered by the hunter Actaeon while bathing with her nymphs in their secret location. In revenge Diana turned Actaeon into a stag to be torn apart by dogs. This well-known story was widely reflected in literature and art, and features in many paintings (including a celebrated mythological series by the Italian Renaissance painter Titian) that are now in the National Gallery, London.

Beside the 'Diana-esque' foreground figure is a carved figure representing deified ancestors (or *tii*), while to the far right in the middle distance a shrouded corpse is placed on a raised platform (or *tupapau*). As observed in Geoff Quilley and John Bonehill's *William Hodges 1744–1797 The Art of Exploration* (2004), the painting can also be read as 'a meditation on the transience of earthly pleasures as a further adaptation of the traditional theme of *Et in Arcadia Ego*'. (Illus pp. 12–13.)

The painting of the *View of Maitavie* [Matavai] *Bay, Otaheite* features Cook's exploration vessels *Resolution* and *Adventure* set against a mountainous backdrop. Matavai Bay is situated on the north coast of Tahiti and is around five miles from the modern-day capital of Pape'ete.

The group of Tahitians in the left foreground includes a classically draped male figure holding a staff and making a dramatic gesture towards the encampment ashore at Point Venus where Cook and his men observed the Transit of Venus on the *Endeavour* voyage. Nearby is a mother with child whose pose brings to mind a depiction of the Madonna and Child.

Georg Forster, one of the shipboard naturalists, befriended William Hodges during Cook's second voyage. He admired some of his work but was vociferous in his criticism of other examples, especially the imagery that had been given a classical twist and which featured as engraved illustrations for the publications of Cook's second Pacific voyage. Forster held up John Keyse Sherwin's engraving of Hodges' artwork *Landing at Middleburgh, one of the Friendly Isles* for particular contempt, blasting its 'Greek contours and features'.

Forster was vehement in criticism of this artwork. In *A Voyage Round the World* (1778), he stated: 'The same candour with which I have made it a rule to commend the performances of this ingenious artist, [Hodges] whenever they are characteristic of the objects which he meant to represent, obliges one to mention that this piece, in which the execution of Mr Sherwin cannot be too much admired, does not convey any adequate idea of the natives of Ea-oowhe or of Tonga Taboo.'

He continued: 'it is also to be greatly feared, that Mr Hodges has lost the sketches and drawings which he made from NATURE in the course of the voyage, and supplied the deficiency in this case, from his own elegant ideas. The connoisseur will find Greek contours and features in this picture, which have never existed in the South Sea. He will admire an elegant flowing robe which includes the head and body, in an island where the women very rarely cover the shoulders and breast; and he will be struck with awe and delight by the figure of a divine old man, with a long white beard, though all the people of Ea-oowhe shave themselves with muscle-shells'.

Forster was also critical of the engravings of the *Endeavour* voyage that included transformations of the pictures of Banks' shipboard artists Buchan and Parkinson. He wrote: 'The plates which ornamented the history of Captain Cook's former voyage [Dr Hawkesworth's publication], have been justly criticised, because they exhibited to our eyes the pleasing forms of antique figures and draperies, instead of those Indians of which we wished to form some idea.'

In his criticism of Parkinson and similar artworks Forster was not alone. Edward Edwards in *Anecdotes of Painters* (1808) wrote damningly: 'In all his productions he discovered too little attention to the true similitude of the objects he represented. This fault pervaded the drawings which he made in the voyage to the South Seas, and was objected to them [*sic*] by those who had before visited the places whence the Views were taken.'

Although there certainly are 'Greek contours and features' to be found in this and other artworks by and after Hodges, his shipboard friend William Wales – one of two astronomers on Cook's second Pacific voyage serving aboard the *Resolution* – leapt to the artist's defence by writing an attack on Forster that was published in 1778 and entitled *Remarks on Mr Forster's Account of Captain Cook's last Voyage round the World*. Wales claimed that this account was actually written by Dr Forster, Georg's father. In fact it is more likely to have been a collaborative work in parts.

After consulting the artist, Wales wrote: 'I am authorised by Mr Hodges to assure the Doctor, that he has not lost any of his original sketches, and that every figure so far as it relates to their dress, manners or customs, are to be found amongst them, actually drawn from the persons which he saw; even the "divine old man with a long white beard," is amongst them.'

Sherwin engraved another of Hodges' Pacific 'landing' pictures for Cook's Pacific account, entitling it *The Landing at Erramanga* [Eromanga]*, one of the*

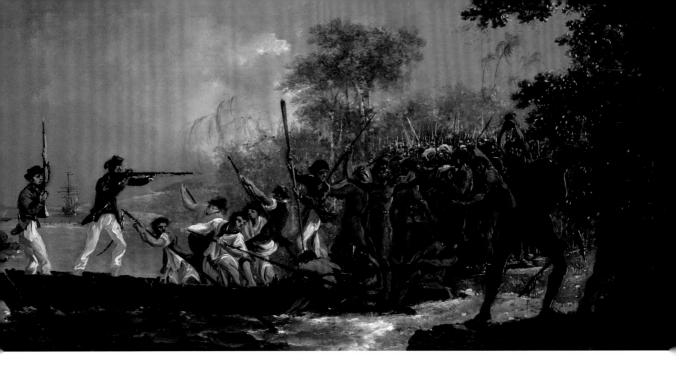

New Hebrides. Hodges also produced an oil version of this subject for the Admiralty that is probably the one exhibited at the Royal Academy of Arts in 1778 with a different title: *View in the island of Erramanga and of the New Hebrides, with the Attack of the Indians on Capt. Cook.*

The original oil painting by Hodges caught the attention of the reviewer of *The General Advertiser and Morning Intelligence* of 2 May 1778, who declared: 'The design of this piece is very faulty', and that: 'A confusion in the grouping produces a most disagreeable effect. The subject, indeed is most difficult to trust; it requires the greatest art to combine the characters so as to preserve the unity of the whole. Confusion in the figures ought to be expressed without confusion in the picture; as a writer ought to treat his subject clearly.'

Sherwin is partly responsible for imbuing Hodges' artwork with a neoclassical feel. The engraving shows several figures – for instance, the man standing holding an axe in the right foreground – that have now been transformed into classical sculpture through clearly defined lines and refined poses. However, the existence of a drawing of this subject by Giovanni Battista Cipriani throws open another explanation as to the neoclassical presence in this picture.

Joppien and Smith in *The Art of Captain Cook's*

Voyages, Vol. 1 (1985), considered that Ciprani's *Drawing for the Landing at Erramanga* executed in pencil, pen and wash, is related to the development of the engraved illustration. Cipriani developed his neoclassical design from an original artwork by Hodges' painting that was then engraved by Sherwin.

Sherwin's artistic training and social connections determined that his professional focus was often directed to the old masters and inspired by classical art. He studied under Francesco Bartolozzi, the lifelong friend and frequent collaborator of Cipriani, and at the Royal Academy Schools. After the death of William Woollett he succeeded him as engraver to King George III, and was also appointed engraver to the Prince of Wales. He was closely associated with members of the Society of Dilettanti. However, perhaps his most popular portrait engraving today is of Captain James Cook after Nathaniel Dance-Holland's oil painting that was published in 1784 by R. Wilkinson. It was engraved in a matter-of-fact style devoid of neoclassical embellishments. Reputedly Sherwin had an annual income of £12,000, most of which was dissipated on reckless gambling, and he died in a London alehouse aged 39.

Many of Hodges' illustrations of landscapes and portraits featured in the official voyage publication are inscribed 'Drawn from Nature by W Hodges', while

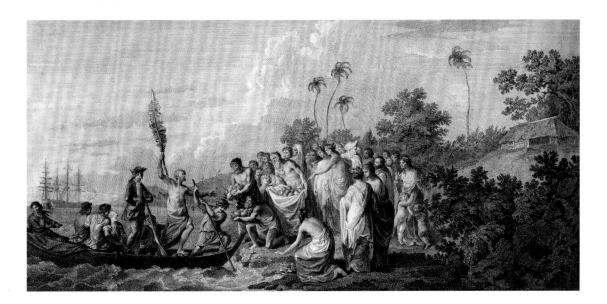

LEFT

The Landing at Erramanga [Eromanga], *one of the New Hebrides*, painted c.1776 by William Hodges (1744–97), oil on panel. National Maritime Museum, Greenwich. BHC1903. Classical references are evident in the postures of some of the New Hebrideans including the standing foreground figure.

ABOVE

Landing at Middleburgh, one of the Friendly Isles engraved by John Keyse Sherwin after William Hodges (1744–97) and published in Cook's *A Voyage towards the South Pole* (1777). Private Collection. Cook leans on his gun in the boat whilst the Tongan chief holds up a plantain, and as they approach the shore a crowd offers fruit to barter.

a lesser number state 'Painted by W Hodges'. The latter inscription appears to convey to the reader/viewer that the composition lacked the 'authenticity' of those 'Drawn from Nature' and would therefore contain an interpretation of an event or view with some flights of artistic fancy. It is likely that Hodges – encouraged by Lord Sandwich, Lord Palmerston, James 'Athenian' Stuart and Banks – was trying to satisfy two audiences: one that demanded accuracy of observation in his voyager art and another with shared interests to the Society of Dilettanti.

John E. Crowley addresses the subject of 'drawn from nature' versus 'painted by W Hodges' and the engravings after his expedition artwork in *Imperial Landscapes ~ Britain's Global Visual Culture 1745–1820* (2011), stating that the latter 'referred to works that Hodges had finished back in London for exhibition at the Royal Academy or presentation to the Admiralty. The landscapes engraved by William Watts … faithfully adhered to Hodges's original drawings; those by William Byrne added a pastoral tone; and William Woollett's "Monuments in Easter Island" and "Toupapow with a corpse on it" took advantage of their melancholic subjects.'

Banks' awareness of the public criticism levelled against some of the voyager art imagery of Cook's *Endeavour* voyage is known through his correspondence in the mid-1790s. This related to his consultancy work with Lord Sandwich, James 'Athenian' Stuart and John Webber among others in the selection of the pictures by the artist William Alexander who accompanied Lord Macartney's British embassy to China (1792–94), for the official publication [see page 103]. Writing from Soho Square in January 1795 Banks states that, 'No engraving to be introduced on any Pretence of an Object Which has not been seen & actually delineated by some person on the Embassy per description given…Cook's 1st voyage lost much Credit Even by drawings being Corrected in England'. By 'Corrected in England' he is referring to the work of Bartolozzi and Cipriani.

Thomas Jones

The Society of Dilettanti was also behind the selection of the Admiralty artist for Cook's third Pacific voyage. The Welshman Thomas Jones, an artist and fellow pupil of William Hodges studying under Richard Wilson in London, recounted in his memoirs that on 8 September 1775: 'An application being made to me about this time by Mr Stewart [*sic*] (the Athenian, as he was called), in the name of the *Dilettanti* Society, to go out with Capt'n Cook in his next voyage, in the situation that Hodges was in his last'. 'Mr Stewart … the Athenian' was of course James 'Athenian' Stuart, Banks' close friend. A portrait of Jones by the Roman artist Giuseppe Marchi is in the National Museum of Wales.

Jones' parents refused to grant permission for their son to sail to the Pacific and so instead (with the backing of the Society of Dilettanti) he travelled to Italy, where he settled in Naples for several years, enjoying the patronage of the diplomat Sir William Hamilton. Jones was inspired by the artwork of Claude and Richard Wilson and delighted in the depiction of Mediterranean light in coastal and landscape views often featuring Italian stone pines. The work of Claude and Wilson in particular would have a significant influence on the composition and creation of some of the voyager artist William Westall's expedition drawings on Flinders' *Investigator* voyage as well as on the Pacific paintings he developed back in Britain with Banks' assistance.

John Webber and classical allusions

Dr Daniel Solander is credited as identifying London-born John Webber, the son a Swiss sculptor, as a suitable candidate for Cook's third voyage after viewing work by him at the Royal Academy of Arts in 1786 – a recommendation that has previously been argued is unlikely to have arisen without consultation with and approval by Banks. Webber was aged 24 when he was approached to sail with Cook on his third Pacific voyage.

What Dr Solander actually saw at the Royal Academy were three artworks: *Two views of the environs of Paris* and *A Portrait of an artist*. The latter was in fact a depiction of his brother Henry, the award-winning sculptor and modeller who worked for Wedgwood.

John Webber's art training included periods in Bern and Paris before entering the Royal Academy Schools in 1785. On the voyage he produced many carefully crafted drawings and 'tinted' watercolours that were influenced in particular by the tuition of the prominent Swiss landscape painter and printmaker Johann Ludwig Aberli. However, Webber also produced a significant body of oil paintings, many of them portraits. An example of his detailed draughtsmanship is evident in his drawing now in the Yale Center for British Art and titled *View on the Island of Cracatoa* [Krakatoa]. It was drawn after the death of Cook in February 1780 while the crew of the *Resolution* and *Discovery* refreshed on the volcanic island for a few days before proceeding on the homeward legs. They found the indigenous people to be friendly, and experienced two springs – one of fresh and the other hot water.

Amongst Webber's wide-ranging subjects engraved for the official Admiralty publication were *A White Bear* and *A Man of the Sandwich Islands, in a Mask*. Webber also published himself prints of his voyager art initially as soft ground etching in parts

ABOVE

View in Queen Charlotte's Sound, New Zealand, hand-coloured etching, after and by John Webber (1751–93), published by him in 1790. British Museum. 1872.0713.565. Part of a series of coloured prints issued separately and later together by Boydell. The town of Picton on the north-east coast of the South Island is located near the head of the Sound.

between 1788 and 1792, that included *View on the Island of Cracatoa* (based on the aforementioned drawing) and also depictions of New Zealand and Tahiti. They were brought together as a set of sixteen coloured aquatints titled *Views in the South Seas…* first published in London by Boydell in 1808, and reissued between 1819 and 1820. This demonstrates the enduring appeal of his imagery relating to Cook's last Pacific voyage. In addition to artworks on paper, the Admiralty acquired four oil paintings by the artist to display at Admiralty House.

During the period when Webber studied at the Royal Academy of Arts painting was not taught. The students were encouraged to develop their drawing skills and learn about art by initially copying and studying antique casts and sculpture, as was the case during the presidency of Sir Joshua Reynolds. Once this was mastered the students would move on to life drawing.

Webber was elected an Associate of the Royal Academy of Arts in 1785 and a Royal Academician in 1791. He was the most commercially successful of the voyager artists and between 1784 and 1791 he

displayed 29 artworks there relating to Cook's third voyage and represented by subjects of Tahiti and the Society Islands, the Sandwich Islands, Canada, Russia and China. However, only three perfunctory notices have come to light on his voyager art exhibits at the Royal Academy of Arts.

The satirist Sir Solomon Gundy was critical of his work, not that it affected Webber's sales. Gundy wrote of him as part of a poetic diatribe published in 1792 that also featured the artist Paul Sandy (a topographical artist much admired and collected by Banks, and with whom he toured Wales) and the architect John Yenn.

He exclaimed:

Webber, 'tis said, that you have much conceit;
The reason why, I never yet could meet,
Correct yourself I beg,
At least, correct your Landscapes daub'd like brass,
With shining Rocks that brittle look to glass,
And clouds like Yolks of Egg.

Webber, however, was generally well liked in his lifetime. According to Pieter van der Merwe's entry in the *Oxford Dictionary of National Biography*, he was 'lively, well-liked and professionally successful'. This entry also states that, by the time of his death in 1793, the artist had amassed a significant amount of wealth and left an estate 'of nearly £5,000' that was divided between family and friends including the artist and diarist Joseph Farington. Webber's ethnographic collection was left to the Library of Bern, and later transferred to the Bernisches Historisches Museum.

A small selection of Webber's Pacific pictures, mostly in oils, feature fascinating classical allusions, for example Webber's *Poedua, the Daughter of Orio* that was exhibited at the Royal Academy of Arts in 1785, one of three recorded oil versions. The attenuated neck, flowing lines of her body and overlong arms are typical of the neoclassical idiom.

To elevate the subject from a documentary representation to a grander composition, Webber has adapted a pose with references to the *Aphrodite of Knidos*, a celebrated work by the Greek sculptor Praxiteles of Athens. It is also referred to as *Venus Pudica*, the 'modest Venus', as she tries to cover her naked pubic area with her right hand.

Such classical references chimed with Banks' circle of art connoisseurs and the interests of the Society of Dilettanti. From the artist's perspective the Royal Academy of Arts was a promotional platform and sales venue and, although in this instance the artwork had been paid for by the Admiralty to later hang in Admiralty House, it was hoped that wealthy visitors would enjoy the exhibit and that this would lead to further commissions and sales of other artworks.

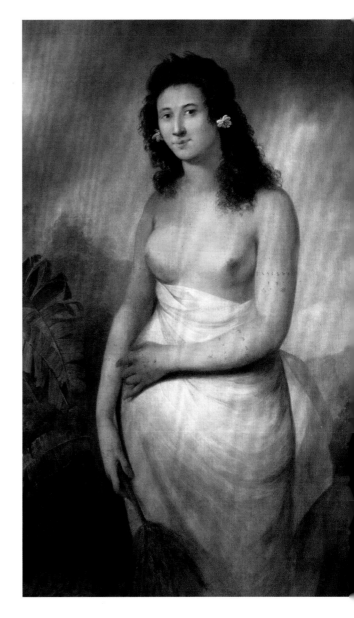

ABOVE

Poedua, the Daughter of Orio, painted c.1784 by John Webber (1751–93), oil on canvas. National Maritime Museum, Greenwich. BHC2957. Poedua (c.1758–before 1788) was the 19-year-old daughter of Orio, chief of the Haamanino district of Ra'iatea (Ulietea), a neighbouring island to Tahiti, and is shown here wearing cape jasmine blossom in her hair and holding a 'fly whisk' to denote chiefly status.

The opportunity to draw and later paint Poedua – who Cook had first met on his second Pacific voyage in September 1773 – occurred on 3 November 1777 when Cook moored his ships at Ra'iatea (called at that time Ulieta or Ulaietea), the second-largest of the Society Islands. He remained there until 7 December. On 24 November, midshipman Alexander Mouat and gunner's mate Thomas Shaw had deserted the *Discovery* under the command of Charles Clerke.

Cook decided to take hostages in order to locate his men. Orio's son and daughter, Ta-eura and Poedua, and her husband Moetua were lured aboard ship and held in the great cabin with the promise that they would be released if they were able to

enlist the help of others in locating the missing men. Webber seized the opportunity to observe and sketch Poedua there. She was pregnant at this time.

Webber's *Catalogue of Drawings and of Portraits in Oyl* [*sic*], now in the National Library of Australia, was almost certainly used by Banks during the process of the development of the artworks into engraved illustrations for the voyage publication. As revealed by the art historian Joppien, it 'bears some inscriptions in Banks' hand' and formed part of his Pacific library. It was an 'inventory of the works delivered [to the Admiralty] and a means of explaining the various subjects to the unprepared, non-specialist viewer', and one that was probably prepared by an assistant aboard the *Resolution*.

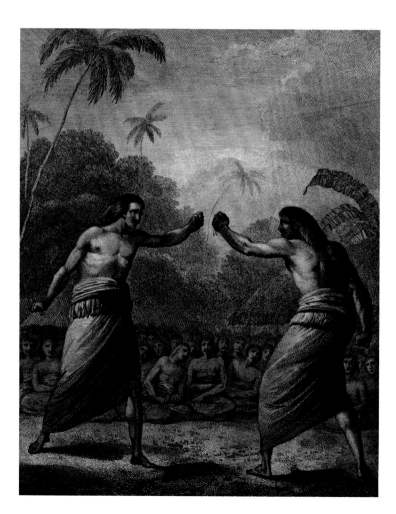

LEFT

A Boxing Match, in Hapaee (Tonga), engraved by Isaac Taylor, after John Webber (1751–93), published in Cook and King's, *Voyage to the Pacific Ocean…* (1784). Private Collection. Men seated in a semi-circle watch the action. The original artwork titled *A Boxing Match, Friendly Islands* (dated 1778), is in the British Library.

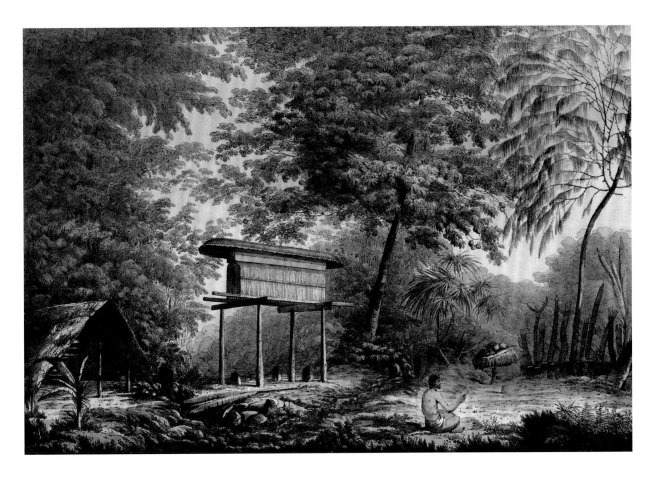

Twenty oil portraits are listed including 'Poedua the Kings Daughter of Ulaietea'. Webber's voyage lasting four years was considerably longer than William Hodges, and it is likely that he also completed some oil paintings prior to arriving back in Britain. Whether he completed a portrait of Poedua has been considered but is probably unlikely.

The first of the three portraits of Poedua, that is dated 1785, was consigned by her descendants for sale to Christie's in 2008, and might be the version exhibited at the Royal Academy of Arts. It is believed to have been taken to Tahiti by the banker Alexander Salmon who travelled to the Society Islands in the 1840s and married into the Tahitian Royal Family. It is the least familiar version, having been unseen by the public for over 200 years. The other portraits are in the National Maritime Museum, Greenwich and the National Gallery of Australia.

John Webber's *A Boxing Match, Friendly Islands*, 1778 is an example of classical allusion in one of his artworks on paper. Joppien and Smith identified that

ABOVE

A Toopapaoo of a Chief, with a Priest making his offering to the Morai, in Huoheine, hand-coloured soft-ground etching by and after John Webber (1751–93), published by him on 1st October 1789. British Museum. 1872.0713.548. The island of Huahine (Huoheine) is part of the Society Islands and was first visited by Cook on 16 July 1769. The tupapau (Toopapaoo) translates as 'the spirits of the dead are watching'; whilst the Marae *(Morai)* was an open-air sacred structure where the dead were commemorated.

the two pugilists, each with one outstretched arm, are reminiscent of the *Borghese Gladiator*. This life-sized marble sculpture of a swordsman, whose sword is not depicted, was sculptured by Agasias of Ephesus in around AD 100.

In the 18th century the *Borghese Gladiator* became familiar through copies and it was reproduced in

prints – notably an example after Joseph Wright's (known as Joseph Wright of Derby) *Three Persons Viewing the Gladiator by Candlelight* painted in 1765 that was well known through a mezzotint, engraved and published by William Pether in 1769.

Wright was a member of the Lunar Society of Birmingham founded in the 1750s (as were Banks and Dr Solander). The Society's name derived from its meetings taking place during the full moon, and its members affectionately referred to each other as 'lunarticks'. Early members who were well known to Banks included Matthew Boulton (the manufacturer and business partner of the engineer James Watt) and Erasmus Darwin (the physician, natural philosopher, and grandfather of Charles Darwin). It is also likely during his stint as scene painter at the theatre in Derby that William Hodges came into contact with Joseph Wright of Derby.

Webber's *A Chief of the Sandwich Islands* was executed in oils and features classical references. It was exhibited at the Royal Academy of Arts in 1787 with the full title of *A Chief of the Sandwich Islands leading his party to battle*. Cook and the *Endeavour* crew were the first Europeans to encounter the Sandwich Islands (Hawaiian Islands) in 1778, which Banks named after his friend John Montagu, 4th Earl of Sandwich. The painting is listed in Webber's inventory under the oil-painting section with the title *A Chief of Owhyhee*.

Nat Williams of the National Library of Australia, the first James and Bettison Treasures Curator, observes that: 'The Chief, wears a red helmet, a feathered cloak and a *maro*, a piece of *kapa* (bark cloth) wrapped around the waist and thighs. He fatefully holds a sharpened "black wood" spear commented upon by Cook in his journal and gestures towards a battle scene in the background.'

Beyond Webber's factual depiction of the chief, the position of his arms and gesturing evoke classical sculptures in general (although not necessarily specific examples). The chief's helmet also attracted comparisons with examples from ancient Greece. In fact, one was made in the early-19th century in Sir Richard Phillips' travel guide *The Picture of London for 1806* within the section addressing the Pacific material displayed at the British Museum. The guide reveals that the 'helmets of feathers from the Sandwich Islands. Among these last is one which, in elegance of form, vies even with the Grecian helmets'.

In the National Library of Australia's Treasures Gallery, Nat Williams also notes of *The Apotheosis of Captain Cook* – an engraving replete with neoclassical references which imagines Cook ascending heavenwards – that: 'It was created by Philippe-Jacques de Loutherbourg from a drawing by John Webber and then engraved by Francesco Bartolozzi. De Loutherbourg, the Franco-British painter, alchemist, occultist and theatrical innovator designed the sensational blockbuster pantomime production *Omai: Or, a Trip Round the World,* which opened to acclaim in Covent Garden in December 1785.'

Williams continues: 'During the final scene of this ground-breaking multimedia event Captain Cook was seen carried heavenward, heralded by Britannia and Fame, in a large oil painting. The print in the gallery is a later and smaller version of this scene and probably commemorates Webber's death in 1793.'

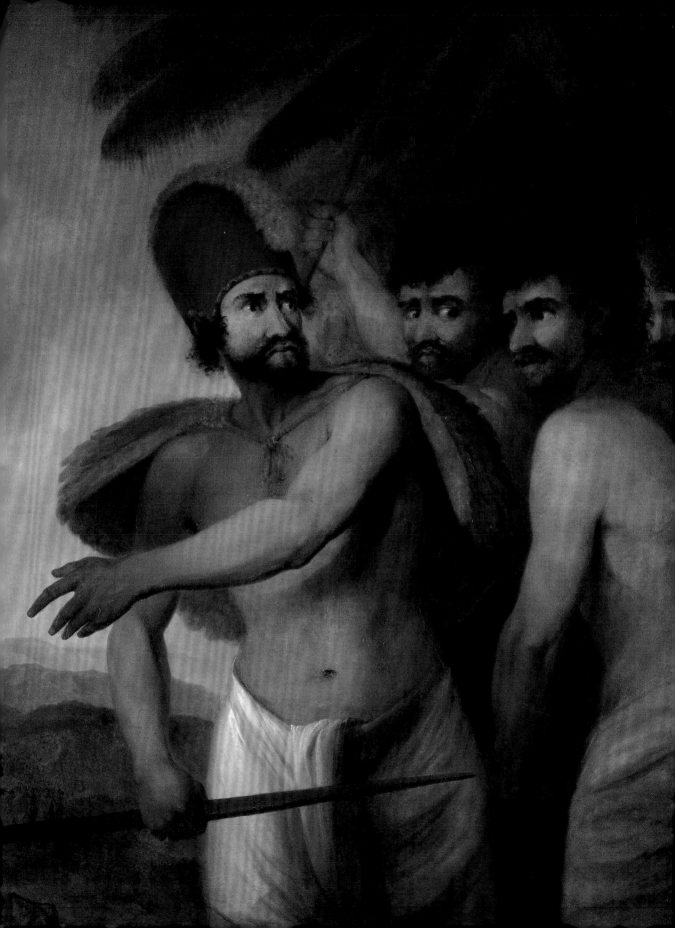

Collections of classical sculpture and their influence on Pacific pictures

Outside of the Royal Academy of Arts, there were various collections of classical sculpture available for artists and others to study in private collections. These collections were often open to the public by appointment either for a fee or free of charge. One notable collection was amassed by Charles Townley, the antiquary and art collector whose Townley Marbles can be seen in the British Museum, of which he was a trustee. Townley had many other shared interests with Banks including membership of the Society of Dilettanti, fellowship of the Royal Society and a passion for the work of the neoclassical artist Johan Zoffany, the artist Banks had lined up for Cook's second Pacific voyage.

Townley commissioned Zoffany to depict him with fellow connoisseurs in the painted library of his home at Park Street, Westminster, which resulted in a wonderfully detailed oil painting revealing examples of his collection of Greek and Roman antiquities. The picture was exhibited at the Royal Academy of Arts in 1790 entitled *A Nobleman's collection*.

Eight years later the painting was reworked to include the acquisition of the Discobolus. This was one of his new star exhibits of the discus thrower, which he took possession of in 1794. This Greek sculpture was originally made in bronze by the Athenian sculptor Myron and completed at the end of the Early Classical Period, circa 490–450 BC. The original is lost but is known through various Roman copies. Townley purchased a version that had been excavated from Hadrian's Villa at Tivoli from the antiquary, artist and art dealer Thomas Jenkins.

Jenkins had travelled to Rome with the classical landscape artist Richard Wilson and decided to stay and establish himself in business.

Viccy Coltman in *Classical Sculpture and the Culture of Collecting in Britain since 1760* (2009) reveals that Zoffany's painting is an amalgam drawing on star exhibits from Townley's collection. Coltman notes: 'The highly-prized sculptures of the Discobolus (left foreground), the drunken faun (behind and to the right of the Discobolus) and the larger-than-life Venus (to the left of the door) were copied from their premier positions in Townley's dining room and painted into Zoffany's library.' You can also see a sculpture of the *Venus Pudica* on a wooden pedestal to the left-hand side of the fireplace, a version of which was referenced by John Webber for his portrait of Poedua.

Townley and Banks attended many of the grand annual openings of the Royal Academy of Arts exhibition prior to its public opening. On several notable occasions Joseph Farington played a leading role in arranging the seating plan. An insight into the eminent attendees who formed part of Banks' influential network can be found in Farington's diary entry of Saturday 29 April 1797 when he noted: 'West [Benjamin West, President of the Royal Academy] came at one – & desired me to assist in placing names of company. [RA dinner]'. On this occasion it was recorded that Sir Joseph Banks was seated with Richard Payne Knight and Charles Townley opposite, and near to Samuel Lysons, Sir George Beaumont, and John Julius Angerstein (the London businessman, merchant, philanthropist and art collector, whose collection went on to form the cornerstone of the National Gallery, London).

Although Johan Zoffany never went to the Pacific, he succeeded in producing arguably the most memorable depiction of the death of Cook at Kealakekua Bay, Hawaii on 14 February 1779. The Hawaiian chieftain with distinctive red-feathered helmet derives from the discobolus, while the posture of Cook lying in the prominent foreground position – highlighting his status – is loosely modelled on the *Dying Gaul* (previously and erroneously known as *The Dying Gladiator*). It is known through Roman copies of what was originally a Hellenistic sculpture by an unknown sculptor dating to around 230–220 BC and probably originally made of bronze.

LEFT

The Death of Captain James Cook, 14 February 1779, painted c.1798 by Johan Zoffany (1733–1810), oil on canvas. National Maritime Museum, Greenwich. BHC0424. The artist drew upon diverse classical antiquities to represent the death of Cook and his murderer on the seashore of Kealakekua Bay.

Precisely what prompted Zoffany to paint this picture is not known for certain. It has been suggested it was inspired by the theatrical performance of *The Death of Cook* at Covent Garden, which he is known to have seen. It might have been a speculative painting intended for Charles Townley or another client. For whatever reason, the picture remains unfinished.

The provenance of the picture is patchy, although it was sold at Christie's in September 1827 and purchased by a dealer who sold it to Cook's widow. On Elizabeth's death in 1835 it was presented to Greenwich Hospital for display in the Painted Hall. The Greenwich Hospital collection, which included many oil paintings, was later transferred on 'permanent loan' for display to the National Maritime Museum in Greenwich that was formally opened to the public in 1937.

Banks was part of an extensive network of like-minded supporters encouraging the transformation of a selection of imagery from the Pacific into a neoclassical style. Followers of neoclassicism advocated the appreciation, study and collection of the classical antiquities of Greece and Rome. To them, and many others in Europe and further afield during the 18th century and early decades of the 19th century, the classical world represented the pinnacle in the cultural achievement of mankind.

This extended to the widespread adoption of Latin – 'the language of ancient Rome and its empire' of which Britain had been a part – among the professional classes and scholars in the 18th century. The clarity of the language gave rise to its use for the formal naming of flora and fauna in the Latin language. Arguably this in part extended to an explanation as to why Banks, with the support of Robert Brown, insisted that Flinders would not initially get his way in naming the largest island continent in the Pacific 'Australia', but rather he was forced to compromise by describing it as '*Terra Australis*, or Australia'.

Banks in his *Endeavour* journal transcribes ancient mythological and real Greek and Roman names onto Pacific people. For example, in Tahiti he calls a fair and just man Lycurgus after the lawgiver of Sparta, while his overeating friend was christened Epicurus; a man was named Hercules on account of his large physical size; and another called Ajax on account of his 'grim countenance one time thought to be a great king'.

LEFT

A Nobleman's collection by Johan Zoffany (1733–1810), painted in 1790 and reworked in 1798, oil on canvas. Towneley Hall Art Gallery and Museum, Burnley, Lancashire / Bridgeman Images. THA2288. The fascination and passion for classical antiquities is brilliantly conveyed in this composition.

What was encountered by Banks, Cook and Flinders in the Pacific was fascinating, exotic and eye-catching but it was not recognised as being on the same level as the achievements of the classical world. However, the assumed European superiority does not imply that the synthesis of some Pacific subjects with the enduring fashionable aesthetic of neoclassicism (which also included Arcadian landscapes of Australia with indigenous people executed in a neoclassical style) was in any way mocking. Yet certainly they attracted some criticism, in particular highlighting the inaccuracies conveyed.

There was a novelty value to the fusion of style and subject which chimed with the interests and passions of members of the Society of Dilettanti and their sympathisers. Banks was concerned about accuracy in terms of the flora and fauna, but he was considerably more liberal in terms of the landscapes and the portrayal of some indigenous people.

In turn, Britain's most prestigious art institution – the Royal Academy of Arts and its training organisation the Royal Academy Schools – also supported the aims of the Society of Dilettanti by sending some students to Italy and Greece, and more importantly by promoting the well-established method of teaching probationers and students to draw and learn about art by studying and copying antique casts and sculpture.

Banks was intimately involved with neoclassical artworks. In the spring of 1789 he engaged the Royal Academician William Hamilton, who had studied under the neoclassical painter Antonio Zucchi, to

ABOVE

An allegorical scene marking the recovery of King George III, engraved by Francesco Bartolozzi (1727–1815) after William Hamilton (1751–1801) and published by Charles Ansell on 4 June 1790. Private Collection. Executed in a neoclassical style, this artwork in the form of a window transparency was displayed in Sir Joseph Banks' home at 32 Soho Square, London on 10 March 1789.

create a rather unusual private/public commission. Zucchi had earlier produced a series of paintings, *The Four Continents*, in around 1768 for the Eating Room of Osterley Park. His artwork for Banks was allegorical and designed to mark King George III's recovery, albeit temporary, from illness. This artwork was later engraved by Francesco Bartolozzi and published in 1790. It was dedicated to Sir Joseph Banks, President of the Royal Society.

Hamilton's original artwork depicts three neoclassical female figures in corresponding classical niches. The central section depicts the King holding the Sovereign's Orb, being crowned by one of the female figures, while Britannia is seated below beside two wingless cherubs, or putti. Joppien reveals that the artwork was intended for public display in Banks' London residence: 'it was executed as a transparency and placed in front of the windows of the façade of 32 Soho Square'.

Joppien and his frequent collaborator Smith, the pioneering authors of voyager art, have produced a remarkable body of work. However, both rather surprisingly overlook Banks' enduring interest, one that arguably could be described as a passion, for neoclassicism. Smith states in *European Vision and the South Pacific* (1988) that: 'Banks himself had little sympathy with classical idealism in the visual arts.' And although the author devotes a chapter in *Imagining the Pacific: In the Wake of the Cook Voyages* (1992) titled 'Greece and the Colonisation of the Pacific', the association with Banks and neoclassicism is not addressed. Meanwhile, Joppien in *Sir Joseph Banks and the world of Art in Great Britain,* published in *Sir Joseph Banks: A Global Perspective* (1994) concluded that 'Banks' approach to art was sober and practical, and essentially a utilitarian one'. This statement is valid in relation to Banks' core private art collection of botanical and natural history, and also a notable number of topographical watercolours by Paul Sandby (a foundation member of the Royal Academy of Arts), in particular those relating to Windsor.

The evidence, however, points overwhelmingly to the conclusion that Banks was in fact fascinated by neoclassicism and that he, and his influential circle, consciously featured this popular style in a selection of Pacific and Australian artworks for widespread public consumption.

As prominent government ministers and Admirals were also members of the Society of Dilettanti, the neoclassical style was in effect officially endorsed at the highest level. For Flinders' *Investigator* voyage Banks approved on behalf of the government artworks by William Westall that featured in the official voyage publication as engraved illustrations. Many of them exhibit classical and neoclassical characteristics, ensuring that the indigenous people – when they do appear – are represented in a harmonious and non-threatening manner. However, in most instances (perhaps with the exception of the death of Cook) there was no attempt to conceal within the commentary and text of the voyage accounts the fact that violent incidents occurred and were on occasions perpetrated by the explorers.

Some of the imagery was specially created with promotional and propaganda purposes in mind. Westall's work was also approved by Banks on behalf of the British government. It was created to make the Pacific and parts of Australia appealing to European sensibilities, to engage readers with voyages of exploration, to encourage follow voyages, and to further investigate where and how parts of the Pacific could benefit Britain. After Banks' death, the words of Captain Matthew Flinders and the images of William Westall were used to promote free British settlement in South Australia.

FIRST AUSTRALIAN ARTWORK

Joseph Banks' role in Matthew Flinders' *Investigator* voyage and the creation and exhibition of the earliest landscape in Europe

Towards the end of the 18th century Sir Joseph Banks, veteran voyager scientist and long-standing President of the Royal Society, communicated to senior members of the Admiralty and government (in particular his friend George John, 2nd Earl Spencer, the First Lord of the Admiralty, who shared Banks' artistic interests as well as fellowship of the Royal Society and the Society of Antiquaries of London) the necessity for Britain to exploit the economic relationship with her colony in New South Wales through detailed surveying of the Australian coast.

On 15 May 1798 Banks wrote to John King, Under-Secretary of State at the Home Office, stating that: 'We have now possessed the Country of New South Wales more than ten Years, & so much has the discovery of the interior been neglected, that no one Article has hitherto been discovered, by the importation of which the Mother Country can receive any degree for the Cost of founding and hitherto maintaining the Colony.'

He continued: 'It is impossible to conceive that such a Body of Land, as large as all Europe, does not produce vast Rivers, capable of being Navigated into the heart of the interior; or … if properly investigated, that such a Country, situate in a most fruitful Climate, should not produce some Native raw material of importance to a Manufacturing Country as England is.'

Banks also recommended that such an expedition should be commanded by Matthew Flinders, a fellow 'son of Lincolnshire', who was encouraged to join the Royal Navy by his youthful reading of Daniel Defoe's *Robinson Crusoe* (first published in 1719). Ironically, he would experience his own personal shipwreck off the north-east coast of Australia.

What finally spurred the British government into action was the sailing of two French ships, *Le Géographe* and *Le Naturaliste*, under the command of Nicolas Baudin from Le Havre in October 1800 to explore the South Pacific. Banks had arranged the passports for these French vessels to ensure safe passage from Britain and her allies during periods of war, as scientific seafaring endeavour at that time was deemed to be a neutral activity.

The motivations for the *Investigator* voyage were many and varied. The potential threat from the French in terms of future claims to settlement in Australia precipitated the government's decision to send a British expedition to explore the coastlines of Australia. Such an expedition was to see if it really was an island continent, or a series of islands, and to identify anything that might be of commercial benefit to Britain and her first Pacific colony.

Flinders was expected to record details of areas that would be suitable for future sailors to visit for the refreshment of their crews and repair of their ships. He recorded the suitability of the natural harbours for visiting vessels; the accessibility of wood to repair ships; the presence of indigenous people for beneficial trade; notable flora and fauna and the

availability of water; and the nature of the soil and favourability of the climate in terms of what, if anything, might be cultivated. In other words, the prospect of places for potential British settlement – or those which offered a strategic military advantage – were never far from his mind on behalf of the British government guided by the Admiralty and Banks.

With the interests of his proposed expedition party in mind, Banks contributed a specific section to the Admiralty Instructions (which were in part drawn up by him) for the *Investigator* voyage. Writing to Lord Spencer in late December 1800, he outlined his 'Hints, respecting the Rout[e] that may be pursued with advantages by the *Investigator* discovery Ship' that were incorporated into the official Admiralty Orders.

Banks stressed that, 'in the whole of this business much discretion must be left to the Commander, & I trust that Lieut Flinders will be Found worthy of That Indulgence, & he may be Allowd, in order to Refresh his People, & give the advantage of Some society to the Painters, to touch at the Fegees [Fiji Islands] or some other of the South Sea Islands in order to Favor science as much as may be in this undertaking, & at the Same time to Render the Survey more than usually accurate.'

ABOVE

Blue swimmer crab, *Portunus pelagicus*, watercolour on paper by Ferdinand Bauer (1760–1826). Based on a drawing circa 1802 finished in London around 1811. Natural History Museum, London. 10593. This large crab is native to Indo-Pacific waters, so there are various places the artist could have seen it. The last pair of legs are paddle-shaped and rotate like propellers.

He continued: 'it may be advisable to instruct the Commander, to use the Tender [a survey brig named *Lady Nelson* with a crew of 17 attached to the colony of Port Jackson, that accompanied the *Investigator* for part of the voyage up the eastern coast of Australia, however after she lost her sliding keels she returned to her home port] as much as possible in the survey, Leaving the greater vessel in Harbor & moving her onwards when another Harbor is discovered; this will give the naturalists time to Range about & Collect the Produce of the Earth, and also allow the Painters Quiet & Repose, Even for finishing a Certain Quantity of their works, on the Spot where they [the sketches] began [*sic*].'

Prior to the publication of Cook's second Pacific voyage, Banks' failed quest to sail again to the South Seas was largely forgotten and he enjoyed respect from the Admiralty and at the highest levels of government. He was given authority (close to total control) to arrange on their behalf key aspects of the *Investigator* voyage prior to departure and after the ship's return. Letters from Flinders and other crew members were sent back to Banks in London via ships heading into British waters, updating him of their progress. From time to time Banks checked matters with the Admiralty officials, although there is no evidence to date of any major decision he made in relation to the voyage

BELOW

Unadorned rock wallaby, *Petrogale inornata*, watercolour on paper by Ferdinand Bauer (1760–1826). Based on a drawing circa 1802 and finished in London around 1811. Natural History Museum, London. 10586. The pale appearance explains the name of this species that is found in north-eastern Queensland, Australia.

– before, during or afterwards – being challenged or overturned.

The ultimate expression of power Banks enjoyed from the Admiralty in relation to the *Investigator* voyage was conveyed to him in a letter dated 28 April 1801 from Sir Evan Nepean, 1st Bart and Secretary to the Admiralty: 'Any proposal you may make will be approved. The whole is left entirely to your decision.' Prior to the *Investigator* voyage Banks and Nepean had had a successful working relationship in relation to the development of the colony of New South Wales.

What Banks wanted altered related to the demands of the shipboard artists. He explained to Nepean in a letter also sent on 28 April 1801: 'The alteration I propose to make in the undertaking of the Scientific men … is Relative to the Scetches the draughtsmen may make during the voyage. In my original draught I Proposed: that all schetches made during the Voyage should without Exception be the property of the Public.'

He continued: 'This was Objected to, I think with Reason, & it suggested, that many Sche[c]hes, Especially Slight ones, would be made in the progress of the business, of no importance to the Public, tho of great value to the Draughtsmen for the Cultivation of their own Talents.'

He then concluded: 'I propose therefore to substitute, that all such drawings as shall be finished during the voyage, & all such scetches as their Lordships shall think not valuable enough to deserve finishing on the Public account, to the disposal of the Artists, but secures all things their Lordships shall ultimately approve to the disposal of the Board'.

Banks demonstrates – by amending this part of his *Memorandum of Agreement for Scientific Party of* Investigator – that he was sympathetic to the interests of the artists in relation to their expedition work and how it might personally benefit them post-voyage.

By the end of April 1801 Banks had assembled the scientific team comprising of Robert Brown and two artists, Ferdinand Bauer and William Westall. Brown supervised Bauer the 'Botanic Draughtsman' and Peter Good, the gardener; Flinders managed

ABOVE

Self-portrait of William Westall (1781–1850), oil on canvas. National Library of Australia. nla.obj-135716302. The artist is likely to have created this portrait to mark his election as an Associate of the Royal Academy of Arts in 1812.

Westall the 'Landscape and Figure Draughtsman'. Banks also selected John Allen for the position of miner. In addition, Brown and the artists were allowed to take a servant to support their work.

Mungo Park had initially been selected for the position of naturalist by Banks, but his preoccupations with African exploration supported through the African Association (an organisation founded in London in 1788 that Banks helped to establish) ruled him out. However, fellow Scot Robert Brown – eager to leave behind his work as an army surgeon to pursue a botanical career – put himself forward for the position through an intermediary. He would later replace Dr Solander as his trusted and long-standing curator-librarian, although their relationship was of a more formal nature.

The appointment of William Westall

The team selection was far from straightforward, especially with regard to Westall's appointment. Several other candidates at different times had been considered for the shipboard position, but for various reasons they declined. One of the main candidates was William Daniell, who had married into the Westall family.

Daniell was an accomplished landscape and marine artist, who excelled as an aquatint engraver and was renowned for his views in India both individually and collaboratively with his uncle Thomas Daniell. William also produced some Chinese subjects as the trading route of the East India ships they sailed on took them first to China before backtracking to India. His engagement to Mary Westall – half-sister to William Westall and sister to Richard Westall (William's influential older half-brother) – was given as one of the reasons for not participating, and they married on 11 July 1801, prior to the departure of the expedition that set sail on 18 July. In addition he explained to Banks that he had commissions to complete for clients.

William Alexander had been an earlier candidate. He trained under Julius Caesar Ibbetson and also probably under Henry Pars (brother of William Pars) who managed William Shipley's drawing school. Alexander had turned down Banks' offer to sail on the *Investigator* because of his wife's ill health, although Banks hoped that he would change his mind. Banks admired Alexander's Chinese subjects derived from his participation on Lord Macartney's diplomatic embassy to China (1792–1794). In fact Banks advised on the selection of Alexander's artworks for the official publication compiled and written by Sir George Leonard Staunton, 1st Baronet. The account was published in 1797 under the title *An Authentic Account of an Embassy from the King of Great Britain to the Emperor of China*. Later in 1808, probably with Banks' influence, Alexander took up the post of assistant keeper of antiquities at the British Museum.

Alexander had been recommended to Banks by Julius Caesar Ibbetson who had also been asked to enlist for the expedition. He had served as a draughtsman on an earlier embassy to Peking (1787–1788) led by Colonel Charles Cathcart, who died before reaching China and had made no provision to pay Ibbetson. A fifth artist, Thomas Hofland, claimed he had been invited to participate on Flinders' voyage.

It is likely that Hertford-born William Westall was recommended for the voyage by William Daniell. However, from the outset there were concerns about his suitability for the position – in particular with regard to his immaturity identified by Banks and Flinders. Westall was only 19 when he was selected for the voyage. Robert Westall, one of William Westall's sons who also became an artist, wrote a biographical sketch of his father that was published after his death in 1850 by the *Art Journal*. In it he recounted that his father 'had entered as a probationer in the schools of the Royal Academy, but had not become a qualified student, when he was recommended to the Government by Mr President West' (the 'Government' having devolved responsibility for the voyage to Banks).

Benjamin West, who succeeded Sir Joshua Reynolds as President of the Royal Academy of Arts, was well known to Joseph Banks, having earlier painted a portrait of the voyager naturalist. He had no reservations that William Westall, artistically at least, was up to the task.

NEXT PAGE

A View of the European Factories at Canton, in China, painted in 1806 by William Daniell (1769–1837), oil on canvas. Yale Center for British Art, Paul Mellon Collection. 720-B.1981.25.210. Daniell turned down Sir Joseph Banks' offer to sail as one of the expedition artists on the *Investigator* voyage, to undertake lucrative commissions relating to his earlier travels to China and India.

On Westall's return to England under the supervision of Banks, he created the first landscape view of Australia by a professional artist with first-hand experience of that island continent that was displayed at the Royal Academy of Arts in 1805.

Robert Westall offers insights into his father's early influences and training. He recalled that William, 'displayed a great passion for drawing when very young, having frequently related that he used to run away from school for the purpose of making sketches from nature. His (youthful) early studies were pursued under the care of his elder brother, the late Richard Westall (Esq) R.A., then at the height of his fame.'

From the outset Richard Westall, the well-connected Royal Academician, was instrumental in the encouragement and development of his half-brother on both a personal and professional level. He was his 'guardian' (for their father died when William was a child) and an artistic mentor, sharing a passion for Claude, a fascination for Richard Wilson and a particular interest in neoclassicism. He helped him with his submissions for the competitions organised by the Society of Arts and facilitated his admission as a probationer to the Royal Academy Schools.

By means of Richard's social and professional network he assisted his brother not only in the period leading up to his appointment and participation in the voyage, but afterwards through helping him to obtain approval from the Admiralty to complete his series of oil paintings of Australia. Richard moved in regal circles, and from 1826 until his death in 1836 he gave weekly drawings lessons to Princess Victoria, who became Queen in 1837.

Richard encouraged William to enter art competitions organised by the Society of Arts and on two occasions he was successful, being awarded the Lesser Silver Palette for his respective submissions, both painted in watercolour. They were entitled *View of the Cottage in Hyde Park* (1797) and *A View up the Thames from the Terrace at Richmond* (1800).

William Westall's period as a probationer at the Royal Academy Schools started in September 1800 and therefore he only experienced a few months of formal training, mostly consisting of drawing from the antique casts and classical sculpture prior to formally joining the *Investigator* expedition. As confirmed by Richard J. Westall, the great-great-grandson of William Westall, the artist left behind a meagre collection of personal and business-related documents and letters. There is no evidence of him keeping a diary, record book or even sketchbooks that might have revealed details of his routine and time spent as a probationer in the Royal Academy Schools – or more importantly his activities aboard the *Investigator*.

Fortunately a sense of what William would have experienced can be gleaned from one of his contemporaries: the landscape painter John Constable, who was a probationer at the Royal Academy of Arts in 1799. Constable recorded some of his art-school experiences, offering valuable insights into day-to-day life, in particular copying pictures by established painters and his artistic interests in Richard Wilson and Claude Lorrain – interests that were shared by the Westall brothers.

Claude was originally named Claude Gellée, and became known as Claude Lorrain, having been born in the Duchy of Lorrain. His reputation as one of the most acclaimed landscape painters endures to the present day. Initially he was taught drawing by his brother Jean. He later studied under Goffredo Wals and subsequently at the Rome workshop of Agostino Tassi (initially working as a servant and cook). High-profile commissions for ambassadors, cardinals and Pope Urban VIII secured his reputation.

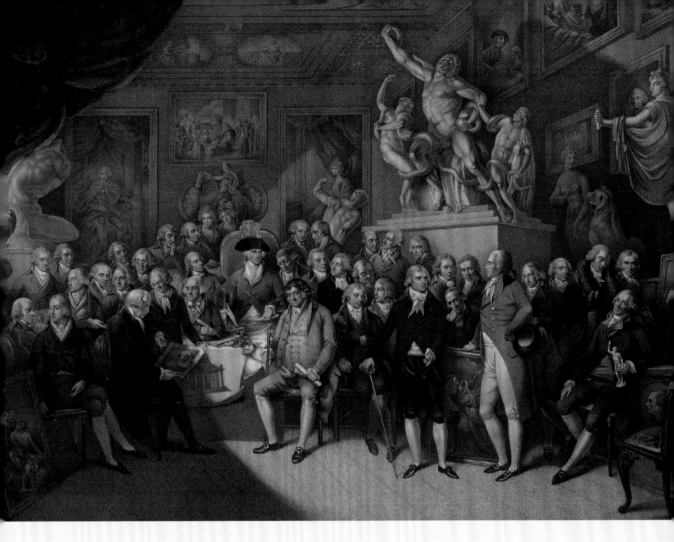

ABOVE

The Royal Academicians Assembled in their Council Chamber, to Adjudge the Medals to the Successful Students in Painting, Sculpture, Architecture and Drawing, engraved and published by Cantelowe W. Bestland in 1802 after Henry Singleton's (1766–1839) painting of 1795. British Museum. 1856.0614.27. The Royal Academicians are surrounded by paintings and classical sculptures including the *Apollo Belvedere*, *Belvedere Torso*, *Laocoön and His sons* and the *Borghese Gladiator*. Benjamin West is in the Presidential Chair; Sir Thomas Lawrence is seated beside a painting in the left foreground; behind him and to his immediate left are Francesco Bartolozzi and William Hodges respectively; Richard Westall looks out from the plinth of the *Laocoön* (part of his left shoulder is square on); Joseph Farington stands to the right, holding his hat under his left arm whilst his right arm rests on a painting; to the right of West the two men standing with their heads close together are Paul Sandby, an artist much admired by Joseph Banks, and Johan Zoffany, who was lined up to travel with him to the Pacific.

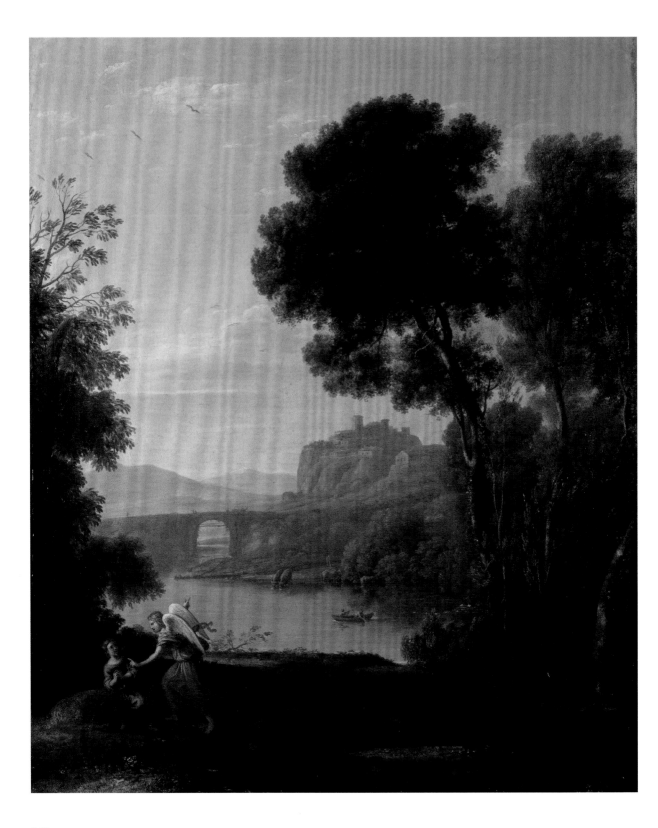

Constable wrote in an undated letter of 1799 to his friend John Dunthorne: 'I have copied a small landscape of A Caracci, [Annibale Carracci] and two Wilsons [Richard Wilson] and have done some little things of my own.' In the same letter Constable also revealed: 'Tomorrow I hope to go on with my copy from Sir George Beaumont's little Claude [Claude Lorrain].'

Sir George Beaumont, 7th Baronet, was a member of the Society of Dilettanti best known today as an art collector, although he was also an artist who regularly exhibited at the Royal Academy of Arts from 1794 to 1825. He owned two small oil paintings by Claude, but the one he is likely to be referring to above is *Landscape with Hagar and the Angel*, painted in 1646 and well known to have been Beaumont's favourite artwork. The other Claude was *Landscape with Goatherd and Goats*, painted in around 1637. Both paintings were bequeathed by Beaumont to the National Gallery, London.

Claude's *Landscape with Hagar and the Angel* was an influential painting in terms of the artistic development of William Westall. He was certainly intimately acquainted with it, and after Beaumont's death he made a lithographic copy published by John Dickinson in 1831 under a different title, *The Annunciation*.

Westall incorporates key elements of Claude's classical landscapes into many of his Australian artworks. These features include arching trees sometimes resembling the Italian stone pines of the Mediterranean, rocks and vegetation that frame his compositions, dark foregrounds, brighter middle distances, the rendering of distant views, and the prominent placement of Claudean classical figures that Westall executed in a neoclassical style.

The stone pine – *Pinus pinea*, also known as the parasol and umbrella pine that are native to the Mediterranean – often feature in Claude's compositions and those of his followers, notably Richard Wilson's. This pine, or something remarkably similar, appears in two of Westall's Admiralty Australian oil painting series, *Entrance of Port Lincoln from behind Memory Cove* and *View of*

the *North Side of Kangaroo Island…*, although James E Eckenwalder confirms in *Conifers of the World: The Complete Reference* (2009) that they were not naturalised in Australia at the time of the *Investigator* voyage.

Earlier Joshua Reynolds, President of the Royal Academy, had recommended to his students in his *Discourse IV* delivered on 10 December 1771 that they should follow Claude's example. He stated: 'Claude Lorrain, on the contrary [to the "locality" of the Dutch school], was convinced, that taking nature as he found it seldom produced beauty. His pictures are a composition of the various draughts which he had previously made from various beautiful scenes and prospects.'

He also stated: 'That the practice of Claude Lorrain, in respect to his choice, is to be adopted by Landschape [*sic*] Painters, in opposition to that of the Flemish and Dutch schools, there can be no doubt, as its truth is founded upon the same principle as that by which the Historical Painter acquires perfect form.'

William Westall may well have been familiar with another celebrated Claude painting in Sir George Beaumont's collection that is titled *Landscape with Narcissus and Echo* and was painted in 1644. Beaumont presented the picture to the National Gallery, London in 1826.

LEFT

Port Jackson, an old blind man, 1802 by William Westall (1781–1850), graphite on paper. National Library of Australia. nla.obj-138878972. A fusion of the artist's experience drawing classical antiquities in London with on the spot portrait drawing to create this intriguing hybrid image of an indigenous Australian.

He would certainly have been familiar with the composition in printed form as it was widely available as an engraving forming part of the *Liber Veritatis* (no. 77). This was a visual checklist of Claude's work engraved by Richard Earlom and published by John Boydell in 1777 that was created 'for the purpose of identifying the real works of Claude [such was his enduring popularity] from others said to be from his hand'.

William Westall was actively encouraged by prominent artists, collectors and patrons to follow Claude's example. The fusion of a classical style with his Australian and Pacific subjects was undertaken, as advised by Reynolds, with the aim to elevate them to grand historical paintings that at that time were considered to be the most worthy an artist could pursue. For some of his landscape views Westall was therefore given widespread encouragement to sacrifice documentary realism and topographical accuracy for a higher artistic purpose.

With the support of his half-brother, William hoped that his voyager art would raise his reputation and accelerate his election to Associate of the Royal Academy, where he would rise fairly swiftly to the highest rank of Royal Academician, thereby enjoying lucrative commissions from collectors and patrons. Wealth for him and his family would follow. At least, that was the ambition and plan.

William Westall's practical art training and the taste and influence of his brother led to neoclassical characteristics in some of his expedition portraits on paper and some of the smaller-scale figures that featured in his Admiralty oils painted on canvas. These were approved of by Banks, and a selection of them featured as engraved illustrations in the official voyage account.

Westall's drawing style developed during the expedition. It ranged from the highly detailed descriptive drawings of the South African landscape – the last stopover before just over a month of sailing brought the *Investigator* into sight of the western coast of Australia – to the fluid and loose lines of the portraits of indigenous Australians of Port Jackson. On occasions he returned to a more detailed style working along the eastern coast of Australia. One of his sensitive portraits includes *Port Jackson, an old blind man* whose face and facial hair appear to be both a faithful appearance of a specific man and an evocation of Greek and Roman sculpture. However, other portrait drawings by him are realistic in nature.

Flinders never refers to Westall as a portraitist, only as a landscape artist, although this reflects his main preoccupation with the surveying of land at sea that was assisted by the artist's coastal profiles. None of Westall's portraits featured in *A Voyage to Terra Australis* published in 1814, and that ultimately was the responsibility of Banks.

As with Ferdinand Bauer, what Banks and Flinders do not feature in the expedition account is intriguing and frustrating. For example, William produced the earliest European images of Australian indigenous art in the Northern Territory, including his 1803 watercolour entitled *Chasm Island, native cave painting*.

There are many examples of Richard Westall's skill as a portraitist that would have inspired William. An unusual example in graphite in a private collection depicts Richard Westall of around 1792. This is believed to be a collaborative portrait with his close friend Thomas Lawrence, later to be President of the Royal Academy of Arts. The joint attribution to both artists has been suggested by Richard J. Westall and is based on the inscription 'T Lawrence & R Westall del.' (in Lawrence's hand), where the two names seem clearly to be joined by an ampersand.

ABOVE

Chasm Island, native cave painting, 1803, by William Westall (1781–1850), watercolour on paper. National Library of Australia. nla.obj-138890799. During Flinders' surveying of the Gulf of Carpentaria he first encountered Australian rock paintings. On 14 January 1803 he wrote in his journal, 'These drawings represented porpoises, turtle, kanguroos, and a human hand; and Mr. Westall, who went afterwards to see them, found the representation of a kanguroo, with a file of thirty-two persons following after it. The third person of the band was twice the height of the others, and held in his hand something resembling the whaddie, or wooden sword of the natives of Port Jackson; and was probably intended to represent a chief'.

Influence of Richard Westall on William Westall's life and voyager art

Norfolk-born Richard Westall and his half-brother William, shared the same father Benjamin Westall, a Norwich brewer. Richard was an established and well connected Royal Academician whose work included biblical, classical, historical, poetical and literary subjects. Richard had been encouraged by the painter and miniaturist John Alefounder to become an artist, and he also studied at the Royal Academy Schools.

An early influence on Richard's work was Thomas Gainsborough, whose rural sentimental scenes with rustic peasants he adapted for his compositions, some of which won him acclaim. A striking example is *A Peasant Boy*, painted around 1794, that is part of the Diploma Collection of the Royal Academy of Arts. Richard became an Associate of the Royal Academy of Arts in 1792 and Royal Academician in 1794. He enjoyed considerable artistic success until the end of the Napoleonic Wars, and William benefited from his brother's affluence and influence.

On 14 May 1804 Joseph Farington recorded in his diary that, 'Westall [Richard] told me He c[oul]d Get by His profession near £2000 a year.' However, Richard's indulgent lifestyle meant that his outgoings often exceeded his income, and later in life he would get into serious financial difficulties. He cleverly arranged for their future brother-in-law William Daniell to lend the money to kit out William Westall for the *Investigator* voyage. Whether or not he was ever repaid is not known. Westall was paid £315 a year – the same as Ferdinand Bauer – whilst Robert Brown was paid £420. Half a year of William's salary was actually advanced for his 'Out-Fit' so clearly this was not sufficient to cover all of his costs.

Remarkably little is known about what Westall or any of the earlier voyager artists took with them on the voyage. He would have used a portable box of paints, but his preferred manufacturer of paint or paper is not known for certain. In a letter dated 8 February 1801 Flinders noted what 'Stationary'

[*sic*] items were on board the *Investigator*, and among them was: 'Reeve's drawing box complete – 1'. This would have been used by Flinders and his officers, and – while it is possible Westall also made use of it to create some of the coastal profiles – he also had his own paints.

Richard Westall produced a large body of classical subjects in a neoclassical style in both watercolours and oils that would have been familiar to William. They included: *The Bower of Pan*, exhibited at the Royal Academy of Arts in 1800, now in Manchester City Art Gallery; *Telemachus in the Bower of Calypso (from Homer's 'Odyssey')*, painted around 1803, engraved in 1810, and now in the Glasgow Museums; and *The Reconciliation of Helen and Paris after his Defeat by Menelaus*, exhibited at the Royal Academy of Arts in 1805 and now in Tate Britain. Some of them were engraved and published as individual prints.

Richard Westall's depiction of the Greek god Pan for *The Bower of Pan* was inspired by the poetry of John Milton. The lithe figures in close proximity, the contrived postures and the focus on musculature relate to characteristics of neoclassical art. This painting was one of four artworks – including *Queen Judith reciting to Alfred the Great, when a child the songs of the bards, describing the heroic deeds of his ancestors*, executed in a neoclassical style – that Westall exhibited at the Royal Academy of Arts in 1800 and that received ecstatic praise from 'Mr Maurice' in *The Gentleman's Magazine* in September 1800. He wrote of the 'beautiful paintings', as he described them, in poetical form:

O thou, from whose energetic pencil flows,
All that in science charms or nature glows!
Westall, from one who burns with kindred fires,
Accept the verse thy matchless art inspires…

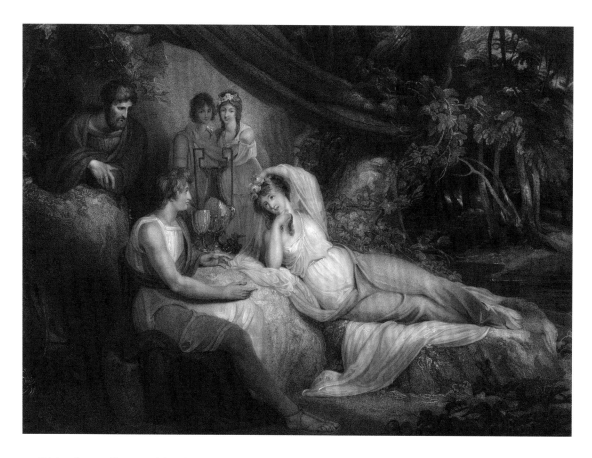

Richard Westall was widely admired in his lifetime and this is further supported in the obituary notice published in *The Annual Register* in September 1837. The reviewer wrote: 'Mr Westall acquired distinction by making finished pictures of historical and poetical subjects in watercolours; a branch of art peculiarly English, and in which he attained to a brilliance and vigour before unknown. His highly finished pictures [that included oil paintings] of "Sappho in the Lesbian Shades, chanting the Hymn of Love", "Jubal, the First Voice of the Lyre", "The Boar that killed Adonis brought to Venus", "The Storm in Harvest", "The Marriage Procession (from the Shield of Achilles)" and many others, were much admired.'

However, he received a fair degree of criticism too. The journalist, poet and satirist John Williams, who used the pseudonym of Anthony Pasquin, was not alone in expressing very negative opinions of some of his artworks. Richard Westall's most committed champion and liberal patron was Richard Payne Knight, a close friend of Joseph Banks who developed a paternalistic relationship with him, extolling high praise on his painting *A Storm in Harvest* exhibited at the Royal Academy of Arts in 1796.

Knight also commissioned a pair of oil paintings from Richard Westall entitled *Flora unveiled by the Zephyrs* and *Vertumnus and Pomona* and executed in the neoclassical style. Both were exhibited at the Royal Academy of Arts in 1807 and 1809 that coincided with the early developmental phase of Westall's series of Australian views for the Admiralty.

Landscape paintings were not Richard Westall's main focus, but he produced one oil in 1811 entitled *Solitude* (now in the State Art Gallery of New South Wales) at around the same time as his brother was developing his Admiralty Australian artworks. As the title of the picture implies, it shows his primary interest is not the faithful description of a particular place but the evocation of atmosphere, emotion, mood and sentiment expressed within an idealised landscape – in this instance one that is dominated by an arching tree with exposed roots.

Westall's painting, or a version of it, was exhibited at the Royal Academy of Arts in 1813 as *Landscape – solitude*. Later in the same year it is likely the same painting was also displayed at the Liverpool Academy with the following appended lines from the poem 'Summer' by James Thomson:

Along these lonely regions, where retir'd
From little scenes of art, great nature dwells
In awful solitude.

Both the title and the arching downcast branches of the trees of Richard Westall's *Solitude* convey a melancholic mood – one that can be connected to Richard Wilson's earlier landscape also entitled *Solitude* painted in 1762. Wilson's was engraved by William Woollet and William Ellis and published in 1778 with a dedication to Sir George Beaumont. Wilson had also been inspired by Thomson's poetry. His painting depicts monks in contemplation in a soulful landscape. The engraving was popular and influential at the time of publication and remained so for several decades afterwards.

The compositions of both Wilson and Richard Westall were the likely inspiration for William Westall's Admiralty painting entitled *Entrance of Port Lincoln from behind Memory Cove,* albeit it also relates to his expedition drawings. Flinders had named Memory Cove as a memorial to some of his crew who had drowned in the area. The sombre sepia palette and the inclusion of a solitary pine tree with exposed roots heightens the emotional impact of William's painting that he had worked up in 1811.

Richard could easily have arranged for William to see Claude's work in Richard Payne Knight's collection. In Knight's obituary notice in *The Gentleman's Magazine and Historical Chronicle* in 1824 it was described as 'masterly' and 'valuable'. It included some artworks that also featured in the *Liber Veritatis*. Knight bequeathed the collection to the British Museum.

From 1790 until 1794 Richard Westall lived at 57 Greek Street on the corner of Soho Square, a mere stroll to Banks' home. It was the home of Thomas Lawrence who later painted Banks' portrait. Professionally Lawrence surpassed his friend Richard Westall. Beyond his success within the Royal Academy of Arts, he received a knighthood and was elected a fellow of the Royal Society, recommended for his 'eminence in art'.

William Westall would also have been living with Lawrence at this time. When Richard left Lawrence's residence to move into 54 Upper Charlotte Street in 1794, this was also the address used by William when he displayed his watercolour *View of the Eldon Hills, Scotland* at the Royal Academy of Arts in 1801. It was his only exhibit prior to his departure for Australia.

From Joseph Farington's diary entry of 31 August 1807 it is known that Thomas Lawrence had been given the opportunity to see the voyager art of Cook displayed at Admiralty House. He recounted, 'Lawrence saw pictures by Hodges & Webber at the Admiralty & thought them their best works.' Lawrence's visit probably related to a prospective portrait commission, perhaps for an admiral or senior official. Whether Banks arranged for Westall to visit Admiralty House to see the artworks by William Hodges and John Webber either prior to or after the *Investigator* voyage is not known for certain, but it remains a possibility as his artworks were destined to hang there.

BELOW

Solitude, engraved by Christian Friedrich Duttenhoffer, after Richard Wilson (1714–82) published in 1802. Yale Center for British Art, Paul Mellon Collection. 4039-B1977.14.14570. The original engraving of Wilson's painting was created by William Woollett with assistance from William Ellis, and first published in 1763. This later version by Duttenhoffer demonstrates its enduring influence and popularity.

Relationship of the Westall family to William Hodges

Another important family association with the Westall family has been suggested by Richard J. Westall, who believes that William Hodges was related to the Westalls. This association can be traced through Sir John Carr, who was Hodges' uncle and a collector of his work. Carr's third wife, Anne Mary Carr, was a second cousin of William Westall. William's brother Richard was certainly a close friend of Carr and Hodges, whose portraits as well as those of other family members he displayed at the Royal Academy of Arts.

This family association is important in providing a catalyst in William Westall's participation in the *Investigator* expedition, and also points to the likelihood of William having studied Hodges' voyager artworks prior to the voyage perhaps recounted with stories of his Pacific experiences. Hodges died in 1797, destitute after a banking venture in Dartmouth, Devon went bankrupt. Carr and Richard Westall tried their best to settle his debts and look after his surviving family.

Even though it appears from the official documents that William Westall signed the *Investigator* expedition contract agreeing to the terms and conditions in the presence of the other team members on 29 April 1801, doubts persisted about the artist's suitability, and Banks pondered a possible replacement. However, in the end William went on the expedition and their concerns largely proved unfounded.

The body of expedition work that William Westall produced is small in comparison to Ferdinand Bauer: fewer than 200 sketches, drawings and watercolours, and probably closer to 180, of which around 150 survive if the number from public collections is added to those in private hands.

Banks made a record list of 157 artworks but it is likely that the artist held back additional work, some of which was distributed to family and friends. The lion's share of the artworks was sold by William's sons, Robert and William Westall, to the Royal Colonial Institute (later renamed the Royal Commonwealth Society) in 1889, and was later purchased by the National Library of Australia in 1968.

William Westall's artistic licence in his voyager art

Farington noted on 14 April 1809 that, 'William Daniell remarked that William Westall, considering the time He was absent from England, and the Countries He visited, made but few drawings, as he did not think of what would be interesting to the Topographer, but only what would, in his opinion "*Come well*" (picturesque).'

William Westall followed the example of Sir Joshua Reynolds in bringing together flora and landscape aspects from different parts of Australia to create his compositions, although in other works his focus is more documentary and realistic. Reynolds' discourse had been further advanced by leading advocates of the picturesque such as the Rev. William Gilpin, Richard Payne Knight and Sir Uvedale Price. Gilpin noted in his *Three Essays on Picturesque Beauty, Picturesque Travel and on Sketching Landscape* (1794) that, 'We must ever recollect that nature is most defective in composition; and *must* be a little assisted.' He also stated that, 'Picturesque composition consists in uniting in one whole a variety of parts.'

Flinders was well aware that the official voyage publication based on his account would be 'embellished' with Westall's artworks. Therefore it was certainly in his interest to ensure sufficient material was created by the landscape and figure draughtsman, so that back in London it could be developed into artworks for engraved illustrations.

Matthew Flinders

Matthew Flinders was already familiar to Banks through his successful surveying of parts of Australia and Tasmania independently and in collaboration with the naval surgeon and explorer and fellow Lincolnshire man George Bass. Flinders' survey work was entitled *Observations on the Coasts of Van Diemen's Land, on Bass's Strait and its Islands, and on parts of the Coasts of New South Wales...* (1801). He dedicated it to Sir Joseph Banks as he was conscious of his powerful position as President of the Royal Society and his patronage of voyages of exploration.

Flinders recorded in the official voyage publication that his personal ambition for the expedition that left Spithead, near Portsmouth, for Australia on 18 July 1801 was 'to make so accurate an investigation of the shores of Terra Australis [Australia] that no future voyage to this country should be necessary'.

To accomplish this his plan, that differed from the Admiralty Sailing Instructions, was to sail anti-clockwise around Australia, starting near modern-day Albany in Western Australia. This was a starting point approved by the Admiralty. He then proceeded along the south coast – exploring fairly close to Esperance, crossing the Great Australian Bight, and into areas fairly close to the cities of Adelaide, and further east, close to Melbourne – before arriving to refresh and resupply in Sydney, Port Jackson.

From there he followed in Cook's wake, exploring parts of the eastern coast that Cook had either missed or had not had the time to investigate, such as Port Bowen (now Port Clinton) and Mount Westall on the north-eastern coast in modern-day Queensland. Then he sailed onwards through the Torres Strait and into the Gulf of Carpentaria. It was here whilst he was enjoying productive periods of surveying that Flinders realised the *Investigator* was leaking so badly that he would have to head back to Port Jackson as fast as possible by continuing anti-clockwise around Australia with as few stops as possible.

Flinders was not able to complete the mission.

However, as Miriam Estensen states in *The Life of Matthew Flinders* (2003), even with parts of the Australian coastline uncharted after returning to England, 'he accurately speculated that in all probability the island continent was a single landmass, and not separated by any seaway or lesser bodies of land'.

If measured against Flinders' unrealistic personal ambition, the voyage of the *Investigator* was a heroic failure as the ship he was assigned leaked badly from the outset of the expedition and it became evident later in the Gulf of Carpentaria that it was no longer fit for purpose.

Evidence of how the sea water made living and working conditions extremely difficult is indicated in a letter Ferdinand Bauer wrote from the Cape of Good Hope in October 1801 to his brother Franz: 'I am sorry to say that throughout the entire voyage so far we seldom had a dry cabin because water was coming in everywhere through the sides of upper-middle deck despite the fact that during this time we were not exposed to any great storm.'

On 6 March 1803 Flinders decided to terminate the voyage at the Wessel Islands and head back to Port Jackson as fast as possible via the western coast of Australia, finally returning on 9 June 1803. However, what he had been able to achieve with that leaky vessel in terms of exploration and charting was extraordinary and resulted in the publication in 1814 (coincidentally the year of his death) of the official voyage account, *A Voyage to Terra Australis*. The publication comprised two main volumes of text and an atlas. Nine engraved illustrations after William Westall embellished the text volumes. The atlas featured 16 engraved charts, 28 coastal profiles after Westall, and 11 botanical specimens on ten plates after Ferdinand Bauer that were described by Robert Brown.

Flinders created for the publication the first accurate map of that island continent, called *General Chart of Terra Australis, or Australia*. He wrote in the

introduction to the publication, 'Had I permitted myself any innovation upon the original term, it would have been to convert it into Australia; as being more agreeable to the ear, and as an assimilation to the names of the other great portions of the earth.' Banks and Brown objected to the sole use of 'Australia' that Flinders desired, but in the decade after Banks' death the name Australia was widely adopted.

Returning to the *Investigator* voyage, on 10 August 1803 Flinders had been reassured that his ship was unseaworthy (falsely, as it turned out as she later took Bauer and Brown back to England). Therefore he was provided with the *Porpoise* in order to sail to Britain to obtain a new vessel. At that time the skills and resources in the colony were not available to construct large ships, and nor were any large vessels available. Westall was also aboard the *Porpoise*, having decided to quit the expedition, while Ferdinand Bauer and Robert Brown dutifully decided to carry on their work in Australia and wait for Flinders' return.

The *Porpoise* was accompanied by two other vessels, the *Bridgewater* and *Cato*. However, on the 17 August 1803 the *Porpoise* and *Cato* were shipwrecked off the north-east coast of Queensland. Flinders returned to

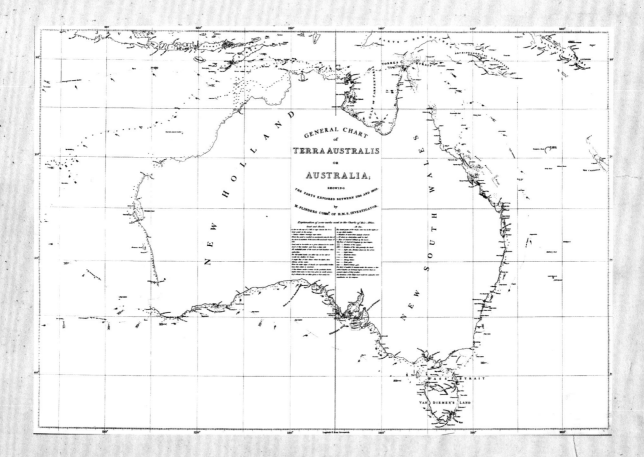

Port Jackson with some of his men in one of the ship's cutters to arrange the rescue of the crew from Wreck Reef. This dramatic and near-fatal incident was represented by Westall in one of his Admiralty oil paintings that featured as an illustration in the voyage publication. It was entitled *Wreck Reef Bank, taken at low water*.

A light-hearted incident occurred on Wreck Reef when William Westall was drying his expedition artworks on the sand: the young midshipman John Franklin (Flinders' cousin, also from Lincolnshire, and later a celebrated although ill-fated polar explorer) cheekily drove a flock of surviving sheep from the ships over his pictures. One example from the collection of Westall's expedition artworks in the National Library of Australia, Canberra displayed evidence of a hoof mark until removed fairly recently by conservation treatment.

On 21 September 1803 Flinders left Port Jackson again, this time aboard the *Cumberland* in company with the *Rolla* and *Francis*. Westall boarded the *Rolla* bound for China. The *Cumberland* was now leaking so badly that Flinders was forced to call into Mauritius – then called Isle de France – to make repairs.

The island's French governor falsely suspected Flinders of being a spy, as Britain was once again at war with France, and the passport that he carried named the *Investigator* and not the *Cumberland*. Consequently Flinders was prevented from returning to England until October 1810.

Banks and many others tried to get him released. Even letters signed by Napoleon Bonaparte were sent to free him from his 'house arrest' on the island. However, it eventually became clear that Governor Charles Mathieu Isidore Decaen was using Flinders as a 'bargaining chip' to ensure his own safe passage back to France prior to the capture of Mauritius by the British on 3 December 1810.

During Matthew Flinders' detainment he was relatively free to pursue his interests within a prescribed area of the island. He lived at Madame d'Arifat's plantation where he conversed in French with her daughters and taught the rudiments of navigation to her younger sons. His flute playing and appreciation of music helped to develop friendships and long-lasting relationships. Flinders socialised with other plantation owners, including Toussaint Antoine de Chazal de Chamerel and his harpsichord-playing wife.

Toussaint's proficiency in art resulted in the only known portrait in oils of Flinders, which was completed in 1807 and is now in the Art Gallery of South Australia. Flinders wrote letters to his family, his friends and his wife (having recently married before departing on the voyage, it would be a long separation), and requests were sent to anyone who he thought could help secure his release.

Gillian Dooley – an Honorary Research Fellow in the Department of English, as well as Special Collections Librarian, at Flinders University in South Australia – in her multifarious writing and lecturing on Flinders reveals the creative and romantic side of this underappreciated British explorer, especially in Britain. Flinders was relatively short in stature but was tall in terms of deeds. He wrote one poem, or song lyric, titled 'My Evening Song' to his wife, and a biographical tribute to the memory of his shipboard cat Trim, who was the first feline to circumnavigate Australia. Sadly, Trim went missing in Mauritius and probably ended up in a cooking pot. The original manuscript of Flinders' epitaph to his four-legged friend is on loan to the National Maritime Museum, Greenwich.

Above all during his detainment, Flinders focused on writing up his journal and developing his cartographical work, as most of his papers and records had been returned to him early on in his detainment. From time to time he succeeded in smuggling out of the island material that was sent back to the Admiralty in London by way of ships that were permitted to call into Mauritius. However, the Admiralty and Banks wanted him back in Britain before a decision could be reached about the viability of producing an official and costly voyage publication. It would be approved.

A significant part of *A Voyage to Terra Australis* would be devoted to a detailed explanation of his unjust detainment in Mauritius by Governor Decaen and the unfounded exploration and discovery claims of the rival French expedition led by Baudin. Flinders would relate in a scholarly and lengthy introduction precisely who had discovered and surveyed what and when in terms of the history of exploration in the Pacific and around Australia, borrowing books from Banks' extensive library at 32 Soho Square to complete this work.

From his captivity in Mauritius on 1 February 1804 Flinders recorded in his journal, 'Even my chart-making &c. into which I have immersed myself as much as possible, cannot prevent me from seriously reflecting upon the injustice, the haughtiness, and Bastille-like mystery with which I am treated. I am kept from my voyage of discovery, from my country, from my family, and probably from promotion.' His hopes of release from Mauritius – repeatedly raised and then dashed – lasted around six and a half years.

Westall's return to London

On 20 September 1803 Westall had sailed aboard the *Rolla* to China and then on to India in search of exotic subjects. In a lengthy letter to Banks dated 31 January 1804 and written from the ship *Carron* in Canton River, Westall expressed his disappointment at the Australian landscape scenery and the reason for his decision to abandon the *Investigator* expedition. He recounted, 'I am sorry to say that the voyage to New Holland has not answered my expectations in any one way; for though I should have been fully recompensed for being so long on that barren coast by the richness of the South Sea Islands which, on leaving England, I had reason to suppose we should have wintered at, instead of Port Jackson. I was not aware the voyage was confined to New Holland only.'

In fact, Westall was right about the plans to visit 'South Sea Islands'. On 28 March 1801 Farington recounted the evidence gleaned from William's uncle Thomas Daniell in his diary that had he agreed to participate on the voyage they were expected to visit 'South Sea Islands'. He noted, 'His nephew is going with Captn. Flinders, to explore & make out the boundaries of New Holland, abt. which there are some doubts, that is whether a *Mediterranean* [*sic*] *Sea* does not pass between those parts which have been supposed to form one Island.– They are also to visit some Islands situated farther out than those of Otaheite.' However, a ship's captain had the authority to change them according to his judgement, and Flinders did.

As Westall did not know of his captain's detainment in Mauritius, his decision not to head directly back to Britain was reprehensible, although perhaps in part it can be explained by his youthful naivety and unfulfilled artistic ambition. Westall offers in his own words an explanation that highlights yet again Banks' far-reaching influence. On 14 December 1803 Westall reached Whampoa where he disembarked. He met David Lance in Canton, an official of the East India Company and one of Banks' trusted botanical agents. Lance despatched plant specimens to Banks in Soho Square.

Westall wrote to Banks from Canton on 31 January 1804 to explain, 'Mr Lance said that as I had

so few sketches of New Holland, there could be no necessity for my returning immediately to England.' Westall also remarked that it was due to Lance who, 'I believe has been attentive to me merely because I was by you appointed [that he had] seen the country about Canton'.

Lance had also provided Westall with letters of introduction to enable him to extend his travels: 'Mr Drummond and the Committee [of the East India Company in China] to the Governors of Ceylon, Penang, Madriz [Madras] and Bombay'.

On Westall's return to London in February 1805 it was Banks who straightened things out with the Admiralty as the artist's decision to quit the expedition and head for China to satisfy his personal ambition – rather than return to England with his expedition artworks or wait in Australia for further instructions – was in contravention of the co-operative spirit of the shipboard contract, one that had been drafted by Banks with full Admiralty approval.

Banks ensured that, after their return to Britain, Westall and the other members of the scientific team received outstanding payments for the voyage by confirming to the Admiralty that – as far as he could deduce from the correspondence with Flinders in Mauritius – the men had all behaved properly and according to contract.

Westall's first Australian artwork

After returning to London in 1805 William Westall, no doubt under his brother's influence, had a change of heart about his opinion of Australia. The 'barren coast' of New Holland was forgotten and he pinned his hopes on Banks' assistance in helping him to develop pictures based on the *Investigator* voyage that he could exhibit and profit from.

Banks agreed but his request was limited initially to one artwork. He used his influence with the Admiralty to persuade them to lend to Westall a selection of his expedition artworks that were in the possession of the Admiralty, to enable him to develop an Australian artwork that would be exhibited at the Royal Academy of Arts in 1805.

It would be the first Australian artwork by a professional artist with first-hand experience of the Pacific. In the exhibition catalogue it was given the long title *View of the bay of Pines, New South Wales, long 150°30"lat 22°20", discovered by Captain M. Flinders in His Majesty's ship* Investigator*, Feb., 1802.*

Banks wrote to William Marsden, Secretary to the Admiralty on 21 February 1805: 'I beg to acquaint you for the information of their Lordships that Mr Westall one of the Draughtsmen employed on board the *Investigator* has returned home & requests to be permitted to finish such of his sketches as their Lordships may not have occasion for, in order to exhibit them to his Friends & the Public.'

He continued: 'As their Lordships are no doubt fully occupied with much more important concerns I beg to offer my services on this occasion & will undertake in case it is thought proper to intrust me with the care of Mr Westalls scetches, to give him such indulgences as I think may be done without injury to their Lordships interest & that of the Public, in the event of a Publication of the Papers at any future time resolved upon.'

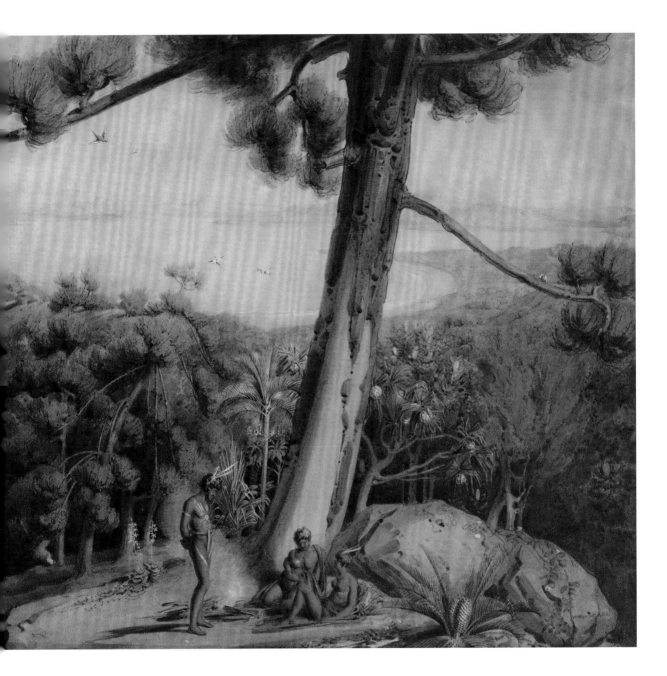

View of the bay of Pines, or Port Bowen, c.1805 by William Westall (1781–1850), watercolour.
National Library of Australia. nla.obj-135185925. If this watercolour is not the example
exhibited at the Royal Academy of Arts in 1805, it is likely to be a similar composition, and
an associated artwork to the artist's Admiralty oil painting of Port Bowen exhibited at the
Royal Academy of Arts in 1812. (Illus pp.148–49.)

Marsden's same-day reply to Banks confirmed his recommendation: 'I am commanded by their Lordships to send you herewith the collection of Sketches, & to request you will be pleased to take the trouble of selecting such as Mr Westall may be desirous of finishing or of making Drawings or Paintings from.'

Prior to his return home Westall entrusted his artworks to be shipped back to London with Robert Fowler, 1st Lieutenant of *Investigator*. Sir John Barrow, 1st Bart, the Second Secretary to the Admiralty, recorded in a note to Banks on 22 August 1804 that, 'Drawings by WW [William Westall] transferred to JB [Joseph Banks] until the artist's return. Preservation post shipwreck.'

Joseph Farington recorded in his diary on 28 August 1804 that, 'Westall also & I went with Him to see His Brother's sketches made in New Holland & sent from China to the Admiralty.' Frustratingly he does not give an opinion of the pictures.

Banks arranged to have Westall's expedition artworks catalogued and conserved as many of them had suffered water damage in Australia. After consultation he wrote, in his typical odd use of grammar and spelling, to William Marsden on 22 August 1804: 'I have been informed by Lieut. Fowler that the Drawings of Mr Westhall [*sic*] the Artist Employd on board the *Investigator* which the Lieut deliverd to you on his Return are by no means in a Secure State they having been damagd by water at the time the *Porpoise* was lost on Wreck Reef & not yet sufficiently freed from The Effects of salt water. His Elder Brother Mr Westhall Royal academician wishes much to be allowed to examine them & put them in a secure state which he thinks he can do.'

The artworks were then deposited with Richard Westall after Banks had supervised the creation of an annotated and numbered list. Each artwork was inscribed with a reference number, usually in the upper left-hand corner of the picture, and given a cursory description. Banks' master list, now in the State Library of New South Wales, is entitled 'A Schedule of such Scetches & Drawings of Mr Westhall Landscape Draughtsman on board His Majesty's Ship *Investigator* as were savd when His Majesty's Ship *Porpoise*, in which he was returning to England was Lost upon Wreck Reef.'

After their sale to the Royal Colonial Institute in 1889 many of Westall's expedition artworks were trimmed so that they could be bound in four large volumes. This process meant that a large number of Banks' reference numbers were lost. The surviving numbers, as revealed below, were vital in the identification of the reference work that Westall consulted to create his first Australian exhibit.

On 5 April 1806 Banks sent a note, also in the State Library of New South Wales, to Richard Westall. It reads: 'I wrote to you some time ago Requesting you to return to me the drawings which your brother lent from the Lords of the Admiralty at my Request to enable him to make the drawing which he exhibited at the last exhibition of the R.A.'

This note was in fact a follow-up as his previous one dated 22 January 1805 had not been answered. Richard Westall wrote back to Banks on 7 April 1806, apologising for the delay and explaining that this was because his brother 'has been abroad several months'. William had travelled to Madeira and Jamaica with letters of introduction from Joseph Farington and others in order to find lucrative commissions.

William Westall returned to Britain later in 1806. His independent attempt at an ambitious print publishing project prior to the development of his Australian artworks was entitled *Foreign Scenery. A Series of Views of Picturesque and Romantic Scenery in Madeira, The Cape of Good Hope, China, Prince of Wales's Island, Bombay, Mahratta Country, St. Helena and Jamaica by William Westall.* It was abandoned after the third part published in June 1813 that in part related to the challenging economic situation in Britain towards the end of the Napoleonic Wars.

Banks recorded a numbered list of the expedition artworks that he had arranged to lend to William Westall on behalf of the Admiralty. By checking the numbers against Banks' 'Schedule', or master list, some of the reference works can now be identified.

Fifteen drawings had been borrowed by William Westall. The numbers relating to Banks 'Schedule' were: 1, 2, 5, 7, 29, 33, 76, 77, 78, 83, 92, 97, 118, 152 and 154. They correspond to Banks' descriptions given below. Numbers 1–118 were included in a section headed 'Scetches on Small Paper', while numbers 152 and 154 were categorised under the heading of 'Finished Drawings'.

Banks' 'Schedule' indicated a total of 157 drawings, a word used then to collectively describe sketches, drawings and watercolours. The 'Schedule' also reveals that: 'The Finished Drawings are very much damaged [and] The Sentences [descriptions] underlined are Copied from some part of the Drawing described.'

They are:

Scetches on Small Paper
1. a tree
2. a Landscape with two Palm trees in [?]
5. a Landscape & seaview with some trees like Pines [–] whole sheet
7. a Landscape with Palm trees & water in the foreground
29. Landscape with Pines & a large trunk in the foreground
33. Scetch of Pines very slight [–] whole sheet
76. Slight scetch of a tree
77. Slight scetch of a Palm
78. Slight scetch of a tree
83. Slight scetch of a Palm <u>Cumberland Isles Oct</u>
92. a figure of a native
97. a native of an old woman
118. Scetch of a Palm of the Cape [–] whole sheet

<u>*Finished Drawings*</u>
152. Rocks with a Pandanus in fruit & Proas at sea <u>Carpentaria</u>
154. woody scenery with 2 natives in the foreground & cranes [?] on the wing
<u>*Distant view of Cape Manifold Port. No. 3*</u>

From this brief correspondence and the additional annotations, it is now possible to establish not only Westall's reference sources for his first Australian artwork exhibited at the Royal Academy of Arts in 1805, but also the likely exhibit itself. Banks referred to it as a 'drawing', which in this instance suggests that it was in fact a watercolour that would have had greater visual impact than a drawing at this prestigious exhibition venue.

One of the expedition drawings Westall borrowed is entitled *Landscape with Pines & a large trunk in the foreground*. Visible on the front of the artwork is Banks' reference number 29. Another drawing is inscribed with the number 33 that was recorded on Banks' master list as 'Scetch of Pines very slight – whole sheet'. Parts of these drawings were adapted and combined with other artworks on the list, which have not been traced, combined with the artist's memory, to develop Westall's 1805 Australian exhibit that was entitled *View of the bay of Pines, New South Wales, long 150°30' lat 22°20', discovered by Captain M. Flinders in His Majesty's ship* Investigator, *Feb., 1802*. It was hung in the Council Room, and was numbered 499 among 813 exhibits.

For some unexplained reason the date in the title of Westall's exhibit, 'Feb., 1802', is given in error. The longitudinal and latitudinal coordinates in the title reveal the mistake. They indicate that the area is Port Bowen, Queensland, which Flinders visited in August 1802. In February 1802 he was still exploring in South Australia.

The vague title of Westall's landscape, *View of the bay of Pines, New South Wales...*, can be explained by the fact that Flinders was detained in Mauritius and was not able to discuss his findings with the Admiralty, the organisation that had the authority to approve his recommendation for a name or confer an alternative. Sometimes temporary names were assigned to expedition artworks and also reference numbers too.

Westall's exhibit caught the attention of the critic of the *St James's Chronicle* of 2 May 1805, who considered it to be 'A remarkable scene, delineated in a bold and masterly style, and well calculated to convey a striking idea of that country and its inhabitants'.

It has long been thought that Westall's 1805 exhibit was destroyed or lost. In fact there is a watercolour in the National Library of Australia that is a likely candidate for this artwork, or a close variant of it. It is catalogued simply as *Port Bowen* and was included in the National Library of Australia's exhibition *Country and Landscape* in 2006 when it was described by Ken Taylor as, 'A romantic landscape setting, reminiscent of a "Golden Age". This picturesque scene with sublime undercurrents of wild nature is adorned by three Aboriginal people alongside a fire at the foot of a gnarled tree'.

This watercolour was also included in an extensive catalogue entitled *Drawings by William Westall, Landscape artist on board H.M.S.* Investigator *during the circumnavigation of Australia by Captain Matthew Flinders R.N. in 1801–1803* that was edited by Thomas Melville Perry and Donald H Simpson and published by the Royal Commonwealth Society in 1962. The large format of the book was adopted so that many of the artworks could be reproduced life-size. Not surprisingly the length of the book title means that it is usually known simply as *Westall's Drawings*.

The catalogue entry for the *Port Bowen* watercolour carried a brief description: 'the hoop pine ... dominates the scene. Two Aboriginal women are sitting at its foot and a male is standing looking at them. This, the largest of Westall's water-colours of Australia, is predominately brown in colour.' The *Port Bowen* watercolour is certainly mainly brownish

LEFT

Landscape with Pines & a large trunk in the foreground, by William Westall (1781–1850), graphite on paper. National Library of Australia (NLA). nla.obj-138883472. Catalogued by the NLA as: *Port Bowen, pines*.

LEFT

Scetch of Pines very slight – whole sheet, by William Westall (1781–1850), graphite on paper. National Library of Australia (NLA). nla.obj-138883326. Catalogued by the NLA as: *Port Bowen, view south across the port*.

in colour, although there is a size discrepancy. The artwork is recorded by the National Library of Australia as measuring 22 x 30½ in, which is larger than that indicated in *Westall's Drawings*. This can be explained by the fact that for that publication catalogue the pictures were measured in their mounted frames and therefore the image size would have been smaller, as opposed to the entire image size recorded by the Library.

The watercolour is often described as featuring 'three Aboriginals', but there are in fact four as the kneeling woman holds and breastfeeds her baby. Her facial features and that of the woman beside her appear more European than indigenous Australian in appearance. Westall has introduced neoclassical characteristics into this picture with the close grouping of the lithe figures, their hairstyles and the depiction of the seated woman with an attenuated neck and overlong limbs.

Port Bowen is signed and inscribed 'W Westall A.R.A'. However, this is almost certainly a later addition either by the artist or possibly by William's son Robert, who is known to have completed some of his father's unfinished pictures after his death. The initials 'A.R.A.' are significant, as they refer to Westall's election to Associate of the Royal Academy of Arts, which occurred in 1812. 'A.R.A' adds status to the work, making it potentially more saleable. Westall exhibited Australian watercolours at later dates in London venues, but there is not a match for the subject of *Port Bowen* in or after 1812.

If *Port Bowen* is the artwork exhibited at the Royal Academy of Arts then perhaps it failed to find a buyer at the time and stayed in the Westall family. The former owner of the picture is listed in *Westall's Drawings* as Dr Mary Gibbons. According to Richard Westall, 'Dr Gibbons, née Westall, was a descendant of the artist.'

In 1807 Westall exhibited a larger variant of *Port Bowen* at the British Institution for Promoting the Fine Arts in the United Kingdom, usually known as the British Institution. Founded in 1805, this London-based organisation exhibited the works of living and dead artists. Membership was restricted, being more conservative in taste than the Royal Academy of Arts. Banks offered advice on the setting-up and running of it.

Westall's artwork was entitled *The Bay of Pines, New South Wales (a drawing)*. Its size was indicated in the catalogue as being 2ft 10 x 3ft 7 in, which is considerably larger than the watercolour of *Port Bowen* now in the National Library of Australia. Its size marks it out as a different picture, although it may well be a larger version of *Port Bowen*. The whereabouts of the picture are not known.

Westall's Australian exhibit of 1805 was almost certainly a forerunner for his large Admiralty oil painting that he displayed at the Royal Academy of Arts in 1812 entitled *View of a port on the east coast of New South Wales, in lat 22°30'S long 150°50'E, discovered by Capt. Flinders, August 21, 1802. Painted by command of the Lord Commissioners of the Admiralty to illustrate Capt. Flinders' voyage.*

An associated watercolour by Westall titled *Port Bowen* (Clinton), signed and dated 1812, was sold by Christie's, Melbourne in 1995 for $36,800 (Australian dollars). The catalogue entry states that, 'This watercolour is a preliminary study for the completed oil painting *View of Port Bowen* (now Port Clinton) in Queensland in the collection of the Admiralty, exhibited at the Royal Academy [RA] in 1812.' However, there are notable differences in terms of the trees, other vegetation and figures that probably discount this statement. As Westall's oil painting of this subject exhibited at the RA had already been purchased by the Admiralty he would have been eager to use this prestigious art venue as a promotional platform to sell related artworks to other clients, hence the creation of a watercolour version. This would seem a more plausible explanation.

A different and more manageable title for the Admiralty oil painting was used for the engraved illustration in the voyage publication, which omitted any reference to the navigational data. It was entitled *View of Port Bowen, from the hills behind the Watering Gully*.

Westall's 1805 Royal Academy of Arts exhibit was the first Australian landscape to be exhibited with a title including both latitude and longitude coordinates. As a Commissioner of the Board of Longitude, it is likely that Banks played a prominent part in the proposition that this should be so. The Board of Longitude papers reveal that other Commissioners and

associated officials from the 1790s to the early 1800s included Evan Nepean, William Marsden, the Astronomer Royal Nevil Maskelyne, as well as the Lords Spencer and St Vincent. They were all part of Banks' extensive professional network, with the last two being signatories of the *Investigator* contract for the scientific team.

In his preface to *A Voyage to Terra Australis* Flinders went into great detail about the importance of longitude. He praised the effective chronometers he took with him on the *Investigator*. After the astronomer John Crosley had prematurely left the ship at the Cape of Good Hope through ill health, it is known that Flinders had at his disposal four chronometers by John Arnold and Thomas Earnshaw: Arnold's (Nos 82 and 176) and Earnshaw's (Nos 520 and 543). Flinders also had one watch by Arnold, No. 1736, designed to be taken up rivers and places where the ship could not go. Crosley was later replaced by James Inman.

Earlier in the voyage account Flinders had stated that he had the most faith in Earnshaw's pocket timekeeper; however, as this was deemed to be Crosley's personal property it had been retained by him. Later in the voyage account, in January 1802, Flinders noted that Earnshaw's chronometers Nos 520 and 543 'generally throughout the voyage shewed themselves to be the best time keepers'.

Flinders could have conveyed to the Admiralty or Banks in smuggled documents and letters (now lost) the navigational coordinates of places. Westall might also have recorded them during the lengthy periods when he worked on the coastal profiles in the 'Great Cabin', alongside Flinders and his officers who developed the navigational data for the charts.

After Westall's return from his travels to Madeira and Jamaica he was spurred on again by his brother William, and became increasingly frustrated at Flinders' absence and the lack of the development of a voyage publication to which he would be paid additional sums of money to provide illustrations.

In 1809 Westall was adamant he had obtained permission from the Admiralty to create a series of oil paintings of Australia. However, because of political complications, the commission suddenly ceased. Westall was at his wits' end and turned yet again to Banks for help. Banks was equally frustrated, and hopeful of Flinders' imminent return.

After Flinders' return to Britain in October 1810, Banks was finally able to move things along with the Admiralty. In the following year he secured authority to superintend the production of *A Voyage to Terra Australis*, a key part of which was to supervise the artists and engravers in the creation of their work.

Banks ensured that Westall completed a series of ten oils for the Admiralty, and arranged for engraved illustrations and coastal profiles after his work to feature in the voyage publication.

PAINTING AROUND AUSTRALIA

Joseph Banks' role in the creation of the first series of oil paintings of *Terra Australis*

As soon as Matthew Flinders returned to London from his detainment of almost six and a half years in Mauritius, he was eager to make contact with Sir Joseph Banks. Writing to Banks from the Norfolk Hotel in London on the evening of Thursday 25 October 1810, Flinders had two principal connected things on his mind: his determination to obtain a backdated promotion, and the progression of the voyage publication that would feature a selection of William Westall's coastal profiles and landscape views. In tandem with the charts, these provided the scientific and visual proof of the parts of Australia that he had discovered, explored and surveyed.

Flinders wrote: 'I have the happiness to inform you of my arrival in England yesterday morning … I saw Mr Yorke [Charles Philip Yorke, First Lord of the Admiralty] this morning, and also the secretaries Messieurs Croker [John Wilson Croker] and Barrow [Sir John Barrow, 1st Baronet] … and I find in everybody a disposition to appreciate what I have done and what I have suffered.'

He continued: 'I first found that my promotion was dated Sept. 24 last, but I have got it put back to April 9; and moreover have the approbation of Mr Yorke to present a memorial to the Admiralty for its being dated at the time it may be supposed I might have arrived, had not my unjust detention taken place.'

Flinders eventually had a morning meeting with Banks at 32 Soho Square on Friday 9 November. He noted in his journal: 'Went to breakfast with Sir Joseph Banks, after which I conversed with him upon the subject of my commission being antedated and upon the writing of the account of my voyage of discovery; upon both which topics he entered with much interest and agreeably to my views.'

Banks was sympathetic and supportive of Flinders' desire to obtain backdated pay and promotion, but – even with Banks' assistance – Flinders only managed to secure from the government some backdated pay. Ideally he should have returned to his native Lincolnshire to live in relative comfort with his new wife, Ann, from whom he had been separated for more than nine years, and where in a more leisurely fashion he could write up his voyage account and develop his charts.

Banks, however, wanted Flinders close at hand in London, where all the records and artworks were stored – many of them at 32 Soho Square that housed his superlative global exploration and Pacific library and *Endeavour* collections. Banks' *Investigator* team, the engravers, printers and publishers were also based there, and so Flinders was forced to move south, which on half-pay he could ill afford to do.

Considering all Flinders had experienced, he returned to Britain in reasonable health. In the latter stages of his work on the publication, his private journal records intensive periods of activity that were frequently combined with the problems of his 'gravelly' complaint. This complaint has often been attributed to the legacy of his amorous liaisons in Tahiti in 1792 (Banks had managed to avoid it on his earlier voyage).

However, a reassessment of his condition has been made by Stephen Milazzo, FRACP and published in *Matthew Flinders – Private Journal* (2015) in an appendix entitled 'Flinders' Last Illness: The Final Five Months of the Journal, February to July 1814: A Medical Interpretation'. He reveals that an STI was not the primary cause of death. By Flinders' own admission his complaint was excruciatingly painful. It prematurely ended his life on 19 July 1814 at the

age of 40; however, fortunately he lived long enough to see through the publication of *A Voyage to Terra Australis* (1814).

Flinders was aware of his expedition achievements although in equal measure he was frustrated by the premature termination of the *Investigator* voyage. Key parts of southern, eastern and northern Australia had been charted by Flinders and they included those not seen or properly explored by earlier Dutch expeditions (notably those led by Abel Tasman) and the French explorers (especially Nicolas Baudin). Parts of these areas would be recorded in charts, captured in coastal profiles, visualised in expedition artworks and developed into landscape and seascape views in oils for the Admiralty.

Flinders would see far more of the Australian coast than Cook, whose primary focus was establishing the outline of the eastern coast by conducting a running survey. Banks and his handpicked *Endeavour* team would have preferred far more stopovers for land-based exploration. When Robert Brown complained to Banks that Flinders had restricted the shore-based activities of the team, Banks defended the captain, stating that compared to his experience with Cook, they had been given considerably more 'landing' opportunities. Although technically Flinders' mission in the *Investigator* was not completed to the thorough extent he desired, it was the first on record to circumnavigate Australia.

On 28 October 1810 Flinders wrote to his brother Samuel who had served as 2nd Lieutenant aboard the *Investigator*: 'I am to dine with Mr Yorke tomorrow, as is Mr Barrow, and we shall then perhaps be able to see whether recourse [in terms of his promotion] may not be had to an order of the King in council. Sir Joseph is to be in town about the 7th of November, and then the subject of the publication of the voyage will probably be discussed. Messrs Brown, Bauer, and Westall, whom I have seen, have been at work for it in their respective departments.'

Flinders confirms in this letter that Westall and the other members of the scientific team had been at work in anticipation of the release of their captain. In terms of the commissioning of the series of oil paintings for the Admiralty, it is not possible to make a clear distinction between that initiative and Westall's artworks that featured as engraved illustrations in *A Voyage to Terra Australis* since they were interconnected. Both projects were managed by Banks with full Admiralty approval.

The close relationship between the commissioning of Westall's oil paintings and the corresponding illustrations is novel in terms of British Admiralty voyages of exploration. Eight of the ten Admiralty oils by Westall featured as illustrations in *A Voyage to Terra Australis*. It could be argued that such a tight correlation between the small number of Westall's Admiralty oil paintings that were destined to adorn rooms in Admiralty House and their use as illustrations in *A Voyage to Terra Australis* was also prudent budgeting by Banks on behalf of the Admiralty.

By contrast the Admiralty's investment in the extensive range of works on paper by William Hodges and John Webber – not forgetting the prices paid to designers and engravers responsible for the prints of their subjects – was far greater. In addition, the Admiralty also paid Hodges and Webber for oil paintings to adorn rooms in Admiralty House. Admiralty records record that 24 oils were acquired from Hodges and four from Webber.

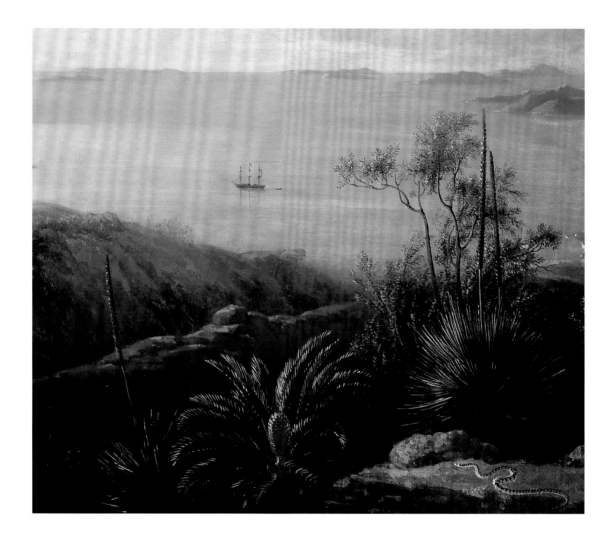

Through Banks' presidency of the Royal Society and his extensive professional and social network of influence, he ensured that Westall developed his expedition artworks that led to the first series of oil paintings of Australia. However, the initial impetus to create a series of paintings came from the Westall brothers and started in 1809 prior to Flinders' return.

On Sunday 2 April 1809 Farington noted, 'Westall [Richard] & Wm. Westall spoke to me about the Admiralty employing Wm. Westall to make complete drawings of the subjects of which the Admiralty have outlines made by Him during His voyage to the South Seas.'

He continued: 'This they did in the instance of Hodges & also of Webber, & the Botanical draughtsman who went with Wm. Westall is now through the recommendation of Sir Joseph Banks, employed for a

ABOVE

In this detail of a painting by William Westall (see pages 197–98) he depicts the *Investigator* moored in Lucky Bay, Western Australia, in January 1802. Under Flinders' command the vessel took the artist and his shipmates on the first recorded circumnavigation of Australia and enabled him to paint the first series of oil paintings of that island continent.

similar purpose, in His own line, at a salary of £200 a year. I sd. I wd. mention it to Sir G. Beaumont & recommend to Westall to converse with Sir George respecting it.'

Farington noted the tradition of engaging voyager artists to develop their expedition artworks into illustrations for the official publications, and the salary paid to Ferdinand Bauer of £200. Unlike Hodges, Webber and Bauer, Westall received no post-voyage annual salary (perhaps as a form of punishment as he had quit the expedition in Australia). He was only paid as and when he completed an oil painting, an intermediate drawing for an engraved illustration or a coastal profile, and after he had sent through his invoice to Banks for approval on behalf of the Admiralty.

Farington also recorded on 18 May 1809 that, 'Westall [Richard] called. He had been with Sir G. Beaumont & spoke to Him abt. Wm. Westall being employed by the Admiralty. Sir George was very civil, but declined giving any opinion on the subject.'

On 23 May 1809 Farington recounted, 'Westall [Richard] called & shewed me a letter recd. from the Admiralty signed by Edwd. O'Bryan, Lord Mulgrave's Secretary. Informing Him, in answer to His letter addressed to His Lordship, that any application from His Brother must be addressed to the *Board of Admiralty*. This Westall considered to be fatal to His hope of obtaining an Order for His Brother to paint pictures or make drawings.'

However, Richard Westall was mistaken in his hasty judgment as Banks intervened to successfully argue the case for William to produce a series of Australian paintings. Banks knew Henry Phipps, 1st Earl of Mulgrave, the First Lord of the Admiralty (1807–1810), as he was the brother of his close friend the polar explorer Constantine Phipps, 2nd Baron Mulgrave, who Banks had proposed to be a fellow of the Royal Society.

On 7 June 1809 Farington noted, 'Sir Joseph Banks has had a conversation with Ld. Mulgrave respecting Wm. Westall making drawings or pictures of the places He visited in the South Seas. Sir Joseph took a warm part for Wm. Westall. Ld. Mulgrave sd that He had [been] applied to as a private gentleman that as a private gentleman He was very much inclined to encourage Artists, but that *He cd not use the public money for that purpose*; and seemed to complain of the application being made to him, on that acct improperly.'

He continued: 'Sir Joseph said that the French, when they made voyages of discoveries published & preserved all that related thereto, but that we sent artists out & on their return hesitated to make use of the fruits of their labours. Lord Mulgrave asked Sir Joseph whether He would take upon Him [self] the responsibility of having such drawings or pictures painted: Sir Joseph said; He would. The result was that Wm. Westall should paint a certain number of pictures, but Sir Joseph & Lord Mulgrave also, recommend to Him to be *moderate in His charges.*'

Banks' negotiations with Lord Mulgrave, as reported by Farington, are evidence of his skilful political manoeuvring in highlighting the competition between Britain and France as regards the Napoleonic Wars (1799–1815). Determined not to lag behind France in terms of producing artworks and illustrations from the *Investigator* voyage, Banks actively took responsibility and control of Westall's expedition drawings.

Farington's entry concluded, 'Westall [Richard] then told me He was at a loss what prices to propose, & that Wm Westall had desired Him to consult me. I stated to Him that I was bred in a school in which prices were moderate, that I did not know that His Brother

had any practise in Oil *painting*, & therefore cd not judge of His pretensions, but that I thought it a great object for Him to be employed for the Admiralty, & that to secure it money ought to be a secondary object.'

As William Westall was known for his drawings and watercolours, his ability to paint in oils was uncertain; however, he would have been helped to develop this skill by Richard Westall with some assistance from his wide circle of artist friends.

Richard Westall played a significant role in assisting him to secure and complete the Admiralty commission. On 8 June 1809 Farington noted, 'Westall [Richard] called & I talked with Him respecting the pictures to be painted by His Brother for the Admiralty, recommending moderate prices. I told him Wilson [Richard Wilson] had only 40 guineas for a Half Length unless Historical figures were introduced.'

Joseph Farington was a well-connected Royal Academician who is best known today as a diarist. If Farington could not personally assist his friends (who included the Westall brothers) or allies, he invariably had a contact who could be of service. The Royal Academician James Northcote recollected, 'How Farington used to rule the Academy! … He was the great man to be looked up to on all occasions; all applicants must gain their point through him.' However, Farington's diary overshadows the fact that he was also a well-regarded landscape painter who became a Royal Academician in 1785. He had been a pupil of the classical landscape painter Richard Wilson, which places him in company with fellow students William Hodges and Thomas Jones.

On 17 June 1809 Farington recounted that, 'Wm. Westall told me yesterday that He has been commissioned by the Admiralty to paint a series of pictures of the subjects He collected in His voyage. Willm. Westall said. The size fixed on was 26 Inches by 18, the price 20 guineas each.'

The prices and sizes indicated above for the oil paintings relate to a provisional plan that was subsequently abandoned. Notes and invoices that form part of Banks' correspondence in the State Library of New South Wales reveal that the actual prices paid for the paintings ranged from 35 to 70 guineas, with dimensions ranging from 23½ x 34 in to 40 x 50 in.

The correspondence relating to Westall's Admiralty commission for some unexplained reason ceases for several months and resumes in April 1810. On Thursday 5 April 1810 Farington was at his diary again and noted the confusion concerning the precise terms of Westall's Admiralty commission.

Farington recollected, 'Westall [Richard] called & shewed me a letter from Lord Mulgrave to Wm. Westall, in which He expressed that when He knows the prices of the two pictures W. Westall has sent to the Admiralty He shall lay them before the Board, but that He considered these pictures as completing a Series painted by others, & that He shd. not have ordered them but from being strongly urged to it by Sir Joseph Bankes, [*sic*] and that no more pictures wd. be required.'

William Westall's frustration with the situation and eagerness to resolve the matter was expressed in his letter of 26 June 1810, now in the Cambridge University Library, to John Wilson Croker, First Secretary to the Admiralty. The artist was adamant that he had been given permission by Lord Mulgrave to execute 'a series of Pictures of different sizes illustrative of the voyage'.

Westall wrote: 'When I say that I received the commission from Lord Mulgrave, I mean only to assure you in the most solemn way, that such was the construction which I put upon the conversation which his Lordship honoured me upon that subject, for the event has unfortunately proved that I misunderstood him. In consequence of the commission I selected with the approbation of Sir Joseph Banks two subjects from the earliest part of the voyage, and when the pictures were finished I sent them to the Admiralty, and began a third of a larger size, of a more advanced period of the voyage and a more interesting subject.'

He continued: 'For the two first, [oil paintings] I have been recently paid Seventy Guineas [35 guineas per picture]. When the third Picture was finished I wrote to Lord Mulgrave requesting his Lordship to honor me with permission to exhibit at the Royal Academy, and to my great grief and surprise received from his Lordship a letter informing me that he never intended to extend the commission beyond the two Pictures already received.'

Westall concluded: 'Not to mention how very imperfectly the voyage is illustrated by merely the two pictures I have sent in, I shall experience a very great loss if the third Picture is thrown on my hands, after the time and care I have employed to finish it. I am therefore induced humbly to request that what has passed may be taken into consideration by the Right Honble. Mr Yorke and the Board at which he presides, and when their Lordships shall have considered the dangers, difficulties and heavy loss which I experienced in this voyage during which I was shipwrecked, they will not I trust deem my request, that they should purchase the Picture either unreasonable or intrusive, particularly when I remark that the botanical Draftsman, a Foreigner [ie Ferdinand Bauer], appointed to the same expedition, whose salary while abroad was the same as mine and whose labours I should hope cannot be considered as more important, has ever since his return been employed in finishing drawings from the sketches made abroad and enjoyed all the time his full salary.'

Westall's quasi-xenophobic remark about Ferdinand Bauer stems from his frustration with his personal situation and his knowledge of the preference given to that artist by Banks. However, this would not have chimed well with Banks, who had a successful history of working closely with and enjoying the company of 'foreigners' including artists, engravers and naturalists, and notably a longstanding relationship with his close friend the Swede Dr Daniel Solander.

There is no known evidence that Lord Mulgrave was dissatisfied with Westall's paintings, and the likely explanation for his decision not to proceed with the agreed commission related to the fact that he was aware his official office was coming to an end. His position as First Lord of the Admiralty had been confirmed by the former Prime Minister William Pitt the Younger. In 1810 Pitt's successor, Spencer Perceval, replaced Lord Mulgrave with Charles Philip Yorke, who served as First Lord of the Admiralty from 1810 to 1812.

Croker, First Secretary to the Admiralty would have redirected a copy of Westall's letter to Banks, who in turn tackled the Admiralty on Westall's behalf and pressed the case for the benefits of paying for additional oil paintings, in tandem with the landscape illustrations and coastal profiles, to be featured in the voyage publication.

Banks was the impresario of the *Investigator* voyage and he was aware that Westall was an essential element in the effective promotion of the expedition. Under his supervision what would start with one of the artist's watercolours displayed at the Royal Academy of Arts in 1805 would end in 1813 with a series of ten oil paintings for Admiralty House, and nine engraved illustrations for the voyage publication, plus 28 coastal profiles for the atlas.

On 15 January 1811 John Barrow, the Second Secretary to the Admiralty wrote to Banks: 'Mr Yorke [First Lord of the Admiralty] … authorized me to write to you the official letter which accompanies this & which I hope will meet your approbation. Captn. Flinders may therefore get into Harness immediately. With regard to the Selection there will be no difficulty; indeed Mr Yorke said he would be quite satisfied to leave it to yourself & depute me to represent the Admiralty – That is to say, the present Admiralty. The next may supply a better representative. At all counts it may be quite as well to commence with all possible speed, and to enable us to do so, You will perhaps write me a short letter in return to desire the papers, Sketches, &c may be delivered to Captain Flinders or any other you many please to name.'

Barrow wrote to Banks again on 15 January 1811: 'Sir, I have received and laid before my Lords Commissioners of the Admiralty your letter of the 13th instant, stating that Captain Flinders is prepared to commence the necessary operations for publishing the Journal of his voyage in the "Investigator", provided that their Lordships should approve of the measure; and at the same time expressing your readiness, in this event, to superintend the management of the draughtsmen, engravers, & etc who may be engaged in the execution of the Work.

'In return, I am commanded to acquaint you that their Lordships consider the information collected during the voyage of the "Investigator" to be of sufficient importance to be laid before the publick in the form of a narrative to be drawn up by Captain Flinders, upon a plan similar to that pursued in the publication of Captain Cook's voyage, and conformable with the 5th and 6th articles of the engagement made by their Lordships with the men of Science employed on the said voyage.'

He continued: 'Under these circumstances I have to express to you the thanks of their Lordships for the handsome manner in which you have been pleased to offer your superintendence to the management of the draughtsmen, engravers &c who are to be employed: an offer of the value of which my Lords are too sensible not to accept of it with pleasure and satisfaction'. Barrow concluded: 'I am therefore to convey to you their Lordships' request that you will take charge of the sketches, charts, journals and the manuscripts now in the Admiralty, which I am directed to deliver up to yourself, or to your order; and further that at your convenience, you will make out and transmit to me for their Lordships information and approval a list of the subjects which you may deem it expedient to select for the embellishment of the publication: it being their Lordships' intention that, as in the case of Captain Cook's third voyage, the drawings and engravings shall be prepared at the publick expense, and the paper, printing, &c paid for out of the proceeds of the work.'

This letter affirms that in early 1811 the Admiralty had finally approved the production of the voyage publication. It also reveals the authority conferred on Banks in terms of its management. Banks arranged for the 'sketches, charts, journals and the manuscripts now in the Admiralty' to be sent to him at 32 Soho Square.

As part of this complex process Banks was also tasked to supervise Flinders in addition to Westall's work and the ten botanical plates (featuring eleven specimens) after Ferdinand Bauer with descriptions by Robert Brown. Banks also supervised the charts, although he was reliant on Flinders to make the initial selection of subjects. The project could not effectively come together without his unwavering commitment.

From time to time Banks checked matters with the Admiralty and sent recommendations, dealing often with Sir John Barrow. They all appear to have been approved. The primary concern of the Admiralty was directed elsewhere with respect to the Napoleonic Wars.

Although Flinders' focus was on the text, charts and coastal profiles, he involved himself in all aspects of the publication, which was welcomed by Banks. From his journal entry on 20 January 1811 he noted, 'Went to Sir Jos. Banks, where it was settled that Mr Arrowsmith [Aaron Arrowsmith, publisher of charts and maps] should reduce and engrave my charts, and call tomorrow to ascertain the scales, and ascertain the number to be engraved. Also, that I should examine Mr Westall's sketches [in relation to coastal profiles] with the author, and form an opinion upon what would be required.'

Towards the end of January 1811 Banks, Flinders and Westall drew up a long list of the landscape views for inclusion in the voyage publication. This was recorded by Flinders in his private journal on 31 January 1811: 'Went with Mr Westall to Sir Jos. Banks, where we made choice of eleven views of Australia for embellishing the voyage.' The number of views was later reduced to nine.

Also, on 13 May 1814 Flinders recorded in his private journal, 'Mr Brown called in the evening, bringing proofs of ten botanical plates.' Flinders certainly had an interest in art, although it was of less interest compared to his passion for music. He made positive contributions to the discussions selecting the artistic material for the publication – in particular relating to their content and also with respect to some of the titles (after all, he had been to those places in Australia and Banks had not). However, in terms of the artistic style of representation, Flinders would have deferred to Banks.

The dominant influence of Banks in relation to the selection of artworks for the voyage publication is highlighted in the following extract from a letter to Sir John Barrow at the Admiralty on 16 January 1811, when he asked 'if their Lordships will also Favor me with the Loan of the Two Pictures Painted by Mr Westall for the office [Admiralty House] I shall be Enabled to judge whether it will be advisable to introduce engravings taken from them among the decorations of the intended Book'.

Flinders was impressed with Westall's depiction of flora in his engraved illustrations to the point that he tried to gain royal approval from the Prince Regent, perhaps with an eye to progressing his promotional prospects, by sending a selection of proof engravings to his librarian the Rev. James Stanier Clarke. On 21 May 1813 Flinders wrote, 'My voyage being now in a state of forwardness, will be immediately announced for publication next spring; and I herewith send you four out of the eight or ten views by W. Westall which it will contain: You will remark the accuracy with which he has preserved the characteristic vegetation of that extraordinary country … and I please myself with the hope, that this voyage may be thought worthy of being classed with those already published under the patronage of His Majesty.'

The selection of Westall's engraved illustrations ran in tandem with the creation of the Admiralty oil paintings destined to hang in Admiralty House. These illustrations – referred to by Banks as 'adornments', 'embellishments' and 'ornaments' – supported Flinders' primary text, provided evidence of British exploration and surveying successes to counter claims primarily from France, and encouraged follow-on scientific voyages and promoted free settlement in South Australia. They were designed to make the voyage publication attractive to the reader and to help with its saleability.

From the extant official documents and letters a timeline can be drawn of the creation of Westall's ten Admiralty Australian oil paintings. The titles are taken from several sources including the Admiralty records, the letterpress on the engraved illustration published in the voyage publication and the exhibition catalogues of the Royal Academy of Arts.

In relation to the Admiralty records, the paintings are listed in their catalogue published by the Admiralty in 1911 that drew upon its 19th-century records. It is titled *Catalogue of Pictures, Presentation Plate, Figureheads, Models, Relics and Trophies: at the Admiralty; on Board H.M. Ships; and in the Naval Establishments at Home and Abroad*. For convenience, it is shortened to *Admiralty catalogue* (1911).

William Westall's Admiralty Australian oil paintings

An explanation of the Admiralty oil paintings follows below, which includes the reasons why they were created and engraved for the official voyage publication, as well as why two of the paintings did not feature as illustrations.

Part of King George III. Sound, on the South Coast of New Holland

[December 1801] Oil on canvas,
24 x 34 in (61 x 86.5 cm).
Painted by March 1810. Engraved by John Byrne.
The title derives from the *Admiralty catalogue* (1911). It featured in the voyage publication titled *View from the south side of King George's Sound*.

The location is close to the city of Albany in Western Australia. It was named by George Vancouver, a veteran of Captain Cook's third Pacific voyage in honour of the King, and he was the first European to explore and chart this area. His work was published in 1798 and titled *Voyage of Discovery to the North Pacific Ocean and Round the World, 1790–1795*.

Banks had a difficult relationship with Vancouver, which probably explains why no professional artists travelled on this voyage. In addition John Webber had already captured scenes and views in parts of north-west America, Canada and Russia. However, with great reluctance on Vancouver's part, Banks managed to arrange for the Scottish surgeon, naval officer and botanist Archibald Menzies to acquire and 'preserve new or uncommon plants' using a 'glazed frame on the quarterdeck' for the Royal Botanical Gardens, Kew.

For Flinders and his crew, King George's Sound had been recommended by the Admiralty as it provided a safe anchorage with access to water and wood. It was an ideal starting point before commencing the extensive survey work.

The key geographical features and names featured in the landscape are provided by Flinders, and more recently by the botanists Kay Stehn and Alex George. The view is taken from Peak Head looking approximately north-north-west along Vancouver Peninsula, with Princess Royal Harbour (left), King George Sound (right), Mt Melville (distance, far left), Mt Clarence, the Porongurup Range (far distance) and the entrance to Oyster Harbour (far right distance).

The picture depicts two Aboriginal Australians

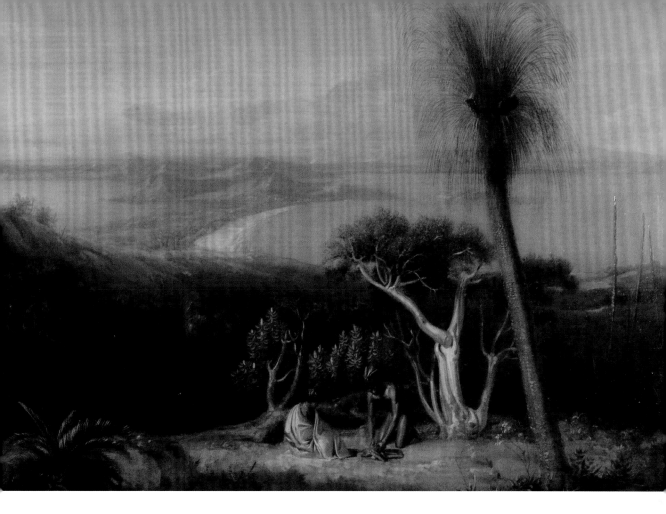

making a fire. The female is attired in a classical-style cloak, while the male has overlong arms typical of the neoclassical idiom approved of by Banks. The figures are prominently positioned in front of a shrub that Alex George believes to be *Banksia verticillata*, commonly known as Albany or Granite Banksia. Placing the *Banksia* in a central position is a conscious acknowledgement and tribute to the authority, expertise and influence of Banks in terms of the *Investigator* voyage and his participation on Cook's *Endeavour* voyage. Banks and Brown probably suggested its inclusion.

The Australian Aboriginals are also positioned beside a stunted eucalyptus and a large tree. The eucalyptus derives from Westall's drawing from the National Library of Australia created later in the voyage at Spencer's Gulf. The movement of items from one geographical area to another to form a harmonious composition was endorsed at the

ABOVE

Part of King George III. Sound, on the South Coast of New Holland, [December 1801] painted in 1810, by William Westall (1781–1850), oil on canvas. National Maritime Museum, Greenwich. ZBA7943.

highest artistic levels at that time. Bernard Smith offers an alternative explanation in *European Vision and the South Pacific* (1988), noting that the artist's landscapes were 'not simply topographical transcripts of nature, but landscapes in which typical specimens of Australian flora have been introduced into the foreground in order to characterize the country depicted'.

The large tree in the right foreground is *Kingia australis*, which derives from Westall's drawing in the National Library of Australia inscribed 'Grass Trees' but usually referred to by the catalogue title,

Port Jackson, grass trees. Both this expedition artwork and others can be viewed in close-up detail on the National Library of Australia website. Banks would have been enthusiastic to feature the *Kingia australis* as a tribute to the *Investigator*'s naturalist, as it had been first named by Robert Brown. To the far right in the mid-distance of the Admiralty painting are three spear-like plants, *Xanthorrhoea preissii* (an example of which is present in the aforementioned drawing) while in the far-left foreground Alex George identities a *Macroza riedlei*, a species native to western Australia.

As with many of Westall's oil paintings, this landscape has an impressive sea view. The artist would use his expedition drawings as a reference source, but emphasis on coastal features within this and other paintings derives from the artist's experience of making coastal profiles for Captain Flinders. They add a fascinating quasi-cartographical quality to his work.

The expedition drawings that closely relate to this painting include the drawing heightened with watercolour inscribed 'Dec 1801, King George's Sound: view from Peak Head'. It is squared up for transfer, demonstrating the serious intent of the artist to develop significant parts of the composition into the Admiralty oil painting.

Westall's Admiralty painting represents the starting point of the *Investigator* voyage in terms of the exploration of the Australian coastline. It is a visual reminder of the success of previous British exploration – notably of George Vancouver, the first European to discover, chart and name this area.

ABOVE

King George's Sound, view from Peak Head, 1st December 1801 by William Westall (1781–1850), graphite and wash on paper, National Library of Australia. nla.obj-138875378.

RIGHT

Bay on the South Coast of New Holland, discovered by Captain Flinders in H.M.S. 'Investigator', [January] 1802, painted in 1810 by William Westall (1781–1850), oil on canvas. National Maritime Museum, Greenwich. ZBA7939.

Bay on the South Coast of New Holland, discovered by Captain Flinders in H.M.S. 'Investigator', 1802

[January 1802] Oil on canvas, 24½ x 34½ in (61.5 x 87 cm).
Painted by March 1810. Not engraved for the voyage publication.
The title derives from the *Admiralty catalogue* (1911).

The bay depicted is Lucky Bay, located fairly close to the modern-day city of Esperance in western Australia. An explanation to its naming is given by Flinders who, concerned about approaching nightfall and being surrounding by rocks, was desperately trying to find a safe anchorage. On 9 January 1802 he wrote, 'The critical circumstance under which this place was discovered induced me to give it the name of Lucky Bay.'

Kay Stehn and Alex George reveal that Westall's view is from 'Mississippi Hill looking towards the eastern side of the bay, looking South westwards, with the islands of the Recherché Archipelago in the distance'.

On 10 January 1802 Flinders noted in *A Voyage to Terra Australis* that the scientific team were eager to explore the area: 'I had intended to pursue our route through the archipelago in the morning; but the scientific gentlemen having expressed a desire for the ship to remain two or three days, to give them an opportunity of examining the productions of

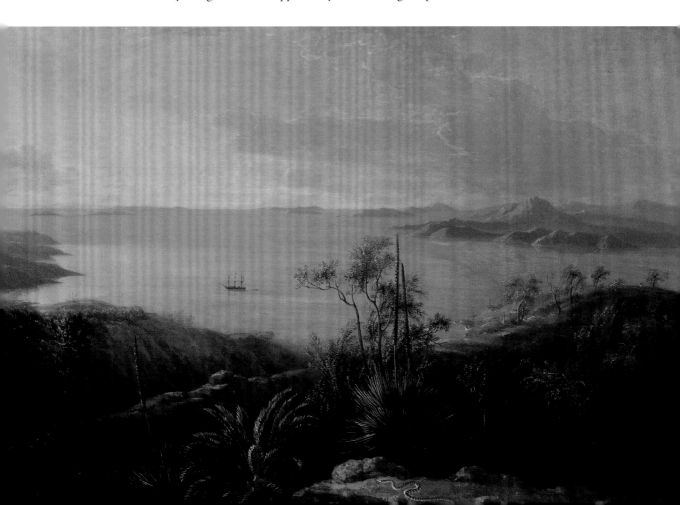

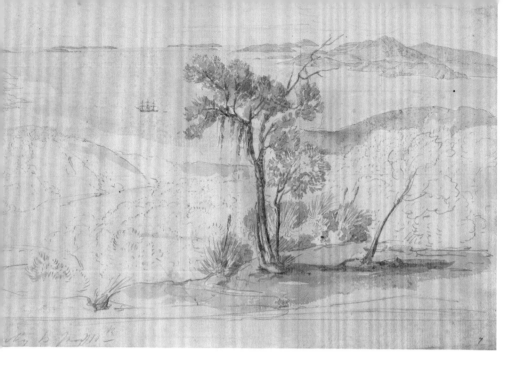

the country, it was complied with; and they landed soon after daylight. I went ashore also, to make observations upon the rates of the time keepers; and afterwards ascended a hill at the back of the bay, to take angles with a theodolite.'

Flinders emphasises the importance of the expedition in terms of surveying. Westall certainly had access to surveying and shipboard equipment, especially telescopes, throughout the voyage that would have been useful for him to observe the expansive landscape surroundings. It is likely that he did use them as an aid to create some of his coastal profiles and landscape views. It is known that Conrad Martens used them on FitzRoy's celebrated *Beagle* voyage.

Although Flinders observed that the 'interior country' was attractive to members of the scientific team, he personally could not discern any viable options for the development of farming: 'The vegetation … consisted of an abundant variety of shrubs and small plants, and yielded a delightful harvest to the botanists but to the herdsman and cultivator it promised nothing; not a blade of grass, nor a square yard of soil from which seeds delivered to it could be expected back, was perceivable by the eye in its course over these arid plains.'

Flinders' observation demonstrates that he was consciously recording information specifically with an eye for the prospects of future British settlement in parts of Australia, although perhaps the deciding factor in Banks' decision not to use Westall's painting as an illustration in the publication related to the presence of the snake that is shown in the posture adopted before striking its prey. The threatening reptile is a *Morelia spilota metcalfei*, commonly called a carpet python. The snake was caught later in the voyage at Thistle Island on 21 February 1802. Westall made a coloured drawing of the reptile, that is now part of the National Library of Australia collection.

The expedition drawings that closely relate to this painting include one that is a very close match, inscribed 'Lucky B., Jany 10th'. It is also squared up for transfer.

Flinders – on behalf of the Admiralty advised by Banks – had in mind throughout the voyage potential areas for future British settlement, and the carpet snake curled up about to strike, although eye-catching, was not a positive promotional element. This is arguably the most obvious reason why the painting was not engraved for the publication.

Entrance of Port Lincoln, taken from behind Memory Cove

> [February 1802] Oil on canvas, 24¼ x 34¼ in (61.5 x 87 cm).
> Painted before the end of July 1811.
> Engraved by John Pye.
> The title derives from the illustration of the voyage publication. The title given in the *Admiralty catalogue* (1911) is almost identical.

Port Lincoln is located at the southern extremity of the Eyre Peninsula around 175 miles from the city of Adelaide. Flinders named the area Port Lincoln after his own home county and as a tribute to Banks. The naming process here is not only significant in terms of proclaiming this part of the Australian coastline as a British discovery to counter rival French claims, but it is also a homage – in this instance a visual one – to Flinders' patron Banks.

Paul Carter considers the significance of Flinders' naming process in his publication *The Road to Botany Bay* (1987). He notes that, 'To the northeast of Port Lincoln is located the Sir Joseph Banks Group of islands. From north to south, these are Winceby, Reevesby [*sic*], Lusby, Kirkby, Dalby,

Hareby, Langton, Sibsey, Spilsby and Stickney.' He believes that: 'The essential point about Flinders' Lincolnshire names in Spencer Gulf is that they preserve the spatial and topographical relationship of the Lincolnshire villages.'

Carter also notes that the process was an intrinsic part of Flinders' quest for promotion after the voyage: 'Flinders saw in his *Voyage* his only chance of obtaining the advancement he thought he deserved. In this context … his complimentary references to both his patrons, the Admiralty Lords … and Sir Joseph Banks (who had a group of islands named after him), in the region of his own discoveries, would be a strong hint about another reputation worth advancing, namely his own.'

The Admiralty painting is a sombre subject, predominately sepia in tone. A Claudean-inspired Italian stone pine (a tree not naturalised in Australia at that time) dominates the compositional space, acting as a quasi-memorial marker. A key part of the title of the painting and engraving, 'from behind Memory Cove', indicates that it was conceived as a tribute to the eight men who drowned in this area, including the ship's master John Thistle, when one of the ship's boats overturned during a heavy swell.

The following extract is taken from the Flinders'

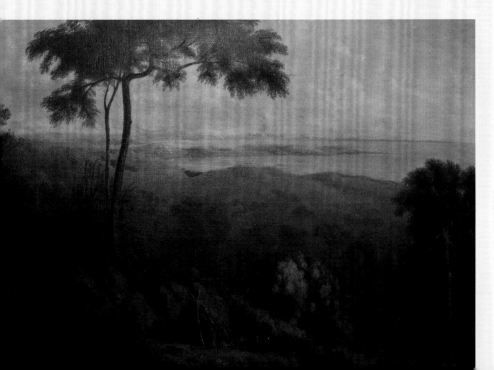

LEFT

Entrance of Port Lincoln, taken from behind Memory Cove, [February 1802] painted in 1811 by William Westall (1781–1850) oil on canvas. National Maritime Museum, Greenwich. ZBA7940.

fair logbook, dated Wednesday 24 February 1802: 'I caused a stout post to be erected in the Cove, and to it was nailed a sheet of copper upon which was engraven the following inscription – Memory Cove – His Majesty's ship *Investigator* – Mattw Flinders – Commander, Anchored here February 22. 1802. Mr John Thistle the master – Mr William Taylor – midshipman and six of the crew were most unfortunately drowned near this place from being upset in a boat. The wreck of the boat was found, but their bodies were never recovered. Nautici cavete!'

Flinders also referred to the engraved illustration (the annexed view) after Westall's Admiralty landscape on 24 February 1802: 'Next day, I went up with instruments; and having climbed upon a high lump of granite, saw the water extending 40 degrees behind the coast, and forming, apparently, an extensive port. The annexed view, taken from near the same spot by Mr Westall, shows what was visible of this fine piece of water, and the appearance of the neighbouring land.'

The expedition drawings from the National Library of Australia that closely relate to this painting include the drawing inscribed 'Feb.23, 1802 distant view of Bay no. 11'. It is the closest match in terms of the arrangement of trees, rocks and the native shelter. The Bay number reference for this artwork is given in error and should read 'Bay no. 10'. Another drawing catalogued as, *Port Lincoln, a distant view* and inscribed 'distant view bay 10' is the closest match to the background landscape and coastal features.

Westall also produced two watercolours of Port Lincoln that are recorded in Perry and Simpson's *Westall Drawings* (1962). The first, from the National Library of Australia, is simply described as *Port Lincoln* and is inscribed 'W. Westall 1802'. It depicts three Aborigines round a fire close to the foreground hut at sunset. The loose handling of this drawing is in marked contrast to the more sophisticated, carefully composed and subtle colouring of the second watercolour that is also entitled *Port Lincoln*, which is now in the National Maritime Museum, Greenwich and was acquired from the collection of Captain A.W.F. Fuller.

It is possible that this watercolour was a preparatory watercolour for the Admiralty oil painting and the engraved illustration for the voyage publication; alternatively, its sophistication lends credence to the likelihood that it could also have been created as an independent entity by the artist for sale. There is no record of it being exhibited, and the claim that it was displayed at the Royal Academy of Arts in 1812 is mistaken.

Westall's oil painting – or far more likely the engraved illustration – was the reference source for the watercolour by Thomas Frank Heaphy (also known as Thomas Heaphy the younger) entitled *A view in southern Australia with Aboriginals spearing kangaroos* painted in 1836, and now in the Art Gallery of New South Wales.

The coastal-scape featured in Westall's painting and the associated engraving of the *Entrance of Port Lincoln from behind Memory Cove* was incorporated by Heaphy into his own picture. The ease with which the Australian Aboriginals spear one of the kangaroos in an otherwise tranquil landscape setting and the presence of the emu and flying bird visually demonstrate that food and water were readily available in this picturesque part of south Australia.

According to the Art Gallery of New South Wales' acquisition record for Heaphy's watercolour, the title is based on an inscription on an old backing sheet that reads 'Fancy

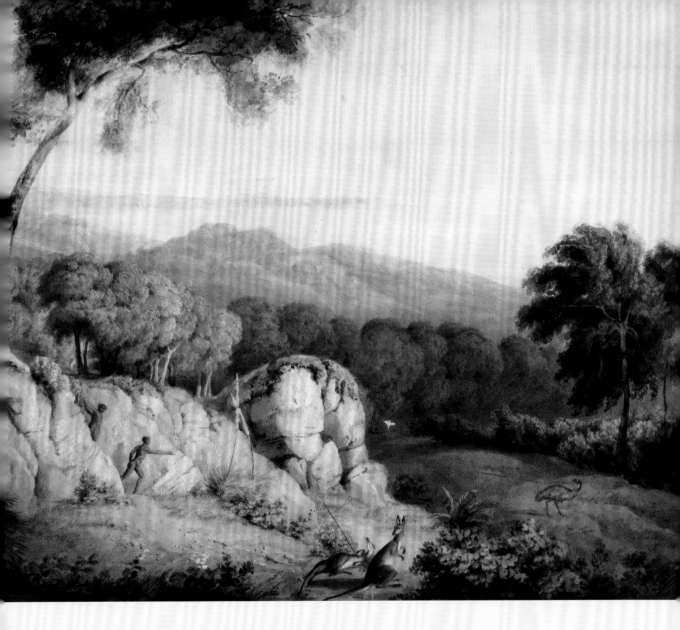

view of S. Australia by Thomas Heaphy the younger'. Heaphy was the son of Thomas Heaphy, a founding member and first President of the Society of British Artists. Although the details of the commissioning of this artwork are not known, it is possible that they related to the campaigns for colonial settlement in south Australia (in which Westall was actively involved). This is addressed in chapter 6.

Westall's Admiralty painting represents Flinders' positive progress eastwards across the Great Australian Bight, and the exploration and naming of new parts of the south Australian coastline reflect that of his and Banks' home county. In addition, by naming Memory Cove the painting offers both a textual and visual homage to the eight men who died when their boat capsized in this area.

View of North Side of Kangaroo Island, discovered by Captain Flinders in 1802 (Illus pp.232–33)

[March 1802] Oil on canvas, 24¼ x 34 in (61.5 x 86.5 cm), signed and dated 1811. Painted by the end of July 1811. Engraved by William Woolnoth.

The title derives from the *Admiralty catalogue* (1911). It featured in the voyage publication titled *View on the North Side of Kanguroo Island*.

Kangaroo Island is around 130 miles from the city of Adelaide. The remarkable number of kangaroos found and killed on this island inspired the naming of the island. Flinders wrote in the voyage publication, 'In gratitude for so seasonable a supply, I named this southern land KANGUROO ISLAND.'

The Admiralty oil painting is in marked contrast to Flinders' first-hand experience on the island. Three kangaroos can be seen in the painting as opposed to the vast number observed and shot by Flinders, Westall and other members of *Investigator's* crew.

On 21 March 1802 Flinders' recorded in the voyage publication: 'I had with me a double-barrelled gun, fitted with a bayonet, and the gentlemen my companions had muskets. It would be difficult to guess how many kangaroos were seen; but I killed ten, and the rest of the party made up the number to thirty-one, taken on board in the course of the day; the least of them weighing sixty-nine, and the largest one hundred and twenty-five pounds.'

Quasi-Claudean Italian stone pine trees dominate this peaceful mountainous coastal-landscape view executed in a predominantly sepia palette. Two emus frame the base of the trees; three kangaroos are close by, while four or five seals (one cub is hard to distinguish) rest by the water's edge.

Westall has given a simplified impression of the passive fauna: the emus (which Flinders thought were cassowaries), kangaroos and seals. By comparison with Bauer's carefully crafted zoological artworks they are crudely depicted. However, the purpose of their respective artworks was very different. Westall's fauna, even in this simplified form, acted as visual props supporting the promotional nature of the painting and the engraved illustration in *A Voyage to Terra Australis*. Banks, Flinders and Westall – encouraged and endorsed by the Admiralty and Banks – have created a tempting colonial prospect.

Flinders' enthusiasm for Kangaroo Island was also communicated to readers of the official voyage publication in his evaluation of the quality of the soil: 'The soil of that part of Kangaroo Island examined by us was judged to be much superior to any before seen, either upon the south coast of the continent or upon the islands near it, with the exception of some portions behind the harbours of King George's Sound … I thought the soil superior to some of the land cultivated at Port Jackson.'

The *Investigator* made two visits to Kangaroo Island: 21–24 March 1802 and 1–6 April 1802. What prompted Flinders to focus on this location was a combination of factors that included the quality of the soil. However, during his detainment in Mauritius, he noted in his journal on 7 January 1809 a shocking discovery he made while reading an old copy of the French newspaper *Le Moniteur Universel* from July 1808. In it was a letter from 'M. Henri Frecynet' (Louis-Henri de Saulces Freycinet) with claims that the French had discovered parts of South Australia that Flinders had first encountered. Flinders noted that 'Kangaroo Island is to be called Isle Decres, and my two gulphs are to be named Golphe Bonaparte and Golphe Josephine.'

Prior to Baudin, Flinders had named the Gulf of St Vincent (Golphe Josephine) and Spencer Gulf (Golphe Bonaparte) after Lords St Vincent and Spencer. They were two of four 'First Lords Commissioners of the Admiralty' to whom Flinders dedicated *A Voyage to Terra Australis*. The others were Charles Philip Yorke and Robert Saunders, 2nd Viscount Melville.

'M. Henri Frecynet' sailed with his brother Louis Claude de Saulces de Freycinet on Nicolas Baudin's expedition to Australia with the *Géographe* and *Naturaliste*. Baudin died during this voyage in 1803. Back in Paris in 1805, Louis Claude was tasked by

the government to contribute to the official voyage publication that also included the involvement of the shipboard naturalist François Auguste Péron. Published between 1807 and 1817, it comprised of three volumes and an atlas, issued under the title *Voyage de découvertes aux Terres Australe*. The atlas featured illustrations after the expedition artists Charles Alexandre Lesueur, who excelled as a natural-history painter, and Nicholas-Martin Petit, who excelled as a figure painter. His portraits of the Aborigines are notable according to *Design & Art Australia Online* for their 'immediacy and directness unlike any previous images of them'.

Although Flinders and Baudin had met by chance in Encounter Bay (close to today's city of Adelaide) on 8 April 1802 and exchanged information about their survey work, the French publication made no reference to any of Flinders' achievements. There is no record of a meeting between the respective expedition artists.

Flinders noted in his journal, 'there is very probably some connexion between them [the false French claims] and my long detention in this island. These encroachments have certainly been made designedly, for every officer of that expedition knew that I had previously seen and explored these parts before the Geographe.'

There are four drawings associated with the Admiralty painting: three from the National Library of Australia and one from the National Gallery of Australia. The first drawing is inscribed *On Kangaroo Island, April 4th, 1802,* and in broad terms is a close match to the Admiralty oil painting in relation to the mountainous background, the general arrangement and shaping of the trees and the positioning of some rocks, although no fauna is present in this drawing.

The second drawing, *Kangaroo Island, seals* depicts seals on a rock beside trees. However, the position of the seals does not correlate to the Admiralty oil painting. The trees are a close match in their arrangement, although they were transformed into Claudean form in the painting. The third drawing is described as *Kangaroo Island, Sailors and Servants,* but no 'sailors or servants' can be seen in the Admiralty painting. The trees and rocks depicted in this drawing also do not correspond to the painting.

A black pencil drawing, *View on the north side of Kangaroo Island* is in the National Gallery of Art, Australia. It was purchased from Nevill Keating Pictures Ltd in July 1982. In terms of the landscape background, rocks and trees, as well as the birds around the base of the trees, it is a fairly close match to the Admiralty oil painting, although no kangaroos or seals are featured. If it does relate to this painting it is likely to date from late 1810, or at the latest early in 1811 as the Admiralty oil painting was completed before April 1811. It might relate to the transformation of the subject into an engraving for the voyage account, or be a later version.

Westall's Admiralty painting represents an enticing landscape prospect to prospective settlers to south Australia. The fauna is tame and the landscape fertile. Flinders emphasised the fecundity of the area in the voyage publication and as reported by William Westall and John Aken in their Q&As for the South Australian Association (addressed in chapter 6). Largely because of these recommendations, Kangaroo Island was initially selected as a place for British settlement.

View of Port Bowen, from the hills behind the Watering Gully

[August 1802] Oil on canvas, 34¼ x 50¼ in (87 x 127.5 cm).
Exhibited at the Royal Academy of Arts in 1812.
Painted by April 1812. Engraved by John Scott.

The title derives from the illustration in the voyage publication. In the *Admiralty catalogue* (1911) it was titled *Landscape, with Sea View and Indian Figures, in the foreground.* When this painting was exhibited at the Royal Academy of Arts in 1812 it featured in the catalogue with a different long-winded title: *View of a port on the east coast of New South Wales, in lat 22°30'S long 150°50'E, discovered by Capt. Flinders, August 21, 1802. Painted by command of the Lords Commissioners of the Admiralty to illustrate Capt. Flinders' voyage.*

Port Bowen, later renamed Port Clinton, is situated on the south-eastern edge of Shoalwater Bay (named by Cook on the *Endeavour* voyage) in Queensland.

Cook had missed Port Bowen during the *Endeavour* voyage. It was discovered by Flinders on 21 August 1802, who stated in *A Voyage to Terra Australis*: 'I named it Port Bowen, in compliment to Captain James Bowen of the navy.' Flinders and Bowen had both

served under Admiral Lord Howe at the Glorious First of June in 1794, albeit on different ships. They became friends in Madeira on the outward leg of the *Investigator* voyage. A portrait of Captain James Bowen by an unidentified artist is in the National Maritime Museum, Greenwich, although remarkably it has not been professionally photographed.

Flinders also noted that, 'Instead of a bight in the coast, we found this to be a port of some extent; which had not only escaped the attention of captain Cook; but from the shift of wind, was very near being missed by us also', and that: 'to the hilly projection on the south side of the entrance … I gave the appellation of *Cape Clinton* after colonel Clinton of the 85th, who commanded the land, as captain Bowen did the sea forces at Madeira, when we stopped at that island'. Colonel William Henry Clinton of the 85th Regiment had a distinguished military career. He was governor of Madeira from July 1801 until March 1802 but advanced in rank to become General Sir William Henry Clinton GCB, KCH. The 85th Regiment was originally raised in Shrewsbury Castle, Shropshire in 1759. It was the first actual regiment of Light Infantry to be raised in the British Army. A portrait of him, attributed to the 'school of' the artist William Beechey, is in the collection of the University of Nottingham.

Although Flinders did not consider the 'country round Port Bowen' fit for cultivation, he was enthusiastic about what was discovered there in terms of the flora and fauna. He wrote in the voyage publication, 'not much can be said in praise; it is in general either sandy or stony, and unfit for cultivation; nevertheless, besides pines, there are trees, principally eucalyptus, of moderate size, and the vallies of Cape Clinton are overspread with a tolerably good grass … There are kangaroos in the woods; hawks, and the bald-headed mocking bird of Port Jackson are common; and ducks, sea-pies, and gulls frequent the shoals at low water. Fish were more abundant here than in any port before visited; those taken in the seine at the watering beach were principally mullet, but sharks and flying fish were numerous.'

He also noted: 'No inhabitants were seen, but in every part where I landed, fires had been made, and the woods of Cape Clinton were then burning.'

Westall's Admiralty oil painting features Australian Aboriginals that were not to be seen in the immediate vicinity, with one standing carrying a dead kangaroo. However, his composition does tally with the captain's observations of the pine trees. Large pine trees dominate the right side of Westall's composition. The artist's preferred palette is displayed in the sepia tones with red tints of the foreground landscape that contrast with the pale blue and green hues of the background coastline.

The hoop pine trees (*Araucaria cunninghamii*) native to Australia are prominently featured by Westall. Flinders considered the prospective benefits of this timber and observed, 'There were pine trees in the watering gully and on the neighbouring hills; but the best, and also the most convenient, were those upon Entrance Island, some of them being fit to make top masts for ships. The branches are very brittle; but the carpenter thought the trunks were tough, and superior to Norway pine, both spars and planks: turpentine exudes from between the wood and the bark, in considerable quantities.'

Flinders also recorded that 'good' water could be found in the area and that Westall's 'sketch' was valuable to determine its location. In this instance the word 'sketch' refers to the coastal profile featured in the atlas of the official voyage publication. He wrote, 'The water was very good; it drained down the gully to a little beach between two projecting heads which have rocky islets lying off them. The gully is on the west side of the entrance, and will easily be known, since we sent there on first coming to an anchor, in the expectation of finding water, but Mr Westall's sketch will obviate any difficulty.'

There are significant changes in terms of the depiction of the flora in the engraved illustration compared to the Admiralty painting. The flora was enlarged in the illustration to create a luxuriant landscape setting with birds of various kinds in the foreground, middle and far distance. Banks was so delighted with this elaboration in John Scott's

engraving that he arranged to pay him an additional fee. On 10 May 1813 he wrote to John Wilson Croker at the Admiralty stating that, 'the Plate so much Exceeds my Expectations'.

The inclusion of the engraved illustration in the text volume, in conjunction with the coastal profile in the atlas work, together highlight this part of the Australian coastline as a safe anchorage in which to replenish and repair ships.

The expedition drawings that relate to the development of this Admiralty oil painting are addressed in chapter 4.

Westall's Admiralty painting represents Flinders' success in traversing not just the entire south coast of Australia but also a significant part of the eastern coastline, as well as in locating this area – one overlooked by Cook and which offered an abundance of pine trees and nearby water thus providing sailors a safe place to replenish and repair ships.

View of Cape Townsend and the Islands of Shoal Water Bay, taken from Mount Westall

[August 1802] Oil on canvas, 34¼ x 50¼ in (87 x 127.5 cm).
Painted by March 1810.
Exhibited at the Royal Academy of Arts in 1810.
Not engraved for the voyage publication. The title derives from the *Admiralty catalogue* (1911).

This painting was displayed at the Royal Academy of Arts in 1810, with a different and long-winded title given in the exhibition catalogue: *Distant view of the Islands of Cape Townsend, from a mountain near Cape Manifold, on the east coast of New Holland. Long 150°, lat 22°, discovered by Capt. M. Flinders, etc, March 1802* [should read August 1802]. The date in the title is an error as the expedition was on the south Australian coast in that month.

Captain Cook had named Cape Townsend after Charles Townshend, 1st Baron Bayning, who served as a Lord of the Admiralty from 1765 to 1770. His surname includes an 'H', which Cook omitted. Cook also named Cape Manifold (part of the Royal Academy of Arts title) and Shoalwater Bay (also spelled Shoal Water Bay). The former was first sighted by him from Keppel Bay on 27 May 1770 and derived its name 'from the Number of high hills over it'. He first sighted Shoalwater Bay on 28 May 1770.

On 26 August 1802 Flinders recounted in the voyage publication that he 'landed with a party of the gentlemen, and ascended the highest of the hills on the eastern side. From the top of it we could see over the land into Port Bowen; and some water was visible further distant at the back of it, which seemed to communicate with Shoal-water Bay. Of the passage where the ship was lying, there was an excellent view; and I saw not only that Cape Townshend was on a distinct island, but also that it was separated from a piece of land to the west, which captain Cook's chart had left doubtful'.

He continued: 'Wishing to follow the apparent intention of the discoverer, to do honour to the noble family of Townshend, I have extended the name of the cape to the larger island, and distinguish the western piece by the name of *Leicester Island*. Besides these, there were many smaller isles scattered in the entrance of Shoal-water Bay; and the southernmost of them, named *Aken's Island* after the master of the ship.'

After the *Investigator* reached Port Jackson, Flinders selected John Aken as master of the ship to replace John Thistle who had drowned in Port Lincoln. Aken was later detained in Mauritius with Flinders, but was released before him and returned to London.

The 'Mount Westall' given in the title of the painting listed in the *Admiralty catalogue* (1911) is directly connected to William Westall. Flinders named it as a tribute to him. He stated in the voyage publication, 'The view was, indeed, most extensive from this hill; and in compliment to the landscape painter, who made a drawing from thence of Shoal-water Bay and the islands, I named it *Mount Westall*.* (*A painting was made of this view, and is now in the Admiralty; but it has not been engraved for the voyage).'

Flinders continued: 'Mount Westall and the surrounding hills are stony, and of steep ascent; pines grow in the gullies, and some fresh water was found there … No natives were seen during our walk, and only one kanguroo.'

Robert Westall recounted in his obituary of his father, published in the *Art Journal*, how Mount Westall derived its name, as well as offering insight into his father's working method: 'One of the most remarkable proofs of young Westall's powers of enduring fatigue and of his enthusiasm for his art, was shewn (*sic*) in an expedition to the summit of a mountain near Port Bowen on the N. Eastern coast of Australia. Captn Flinders proposed that a large party should set off and whoever first reached the summit should have the honour of its being named after him. Mr W. was the first who gained the summit.'

He continued: 'In the meantime [he was] struck with astonishment at the magnificent prospect which lay beneath him, comprising Broad Sound and Shoalwater Bay, with a horizon of sea, extending beyond the most distant of the Northumberland Isles which lay northwards … Mr Westall, notwithstanding his fatiguing climb commenced sketching and was engaged for three hours in depicting the splendid panorama at the end of which time, the grateful scent arising from the boiling pot, the rest of the far-lagging party having joined them, somewhat checked his enthusiasm.'

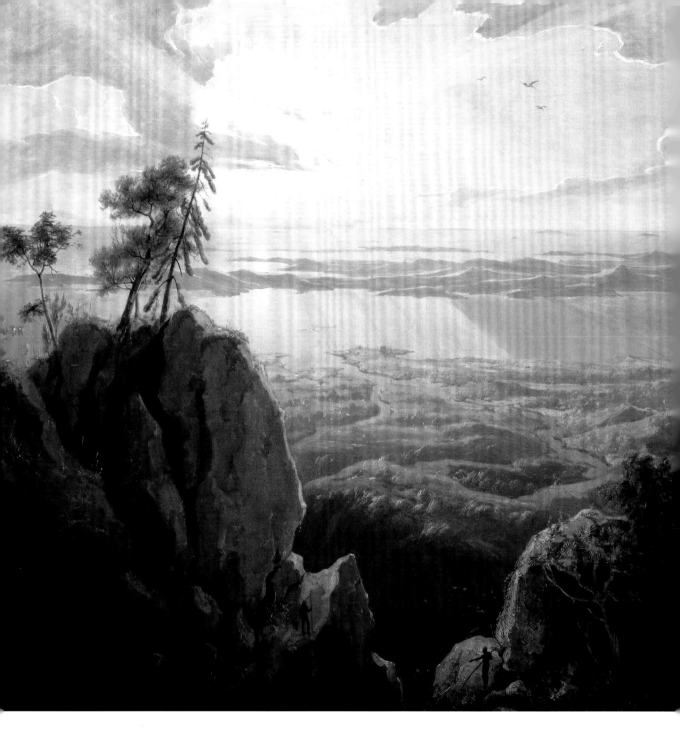

View of Cape Townsend and the Islands of Shoal Water Bay, taken from Mount Westall, [August 1802] painted in 1810, by William Westall (1781–1850), oil on canvas. National Maritime Museum, Greenwich. ZBA7914. The expedition drawings by Westall relating to this painting reveal that some were drawn in late August and others in early September.

He concluded: 'But the sketch produced was one of the most elaborate and was said by Flinders to comprise one of the most important discoveries made in the course of the voyage … The subject of this sketch … is embodied in a picture now in the possession of the Admiralty.'

View of Murray's Island, with Natives offering to barter

[October 1802] Oil on canvas, 24 x 34 in (61 x 86.5 cm).
Painted by November 1812. Engraved by John Pye and William Finden.
The title derives from the *Admiralty catalogue* (1911) and is almost identical to the illustration in the voyage publication.

'Murray's Islands' are situated in the eastern area of the Torres Strait close to the northern end of the Great Barrier Reef and around 120 miles from the farthest northern point of Cape York. Three islands are inhabited – Murray (Mer), Dowar islet and Wyer islet – with Murray the largest and populated by the Melanesian Meriam people.

They were named by Captain Edward Edwards whose Admiralty mission in the *Pandora* was to search for the *Bounty* and her mutineers in 1790. On 29 August 1791 she was wrecked close to the 'Murray's Islands' on her homebound voyage, although Edwards eventually returned to England with 78 original crewmen and 10 mutineers. Edwards wrote, 'The islands, which I called *Murray's Islands*', although why precisely is not yet known.

He continued: '[they] are four in number, two of them are of considerable height and may be seen twelve leagues. The principal island is not more than three miles long. It is well wooded and at the top of the highest hill the rocks have the appearance of a fortified garrison. The other high island is only a single mountain almost destitute of trees and verdure. The other two are only crazy barren rocks.'

Flinders was almost certainly familiar with key parts of Edwards' voyage. Edwards had observed the presence of vessels from Murray's Islands as he had sailed in the same waters under Captain William Bligh aboard the *Providence* on his second successful breadfruit voyage.

A comparison between Flinders' voyage publication record of 30 October 1802 and Westall's oil painting shows that they correlate closely. Flinders observed, 'We had scarcely anchored when between forty and fifty Indians came off, in three canoes. They would not come along-side of the ship, but lay off at a little distance, holding up cocoa nuts, joints of bamboo filled with water, plantains, bows and arrows, and vociferating *tooree! tooree!* and *mammoosee!* However, their initial reticence to engage with the explorers soon passed and Flinders noted that 'A barter soon commenced.'

He continued: 'The colour of these Indians is a dark chocolate; they are active, muscular men, about the middle size, and their countenances expressive of a quick apprehension … our friend Bongaree [proper name Bungaree, an

LEFT

Mount Westall, view north across Strong Tide Passage and Townshend Island, inscribed, 'Sept. 2nd…', drawn in 1802 by William Westall (1781–1850), graphite on paper. National Library of Australia. nla.obj-138884527.

Aboriginal Australian from Broken Bay, north of Sydney who was on the *Investigator* as a translator] could not understand anything of their language … The arms of these people have been described in the voyage of captain Bligh; as also the canoes, of which the annexed plate, from drawings by Mr Westall, gives a correct representation. The two masts when not wanted are laid along the gunwales; when set up, they stand abreast of each other in the fore part of the canoe, and seemed to be secured by one set of shrouds, with a stay from one mast head to the other.'

In addition to being a commemoration of Flinders' encounter with the 'Indians' there is also evidence of another significant reason for the creation of the oil painting and its inclusion as an illustration in the voyage publication. Flinders stated that, 'Murray's Islands may be considered as the key to the best passage yet known through Torres' Strait.'

Flinders qualified this statement with the following details, which revealed that the passage he identified was suitable only for small vessels in good weather conditions. He wrote, 'This opening is a mile wide, and lies five or six miles, nearly E.N.E., from the largest of Murray's Islands; it would consequently be more direct to pass through it than follow the Investigator's track round the north-eastern reefs; but from the narrowness of the opening and the many green spots where the depth is unknown to me, I dare not recommend it to a ship though very practicable for small vessels in fine weather.'

In fact, Flinders considered this discovery of such importance that on 12 November 1803 he wrote from the *Cumberland* in Coepang Bay (now Kupang Bay) in Timor, to Philip Gidley King, the third Governor of New South Wales (succeeded by William Bligh), to relay the information. It took some time for King to read the letter as it arrived in Sydney in April 1805 during Flinders' prolonged detainment in Mauritius. The engraved illustration therefore can also be viewed as a pictorial promotional link to Flinders' navigational discovery offering practical and potentially economic value to seafarers.

More detailed information such as this would also have been conveyed to the British East India Company who provided *batta*, or 'table money', for Flinders and the 'scientific gentlemen' – half before the voyage and half on their return – for any useful intelligence gleaned during the voyage. This would have been facilitated and sanctioned by Banks.

The Torres Strait was of significance to Cook and Banks on the *Endeavour* expedition.

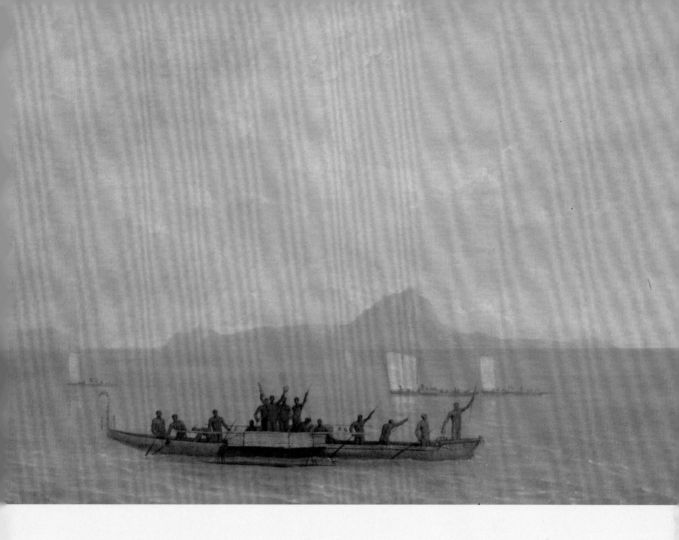

On 22 August 1770 at Possession Island in the Torres Strait Islands group, Cook had claimed British sovereignty in the name of King George III. He wrote in his journal that he, 'took possession of the whole Eastern Coast … by the name New South Wales, together with all the Bays, Harbours Rivers and Islands situate upon the said coast'. The area would later become part of Queensland. Cook was marking out this eastern strip from the larger western area called New Holland that related to earlier Dutch exploration, discoveries and prospective claims. However, those claims did not materialise.

The expedition artworks from the National Library of Australia that relate to the Admiralty oil painting include the drawing catalogued as, *Murray's Isles, natives offering goods for barter* that features the largest canoe in close up view with figures; and a drawing inscribed, *Murray's Isles Oct. 29th 1802* that depicts a mid-range view of canoes set against the backdrop of the islands. These were referenced by Westall for his watercolour inscribed, *Murray's Isles Oct. 29th 1802* that is a close match to the oil painting in terms of the configuration of figures and their gestures although there are some differences – notably in the number

of canoes depicted and the arrangement of some of the Aboriginals. In addition the mountainous island backdrop of the oil is less prominent and no birds are visible. The watercolour was badly damaged by salt water at Wreck Reef.

Westall's Admiralty painting represents not only an exotic encounter, but a mutually beneficial one, with an amicable indigenous people – the Torres Strait Islanders – willing to barter. As specified by Flinders elsewhere in the main publication text, this area was also the key to a short-cut route through the treacherous Torres Straits, and hence the image is a visual reminder of the *Investigator*'s success in identifying an economic benefit for seafarers and traders.

ABOVE

Murray Isles [i.e. Islands], *natives offering goods for barter*, drawn in 1802, by William Westall (1781–1850), graphite on paper. National Library of Australia. nla.obj-138892598. One of the expedition drawings Westall used to produce his oil painting.

View in Sir Edward Pellew's Group; – Gulph of Carpentaria

> [December 1802] Oil on canvas, 24 x 34 in (61 x 86.5 cm).
> Painted by December 1811.
> Engraved by John Pye. Exhibited at the Royal Academy of Arts in 1812.
> The title derives from the illustration in the voyage publication.
> In the *Admiralty catalogue* (1911) it was titled *View of Sir E. Pellew's Groups, Gulf of Carpentaria, discovered by Captain Flinders in 1802.*

The painting was exhibited at the Royal Academy of Arts in 1812 with a different and long-winded title in the catalogue: *View from one of Seaforth's islands, in the gulph of Carpentaria, in lat 15°16"S long 136°40"E, discovered by Capt. Flinders, Dec. 16, 1802. Painted by command of the Lords Commissioners of the Admiralty to illustrate Capt. Flinders' voyage.*

The view is from Cabbage Tree Cove on the east shore of North Island with Vanderlin Island in the background. They are two islands of five that are still known today as the Sir Edward Pellew Group. The painting has important botanical and cartographical connections.

The Royal Academy of Arts title is complex and long, and so this subject is usually known by that used for the engraved illustration: *View in Sir Edward Pellew's Group; – Gulph of Carpentaria.* However, the original exhibition title was specifically created with Banks' input and this is reflected in the name 'Seaforth'. Francis Humberston Mackenzie, 1st Baron Seaforth, and other family members were well known to Banks and Robert Brown.

Baron Seaforth was familiar to Banks for several reasons: he had inherited considerable estates in Lincolnshire, although his money (and debts) were accumulated by focusing on those in Scotland; he was a fellow of the Royal Society and the Linnean Society; and he was an enthusiastic botanist and plant collector, who during his governorship of Barbados in 1801–06 had sent back home specimens to Banks.

Brown named a palm tree after the family name *Seaforthia elegans* (elegant palm) whose habitat is in eastern Queensland and northern Australia. Banks had been a good friend of Seaforth's older cousin Kenneth Mackenzie, 1st Earl of Seaforth (1744–81), who died without a male heir and so passed the title to Francis. He was depicted in Sir Joshua Reynolds' *The Dilettanti Gem Group*, which also featured Banks.

The botanist James Britten in *The Journal of Botany – British and Foreign* (1912) cited Baron Seaforth's entry in the Rev. Abraham Rees' (ed.) *The Cyclopædia; or, Universal Dictionary of Arts, Sciences, and Literature* in which he was described as 'a liberal and very intelligent cultivator and patron of botany, who enriched the gardens of Britain with numerous West Indian varieties and Brown, in dedicating to him the genus *Seaforthia*, styles him "botanicus periti cultoriss et Fautoris"'.

However, the initial naming of the islands as 'Seaforth' was short-lived in deference to the wishes of Flinders. Banks appears to have accepted the name change without question.

For the engraved illustration of the painting the title omitted any reference to Baron Seaforth; instead Flinders was able to feature his preferred name, Admiral Sir Edward Pellew, 1st Viscount Exmouth. He explained his reasons in the voyage publication, recounting that he had done this 'in compliment to a distinguished officer of the British navy, whose earnest endeavours to relieve me from oppression in a subsequent part of the voyage [his detainment in Mauritius] deemed by gratitude, I have called this cluster of islands Sir Edward Pellew's Group'.

He continued: 'The space occupied by these islands is thirty-four miles east and west, by twenty-two miles of latitude; and the five principal islands are from seven to seventeen miles in length.' And: 'Of the "five principal islands": North Island, West Island, Centre Island, South West Island and Vanderlin Island, the last is the largest of the group.' The name of this vast area where they are situated is

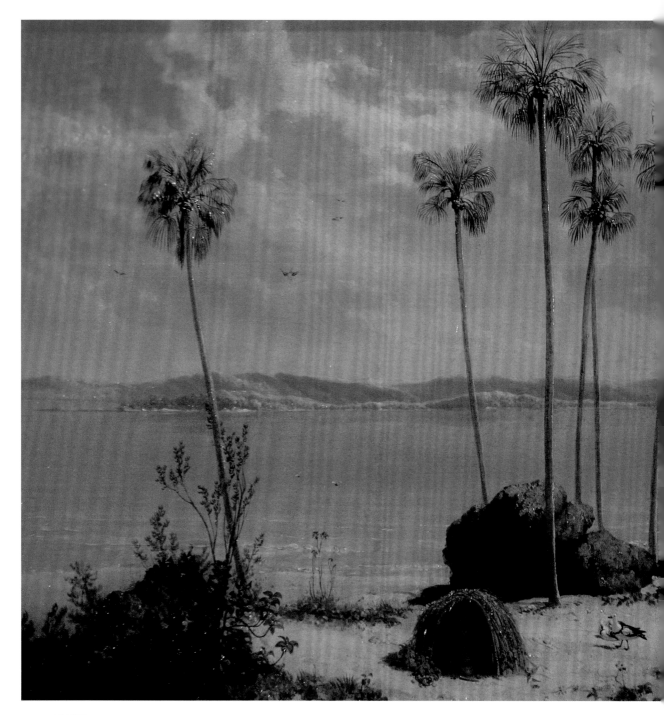

View in Sir Edward Pellew's Group; – Gulph of Carpentaria,
[December 1802] painted in 1811 by William Westall (1781–1850),
oil on canvas. National Maritime Museum, Greenwich. ZBA7944.

the Gulf of Carpentaria, a name that reflects earlier Dutch exploration. It had been explored by Jan Cartensz in 1623, and it was named after Pieter de Carpentier, the governor of the Dutch East Indies.

Vanderlin Island had been named after Cornelis van der Lijn the governor-general of the Dutch East Indies from 1646 to 1650, who was a supporter of Abel Tasman's voyages of exploration in the early 1640s. Tasman had speculated – inaccurately – that the group of islands were part of mainland Australia. He believed that Vanderlin was a cape. Flinders proved it was an island, and pondered in the voyage publication on why Tasman had failed to identify it correctly. The background of Westall's oil painting is confirmed by Flinders in his own words: 'the land in the back ground is Vanderlin's Island'.

On 16 December 1802 Flinders recorded the discovery of the Cove: 'My attention was attracted by a cove in the Western shore, upon the borders of which, more abundantly than elsewhere, grew a small kind of cabbage palm, from whence it was called *Cabbage-tree Cove*. This presented the appearance of a complete little harbour.' Unfortunately, the water of what Flinders called the 'complete little harbour' was too shallow for the ship's boats to navigate.

A key part of Flinders' exploration mission was the recording of geographical information in terms of ruling in or out areas of Australia that might be useful for Britain in terms of refreshing visiting ships, and also the potential for future colonial settlement. In the voyage publication he noted of the islands in the group that, 'in no case did I see any near approach to fertility; yet all the larger islands and more especially the western side of Vanderlin's, are tolerably well covered with trees and bushes, and in some low places there is grass'.

Flinders remarked on cabbage palms (which Westall specifically places in a dominant central position in his painting) in the voyage publication: 'The cabbage palm, a new genus named by Mr Brown *Livistona inermis*, is abundant; but the cabbage is too small to be an interesting article of food to a ship's company and of the young leaves, drawn into slips and dried, the seamen made handsome light hats, excellent for warm weather.' Flinders also noted that nutmeg was found on Vanderlin's Island and that sandalwood had been discovered by Robert Brown.

Flinders wrote in relation to the engraved illustration of the subject: 'Under a shed of bark were set up two cylindrical pieces of stone, about eighteen inches long; which seemed to have been taken from the shore, where they had been made smooth from rolling in the surf, and formed into a shape something like a nine pin. Round each of them were drawn black circles, one towards each end; and between them were four oval black patches, at equal distances round the stone, made apparently with

ABOVE

*Sir Edward Pellew's Group,
Vanderlin's Island from
Cabbage tree Cove, North
Island*, drawn 21 December
1802 by William Westall
(1781–1850), graphite on
paper. National Library of
Australia. nla.obj-138889143

charcoal. The spaces between the oval marks were covered with white
down and feathers, stuck on with the yolk of a turtle's egg, as I judged
by the gluten and by the shell lying near the place.'

He continued: 'Of the intention in setting up these stones under
a shed, no person could form a reasonable conjecture; the first idea
was, that it had some relation to the dead, and we dug underneath to
satisfy our curiosity; but nothing was found.' He added: 'This simple
monument is represented in the annexed plate [Westall's engraved
illustration], with two ducks near it.'

The indigenous Australian specialists John Bradley and Amanda
Kearney in '"He painted the law": William Westall, "stone monuments"
and remembrance of things past in the Sir Edward Pellew Islands', in
Journal of Material Culture (2011) provide insights into the historical
and modern-day significance of the 'two cylindrical pieces of stone'.
They noted: 'These stones are *kundawira*, powerful memorial stones
associated with the death rites of the Yanyuwa. Today, *kundawira* can
be found scattered across the coastal margins of Yanyuwa territories;
however, they are no longer used in the daily and ritual lives of Yanyuwa
elders and their families.' They note that the Yanyuwa Aboriginal people
have a longstanding association with Barranyi (North Island).

Bradley and Kearney convey their approval of the painting in terms
of the way 'Westall manages to convey a sense of the bleached blue of

the tropical North, but also the long, low horizon so typical of this area of Australia'.

Bernard Smith was also enamoured with the artwork, stating in *European Vision and the South Pacific* (1988) that it was remarkable for its 'sustained and uncompromising high tonality throughout'. He went on to note that Westall was 'clearly seeking to render the visual effect of ... the blinding sunlight of a tropic noon'.

The art historian Elisabeth Findlay – in the catalogue for the exhibition *Turner to Monet: the triumph of landscape* held at the National Library of Australia in 2008 – acknowledged Smith's observations and also considers how Westall's artwork differed from 'standard Picturesque paintings'. She wrote: 'It is notable both for its heightened sense of light and the well-defined horizontal lines, delicately intersected by palms. In standard Picturesque paintings the foreground is dark and brooding, receding to a light background, usually with one tall feature, such as a tree or a mountain, placed at the side to frame the composition. By placing the palms in the centre of a sun-drenched vista, Westall negates this customary sense of recession and avoids neatly enclosing the scene; instead it is left open, clear and light.'

There is only one recorded expedition drawing that directly relates to this painting. It is titled *Sir Edward Pellew's Group, Vanderlin's Island from Cabbage tree Cove, North Island*. The drawing is also squared up for transfer, although there are some notable differences between the drawing and the oil painting. Bradley and Kearney note that the drawing, 'is in many regards a much more realistic view of the Pellew Islands. The cabbage palms, central in both pictures are much more realistic in the original sketch than the stylized palms in the painting. Vanderlin Island has a much lower profile that more accurately reflects the reality, as does the distance between the rock formations and the actual sea. In the painting, the scene is presented as a near idealized tropical beach. The east coast of North Island from where the view is constructed is quite rocky with little beach area.'

Westall's Admiralty painting represents a harmonious and idyllic scene in the Northern Territory. The landscape backdrop of Westall's painting depicts Vanderlin Island surveyed by Flinders, which Abel Tasman mistakenly believed to be part of mainland Australia. Yet this optimistic image, with botanist and botanical associations, is at odds with the reality that Flinders would soon have to abandon the mission, leaving parts of the Australian coastline to be surveyed by others, and return post-haste to Port Jackson as the *Investigator* was leaking so badly.

ABOVE

Admiral Edward Pellew, 1st Viscount Exmouth (1757–1833), painted in 1804 by James Northcote (1746–1831), oil on canvas. National Portrait Gallery, London. NPG140. The portrait reflects the courageous nature and dutiful service of this distinguished officer.

View of Malay Road from Pobassoo's Island

[February 1803] Oil on canvas, 24 x 34 in (61 x 86.5 cm).
Painted by March 1813. Engraved by Samuel Middiman.
The title derives from the illustration in the voyage publication.
It is described in the *Admiralty catalogue* (1911) as *View of Malay Bay from Pobassos Island.*

Pobassoo's Island was named by Flinders after Pobassoo, the Malay chief of a fishing fleet encountered in February 1803. The meeting with the chief also inspired the naming of their meeting place: Malay Road in Malay Bay.

Pobassoo Island is part of The English Company's Islands, in the Northern Territory of Australia. It is 122 miles from Groote Island and 256 miles from Vanderlin Island.

The chief was 'in charge of six proas, a unit in the larger fleet of sixty encountered in Malay Road'. Several fishing vessels are clearly visible in the right mid-distance of Westall's painting. Flinders noted in the voyage publication that on 17 February 1803, 'Under the nearest island was perceived a canoe full of men; and in a roadsted [*sic*], at the south end of the same island, there were six vessels covered over like hulks, as if laid up for the bad season.'

Flinders recounted in the voyage publication, 'So soon as the prows [*sic*] were gone, the botanical gentlemen and my self proceeded to make our examinations. The place where the ship was anchored, and which I call *Malay Road,* is formed by two islands: one to the S.W., now named *Pobassoo's Island.*' He also observed that, 'The proas were … of about twenty-five tons and carried twenty or twenty five men each. Pobassoo's proa mounted two small brass guns obtained from the Dutch.'

Flinders also named several of the islands in the vicinity after officers of the Hon East India Company (including Astell, Inglis, Bosanquet and Wigram, with the whole cluster named the English Company's Islands) as a tribute to their financial support of the *Investigator* voyage. He wrote, 'Malay Road is formed by two islands: one to the S.W., now named Pobassoo's Island, upon which was a stream of fresh water behind a beach; the other to the north, named Cotton's Island, after captain Cotton of the Indian directory'.

On the morning of 18 February Flinders noted that, 'I went on board Pobassoo's vessel, with two of the gentlemen and my interpreter, to make further inquiries and afterwards the six chiefs came to the *Investigator*, and several canoes were along-side for the purpose of barter'.

Flinders met 'a short, elderly man' (Pobassoo) and discovered that his vessels were part of a much larger fleet of ships belonging to the Rajah of Bori (Celebes) that had sailed from Macassar with the north-west monsoon in December. He recorded that Pobassoo 'said they were upon the coast in different divisions, sixty prows [*sic*], and that *Salloo* was the commander in chief'. They fished in the Gulf of Carpentaria for sea cucumber (trepang or bêche-de-mer), which was dried and then transported to the Tanimbar Islands (Flinders calls them Timar-laoet) in the Maluku province of Indonesia where it was sold to Chinese merchants.

During this encounter Westall had the opportunity to create his pencil portrait of Pobassoo. The loose-fitting garment and turban-like headgear of his attire depicted by Westall are the likely inspiration for the garb of the foreground figure in the Admiralty oil, although it is not clear if the figure is supposed to be a specific portrait of Pobassoo. Flinders makes no reference to Westall's engraved illustration in the voyage publication.

Westall's oil painting at first sight brings into mind a neoclassical warrior looking out towards the fishing vessels at anchor in a brooding landscape with an approaching monsoon. He holds a spear in his right arm and in the left he clutches a vivid red garment or piece of cloth. His demeanour is uncertain and his subsequent actions unknown, but it is possible that he is signalling to the fleet. Westall has created a scene in *Terra Australis* that evokes one from ancient Greece or Rome. The style linked to Banks' fascination with the classical world and neoclassicism. Westall certainly referenced earlier paintings and prints by and after Claude, Gasper Dughet, Richard Wilson and William Hodges, as well as other artworks, to compose his painting.

In addition to the portrait in graphite of Pobassoo, there are four other drawings associated with the Admiralty oil painting by Westall in the National Library of Australia. The closest match to the painting is entitled, *The English Company's Islands, Malay*, which features the

BELOW

The English Company's Islands, Malay Road, drawn in 1803, by William Westall (1781–1850), graphite on paper. National Library of Australia. nla.obj-138887179.

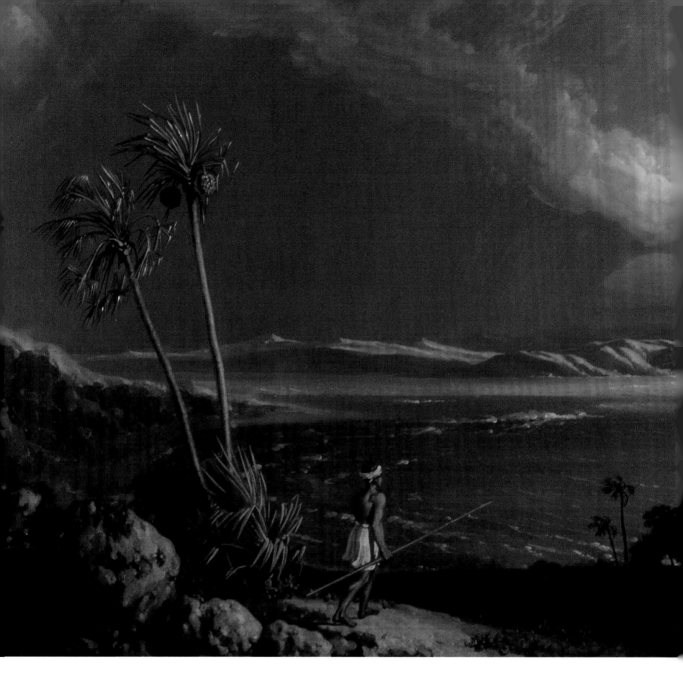

sweeping coastal landscape. A second drawing features a distant view of the fishing fleet alongside the *Investigator* and is titled, *The English Company's Islands, the Malay fleet*. The third and fourth depict close-up views of a proa under sail and both are catalogued as, *The English Company's Islands, Malay proa*.

Westall's Admiralty painting represents an exotic encounter in terms of the meeting with a fleet of Malay fishermen and their chief Pobassoo. Inspired by Westall's pencil portrait of the chief, the foreground classical figure looks out to sea in a brooding landscape with an oncoming monsoon. Such a subject was conceived to engage with the sensibilities and tastes of Banks' influential circle that included members of the Dilettanti Society.

View of Wreck-Reef Bank, taken at low water

[August 1803] Oil on canvas, 23½ x 34 in (59.5 x 86.5 cm).
Painted by July 1813. Engraved by John Pye.
The title derives from the voyage publication, and is almost
identical to the title in the *Admiralty catalogue* (1911).

Wreck Reef, or Wreck Reefs, is located in the southern part of the
Coral Sea Islands around 280 miles from the city of Gladstone in
Queensland.

On 10 August 1803 Flinders left Port Jackson as a passenger aboard
the *Porpoise,* an old Spanish prize attached to the colony, which had
been sent out to Sydney by Banks with plants that he considered 'useful
or necessary' for the colony. Flinders in the *Porpoise* was accompanied
by the *Cato* of around 450 tons, built in Stockton-on-Tees and
commanded by Mr John Park. Also with them was the Hon. East India
Company's vessel *Bridgewater* of around 750 tons commanded by EH
Palmer. Initially they sailed together, although Flinders' quest was to sail
back to Britain to obtain a seaworthy ship in which he could complete
his surveying around Australia. However, all did not go according to
plan, for on the morning of 17 August 1803 the *Porpoise* and *Cato* hit
the uncharted Wreck Reef Bank.

In Alfred T. Storey's *Lives of James Holmes and John Varley* (1894)
he recounts first-hand information purportedly derived from William
Westall (although it is more likely to have come from his son Robert
Westall): 'The *Porpoise* stuck fast, but the *Cato* rolled over and sank
in deep water, her men having barely time to scramble on shore.
Westall used to say that it was a miracle that many more did not lose
their lives, as when the catastrophe happened nearly all the men were
playing cards in the forecastle.'

The *Bridgewater* was on the eastern side of this chain of reefs
measuring around 18.5 miles in length, and sailed away without
attempting any assistance. She successfully reached India where her
captain falsely reported that all lives had been lost aboard the other
two ships.

Westall's painting depicts the tents on the sandbanks with a blue
ensign flying upside down, a widely recognised distress signal (although
meaningless to indigenous people), and the remains of the *Porpoise* to
the left. On 25 August 1803 Flinders noted in the voyage publication
that, 'it will be proper to say something of the sand bank to which we
were all indebted for our lives; In the annexed view of it, Mr Westall
has represented the corals above water, to give a better notion of their
forms and the way they are seen on the reefs; but in reality, the tide
never leaves any considerable part of them uncovered'.

ABOVE

*View of Malay Road from
Pobassoo's Island,* [February
1803] painted in 1813 by William
Westall (1781–1850), oil on
canvas. Pobassoo is also spelt
Pobasso, and sometimes misspelt
Probasso. National Maritime
Museum, Greenwich. ZBA7936.

Flinders continued: 'The length of the bank is about one hundred and fifty fathoms, by fifty in breadth, and the general elevation three or four feet above the common level of high water; it consists of sand and pieces of coral, thrown up by the waves and eddy tides on a patch of reef five or six miles in circuit; and being nearly in the middle of the patch, the sea does no more, even in a gale, than send a light spray over the bank, sufficient, however, to prevent the growth of any other than a few diminutive salt plants.'

Although *Wreck Reef* was the last of Westall's Admiralty oils to be completed, the subject matter was the first to appear in printed form when the Rev. James Stanier Clarke selected it for the frontispiece of his publication *Naufragia, or Historical memoirs of shipwrecks and of the providential deliverance of vessels* (1805). The letterpress of the print reveals that it was 'Drawn by W. Westall', 'Engraved by John Bye' (an error that should read Pye) and 'Published by J. Mawman, 32, Poultry, Augt 10th 1805'.

In Westall's depiction of *Wreck Reef* created for Clarke he has brought the sand-reef with tents and drooping flag into closer view. What is particularly striking about this image, though, is that it is the only one to feature three men in the right foreground: two on a shallow bank and one close by in a boat. The human presence here – not visible in the Admiralty painting or the engraved illustration – visually supports Clarke's compiled stories of human deliverance in *Naufragia*.

A first-hand account of Westall's personal experience of the shipwreck was also featured in *Naufragia* with the heading 'Additional Remarks communicated by Mr William Westall'. The lyrical style of writing heightens the tension of the dramatic incident, although it is likely that Clarke was also involved in the content and writing style. Westall recollected, 'We were assembled in the Cabin … when I suddenly heard the Crew … and hurrying on Deck, beheld Breakers on our Larboard Bow. The Coral Reef showed itself in a long line of Foam, seen indistinctly through Gloom of the approaching

ABOVE

The English Company's Islands, Probasso, [Pobasso] a Malay chief, inscribed, '*Probasso* [Pobassoo] *Malay*', 1803 by William Westall (1781–1850), graphite on paper. National Library of Australia. nla.obj-138888247.

Night. When the Ship struck, one general Groan resounded throughout for not a possibility appeared that anyone could be saved. The Night was remarkably Dark.'

In fact, remarkably few seamen lost their lives. Flinders was instrumental in arranging the rescue of the survivors on Wreck Reef by rowing with a select crew around 700 miles, with some sail assistance, back to Sydney.

Westall considered himself to have been fortunate to survive, although according to Flinders some of his expedition artworks were not so lucky. He noted on 23 August 1803 that 'Mr Westall, the landscape painter, had his sketches and drawings wetted and partly destroyed in his cabin.' The full extent of how many artworks Westall lost or were destroyed is not known.

Flinders' final reference to an artwork by William Westall was noted in his journal on Saturday 31 July 1813. He recorded, 'Mr Westall left with me a painting of Wreck Reef; the last intended for the voyage.'

The drawing in the National Library of Australia titled *View of Wreck Reef Bank taken at low water, Terra Australis* appears to be a preparatory drawing for the Admiralty painting. However, on closer examination this cannot be stated categorically.

The drawing is not consistent with Westall's draughtsmanship during or after the expedition. It displays an uneven and heavy hand that is in sharp contrast to the dexterity of Westall's drawing style, and the foreground details of coral and some flora are poorly represented. This points to the likelihood that this drawing is a later copy after John Pye's engraved illustration originally produced for *A Voyage to Terra Australis*. The inscription on the artwork itself, *View of Wreck Reef Bank taken at low water, Terra Australis*, derives from the letterpress of the illustration from the official voyage publication, although the additional words 'Terra Australis' have been added to the title of the drawing.

Other known artworks loosely relate to Westall's Admiralty oil painting: one is entitled *The wreck of the* Porpoise – in the collection of the National Gallery of Victoria – and the other is entitled *Study for a painting of Wreck Reef* in the National Maritime Museum, Greenwich. The wreck is a background feature in the NGV's drawing, with the primary focus being a close-up view of sailors manoeuvring one of the ship's boats to rescue men from the sea. This drawing relates to the watercolour entitled *Wreck of the* Porpoise, *Flinders Expedition* in the National Library of Australia.

The title given to the National Maritime Museum's drawing of *Study for a painting of Wreck Reef* was probably due to a former cataloguer at the museum. It is squared up for transfer, although it does not correlate to the Admiralty painting. It portrays an imagined aerial view depicting the arrangement of tents erected on *Wreck Reef* – with the *Porpoise* and *Cato* clearly visible – and beyond, a ship sailing away that Westall intended to represent the *Bridgewater*.

An additional watercolour of *Wreck Reef*, now in a private collection, was formerly the property of Mrs B. Westall and appears to be an important developmental artwork relating to Westall's oil painting. The entry in Perry and Simpson's *Westall's Drawings* (1962) noted that, 'This view is similar to the oil painting … but the flag is drooping and there are some minor differences. The colouring is lighter, bluer, and more delicate. It was probably left unfinished by Westall.'

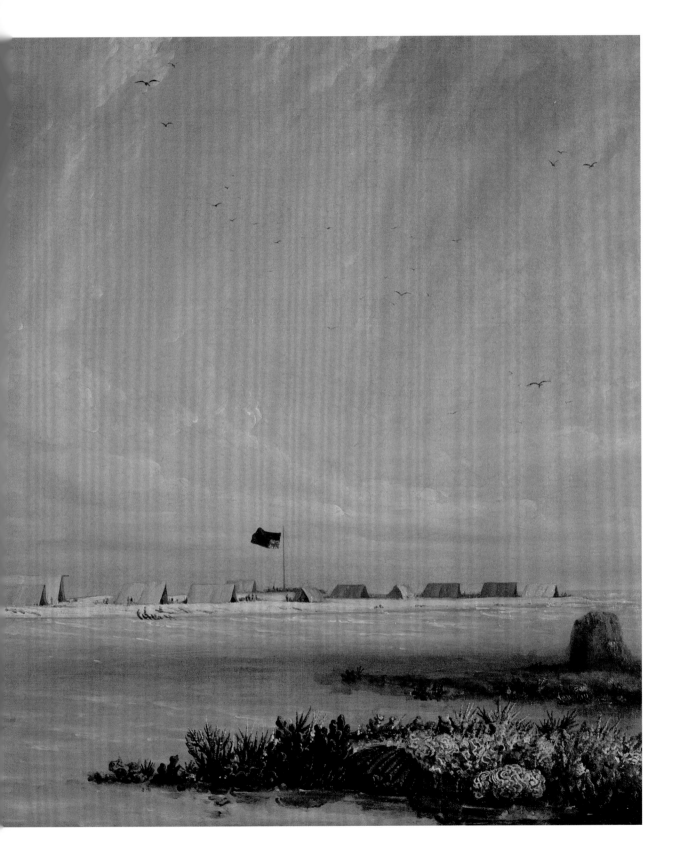

Finally there is a curious drawing sold by Anthony Spink and now in a private collection that is attributed to William Westall and is inscribed *Shipwreck, Wreck Reef*. In the foreground it depicts two survivors on a reef next to a framed picture presumably created by Westall situated close to one of the wrecked ships.

Reviews of Westall's engraved work are scarce. However, a reviewer in *The Eclectic Review* of April 1819 found beauty in the engraved illustration of Westall's *Wreck Reef*. He observed, 'This is but an indifferent subject for the landscape painter; but the associated circumstances, and the perfectly marine character of the view, give a peculiar interest to the very beautiful engraving from Mr Westall's drawing of the surface of the reef last just seen with corals, weeds, and fowls, above the rippling, and of the sand bank, with the two crews amicably united.'

Westall's Admiralty painting represents the determination and heroism of Flinders in terms of surviving the shipwreck of the *Porpoise* and *Cato*, and arranging the rescue of the survivors by reaching Port Jackson in one of the ships' boats. Visually and textually it represents a *Robinson Crusoe*-like chapter in the *Investigator* voyage – a publication that Flinders had read as a youth and one that inspired him to join the Royal Navy.

Willliam Westall's Australian and Pacific subjects created as oil paintings for the Admiralty (three exhibited at the RA) and nine landscape views engraved for *A Voyage to Terra Australis* (eight derived from the series of ten Admiralty oils) were selected by Banks – and later with Flinders' assistance after his arrival back in London post-October 1810 – with the full approval of the Admiralty. Banks and Flinders wanted the Admiralty paintings and associated illustrations to serve a purpose individually and support the others in terms of a coherent visual voyage narrative.

The illustrations were an aid to highlight the success as far as it went of the *Investigator* voyage, to visualise new geographic areas and some notable and memorable incidents and encounters in Australia, and also to counter French claims to territories on that island continent. In addition, they acted as promotional pictures, with the painting and illustration of Kangaroo Island acting as a tempting prospect in terms of British colonial settlement in south Australia.

To complete the series of nine illustrations for the voyage publication, another original artwork by Westall was selected – this time relating to drawings in graphite and watercolour. The engraved illustration (size 16 x 22.6 cm) is entitled *View of Port Jackson, taken from the South Head* and was engraved by John Pye. In both the chronological order of the voyage and in the sequence of the illustrations in the voyage publication, it appears after Port Lincoln and before Port Bowen.

View of Port Jackson, taken from the South Head

Supported by Flinders, Banks wanted to include in the voyage publication an illustration of the colony of New South Wales that he had been instrumental in founding. Westall's composition features a distant view of the colony. In closer view can be seen the grass tree (left), a eucalyptus (right) and a *banksia* (in the centre). The prominent positioning of the *banksia* spotlights yet again Banks' importance in the development of British interests in the Pacific.

In the foreground two seated Australian Aboriginals are beside a fire: a male on a large rock and the woman resting on the ground below. They appear oblivious to the European presence represented by a depiction of Sydney inaccurately described by two lines of buildings in the distance. Westall has transformed them into ancient Europeans. Their stylised hair, attenuated necks (particularly the woman), overlong limbs and postures are rendered in the neoclassical style that fascinated Banks and was advocated by the Society of Dilettanti.

Westall's watercolour in the Mitchell Library, State Library of New South Wales is a close reference source, although there are notable differences in the foreground vegetation, which points to other references being used. The watercolour is inscribed *Port Jackson* on the verso and is signed and dated twice 1804. It is also squared for reproduction.

Recently, a new likely reference source has come to light in the form of a drawing entitled *Port Jackson Harbour, New Holland*. This was drawn by the artist in 1802, and was sold by Deutscher and Hackett auctioneers in Melbourne on 29 November 2017 for $61,000 (Australian dollars). It is a fairly close correlation to the engraved illustration, albeit devoid of the neoclassical figures.

Westall used additional expedition artworks to develop the watercolour of *Port Jackson*, including a graphite drawing now in the National Library of Australia, that bears no inscription, and features a similar arrangement of neoclassical Australian Aboriginal figures (albeit with two children beside the woman). The distant stylised view of Sydney is also featured in this drawing.

Another watercolour titled, *Distant View of the Town of Sydney, from Between Port Jackson and Botany Bay* is also similar to the engraving for the voyage publication. It was sold at Christie's Melbourne in 1992 for $198,000 (Australian dollars). The title derives from an inscription on an old label on the reverse of the picture, however it cannot be determined with certainty if this is the watercolour exhibited at the Associated Artists in Water Colours in 1808. Westall's relationship with the watercolour societies is addressed in the next chapter.

There is a Westall watercolour entitled, *Port Jackson, Sydney*, dated 1804, in the V&A Museum, that has been mistakenly suggested as the source for the engraved illustration. It is, however, certainly an associated artwork that features a different arrangement of neoclassical Australian Aboriginals in the foreground and a distant view of Sydney. Stylistically it was produced around the same time as Westall's *Port Jackson* in the Mitchell Library. (Illus p.108.)

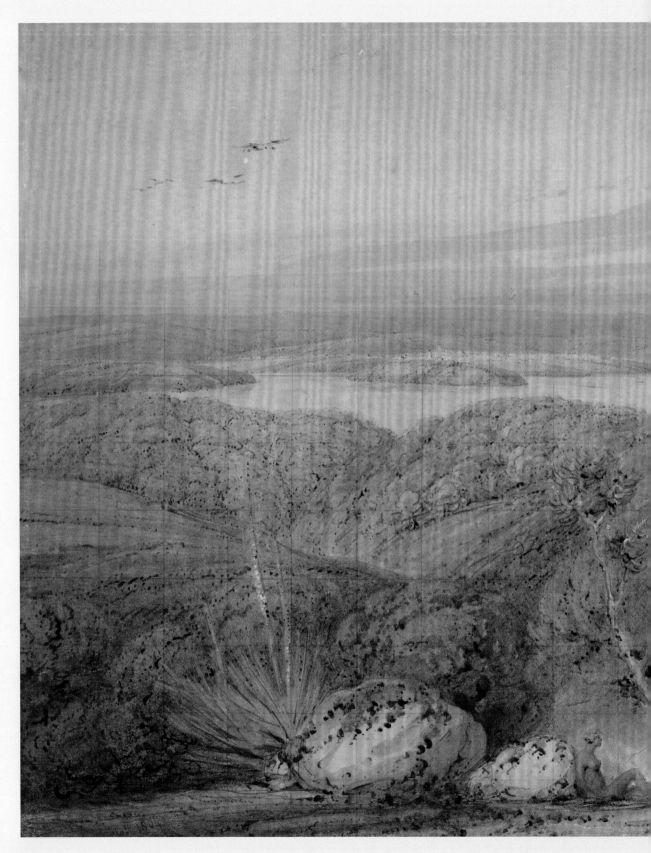

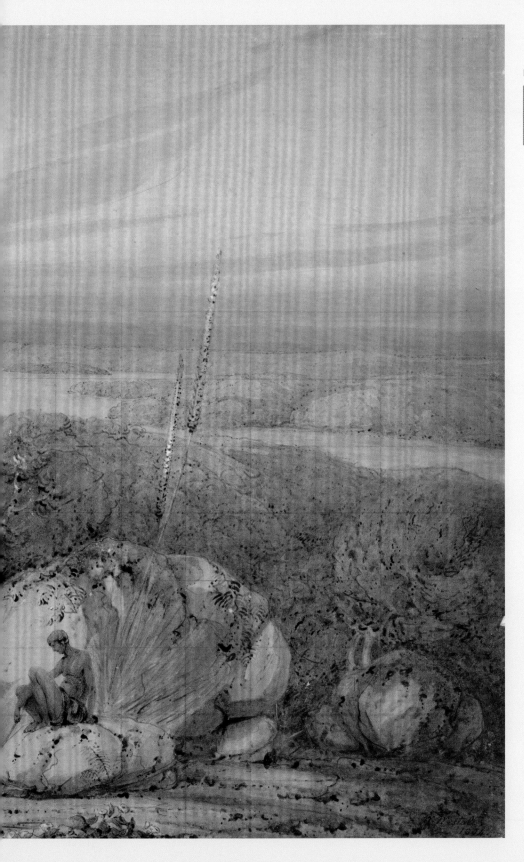

LEFT

Port Jackson; a group of natives, drawn in 1802, by William Westall (1781–1850), graphite on paper. National Library of Australia. nla. obj-138879423. Indigenous Australians executed in a neoclassical style to satisfy the taste of a European audience.

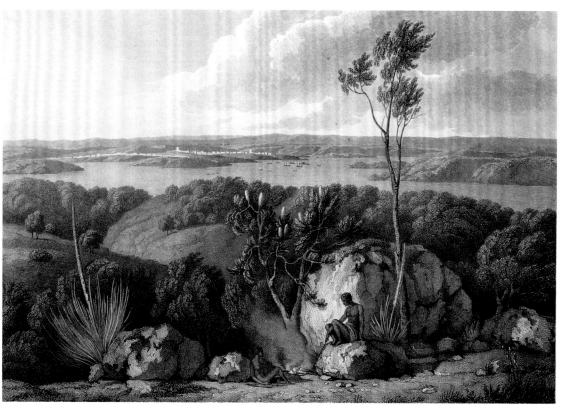

Flinders reveals in his private journal that he met John Pye at 32 Soho Square, who was there to discuss with Banks the subject of the engraved illustration, *View of Port Jackson, Taken from the South Head* (although Flinders mistakenly refers to Pye as Pine). On 5 March 1811 Flinders noted, 'Called at Sir Jos. Banks whom I found engaging Mr Pine to engrave Mr Westall's drawing of Port Jackson.'

Letters from Banks to representatives at the Admiralty indicate the prices paid to John Pye for his engraved work. He engraved four of the nine illustrations for the voyage publication. Pye received 45 guineas for three of the engraved plates, and 50 guineas for the fourth. On 6 January 1812 Banks contacted John Wilson Croker with regard to the payment process for Pye.

Banks wrote, 'I beg to recommend to you the Bearer Mr Pye who brings with him the Proof of a Plate for the illustrations of Capt Flinders' voyage which does him much Credit, I therefore Request of you to submit this Proof to the Lords of the admiralty & to move their Lordships in Case They approve the Plate to give orders that the Sum of Forty Five Guineas the Price agreed for be Paid to Mr Pye.' Sometimes Banks would pay the engravers himself and reclaim the money from the Admiralty. The Admiralty had the opportunity to form their opinion and reject the plate, although there is no evidence of this having occurred.

Banks would have been eager to continue promoting British interests in the Pacific – in particular Australia – but the Napoleonic Wars determined that the focus and finances of the government would largely be directed to matters closer to home for some time to come.

However, what Banks had set in train with the recommendation of Botany Bay as a penal colony, derived from his participation on the *Endeavour* expedition, led to the establishment of the first British colony in New South Wales in 1788; and the continuation of the survey work of Australia with the *Investigator* voyage, championed by him, would after his death lead to free British settlement in South Australia.

PROMOTING AUSTRALIA IN PICTURES

Joseph Banks' encouragement of the voyager artist William Westall and his involvement with free settlement in south Australia

Beyond the Royal Academy of Arts and the British Institution, Banks helped William Westall to exhibit Australian and Pacific pictures at the London-based watercolour societies. Westall was obligated to seek permission from the Admiralty (who relied on Banks' guidance and supervision in such matters) if he wished to exhibit any Australian and Pacific subjects prior to the publication of the official voyage account. He was free to display his Chinese and Indian subjects as they did not represent a conflict with the interests of the Admiralty. Banks provided further access for William to his expedition sketches, drawings and watercolours, which – although they were now officially the property of the Admiralty – were stored at 32 Soho Square.

During Banks' lifetime Westall exhibited three Australian artworks at the Associated Artists in Water Colours in 1808 that were entitled: (1) *Distant View of the Town of Sydney; from between Port Jackson and Botany Bay, New South Wales*; (2) *View on the Coast of New Holland* and (3) *Wreck of H.M.S.* Porpoise *and Merchant Ship* Cato, *on an unknown Coral Reef, near the coast of New Holland*. He also exhibited one at the Society of Painters in Water Colours in 1812, entitled *View of Port Jackson, New South Wales*.

On 16 April 1808 the private view of the first exhibition of the Associated Artists in Water Colours was held at 20 Lower Brook Street, Grosvenor Square in London. Records of that society including correspondence with William Westall are held in the V&A Museum library, and reveal that the exhibition was 'Open from Nine, until dusk' with an admission charge of one shilling and a catalogue sold at sixpence.

From an obituary notice in *The Athenaeum* (2 February 1850) looking back at the life and work of William Westall, it is known that various eminent artists attended, many well known to Banks. They included William Beechey, William Daniell, Joseph Farington, John Landseer, Thomas Lawrence, Thomas Phillips, Benjamin West and Richard Westall.

The engraver John Landseer recollected, 'Of William Westall, having heard much, we were taught to expect much, and were not disappointed. Among all the circumnavigating artists, we have not seen another who so successfully transports us to the various countries which he represents.' He also revealed that the exhibition, 'was insufficiently advertised, and had but few visitors. The day I was there; there was but three other persons in the room, and one of them was the artist's brother'. Although Banks may not have been at the private view, he almost certainly would have visited the exhibition on another occasion.

Landseer was complimentary about William's 'drawings' that 'consisted chiefly of joss-houses, Indian forest-scenes, with banyan trees, Cavern temples, &c, were more effective and more richly coloured than the average of their draughtsman's subsequent productions'.

From the descriptions above, Landseer recollected Westall's Indian and Chinese exhibits, although he only displayed one of each subject. Some of these subjects were particularly well received and noticed in reviews on different occasions too. Surprisingly Landseer makes no reference to the three Australian subjects that were on display.

By the end of June 1809 Westall wrote to the Associated Artists in Water Colours, offering his resignation because of his commitment to what he believed was an agreed commission to produce a

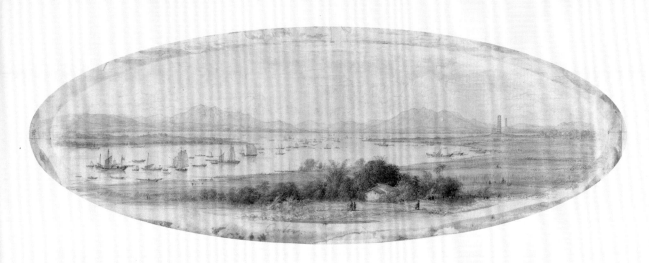

series of Australian oil paintings for the Admiralty.
He stated, 'In the note which I gave you on Friday
last I informed you that I believed I should be able
to contribute ten drawings for the next exhibition. I
now find that from my engagement for oil pictures
it will be impossible for me to make that number
sufficiently large to be of any use to the exhibition or
to my own reputation.'

He concluded: 'Under these circumstances I
think it right to resign my situation as a member
of the Society; I do this with great regret but I
feel strongly the necessity of attending entirely to
the commissions which I have received instead of
employing part of my time in speculations so little
likely to be beneficial to me.'

Westall's disillusionment with the Society and
his lack of success in selling watercolours there can
be discerned in the aforementioned letter extract,
as can his hope that the Admiralty commission
would be beneficial for him. Westall's relationship
with the Society of Painters in Water Colours was
also short-lived and formally ended in 1812. In that
year he exhibited one watercolour entitled *View of*
Port Jackson, New South Wales. It is not yet possible
to determine if this relates to the watercolour in the
Mitchell Library, the one in the V&A, or another
artwork, perhaps the picture sold at Christie's,
Melbourne in 1992.

Farington also noted, 'Thus the impediment
of his [William Westall] being a Candidate for the
situation of Associate of the RA [Royal Academy of
Arts] was done away.' The last statement reveals the
politics and rivalries inherent between the competing
art societies of the time. On 2 November 1812
William Westall was elected an Associate of the Royal
Academy of Arts. In part this was also a reflection of
peer approval of his four Australian exhibits at the
Royal Academy of Arts supported by Banks in 1805,
1810 and 1812.

Promoting Australia through William Westall's illustrations of Australia

As Banks was empowered by the Admiralty to superintend the publication *A Voyage to Terra Australis* (1814) he would certainly have been involved in the production of books of engraved illustrations after William Westall's work that originally featured in the main text volumes. These books of prints have a cover label that is titled *Views of Australian Scenery Painted by W. Westall, engraved by Byrne, Nine Very Fine Plates…*

The wording on the cover label of this set of prints has caused some confusion and raises the question of whether the engraver John Byrne was solely responsible for producing them. An explanation lies in the necessity to compress the extensive title information of the nine prints after Westall's artworks into a simple sales format to fit the cover label.

As John Byrne was the engraver of the first illustration that featured in *A Voyage to Terra Australis*, his name appears first on the label. Byrne was one of six engravers working on the project, all supervised by Banks. They others were William Finden, Samuel Middiman, John Pye, John Scott and William Woolnoth. In fact, John Pye engraved four of the nine plates, with Byrne only producing one.

All the engraved illustrations of *Views of Australian Scenery* are dated 'Feb.12, 1814', as indeed are the prints featured in the official voyage publication; however, there is no conclusive evidence that the sets of prints were issued prior to the publication of *A Voyage to Terra Australis* as has been suggested. The illustrations were a significant promotional sales factor for the voyage publication and it would have been commercially counter-productive to release them prior to the main publication in July 1814.

The engraved plates are all inscribed with the name of the artist and the engraver's name. After Westall's name there are two sets of initials that are included to assert his artistic and scientific credentials. Firstly you can see the initials A.R.A., confirming that he had been elected an Associate of the Royal Academy of Arts – the first step towards being elected a Royal Academician (the highest status within that organisation, with the exception of the presidency).

In addition to A.R.A. you can see the initials F.L.S., the abbreviation for Fellow of the Linnean Society. Westall was elected a fellow not long after his return to London. Banks was the first 'honorary fellow'. Later in 1830 Westall also became a member of the Royal Geographical Society, proposed by various members including Robert Brown.

From the inscription on the labels of several sets of *Views of Australian Scenery* from collections of the National Gallery of Australia, National Library of Australia, the State Library of New South Wales, the State Library of Victoria, and others, it is known that they sold for 15 shillings, £1.1 s, and one guinea.

If Banks was not the driving force behind the production of these sets of prints on behalf of the Admiralty, he certainly would have been consulted. Profit from the sales were presumably being paid to the government, although the returns would have been modest indeed, especially compared to the costly production of the expedition account.

A small number of reviews of the publication that focused on Westall's imagery – and to a far lesser extent Ferdinand Bauer – were published. Their work received praise, although there was also some criticism for Westall too.

In September 1814 *The Critical Review, or Annals of literature* included a lengthy review of Flinders' *A Voyage to Terra Australis*. However, the writer simply listed the illustrations and declared them to have 'enriched' the publication.

In December 1814 the critic of the *Literary Panorama and National Register* proclaimed that,

'National works should be executed in a style to do credit to national abilities … but the views, engraved by various artists, are extremely creditable to the state of science, and the arts among us. These are from the pencil of Mr William Westall, who accompanied the expedition, as a professional landscape painter. Several of the pictures have acquired him great reputation in late exhibitions. The minor views are also touched with spirit, and may be accepted as accurate.'

In *The Monthly Review* of May 1815 the picturesque nature of Westall's subjects was noticed and the selection of subjects found wanting. The writer noted, 'The views accompanying the narrative are engraved from drawings taken by Mr Westall. They possess great delicacy, both the designs and the engravings being picturesque representations of nature: but, except in two or three of the plates, the artist has left us to wish that he had directed his choice of subjects to such as would have conveyed more new information.'

A similar sentiment was conveyed in *The Eclectic Review* of April 1819 whose writer found beauty in the engraved illustration of Westall's *Wreck Reef*. However, on the whole the critic was not enamoured with the publication itself. He stated that the reader would find 'very little, from the nature of the case, of moral interest, but little of entertainment, in a higher or humbler sense, but little diversity of novelty (for the immense extent of the tract) of the objects in natural history, and a destitution quite marvellous of whatever could enchant or elate the imagination with aspects of the picturesque'.

Perhaps the contributors to the *Monthly Review* and *Electric Review* were comparing Westall's subjects with those illustrations featured in the earlier Pacific publications of Dr Hawkesworth and Cook, or perhaps with those relating to New South Wales by Governor Arthur Phillip (1789), John White (1790) and David Collins (1798, 1802, 1804). Collectively these offered descriptions and featured images of a more engaging, exotic and sensational nature.

Flinders died on 19 July 1814 but not before he was able to see the publication through to completion. 1,150 copies of *A Voyage to Terra Australis* were printed, although his wife Ann and the scientific team would receive no royalties from the publication.

In April 1821 Ann wrote to the publisher George Nicol of the voyage account: 'I merely wish for a statement of the account, how the matter stands, whether the sale has cleared the expences [*sic*] of publishing? And whether anything more can be done towards furthering the sale of it, or what is the plan to be pursued concerning it?'

Although the publisher's accounts indicate that Ann was paid the sum of £190 in royalties, this was in fact a payment made because of her dire financial circumstances and in anticipation of profits that failed to materialise. Banks tried his best to help her but with limited success.

The financial failure of *A Voyage to Terra Australis* was not the fault of Banks or his specialist team but rather the result of an unfortunate set of circumstances. Arguably a voyage account of an incomplete expedition published so long after the event did not capture public interest at a time of upheaval and economic restraints resulting from the protracted Napoleonic Wars. Yet the voyage publication was of immense value on various levels, not least in terms of the charts and coastal profiles to aid navigation for seafarers that included the developing British colony in New South Wales.

In the year after the publication of *A Voyage to Terra Australis* Governor Lachlan Macquarie made a formal request to the Admiralty to send him the work – one that would ensure Westall's art would become known in New South Wales initially through the engravings featured in the main volumes, and later through paintings made after four of Westall's Australian engraved illustrations were featured in the Dixson and Macquarie wooden collectors' chests, created around 1818.

On 28 June 1815 Macquarie wrote to Lord Bathurst, Secretary for War and the Colonies: 'Being informed that the Nautical Surveys of the late Captn. Flinders, and the History of his Voyage along the Coasts of this Country, have been published under

the Authority of the Board of Admiralty, I avail Myself of this Information to State to Your Lordship that the Surveys and Charts of Mr Flinders, with the History of the Coast Connected therewith, would Afford the Government of this Country Very great service, as Documents of Established Authenticity, to resort to for Occasional References; and I beg Leave to request the Work and Charts of Captn. Flinders to be provided and Sent hither for the Use of this Government.'

The Governor had to wait around 20 months for his first sight of publication. On 4 April 1817 he wrote to acknowledge safe receipt: 'I beg leave to acknowledge the Receipt of Captn. Flinders' Chart of Australia and the Journal of his Voyage, which I have received in Duplicate, and have now return Your Lordship my best Thanks for sending this very Interesting Work for the use of the Colony.'

In *Joseph Lycett – Convict Artist* (2006) Richard Neville (Mitchell Librarian, State Library of New South Wales) considers that at the time Macquarie received his copies of the publication the colony of New South Wales supported a very small art community and most of those artists were convicts.

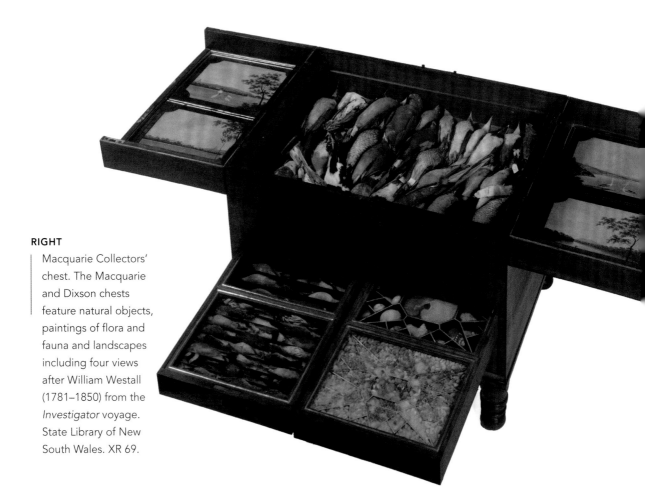

RIGHT

Macquarie Collectors' chest. The Macquarie and Dixson chests feature natural objects, paintings of flora and fauna and landscapes including four views after William Westall (1781–1850) from the *Investigator* voyage. State Library of New South Wales. XR 69.

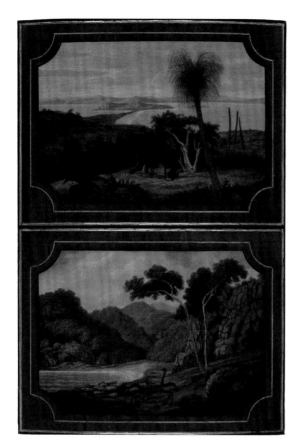

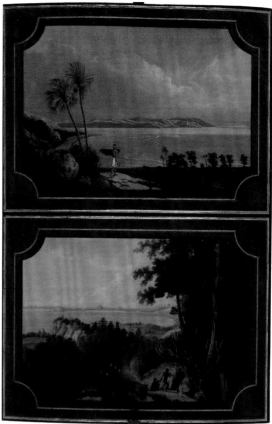

Neville noted that 'in 1820 the non-indigenous population of New South Wales stood
at 23,939 and of these only 1307 had come free, 1495 were born in the colony and 5668
were children. More than half were convicts, or had been … It was a small, and potentially
sensitive, market. Art was something which colonial governments were reluctant to allow
too much freedom.'

He also observed 'that Macquarie wanted to control colonial representations. In this
instance, if few others, Macquarie would have found considerable accord with the vision
of colonial patrons. They wanted images that mitigated the impact of the origins of the
colony through documentation of its progress. They also concentrated almost exclusively
on two genres: celebratory natural history images and images of Aborigines. These helped
distinguish this colony from other places, and gave "a locality to the land" (a function which
Judge Barron Field considered Aboriginal people usefully provided to colonial vistas)'.

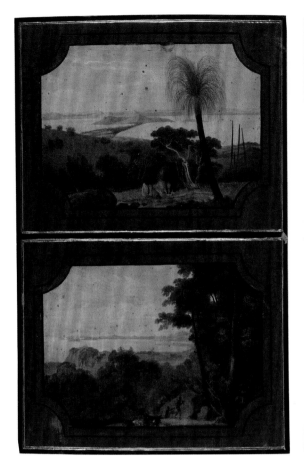

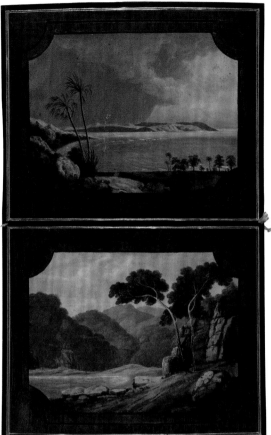

Although Westall had spent some time in New South Wales, there is frustratingly no evidence of his interaction – then or later through correspondence – with any of the artists in the colony and perhaps this can be explained in the light of Neville's account of the control exerted by Macquarie on the artistic community. The convict and free artists working in Sydney included John William Lewin and Joseph Lycett, and Captain James Wallis, the Commandant of the penal colony of Newcastle from 1816 to 1818. Wallis had a close working relationship with Lycett collaborating on the creation of the Dixson and Macquarie collectors' chests.

Elizabeth Ellis in *Rare & Curious: The Secret History of Governor Macquarie's Collectors' Chest* (2010) described Macquarie's collectors' chest as an 'enigmatic wooden cabinet filled with painted panels and exotic treasures' – a description that could equally be applied to the Dixson chest. Ellis explains that there are several unanswered questions in relation to the creation and purpose of both chests.

Sir William Dixson – the Australian businessman, collector and philanthropist – purchased the Dixson chest in London in 1937 and presented it to the State Library of New South Wales, where it is part of the Dixson Galleries collection. Its provenance

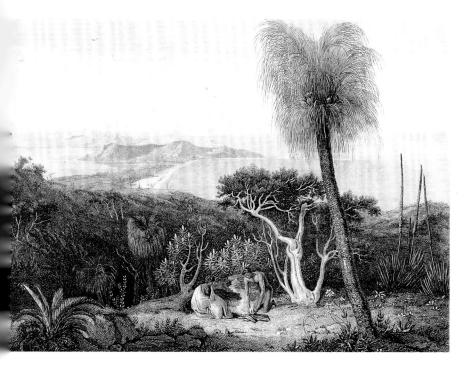

LEFT

View from the South Side of King George's Sound, engraved by John Byrne (1786–1847) after William Westall (1781-1850), published by G. and W. Nicol, 'Feb.12, 1814', for the official voyage publication Vol.1, facing p.60. Hordern House.

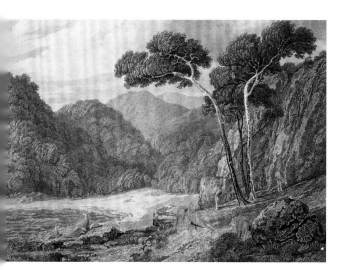

ABOVE

View on the North Side of Kanguroo Island, engraved by William Woolnoth (active 1805–50) after William Westall (1781–1850) published by G. and W. Nicol, 'Feb.12, 1814' for the official voyage publication Vol.1, facing p.184. Hordern House.

ABOVE

View of Port Bowen, from the hills behind the watering Gully, engraved by John Scott (1774–1827) after William Westall (1781–1850), published by G. and W. Nicol, 'Feb.12, 1814' for the official voyage publication, Vol. II, facing p.38. National Gallery of Australia.

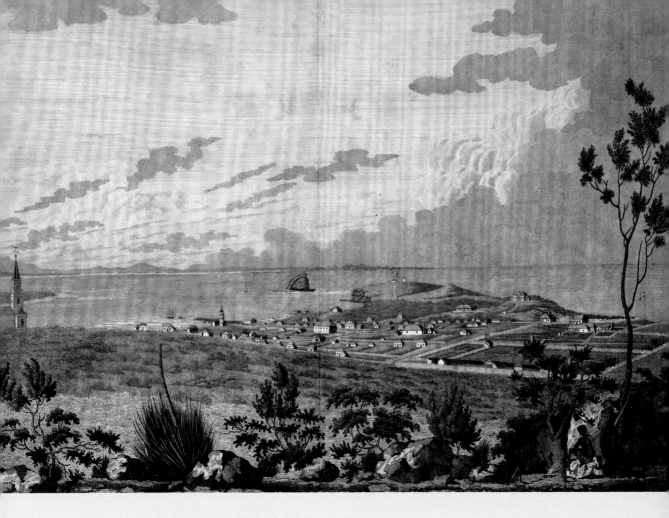

before that date has not been ascertained, although Ellis believes that, 'A slight contender as first owner … could be Barron Field, J. H. Bent's replacement as judge of
the New South Wales Supreme Court'. Field arrived in New South Wales in 1816.

There is, however, a provenance for Macquarie's chest, which also forms part of the State Library of New South Wales. It has been traced to Newcastle in Australia, and is now believed to have been a gift from Captain James Wallis to Governor Macquarie, who took it back to England with him in 1822.

Among the painted panels in the two chests are four examples after William Westall's engraved illustrations featured in the voyage publication. These copies have been attributed to Joseph Lycett, the Staffordshire-born artist, forger and convict who referenced Westall's illustrations from one of Governor Macquarie's copies of Flinders' voyage publication. The subjects are (in chronological order): King George's Sound; Kangaroo Island; Port Bowen and Malay Road.

These panel pictures are executed in a crude style compared to Westall's illustrations, although they possess spirited charm. The copies

in both chests differ from the originals noticeably in the omission of some animals, figures and vegetation. The blue garment held by the foreground figure in the panel picture referenced from *View of Malay Road from Pobassoo's Island* in the Dixson chest proves that the copyist was working from the black and white engraving, and had no knowledge of the red colour used by Westall for his Admiralty oil painting.

Neville has convincingly argued that 'it is likely that Westall's views were included to elevate the tone of the chests, by including in the cycle a series of Australian landscapes by a professional fine artist, whose status had been conferred by the Academy – Westall had been made an associate of the RA in 1812. These landscapes, bound up with the prestige of the *Investigator* voyage, were by virtue of this association more significant. Possibly Wallis hoped that some of this respect might be imparted into his own domain.'

BELOW

Cape Wilberforce, Australia, a Baxter print after William Westall (1781–1850) published in 1837. Private Collection. George Baxter (1804–67) was a pioneer of colour printing, however despite winning many awards his lack of business acumen resulted in the company becoming insolvent in 1860.

Captain James Wallis also collaborated with Joseph Lycett to produce a series of engraved views of New South Wales, which were published as engravings in 1819, 1820 and 1821. One of them engraved by Walter Preston around 1818 is entitled *Newcastle, Hunter's River, New South Wales*. It reveals another example of the colonial interest in Westall's European interpretation of the landscape of New South Wales, as the right foreground arrangement of the figure and the flora have been adapted from Westall's illustration *View of Port Jackson, taken from South Head* that featured in the voyage publication.

In the 1820s Westall returned to Australian subjects for exhibition in London. He displayed two pictures of Cape Wilberforce at the Royal Academy of Arts and British Institution in 1826 and 1827 respectively. Their original titles were similar, with the one displayed at the British Institution being described as *Cape Wilberforce, looking into the Gulf of Carpentaria, from the Indian Ocean, Australia, discovered by the later Captain Flinders, in His Majesty's ship* Investigator. The size of the painting was given as 3ft 9 x 5ft 2 in.

The example exhibited at the Royal Academy of Arts was picked out by the critic of the *Review – Literature, Arts &c,* 1826 as one of the 'many pictures of high claims to attention'. The status of the painting was also affirmed by Robert Westall, who in the obituary notice of his father described *A view of Cape Wilberforce, in the Gulf of Carpentaria…* as being one of his father's 'principal pictures' exhibited at the Royal Academy of Arts. The current whereabouts of the painting are not known, although the composition is revealed through a Baxter print addressed below.

Why Westall selected *Cape Wilberforce* as a subject to exhibit in London in the 1820s is not known for certain. Both Flinders (who died 1814) and Banks (who died in 1820) were no longer around to appreciate the painting. Cape Wilberforce is in East Arnhem in the Northern Territory, located south-east of the English Company's Islands (also named by Flinders), close to where Flinders met Pobassoo and the fishing fleet.

Cape Wilberforce had been named by Flinders on 14 February 1803, as he explained in his journal: 'after [William] Wilberforce the worthy representative of Yorkshire'. His worthiness in part related to his celebrated leading role in the abolition of slavery.

After returning to London, Flinders enlisted Wilberforce's assistance to gain backdated promotion, but Flinders declined Wilberforce's offer to raise the matter in parliament. On 18 June 1811 he noted in his journal, 'Recd. a note from Mr Wilberforce, saying that the decision I made not to bring my case before parliament was, he thought, correct. That he had tried to induce Mr Yorke [Admiral] to alter his opinion upon the subject, but in vain.'

The display dates of the *Cape Wilberforce* paintings correspond to the period after Wilberforce's resignation from parliament due to ill health. However, perhaps the subject was intended as a pictorial reminder of his influence as an anti-slavery campaigner.

William Westall and free settlement in Australia

Following the end of the Napoleonic Wars and the ensuing *Pax Britannica* there was a resurgence of interest in the prospect of creating free settlements far from British shores. By the end of the 1820s Australia was being considered again, and by the early 1830s several initiatives had been proposed by various organisations. In relation to settlement in south Australia, of particular interest were the locations surveyed by Flinders during the *Investigator* voyage, notably Kangaroo Island and land close to what would become the city of Adelaide.

The British campaigner Edward Gibbon Wakefield was one of the most important advocates of colonisation of south Australia who believed that the location could provide a solution to the social problems in Britain such as overpopulation. He was befriended by the philanthropist Robert Gouger, who took up the cause through the South Australian Association formed in November 1833 and helped to carry it through to completion. Their office was close to the Society of Arts on the Strand in London. In 1834 the British government passed The South Australia Colonisation Act. This was an 'Act to empower His Majesty to erect South Australia into a British Province or Provinces and to provide for the Colonization and Government thereof'.

Westall is intimately connected with the establishment of British settlement in south Australia through his words and pictures. He submitted a statement in Q&A form (for which he would have been paid in money or shares) that was circulated in publications by and for the South Australian Association including *South Australia: Outline of the Plan of a Proposed Colony To be Founded on the South Coast of Australia* issued in 1834.

As revealed in Westall's interview below, he certainly had changed his mind about what he had previously described to Banks as the 'barren coast' of Australia; rather parts of it now were described as 'Luxuriant'.

William Westall, Esq. 5, North Bank, Regent's Park.

Q. *You accompanied Captain Flinders' expedition as landscape draughtsman?*

A. *Yes, I did.*

Q. *On what part of Spencer's Gulf did you first land?*

A. *At Memory Cove, where the land appeared to be very good, the grass luxuriant, and the trees of a good size; one hut and other recent traces of natives were discovered.*

Q. *How far did you go inland at Memory Cove?*

A. *About three miles.*

Q. *Did you find water there?*

A. *Yes, and it was good, but in small quantities.*

Q. *Did you land at Thistle's Island?*

A. *Yes; I went about a mile and a half inland, and shot four kangaroos there.*

Q. *What appearance did the face of the country present?*

A. *The trees were high, and the grass luxuriant.*

Q. *What was the appearance of the land at Port Lincoln?*

A. *From reference to the sketches I made at the time, I am of opinion that the land between Port Lincoln and Memory Cove is well wooded, and that the trees are of a good size. Sleaford Mere is wooded down to the water's edge, but I should think the shore immediately west of Port Lincoln is barren.*

Q. *Did you land northward on Boston Bay?*

A. *I do not recollect that any of our party were there.*

Q. *Did you ascend Mount Brown?*

A. *Yes.*

Q. *What appearance did the land present?*

A. *The land was flat and well wooded as far as the eye could reach.*

Q. *Did you land in Kangaroo Island?*

A. *Yes; and while there, I walked over various parts of the eastern side.*

Q. *Was the land fertile?*

A. *Certainly: the trees were large, but a number of them had been thrown down apparently by some unusual cause. Young ones were growing up between them, and the grass was thick and short. We found a great number of very large kangaroos there.*

Q. *Was the land at Port Lincoln better than that at King George's Sound?*

A. *Certainly, much better.*

Q. *Was the appearance of the land at Kangaroo Island superior to that at Port Lincoln?*

A. *Yes, decidedly.*

I have looked over this statement, and to the best of my memory believe it to be correct.

(signed) W. Westall

Westall was one of several expert witnesses used to promote the interests of the South Australian Association in this and other publications. In addition, extracts written by Flinders in the official voyage publication were used, as well as information from official French voyagers and seal and whale traders relating to their expeditions in the 1810s and 1820s.

The importance of Westall's testimony to that organisation is that he added greater credence to the campaign for he was also an eyewitness – the only one in fact who had served with Flinders on the *Investigator* during the survey work of south Australia. John Aken, the master of the *Investigator*, had also submitted a statement that was published in the *South Australia: Outline of the Plan of a Proposed Colony…* 1834 publication, although he first joined the *Investigator* (as he reveals in the Q&A below) later on in the voyage at Port Jackson.

Key parts of Aken's statement are given below and were published alongside those of Westall and other witnesses.

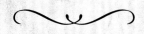

Mr John Aken, 321, Wapping.

Q. *You accompanied Captain Flinders on his Voyage of Discovery in the* Investigator?

A. *Yes, I joined him at Port Jackson, as master.*

Q. *Were you employed by Captain Flinders in collating and revising the Maps of the coast surveyed by him prior to your joining him as master?*

A. *Yes, I collated all the documents relative to his discoveries, and assisted him in completing the Maps afterwards published in England.*

Q. *During the time you were thus employed, had you opportunities of learning Captain Flinders' opinion relative to the eligibility of certain parts of the coast for the establishment of a Colony?*

A. *Yes, we frequently conversed upon the subject, and we had sufficient time for the purpose, in consequence of my being his fellow prisoner for some years in the Isle of France. [Mauritius]*

Q. *Do you recollect, what was his opinion as to the eligibility of establishing a Colony in the neighbourhood of Spencer's Gulf?*

A. *I can speak confidently upon this point: his opinion was decidedly in favour of establishing a Colony in the neighbourhood of Port Lincoln, although not exactly at the Port itself. He had used to talk of Fowler's Bay, and Kangaroo Island as desirable places for settlement in consequence of the fertility of the land.*

Q. *Do you recollect whether the majority of the officers who accompanied Captain Flinders were also of this opinion?*

A. *Yes, the opinion was certainly general amongst them: and it is strongly impressed on my mind in consequence of my conversations with him.*

I have carefully examined this evidence, and to the best of my knowledge, I believe it to be correct.

London, 23rd April, 1832
(Signed) J. Aken

Westall's supporting words, utilised in earlier publications, were reused for Edward Gibbon Wakefield's *The New British Province of South Australia* (1834) along with some useful maps – one of which clearly identifies Kangaroo Island. He related that, 'Mr Westall, the artist who accompanied the expedition, has kindly furnished such facts as he recollects which are likely to be interesting, and which are not embodied in Captain Flinders' narrative. This gentleman possesses still some sketches which he made at the time, from which a very accurate opinion may be formed of the kind of country.'

He concluded: 'It is to be regretted that these sketches have not been published – those of Port Lincoln, Sleaford Mere, and Memory Cove with a sight of which we have been favoured by Mr Westall, are most interesting.'

Despite Wakefield's claim, two of Westall's south Australian subjects did feature as illustrations in the publication in the form of wood-engraved illustrations. They were entitled *Entrance of Port Lincoln, Taken from behind Memory Cove* and *North View of Kangaroo Island*. To affirm the authenticity of the images the letterpress also indicated that they were both 'Painted by W. Westall, A.R.A., F.L.S., for Flinders' Voyage to Terra Australis'.

The wood-engravings featured again in the second edition of Wakefield's publication issued in 1838. The same supporting words used by Westall in his Q&A in relation to Kangaroo Island were also included. The prints were made by an unidentified printmaker and are based on Westall's originals, although an intermediary hand (unlikely to be Westall's) has interpreted them in a looser style whereby a considerable amount of the detail in the original formats of painting and engraving has been omitted.

It is also known from Robert Gouger's diary entry of 6 April 1835 that William Westall offered to produce six engravings to promote the new colony. Gouger noted, 'I have had a long conversation with Westall. He proposes to sell me six engravings of South Australia for £15 each. I have consented to purchase them, and shall at once issue a prospectus about them.'

The prospectus was issued inviting subscriptions for 'Six Original Views of Kangaroo Island, Cape Jervis, Mount Brown, Sleaford Mere, and Port Lincoln from two positions, in the new colony of South Australia; Drawn and Engraved in Aquatinta by William Westall, Esq., A.R.A.' However, although advertised, the publication of the six prints by Ackermann and Co. was in fact abandoned.

Jane Hylton, in *A smiling and happy land: pre-settlement images of South Australia* (2012), believes that the various prints of south Australia produced after Westall's illustrations that originally featured in *A Voyage to Terra Australis* and variants were 'accepted as testimony of their being "truthful" images by someone who had seen these views with their own eyes', and that, 'Now readers were more able to form a "picture" in their minds of what their new home might look like'.

A variant of Westall's *Entrance of Port Lincoln from behind Memory Cove* featured in the *First Report of the Directors of the South Australian Company,* 1836, on the fold-out frontispiece, with the title *Port Lincoln, taken from the South*. It was acknowledged as being drawn and engraved (etching with aquatint printed in black ink) by William Westall, who became an accomplished printmaker post-*Investigator* voyage. It was published by Ackermann and Co. in 1835.

In October 1835 the South Australian Company had been established as a joint stock company by George Fife Angas and other merchants. It developed out of the South Australian Association but had different views on the sale of land.

248

LEFT

Entrance of Port Lincoln, taken from behind Memory Cove, by an anonymous engraver after William Westall (1781–1850), wood-engraving published in *The New British Province of South Australia* (1834). Private Collection.

BELOW LEFT

North View of Kangaroo Island by an anonymous engraver after William Westall (1781–1850), wood-engraving published in *The New British Province of South Australia* (1834). Private Collection.

Hylton reveals Westall's landscape view published by Ackermann and Co. in 1835 for the *First Report of the Directors of the South Australian Company*, 1836, also featured in George Fife Angas' post-settlement propaganda publication written on his behalf by John Stephens. It had the impressively long title of *The Land of Promise: Being An Authentic and Impartial History of the Rise and Progress of the New British Province of South Australia; including Particulars Descriptive of its Soil, Climate, Natural Productions, &c and Proofs of its superiority to all other British Colonies. Embracing also a Full Account of The South Australian Company with Hints to various Classes of Emigrants, and Numerous letters from settlers concerning Wages, Provisions, their Satisfaction with the Colony, &c By One Who Is Going*, and was published in 1839. It is, not surprisingly, usually shortened to *The Land of Promise*.

In 1839 the publication was reprinted under the revised title *The History of the Rise and Progress of the New British province of South Australia: including particulars descriptive of its soil, climate, natural productions, &c*. It also featured a variant of Westall's landscape view. However, this time the depiction of *Port Lincoln* is credited to A Butler, after William Westall, and was reproduced as a lithograph.

Butler produces a fairly close copy of Westall's original that was published by Smith, Elder & Co., although in execution it is less sophisticated compared to Ackermann and Co. Perhaps the South Australian Company benefited from a lower fee charged by the artist/printmaker 'A Butler' (of whom nothing is yet known) for producing a black and white lithographic variant of the subject, as opposed to the higher rate that William Westall most likely would have charged now a senior Associate of the Royal Academy of Arts.

Hylton addressed a key source of criticism of Westall's engraved landscape view of Kangaroo Island that featured in the voyage publication. It relates to the artist George Hamilton, who believed that he had been misled by Westall's illustration. Hamilton wrote under the pseudonym John Newcome and his article entitled 'My colonial experience' was published in the *Adelaide Miscellany of Useful and Entertaining Knowledge* on 9 September 1848.

Hamilton wrote, 'The absence of seals, kangaroos and emus that enliven the views [of Kangaroo Island] … mixed up in my mind with all seaside scenery in this part of the world, took from it in my opinion its Australian character, the more so, as no black men or women were gazing in wonder at our noble vessel as she sailed majestically along … My ideas of the aspect of this colony having been formed from such pictures of it, as had occasionally been shewn to me … it is not surprising that the scene appeared incomplete without them.'

Most of the ships that sailed in 1836 with free settlers headed for Kangaroo Island in South Australia. The first vessels to depart in February were the *John Pirie* and the *Duke of York*. They were followed by the *Cygnet* and *Lady Mary Pelham*, the *Emma*, the *Rapid* (with Colonel William Light) and the *Africaine* (with Robert Gouger) and *Tam o' Shanter*.

Surveyor-General Colonel William Light considered Kangaroo Island unsuitable, and eventually a location on the mainland of Australia was agreed and colonial government formally commenced on 28 December 1836 in the embryonic city of Adelaide.

Flinders' deliberations on possible places for colonial settlement – alluded to in *A Voyage to Terra Australis*, elaborated upon by John Aken in his Q&A, and allied to Westall's promotional images and words – derived from an expedition championed by Banks that connects them all to the establishment of the first free colonial settlement in Australia.

The resurgence of British interest in Australia in the 1830s caught the attention of the commercially astute printmaker and publisher George Baxter, who issued a version of Westall's oil painting *Cape Wilberforce* as a Baxter print. It featured in *The Pictorial Album or, Cabinet of Paintings for the year 1837*, which contained 'eleven designs, executed in oil colours by G. Baxter from the original pictures with illustrations in verse and prose'. In this 'Album' Westall's *Cape Wilberforce* was used in the chapter entitled 'Cape Wilberforce – The Avenger and his Bride' to illustrate the fictional tragic tale of Frederick

BELOW

Port Lincoln, by A. Butler after William Westall (1781–1850), zinc lithograph, published by Smith, Elder & Co., in 1839. Private Collection.

250

Granville and Jules D'Emden that included references to Flinders' *Investigator* voyage.

From the late 1830s William Westall's work rate slowed down. He experienced a terrible ordeal in the following decade – recollected although not fully explained by his son Robert Westall in his father's obituary. Robert recalled, 'In the autumn of 1847 Mr Westall met with a very severe accident, not only breaking his left arm, but receiving serious internal injuries. From the effects of this he never recovered; and during the last winter [in 1850], a succession of severe colds terminated in a bronchial attack, accompanied by dropsy, which carried him off after a few weeks of suffering.'

However, Robert Westall also revealed that his father had returned to an Australian subject towards the end of his life, and that 'His last illness intercepted the progress of a painting of "Wreck-reef a few days after the loss of the *Porpoise* and *Cato*," which he commenced a short time previously'.

Westall's engagement with the Pacific, and specifically Australia, went beyond art into financial investments. His assets that were transferred to his three sons after his death included shares in the Union Bank of Australia that had been first established in London in 1836. The bank was later subsumed into the Australian and New Zealand Banking Group (ANZ). It is highly likely – although not yet conclusively proven – that Westall received payment or shares from this bank for Australian artworks, perhaps to be used for promotional purposes.

Conclusion

Today Sir Joseph Banks – in sharp contrast to Captain James Cook – is better known in parts of Australia, New Zealand and some Pacific Islands than in his home country. Explanations are to why this is so often focus on the lack of his name on publications.

The fact that he swapped the life of an adventurer at sea to that of a shore-based administrator probably didn't help in terms of maintaining the profile of this hardworking gentleman-naturalist who was President of the Royal Society for more than 40 years. History mostly remembers the men and women of action, and not so much those pushing from behind. However, Banks was a supremely skilful enabler and connector, who could and did make things happen for others.

Banks ought to be better known today – among many other things – for encouraging professional artists to participate on voyages of exploration and discovery to the Pacific, and for his prominent part in supervision of the Admiralty publications featuring their work (a selection of which were executed in a neoclassical style at his behest) and those of his associates. In addition to public benefit, he assisted the artists to develop their work for exhibition in the hope of advancing their own careers.

The deaths of Alexander Buchan and Sydney Parkinson on the *Endeavour* expedition highlighted the hazards of voyages of exploration. William Hodges, the Admiralty artist on Cook's second voyage, produced some of the most sensational Pacific oil paintings not only in terms of subjects but also of application of paint and lighting effects. Although he was elected a Royal Academician and later produced striking artworks in India, he struggled financially and died destitute after embarking on an ill-fated banking venture.

John Webber, the Admiralty artist appointed for Cook's third fatal quest into the Pacific, was the most commercially successful of the group. Webber's carefully selected subjects and detailed watercolours, and oils, attracted many buyers and commissions. His voyager subjects endured as subjects for many years at the Royal Academy of Arts and he issued prints of a selection of his Pacific subjects that continued to be published in the early 1820s.

While Ferdinand Bauer and William Westall – who both produced memorable work of a very different kind – were in part victims of the financial constraints in Britain towards the close of the Napoleonic Wars, Bauer's skill led Bernard Smith to describe him as 'the Leonardo de Vinci of natural history painting'. However, his collaborations with Robert Brown on Australian flora, although ground-breaking, were poorly received commercially. Brown's unillustrated *Prodromus Florae Novae Hollandiae et Insulae Van Diemen* that described more than two thousand species was published in 1810. In 1813 Bauer produced a book known by the shortened title of *Illustrationes Florae Novae Hollandiae* that illustrated the species in Brown's *Prodromus*. By 1814 Bauer had returned to Austria.

Westall became an Associate of the Royal Academy of Arts but progressed no further. Art then and now was a very competitive business and so he entered 'the book trade', producing drawings and prints for publishers (some by himself), and continued to exhibit diverse subjects. He became a successful commercial artist but regretted that he was not able to make a career as a fine artist.

Incredibly Westall's remarkable series of ten Australian oils created for the Admiralty and championed by Banks have yet to be collectively displayed to the public in an art gallery or museum. It is hoped that this might now change.

All the voyager artists in various ways can be connected to Sir Joseph Banks. In October 1780 Captain James King acknowledged Banks' assistance in securing for him the paid position of co-writer of Cook's third Pacific voyage when he wrote: 'It is with real pleasure & satisfaction that I look up to you as the common Centre of we Discoverers'.

Banks was at the centre of British maritime discovery and the art of exploration.

Index of Artworks and Artists

Admiral Edward Pellew, 1st Viscount Exmouth 217
Aliament, F. C. 121

Bartolozzi, Francesco 114, 115, 116, 146
Bauer, Ferdinand 60, 61, 62, 63, 64, 65, 152, 153
*Bay on the South Coast of New Holland, discovered by
 Captain Flinders in HMS* Investigator 197
Bestland, Cantelowe W. 159
Boats of the Friendly Islands 8
Boott, Francis 93
Boxing Match, in Hapaee, A 138
Buchan, Alexander 20
Butler, A. 250
Byrne, John 241
Byrne, William 30–31

Cape Wilberforce, Australia 243
Ceyx and Alycone 126
Chambers, Thomas 119
Chasm Island, native cave painting 164
Chief at Sta Christina, The 121
*Chief of the Sandwich Islands leading his party to
 battle, A* 141
Cipriani, Giovanni Battista 114, 115, 116, 117
Cook, Thomas 134
Crosse, Richard 56

Dance in Ra'i tea, A 117
Dance-Holland, Nathaniel 88
Daniell, William 156-57
Death of Captain James Cook, The 142
de Chamarel, Toussaint Antoine de Chazal 151
Destruction of the Children of Niobe, The 122–23
Dilettanti Vase Group, The 101
Duttenhoffer, Christian Friedrich 170

English Company's Islands, Malay Road, The 219
*Entrance of Port Lincoln, taken from behind Memory
 Cove* 248

Fisher, Edward 109
Forster, Georg 36, 38

Hall, John 121
Hamilton, William 146
Heaphy Jr, Thomas 200–1
Highmore, Joseph 69
Hodges, William 12–13, 22–23, 35, 40–41, 42–43,
 66--67, 96–97, 118–19, 121, 124–25, 128, 132,
 133, 206

Jacobé, Johann 110

Kangaroo Island, a bay on the north-east coast 203
King George's Sound, view from Peak Head 196

Landing at Erramanga, one of the New Hebrides, The
 132
Landing at Middleburgh, one of the Friendly Isles 133
Landscape – solitude 168–69
Landscape with Hagar and the Angel 160
*Landscape with Pines & a large trunk in the fore-
 ground* 181
Lawrence, Sir Thomas 90
Lorrain, Claude 160
Lucky Bay 198
Lycett, Joseph 239, 240

Macaroni Penguin 53
Man of New Caledonia 121
Man of Nootka Sound, A 52
Man of the Sandwich Islands, in a Mask, A 134
Miller, John Frederick 55, 71
Mortimer, John Hamilton 27
*Mount Westall, view north across Strong Tide Passage
 and Townshend Island* 210
Murray Isles, natives offering goods for barter 212

Narta, or Sledge for Burdens in Kamtchatka, The 46

Newcastle, Hunter's River, New South Wales 242
New Zealand War Canoe bidding defiance to the Ship 84
Nobleman's collection, A 144
Nodder, Frederick Polydore 75, 76
Northcote, James 217
North View of Kangaroo Island 248

Omai, A Native of the Island of Ulietea 110

Parkinson, Sydney 19, 28, 30–31, 55, 70, 74, 75, 76, 78, 84, 85, 116, 117, 119
Parry, William 45
Part of King George III. Sound, on the South Coast of New Holland 195
Party from His Majesty's ships Resolution & Discovery Shooting sea-horses 48–49
Pickersgill, Henry William 94
Poedua, the Daughter of Orio 137
Port Jackson 228–29
Port Jackson; a group of natives 230
Port Jackson, a native 161
Port Jackson, an old blind man 162
Port Jackson, Sydney 108
Port Lincoln 250
Port Lincoln, taken from the South 251
Portrait of a large dog, A 81
Portrait of Otegoowgoow 85
Portrait of the Kongouro from New Holland, A 80
Preston, Walter 242
Pye, John 230

Reynolds, Sir Joshua 86, 99, 101, 109, 110
Reynolds, S. W. 99
Rigaud, John Francis 36, 114–15
Royal Academicians Assembled in their Council Chamber, The 159

Say, William 101
Scetch of Pines very slight – whole sheet 181
Scott, John 241
Scriven, Edward 166

Sharp, William 52
Sherwin, John Keyse 133
Singleton, Henry 159
Sir Edward Pellew's Group, Vanderlin's Island from Cabbage tree Cove, North Island 216
Solitude 170
Spruce Fir of New Zeeland, The 38
Strahan, William 38
Stuart, James 'Athenian' 99
Stubbs, George 80, 81

Taylor, Isaac 138
Telemachus relating his Adventures to Calypso 166
Thornthwaite, John 35
Toopapaoo of a Chief, with a Priest making his offering to the Morai, in Huoheine, A 139
Two of the Natives of New Holland, Advancing to Combat 119

View from the South Side of King George's Sound 241
View in Pickersgill Harbour 40–41
View in Queen Charlotte's Sound, New Zealand 136
View in Sir Edward Pellew's Group; – Gulph of Carpentaria 214–15
View in southern Australia with Aboriginals spearing kangaroos, A 200–1
View in the Island of Cracatoa 135
View in Ulietea 51
View of Cape Stephens in Cook's Straits with Waterspout, A 124–25
View of Cape Townsend and the Islands of Shoal Water Bay 184–85, 208–9
View of the Cape of Good Hope, A 22–23
View of Malay Road from Pobassoo's Island 220–21
View of Matavai Bay, in the island of Otaheite, A 66–67, 118–19
View of Murray's Island, with Natives offering to barter 211
View of New Caledonia in the South, A 206
View of North Side of Kangaroo Island 232–33
View of Port Bowen, from the hills behind the watering Gully (engraving) 241

View of Port Jackson, taken from the South Head 230

View of the bay of Pines, or Port Bowen 176–77

View of the European Factories at Canton, in China, A 156–57

View of the Indians of Terra de Fuego in their hut, A 115

View of the inside of a house in the Island of Ulietea, A 116

View of the Monuments of Easter Island, A 42–43

View of Wreck-Reef Bank, taken at low water 224–25

View on the East Coast of Australia 24

View on the North Side of Kanguroo Island 241

View taken in the bay of Otaheite, Peha, A (Tahiti Revisited) 12–13

Wallis, Captain James 242

War-Boats of the Island of Otaheite and the Society Isles, The 96–97

Webber, Henry 104

Webber, John 8, 46, 47, 48–49, 50, 51, 52, 53, 134, 135, 136, 137, 138, 139, 141

Westall, Richard 35, 166, 168-69

Westall, William 24, 108, 148–49, 154, 161, 162, 164, 176–77, 181, 188, 195, 196, 197, 198, 203, 206, 208–9, 210, 211, 212, 214–15, 216, 219, 220–21, 222, 224–25, 228–29, 230, 232–33, 235, 238, 239, 240, 241, 243, 248, 250, 251

West, Benjamin 2

Whampoa and the Canton River 235

Wheatley, Francis 105

Williamson, Thomas 166

Wilson, Richard 122–23, 126, 170

Woolnoth, William 241

Zoffany, Johan 142, 144